D0936829

# A LOVE AFFAIR

*Gertrude Vanderbilt Whitney*

# A
# LOVE
# AFFAIR

*Richardson & Snyder*
*1984*

# A LOVE AFFAIR

## 1

The Maison Feodor was filled with the restlessness of Saturday morning. At noon the massive street doors and the iron grille would be closed by Auguste until Tuesday. Monday was *jour de fête*.

Years ago this relic of the Faubourg aristocracy had been transformed into a *maison de couture*.

Now lighthearted, or tired, girls, and middle-aged women arrived hurriedly each morning and took up their work. Some created dresses, some cut patterns, some sewed and sweated in morose rooms. The great windows which were bare since the old days to let in the light, would have shocked the eyes of earlier generations. Once brocaded curtains shut out the sun leaving somber hue for those within, and protecting them from the eyes of the passerby.

Madame la Marquise de Portier, known to the world as "Madame Feodor," stood in her private citadel on the *grande estrade* reviewing the gowns, evening wraps and summer effervescences before their delivery to patrons. Her shiningly up-to-date appearance was duplicated from all angles by the walls of her mirror-lined workroom. Every

gesture of the women there was multiplied in the cunningly angled mirrors.

Madame's well-disciplined face and figure, and her air of using them to her own (and everyone else's) satisfaction, never deserted her. Now the bold look in her eyes turned to an expression of adoration as she inspected one of her own creations.

"How very subtle," she murmured ecstatically. "Clothes, when understood, can approach the divine."

She lingered over the dress, touching the folds lovingly as though they were precious to her. Other garments she looked at did not satisfy her—one in particular.

"*Oh, la, la, quelle sottise, ma petite.*" She looked piercingly at the girl who was presenting it. "You will have to stay this afternoon." She pointed out flaws.

The girl's head drooped. "I did my best."

"No, no, you have put no love in it. There, don't cry. You will stay and rectify the faults." She raised her voice in order that all the girls waiting to show their craftsmanship should hear. "It is insupportable that execution should not be perfect in my *atelier.* You all must be *artistes.*"

As she turned to inspect the next dress, she caught in one of the mirrors the reflection of Madame Nada, standing in the doorway. "Come in, Sandra. Is Mademoiselle Yolande's order complete?"

The girls made room for Nada to pass. One of them whispered to a newcomer, "She is the exception—*une américaine.* She has the best *clientèle* of any *vendeuse* here. You will be lucky if you can work under her."

"I hope you will be pleased." Sandra's low voice had a coolness in it. She spoke rather fast, as though not to take

up too much of Madame's time. "I hate to interrupt, but a new customer is in the salon."

Feodor was examining another dress. She gave a nod of approval, then a sidewise glance at the younger woman.

Sandra was smiling. She appeared full of life while everyone else seemed harassed, for the noon air was sodden. But Sandra brought a slight, provocative sense like a cool perfume stirring around her.

"A German customer, I suppose?" Madame asked with great indifference.

"No, a rich American. I know her slightly. She has come in with an order as long as a comet's tail."

"Is she smart—wears her clothes well?" The great *couturière* examined another dress. "Good execution, this will go a long way to remedy the lady's faults of construction. I am pleased."

Sandra replied that the customer was fairly smart in appearance and had distinct possibilities. "Will you find it possible to see her soon? She wants to meet you," Madame Nada said, moving towards the door. She stood for a moment to look back.

The curve of Feodor's lips turned her smile crooked as she quoted a well-known saying about herself: "'Personality plus clothes.' I'll be there directly."

Madame Nada, the *vendeuse*, turned into Sandra on her way back to the show salon. The long corridors, the rooms through which she passed, with their old *boiseries*, were beautiful, she thought. Today she was conscious of her happiness and her body felt as light as when she was a child.

The new customer sat watching as a parade of *mannequins* silently came into view.

When Feodor glided in, her smooth hair glowing, the corners of her oriental eyes elongated by kohl, her indifference and hauteur were coldly appraising. The American woman ordered five more dresses, and went away thinking, "I must cultivate her walk."

Nada glanced at the mantlepiece to see the Louis XVI clock. "Three minutes past eleven," she said to herself. "In an hour I shall be singing in the streets, and not all the king's horses and all the king's men could stop me, not even the gendarmes. *They* always understand.

She did not dare to reflect, or to remember the new vein of events that was shaping her life, leading her away from security. All morning had brought her to standstills. She must be alert and resolute. She must assemble samples for the new customer. "She's very ugly, but what a figure! That model—*L'après-midi d'un Faune*—hardly anyone could wear it. In orange it will make her a sensation."

At the door of the salon, the salesgirls and fitters were effacing themselves to let a stout, important-looking woman come in. It was the Baroness Rosenstein who, at the sight of Nada, threw up her hands in a gesture of expostulation, shaking her head from side to side like a marionette.

"You sent me a dress I cannot wear!" she shrieked. "My dress for the gala last night. The Baron would not allow me to appear in it!" Her voice rang so that everyone in the room could hear.

Nada's expression remained unchanged. She waited. "I advised you, Madame la Baronne," she said quietly, "not to have it cut so low."

10

The other *vendeuses* turned away to hide their smiles.

"The neckline is no lower than those worn by that Yolande woman," she said.

All Paris knew the Baron paid for Yolande's clothes.

Nada remarked, "Shall we modify it? Of course the Baron is jealous of you."

The stout woman knew it was not true, but she was glad Nada had said it. She enjoyed having an American lady wait on her. She would have liked it better were her *vendeuse* English. Later in the fitting room, as the dress was forced into lines that flattered her abundance, she thought, "Nada is clever. I appear to have lost pounds."

The clock lingered on toward noon. At last, the hands closed together at twelve. Church bells clanged rhythmically, no two beginning at the same time. Workmen's whistles shrilly sounded their note of freedom.

Saturday mornings were always filled with fears of imminent problems. Delays, unexpected necessities might arise, curtailing the holiday. Yet despite the apprehensions, a certain radiance filtered through each *atelier*, each fitting room, and all the stately salons of Madame's establishment.

Anticipation, or the memory of other weekends, lent an electric quality to the air, so that as the girls and elder women began to leave, the chatter rose to a level of excitement which no decorum could control. Banter took place between bitter enemies, smiles broke out when there was nothing to smile about. And faces betrayed hopes and desires too poignant to be hidden.

Downstairs, old Auguste would soon lock the doors

firmly, with the resolute face of a man who could resist an army. He knew that each little *poule* wanted to get away quickly to her lover. He liked to think of them scattering down the streets into the outstretched arms of romance.

Auguste's lost youth was reborn every Saturday noon. Later, Auguste would go back to Passy and his granddaughter. They would take an excursion boat up the Seine, armed with a basket lunch and his fishing rod. He usually caught nothing at all.

Upstairs, in the *vestiaire*, hats were being set at rakish angles, on heads that bobbed. Everyone was hurrying. Sandra came down first with a cheerful nod for Auguste. She slipped him some coins, "For your granddaughter," she said.

The sudden appearance of daylight as she reached the sidewalk struck her in the eyes, and blurred the street. Now that she was free, she was in no hurry. She very much wanted to be part of the crowd. She walked home, instead of taking a bus or a taxi.

She was used to being stared at. She felt no wish to evade the illuminated faces of the men who passed by.

*They don't know I'm thirty-seven*, she thought gaily. *Perhaps I am not.*

Yet on the boulevard, the pressure of inadvertent pushing, the bold stares, and the thickening holiday crowd became repellent to her. She called a taxi. Then she lapsed into her own thoughts. The outside world receded. Sandra Fane began thinking about the preceding month.

It had been only a month since she had met Marston Overstreet— A month lived in a glamorous mist, like that smoky fog that often comes at dawn. Filled with delicious

12

memory, she was oblivious to the streets; nor was she conscious of time till the driver tapped on the closed window between them. She was sure, although she had not heard him, that he had tapped before. She had no idea how long the taxi had been in front of her apartment house.

The driver relaxed on his seat, his cap pushed to the back of his head. Sandra sprang out into soft, fading light. *"Le printemps"* he remarked indulgently, as if it explained everything. *"C'est beau, le printemps."*

He watched her until she disappeared through the entrance.

The moment she was upstairs in her nondescript, grey hallway, she resumed her old life. This was reality, where Sandra had lived for three years.

Instinctively her eyes fastened on the table where Louise, her maid, put the mail. Today there was a big pile of letters—American mail, too—topped by a *petit bleu*.

Her calmness deserted her. Sandra was panicky. Had something happened? Marston could have been called out of Paris. She knew his mind was unchanged about seeing her. She would have staked her life that his desire to meet her at the château was unshaken. But his wife and his children were responsibilities Marston had to reckon with.

The realization struck her, as though a dam had broken, and Sandra was being swept into the millrace.

She held the *petit bleu* in her hand.

She tore open the perforated edges of the message. It was not from Marston. That was fine because it meant they would meet at the château.

Sandra was alone. Louise was fixing her luncheon. She was lonely, and while she felt joyous about the near future,

13

she also felt she had crossed a bridge and having made it to the other side, had turned to see that the bridge was no longer there.

Sandra felt a sense of happiness. She opened the door to the sitting room. Her friends said she had made the hall nondescript just to wind you up. The pink walls of the room, the flame colored curtains and harmonious mixture of antique and modern furniture had great charm. Sandra thought of Marston every day. Not just today.

In the shady dining room, Louise had laid out a cold luncheon.

"Are my bags packed?" Sandra asked.

It was Louise's habit not to waste energy on words. "The bags are ready, she said. "The bath is ready. The black-and-white suit is laid out."

"In three quarters of an hour I'll want a taxi."

"Shall I forward your mail, Madame?"

No flicker of interest showed on Louise's face.

"No, that's not necessary. I am staying with friends in the country and will be back Tuesday morning. As you know, Monday is a holiday. You might take a little holiday yourself, Louise."

"*Merci*, Madame, the apartment is very comfortable." Louise moved towards the door in her peasant's tread. Sandra reflected she didn't mind her *bonne*'s clumsiness because of her qualities. She was interested only in her work. And her cooking was superb.

The door closed behind Louise. Sandra smiled, thinking, "She calls her husband, *mon homme*."

She often imagined the life Louise and her husband had pieced together from one night off a week, and every other

14

Sunday from two to six. A year ago, after six months of service, Sandra asked, "Louise, what does your husband do?"

A laconic answer ended the conversation, *"Il travaille."*

Precisely at the time fixed, Sandra found her bags in a waiting taxi.

*"Bon voyage, Madame,"* Louise closed the door.

The car sped forward in a crazy way. As if to match her mood it seemed to cry: *"A bas la prudence."* She sat back smiling. The driver turned his head for a second to grin at her. *Ah! la, la, mademoiselle was going to the Gare Montparnasse, probably for the holiday.* Sandra was happy.

She said, "I am not in such a hurry, even if I am catching a train."

The driver turned to her again, an impish look on his face, *"Pardon,* Madame."

Sandra laughed, "I don't want to die before the weekend," she said.

"Fear nothing, we shall progress like a *pompe funèbre."*

They started violently forward. A few moments later, with a sudden squeal of brakes, the taxi halted at the station.

Usually Sandra did not travel first class, but today was different. She felt her trip was uniquely exciting. She imagined that everyone in the *Gare* must be going to Dreux. But to her surprise they scattered in various directions, and when her porter deposited her bags, her carriage was empty. Just as the train was about to start, a youngish man hurled himself into the compartment, aided by three porters carrying an avalanche of ultrasmart luggage—grips, golf clubs, and tennis racquets. There was no time to arrange them; they were just heaved in. They cluttered up the floor and filled seats except the one to which Sandra had quickly retreated.

15

The door slammed. It was evident that in the turmoil the new arrival had not noticed the other passenger in the compartment. He collapsed on a pile of disordered bags, mopping his face.

"I can't believe it. Archie Cummings!" Sandra exclaimed from her corner.

He looked bewildered. "Sandra Fane!" He did not move, but went on mopping his face while staring at her.

Her first thought was to wish she had gone second class. Anything to avoid conversation. She had been talking all day, even taxi drivers would not leave her any privacy. Yet Dreux was only thirty-five miles away. She wondered, with a shock, if Archie Cummings were going there, too.

"I can't move," he said. "Come over and shake a friend by the hand."

"How do you even expect me to *move?*" she asked. "I'm barricaded."

"Climb over into my trench. I haven't talked to you in years. Just saw you just once, from a distance." He rested his hand on a pigskin valise. "God, were you bruised by my luggage?" Without waiting for an answer, he drifted off. "If I'd missed this train, there would have been hell to pay."

"Archie, I never saw such a mountain of luggage. Are you going off for India?"

Her companion smiled amiably. "Just a weekend. It's at the Jouvenet's," he explained.

"Deauville, isn't it?" She softened her voice to one of indifference. Deauville was hours beyond Dreux and if Archie Cummings was going so far she had no real reason to mind his being there.

16

He nodded, replaced his blue striped handkerchief in the upper left-hand pocket of his coat, so that just the correct amount was visible, and took out his cigarette case.

"Why didn't you bring your valet and your car with you?" Sandra said.

"I didn't think of it." There was a kind of simplicity about Archie. You picked up your conversation with him exactly at the point you had left it a year or more ago.

"I'll get some of this trash out of the way," he said, without moving except to light a cigarette. He blew out a big breath. "Lord, I'm dead beat."

Sandra laughed. "I won't bother you for long. I am getting out at the next station."

"Not going to the Jouvenet's?" He spoke regretfully.

"No, I'm staying with some old friends."

"Why isn't this a vestibule car? Then I could get a porter to clear away this stuff. I can't sit here shouting at you." He looked at the luggage angrily, as though it belonged to someone else. With a great effort he got up and cleared a small space on the seat opposite Sandra.

"Things do change in as short time, don't they? By the way, have you married again?"

She shook her head.

"How long ago it seems. Dear old Tony, he was a great scout until he got running wild. Wasn't good to be married to him then, I'll bet." He puffed at his cigarette. "Sorry, I forgot, would you like one?"

Sandra was thinking how little Archie had changed since the Boston days, except to have acquired a certain continental veneer. She shook her head.

"Have you done anything I ought to know about, Archie?" she asked. "You're still at the top of your form in sports, I've heard."

"Nothing I would have time enough to tell you now." And in a moment he went on: "I always said it must have been tough for a New York girl to live in a provincial town."

"Don't be silly! Tony was born and bred on Beacon Street, and always worked in his father's bank. I liked Boston." She heard little of Archie since he had come to live abroad, except in the social columns.

"You sold that place of yours on the North Shore?" he said.

"It went with everything else after Tony died." Then she said quickly, "That wasn't his fault. It was just the unfortunate twenty-nine crash. Aren't you going to tell me about yourself? You used to be wild, but not very exciting," she said to Sandra. "You look pretty busy."

"I'm just the same. As you know, I was one of the few lucky ones who made money in thirty-one. That's not considered anything to boast about, but it was convenient." He sat back. "Tough luck for you though, left flat."

"You know you don't look a year older," she said, and was thinking, *He always has been rather like a handsome mummy preserved in wrappings from any real touch with life.* She turned to look out the window. To her, Archie was suddenly blotted out. It was as if he had not been there. Sandra disappeared into her own thoughts.

It seemed that being out of Paris was like liberation from a system which blurred your vision. Back there in that overenergized city, there was an intangible personality in

the buildings, even in the air and the smell of the pave-
ments, which made you feel and act like everyone else, and
she was not acting or feeling like anyone else. No one was
as free or as happy as she was, now.

Archie kicked a bag aside to give himself more room, so
that Sandra paid attention to him again. "Isn't it lovely?"
she said spontaneously, with a wave of her hand towards
the pale wheat fields.

Archie looked out as though expecting to find some star-
tling sight. "What?" he asked. Then he sank back in his seat.

"Is there anything so beautiful as wheat fields in France?"
She felt foolish after she had said it.

"France is jolly, but I like England or sailing better."

Her eyes went back to the passing landscape.

"How do you manage," he asked, "To look so cool and
collected?"

He did not listen to her answer. He was tracking down in
his mind what he had heard of her in recent years. After
Tony Fane's death she had come abroad to live. Now San-
dra was in Paris to make a living at— "Are you still in that
dressmaking place?" He seemed uneasy, as though he hated
to think of anyone working.

"Oh, yes. It's fun. I like it."

"I never thought you would stick to it all these years."

"It's only three, Archie."

"That's a hell of a long time to work."

She smiled, "I'm lucky. Madame Feodor is a great artist.
She's my boss. Tell me, anything special happened to you?"

He didn't answer. "Sandra, did you ever think of marry-
ing again?" He handed her a cigarette.

"Don't be banal." She remembered that besides sports Archie's absorbing interest was people. She was apprehensive because she knew he was astute about people. He could fill in the details of a sketchy story with uncanny deftness. Sandra leaned towards him, "At least tell me what you do to keep busy since you've deserted America?"

He responded amiably. "Hunting and shooting in England, polo, too. Big game in Africa, cruising in the Mediterranean. Going back to America when I have to. That's all, except for the usual fun."

"You're not in Paris much?" she asked, her face showing no expression.

"Just off and on."

Sandra waited for more but he said nothing. Then he asked, in a practical tone, "And how do *you* keep your life interesting?

"I work."

"You two didn't hit it off very long." He interrupted as she seemed about to speak. "One thing a man learns here is moderate drinking, to conserve his energies for better pastimes."

"Americans drink like mad when they are abroad, Archie, you know that."

"Not if you *live* here and have any sense."

"Funny I haven't seen you in Paris. I can't figure why you're here. You used to hate foreigners."

Leaning forward he looked at her more closely, as he said, "Everyone is darn nice to me. And the people are civilized; they know how to live."

His platitudes bored her. Once again, she stared out of the window. She would have liked to be pleasant, but their talk stirred old memories that seemed painfully close.

Then he retreated to personalities. "I saw you one night at Ciro's. I meant to go over to say hello, but you were too busy. There was one of those important fellows monopolizing you, and every woman in the room was looking daggers at you! Marston Overstreet, I mean. That's what you like, isn't it?...Important men. Or perhaps a great lover. They say he is just that. Therefore, the daggers." He gave her a sly glance out of his pale blue eyes.

*Not kind eyes*, she thought.

Archie leaned back. At any mention of Marston Overstreet, Sandra always had consciously to control herself. Now she felt that Archie could see right into her thoughts. She wondered if he referred to the first night she met Marston. She had met him at Ciro's, with other people, only twice. On the second meeting, they had scarcely spoken because by then their decision had been taken, and caution was vital.

"You were all in white," Archie continued, watching her closely, "and looked damned handsome. Paris does something to women. It's certainly done it for you."

She made a mock bow to hide an embarrassment for which she hated herself. He said Ciro's was *démodé* and stupid. "London's the place. Nobody has anything except credit, and they stretch it like an elastic band. It seems endless—just endless!"

Then she heard Marston's name again. "He was giving you a whirl, all right."

"I liked him. You're right. He's made a career for himself. He uses his brain to some purpose."

"So every woman seems to think," declared Archie. "Beware, little girl. You may call it brains, but you must know he's a number one ladykiller." He leaned forward confi-

dentially. "They say he's ruthless with women, but haven't you learned how to take care of yourself?"

"I'd take a chance with him if he'd let me."

"Tempting fate?" Archie said.

She went on evenly, "I hear a lot about what a brilliant lawyer he is."

"He is too much," Archie burst out peevishly. "Richer that Rockefeller and as aggressive as Mussolini." He paused, waiting for effect, "But all the same he has a wife. Gossip has it that Mrs. Overstreet rules him with velvet claws, and watches him day and night. She's something of an invalid, but gets every little thing she wants."

Sandra felt her defenses improved by Archie's malicious gossip.

"Speaking of wives," she said experimentally, "Don't you think you would find use for one yourself?"

Archie's expression sobered. How easy it was, she thought, to change the direction of his mind.

He took his silk handkerchief out of the pocket of his grey suit, flicked an imaginary speck off his coat, sighing, "There are too many women to be had. I would rather share a bunch of fascinators than have one mediocre angel to myself. That's the only chance you've got today. If you're not married, at least she can't make you *cocu*."

"Lucky!" Sandra said, jumping to her feet. "Here's Dreux. Archie, give me a hand, you lazy idiot!"

"Don't worry, we're not there yet," Archie said. He looked out of the window. "Who on earth are you seeing in this God-forsaken hole?"

"A friend from Boston," Sandra said. "Stop over with me. You'll charm her."

22

"You're pulling my leg. You're far too merry for that. She has got a man for you?"

"A couple of Maharajahs. And a creepy Argentine. It's not much, I admit, but I'm going to make the most of my opportunities. Here we are."

Archie did not move while Sandra began searching out her bags from Archie's mountain of gear.

"What's your hurry? The porter will find them when the train stops."

Sandra sat down helplessly. Suddenly she asked, "Why do you happen to be travelling in a plebian train?"

A playful, sly look came into Archie's pale eyes. "Sometimes trains are more convenient," he said.

*He's cheating*, she thought, *So am I—in a different way.*

Archie was at pains to point out that he was meeting someone here at the first stop out of Paris, and then going on to the Jouvenet's.

*He's having an affair*, she thought, *And he thinks, of course, I do, too. Why not?* Archie, grinning, was looking sly.

As the train pulled in, Sandra said, "I'll promise not to peek to see who it is," she said.

"I am going to try Paris for a while. What's your address?" He brought out a small leather book from the inside pocket and wrote it down.

As the train stopped with a jerk, a porter appeared, looking helplessly into the crowded compartment. With Sandra's aid he extricated her bags and handed them over to the stationmaster. She waved goodbye, but Archie was staring from the compartment down to the end of the platform at the fashionable silhouette of a young woman. A chauf-

feur burdened with her luggage was standing nearby.

Sandra drew back into the shelter of the waiting room door. She watched the smart chauffeur shoving the woman's last bag into Archie's compartment, and the porter scurrying to jump on the now slowly moving train.

She wished she had not travelled first class on the 15:05 from the Gare Montparnasse.

Hurriedly, she went to the *sortie*. "*Bonjour*, Madame, your ticket?" They always exchanged greetings. She fumbled in her bag, found it and passed through the gate.

It seemed to her that she was coming out into an utterly strange place. The man at the *sortie* noticed she looked pale. Her eyes seemed bigger and darker. He could have sworn there were tears in them. She had been coming often lately, always on Saturdays and Sundays. Everyone in the village knew she had been redecorating the little Château de Fleuris. Yet she had always come alone. Oh, *les Américaines*! An imcomprehensible race. Hard, business-headed people, who used to be so sympathetic before the war. How they have changed!

The car which had taken her so many times to the château waited outside. Her bags had been put in. She tipped the stationmaster while he spoke of the weather. Was she really at Dreux? Was this the day she had dreamed about every day last month? And she thought as she moved on the drive, *Nothing matters but just this. It can't be cheapened by Archie or any number of Archies. If Marston tires of me ever—that would be my personal tragedy. There will never be anyone else for me, and I shall live in the memery of this summer if I grow to be a hundred, because*

24

## A Love Affair

*I have never before have had any memories that I could live on.*

In ten minutes she would arrive at their new hideaway.

It was a temporary home in more ways than one, but she was not going to think of that now. She knew the house meant love, with eternity in it. She had known this from the beginning. She had not struggled against its dangers or its finality. She had accepted Marston in her arms without illusions. She knew he was many-sided, and that he could be slashing in his judgments. But she also knew that he was many other things. Despite what she had heard from Archie, and from others, her instinct was true, and the gossip didn't matter. She knew that beneath the brilliant surface were those other things that really counted, by which Marston had won her, just as she had hoped he would.

The drive would be too short. *If I had only been alone on the train. I needed to be alone*, she thought. *I kept my head above water all last month. I am in an unreal calm.*

Her thoughts went on, endless, like a twisting road, until at last the car turned through the neglected gateposts onto the gravel driveway to Château de Fleuris. She noticed, as she had many times before with excitement, that she could not see the château because of the planting. She waited for the sight of her turret. The car slowed down for the sharp turn. There it was, very nearly in the center of an open space of meadows, fringed with forests and orchards.

Beyond the narrow terrace, the little gravel circle for cars, a meadow sloped gently towards a stream. She just could make out the low roofs of the main house.

Sandra got out of the car slowly, staring at the grey walls,

25

while the driver left her bags at the door. She walked up the low steps, crossed the paved terrace and turned to look down across the field to the stream beyond. It meandered pleasantly as though too lazy to move faster. The sun touched it in spots, and close to the spots were deep shadows made by the branches drooping over it. The horizon was a broken blue line. She thought, *Shall I always look at this as a fugitive, who must hide the beauty of her life, and resort to subterfuges?* And she hesitated a moment, and then, went quickly into the house.

## 2

The door of the château stood open before her. There was no one at the door, there was no one in the hall, the drawing room, or the library. Everything was in order. Since her last visit, her work had been beautifully completed and brightened by flowers.

She could hear no sound. She walked into the dining room and saw that the table was set for two. She had never seen the table set nor the silver showing in the sparkling light where the sun shone in and touched it. Exotic peaches and grapes in glass bowls stood on either side of a centerpiece of anemones. In the hall, she thought prosaically how lucky it was that the structural changes had already been made when she stumbled on this house. There never would have been time to convert its old interior into a modern one. It had been easy to take out more furniture than she had put in; paint, common sense and taste had brought about a transformation.

Upstairs also was mute. Her bedroom and adjoining bath were immaculate, serene, garnished but uninhabited. She took off her hat and patted the disorder of her hair in front of her dressing table.

Then quickly she stepped across the hall to Marston's room. It was more personal. She felt a thrill to see that his bags had already arrived and been unpacked. On the bureau his toilet articles were spread out, in the bathroom his shaving things were placed neatly on the glass shelf over the basin. Evening clothes lay on the bed. *How very peculiar,* she thought, *Why, I am living with him!*

She sat on the top step of the staircase and listened again. The château was so quiet even her thoughts became a part of its calm. She could not quiet them.

*Marston wanted me to decorate the house,* she remembered. *He would take care of the servants. He must be a genie, evoking them from a mythical land.*

She had come early to give some final touches to her decorating work. But having come, there wasn't a single detail she had the desire to change. On her last visit, each article, each color and form had seemed beautiful and exciting. Now their importance seemed to have vanished.

She went slowly down the circular staircase without noticing the things that had at first delighted her—the unevenness of the steps and the irregularities of the stone walls.

In the hall below, the silence became painful. She stood for a second as though in a shadowy space cut off from contact with that she loved. She hoped her favorite part of the château would revive her.

She crossed the little stone-paved terrace and turned to look back at the façade of her house, particularly the tower. It was her joy. It jutted out from one corner of the building, robust and circular in form, making a happy accent for the flat walls from which it rose. Because of its just imperfec-

tion and the quaintness of the stairway coiled around its pillar of stone, she had picked this house among all the others. Yet today the tower said nothing to her. She turned away feeling strange.

Indifferently, she followed the terrace, crossed the circle of gravel, and took the winding path that led through the meadow to the river.

If she had ever felt the beauty of the house, or of the stream nearby, it now seemed alien without Marston. At noon she had left Maison Feodor, alive and vibrant. She saw her youthfulness in the response in men's eyes.

Now, under a tree on the edge of the stream, she sank into the grass. In just the flick of an eyelid she felt she was at one with the ancient trees and with the old château and its forgotten memories.

Marston had told her that this afternoon he would be involved with a queue of witnesses for a case of international importance scheduled to come to court on Tuesday. It meant he would be late. Through the haze, Sandra's thoughts coursed backward, as her memory summoned up the salient moments of their brief life together. One truth came to her—*It is no plunge of the senses that has precipitated us into our affair. We have been yearning for something which both of us want.*

Almost a month ago Marston told her that within three weeks his summer would be clear. His family were leaving for his villa on the Riviera. They would be away from Paris for several months. As he had stood facing her, he asked Sandra to find a house and make it livable. She had been very happy, and she laughed. Suddenly he had put his head

in her lap. "Sandra, for God's sake, don't laugh."

The river flowed on with its mild eddies and currents. Sandra followed it.

They had recognized silently between them that when the opportunity for love came into existence, their honeymoon would begin. There would be no subterfuges. They would live openly. Neither Marston nor Sandra could accept snatched moments of passion at Sandra's apartment— or in resorts or hotels.

He said he did not want her—she remembered the day very well—to describe the house she found. It should be her surprise for him. He had been firm about it.

In the end she had agreed with all his decisions, except one. She refused to leave the Maison Feodor.

"Just for the summer," he had insisted.

She had risen from the sofa and had turned to face him. "No, you tyrant." Then she had summoned up a smile. "I can't. And besides, Marston, the house is only for the summer. We settled that yesterday. When your family comes back in the autumn you will be in the Paris house. We will not speak of it again. Not this summer— Perhaps never."

"Sweet heart," he said, as though it were two separate words. He kissed her hand. "I may have free days, but working at Feodor's you won't have any. Just weekends."

It had been difficult for Sandra to say no, but one thought kept recurring: *I must have a place to renew my life. Even after he leaves me, I must have some sort of career.*

A sense of dread lay just beneath her happiness. Perhaps it was an open-eyed conviction that events could be powerful enough to humiliate her before the very real odds of Marston's wife and children.

Marston had then said, as though it were a small matter, "There are ways I can fix it for you to go back to the Marquise."

She remembered that her, "Thank you very much," had hurt him. Then she had said quietly, "I want to go on with my work."

In a sense, he had made her feel that her work was demeaning to his masculine self-importance. The matter was not discussed again. Not for a long time.

Now she stretched and sank backwards on the cooling grass. She would rest by the stream here where it tumbled over little rocks with a splashing, cool sound.

All her resolve seemed to have gone away and left her. The silent château gave no response, no echo of the delight of the past weeks. She had momentarily lost her deep consciousness of Marston, so much a part of her now. She could recall faint echoes of his profundity, his quality, as well as his superficial traits, but the essence of him evaded her, just as her house had failed her, today. Oddly the moment which should have been filled with anticipation took on the cadences of a summary report: *He is brilliant, he is fifty, we are launched on an experiment, he knows me very little, I know him very little, he is far more practised in life than I am. Yesterday I knew I loved him, at noon today I loved him, and now I love him better than I have ever loved him.*

On the farther side of the stream she saw the forest, and opening at one point of its shadowed depths a pathway. It lost itself. Her eyes dimmed. She slept.

It was more than two hours later when she heard the water against the rocks, then opened her eyes to look up in-

to a pattern of green leaves stencilled on the sky. She made one quick movement which brought her to her feet. Now, fully awake, she turned toward the house.

The round tower showed more shadows in the angular light of late afternoon. Sandra hurried up the path to the still house. She reached her room. Her bags had been unpacked. She wished someone would appear to make the château seem real.

Should she wait in her crumpled suit? Anything was better than being disheveled. Her bathroom smelled of heliotrope and the tub had been run, her fresh clothes had been laid out carefuly. Even the tea gown lay on the bed. It had been selected by the same invisible people who hid somewhere in the château. The gown was yellow. She had imagined herself in blue tonight, but she put it on anyway.

She went into the hall and crossed over to Marston's room. His clothes were laid out as she had seen them, but his bath had now been drawn.

She went down the stairs, which seemed to suddenly vibrate. She paused, her feet clinging on the uneven steps. And then every nerve in her body responded. *I think he is very near now. I'll be alive again.* Frightened, happy, she sat on the steps. The turbulence which she felt held her huddled in a curve of the stairway. Then the necessity to be nearer to him drove her down into the hall.

Now she could hear the approach of his racing car. She know the sound well. She noticed the eagerness with which he got out of the car, his eyes on the entrance. She had been sure he would examine the house she had chosen, and which he had never seen. She went towards him.

Then he stopped. At last, she had the feel of his arms on her body and the texture of his lips on hers.

An ecstatic pain seized her and left her faint. She felt the soft air laden with odors of blossoms and of meadows sweep over them, heavy with promise of love.

"Sandra!" There was only gentleness in him as he held her. Yet when he kissed her the emotion she felt was so great it seemed spiritual.

They moved apart. Then, giddy as if suddenly blinded by too much light, she waved with an uncertain gesture towards the fields. Neither of them spoke or wished to, but she knew the moment must be fulfilled before she reached a breaking point.

He followed her hand with his eyes, aware suddenly of the twilight. In that enchanted spell between day and night Sandra felt the glow of the sun and the tender promise of night. Even his silence gave her joy.

Without him here today she could not feel beauty, nor summon up the blurred memories of their brief life together. Now as she turned towards the door she saw everything before her. Their own bodies close together, passing through—from half light toward an illuminated distance.

They stood without moving. It flashed across her mind that she had said to herself, *All the passion in me must have dried up*. Yet at this moment her passion came back in an almost insupportable rapture.

His eyes turned to the meadow and the stream. "I am sure it is beautiful, Sandra. But let me look at you."

She touched his arm spontaneously, and as she touched him she felt his breath.

33

Then they were in the hall, his eyes clear and intense as she faced him. "Elves, gnomes—who does your bidding here? Invisible hands satisfy my wants. The flowers are rarer than those that grow in the earth. The fruit is the gift of the orchard god. And the bath—she smiled at him, "I think it's pure champagne."

He smiled. "Tonight," he said "I look at nothing, I admire nothing, except you."

She led Marston to the tower. He peered into the circular height, took a step upward, then looked back at her.

"When would you like dinner?" she asked.

"I'm hungry. Half an hour? I didn't have time for lunch."

She went farther into the empty hall and spoke in French to an imaginary personage. "What is your name?"

Marston answered from under the arch of the stairway, "Maurice."

"Maurice," she said solemnly, "Serve Monsieur's dinner in half an hour!"

She heard Marston chuckle as he quickly disappeared around the curve.

Back in the drawing room, her thoughts, stirred by her emotions, brought back the whole gallery of images of him. She reviewed magically their meagre chronicle: how they first met, the impression he had made on her that evening at Ciro's. When they danced she had found him taller than he seemed. When he talked to her she had made two discoveries. His eyes were set so far apart that they made his nose look wide, which she knew it was not. He also had two very different looks in his widened eyes. These looks changed when one least expected it, with surprising speed. The rest of his face was a mask. Sandra had thought of it as being under great control, like his body, which moved

quickly, symmetrically, and masterfully. She thought of each of these traits as brush strokes in an ancient master's painting.

While she lit a cigarette, she tried to define what she meant by his two looks. One look concentrated on an inner thought. It was a baffling look. The other admitted you into an intimacy so total that it was startling. Yet in a flash a look could exclude you, and it was this flash which frightened Sandra. But all that was in the past. Her thoughts now turned to the future—which would be its own story.

When she had smoked two cigarettes, Marston was in the room. Immediately a very visible Maurice followed with a tray of cocktails and canapés. The myth of Maurice the elf vanished, the invisible hands were now filling her glass. She was glad the game was over. Maurice was middle-aged and respectable.

Twenty minutes later in the dining room Marston adjusted her chair himself. His hand brushed her bare arm. He took the seat opposite, separated from her by a bouquet of anemones. The peaches and grapes were on either side, her lover was *vis-à-vis*. Four tall candles placed at the corners of the table gave a light that made shadows on the cloth.

Using the incidents of the day as a foil to his intensity, he filled the first minutes of their intimacy. She wanted to reply brightly, but her almost painful happiness threatened each moment to bring silence. She saw that her yellow gown pleased him. *I was wrong about blue,* she thought. And somehow the ease with which he talked made it easier for her to listen.

He was thinking his own thoughts. That her lips were his, that he had known from the beginning how primitive was their mutual desire. It was she who had checked him. She

had once denied herself passion. Her life of widowhood was wrong, a sin, he felt, against her vitality. Sandra was a woman ill-fitted to trifle with love, and she had not done so. He was convinced of that. She had cut down to the deepest part of herself and levelled it. Until now.

*But*, he thought, *I have awakened what slept within her. It is so strong, that it masters her.*

After Maurice had set the coffee and liqueurs on the table, he silently vanished. Marston abruptly told Sandra that the maître d'hôtel neither spoke nor understood English, and that his wife was both cook and maid. "They are efficient, but not curious."

"He looks like a stage butler," Sandra said.

"Oh, no," he frowned, putting down his fork, "Stage butlers have ulterior motives. He has none."

She reached forward to pluck an anemone from the centerpiece, but she withdrew her hand without a flower.

Then Marston got up, moved his chair and wine glass near Sandra, but did not sit down. He stood behind her, very close. She felt one of his arms near her head, so near that if he moved at all he must touch her, and she did not want him to move then. She just wanted to know he was there. But a force drew her head towards him till it rested against the back of the chair, and some power opened her eyes which had closed, so that she saw his face bent over her. Then as his lips touched hers, her restraints were broken. She was dropping over a precipice towards possibilities very deep and far away. She had almost no consciousness, only this poignant almost painful acceptance of emotion.

36

He sat beside her. He spoke softly of their love. His eyes were intimate. Finally he said, "Now I am speaking to my own self, which is you."

After a while he smiled. "You funny little reserved child. Do you know you have never, except this afternoon when you put your hand on my arm, never once kissed me of your own free will."

"It's not true."

"Oh, but it is. Do you think I would forget?"

She could not move or speak.

"Well, sweet heart, if it is so hard—"

"Stop teasing," she broke in.

He laid his hand on her head and drew her to him. "You don't know anything about yourself. Even I know you much better than you do."

She looked at him and deeply sighed. "If I did not love you in the way that I do," she said, "It would be very easy to be demonstrative!"

Marston understood.

"Is there such a thing as loving too much?" she asked.

He rested one hand on her bare shoulder and looked at her as he said, "I can't say until you tell me just how much you love me."

He saw in her face that she was free from all constraint, so enhancing her beauty that he thought, *I never before realized how perfect she is.*

"Today," she murmured and she touched his cheek with trembling fingers, "Today *you* could not talk of the fields and furniture, and tonight I cannot talk of love."

"My darling, you are right," he said

37

### A Love Affair

Though their faces were close and their eyes open, her lips groped for his as though she could not find them.

# 3

A small space separated Sandra from Marston, who leaned against an ivy covered stump. His blue shirt was open at the neck, his bare ankles ended in canvas sneakers which stuck out of grey slacks. He could have touched her without moving, but after a night of stormy passion it was a physical intensity that brought her closer, it was the possession, of her moods and her tendernesses. Silently he watched her face, following the changes in her expression.

Today she had oval eyes, eyes which were fixed intently on the clouds. He was sure she saw neither the tree tops, nor the larks, nor the meadow, nor himself, but some inner vision that was a private reality. *What is it she sees? What is she thinking? Is it possible she dreams about me as I dream about her? She loves me. In her long, fragrant body she holds the power to do what she wants with me.*

Sandra continued to look at the clouds. There was no tension in her body. It pleased Marston to see that the sleeves of her dress were short, for he could follow her delicately curved arms which rested on the blue folds of her skirt.

Gradually the intensity of her gaze spread over her face till, reaching her mouth, it settled in a tiny pucker at the corner. And he was aware of her withdrawal, as one knows the perfume of a budding flower.

Often before he had wanted to *"touch the sunlight heights"* of sensual happiness. Now he knew he had never before reached above the middle level. Intellect and the senses had been his two approaches to woman. Neither the simple sensuality of his early married life, not the byways of his infidelities had brought him such entrancement. It was his fusion of mind and senses that made him curious to know what preoccupied her, yet not to ask. She had a right to her silences. It seemed that her silences always drew them closer. His sense of life with Sandra swept on hour by hour in a joyous flood. He wanted to be carried in its torrent forever. And silence was only a new current.

Sandra's face turned slowly to him. "I am afraid to speak." Her voice was so low it merged into woodland murmurs. "If I talk, I'll disturb all the little things that are making sounds in the air around us."

To Marston her words were poetry. *I am drunk,* he said to himself. *Drunk with the magic of Sandra near me on the grass, in this sun and this air, and with the beauty of things speaking so sensuously to me here.*

"Is your name Marston Overstreet?" she asked, turning her head to look at him.

He said, "Yes."

"And you are a celebrity in a place called Paris?" She turned to smile at him.

He nodded his head.

40

"You. Yourself. You, sitting there, you are Marston Overstreet?"

"I am."

She turned away and shook her head. "No, you are only—"

Leaning over her, he said, "Only what?"

"My lover."

"You are right." He touched her arm.

She gazed at it so steadily, he said, "What in heaven's name are you thinking?"

"Of my lover's hands and their infinite rights over me." She leaned towards him.

Marston saw in her face an expression of wonder. When, then, she described his hands, he felt that they did not belong to him but that his relation to her was part of herself. In the future, when he used them, whether for expression or in mere routine, these hands would be a part of her which her absence still left intact. She called them conquering and masculine and, without offending him, she called them beautiful. She spoke dispassionately of the shape of the knuckles and the clear shaped nails. But after a pause when she continued, he heard a break in her voice. "These long fingers," she said, "Have the same quickness and strength that runs all through this body I love."

He felt dizzy hearing the catch in her breath, he did not really hear her first words as she went on to tell how defeated she had felt before he arrived yesterday.

The dizziness passed. He listened, his eyes half closed.

"I had no feeling. I might have been one of those round rocks down there on the edge of the stream. Do you see

that little path beyond?" She nodded her head in its direction. "See. It starts in the sunlight and is lost in shadow. It looks beguiling, shall we follow it some time?" Her voice was musical.

He moved his hand to touch her throat. "I'd rather it started in shadow and ended in light," he said half smiling.

"Oh, it comes into the light, just on the other side of that shadow," she said. "I'm sure."

"And after having no twinges yesterday," he asked, "What happened?"

She answered teasingly, "I slept here."

"You slept when you were expecting me?" He took a cigarette and lit it.

"Yes."

"And, my darling," she continued, "While I was sleeping here peacefully and innocently, you were corrupting witnesses, or making persuasive arguments to wavering clients with your nose wrinkled in a frown."

"One does not frown with one's nose," Marston said.

"One is not supposed to. But you do."

"That's not as bad as flirting with your curls. That is positively immoral."

Sandra sat up. "Don't you call corrupting witnesses immoral?" she asked.

"I was going to take that up later."

"Oh, yes," Sandra said. "I can see you handing out huge cigars and bribes and promises like any corrupt Tammany Hall politician."

He relaxed once more against the tree. "So that is your idea of the noble profession of the law!"

42

"Certainly. That, and exaggerating the difficulties of your clients."

"I'll never take a case of yours," he said.

Marston never talked about work. Sandra jumped at the opening. She looked solemn. "What would you do if someone asked you to take his case and he told you he was guilty? Would you take it?"

He shook his head.

She continued, leaning towards him, smiling now. "Not if he had done it for some good reason?"

"Good reason?"

"Yes. For love, or to prevent someone else from being accused. Or because he had a sick child," she said.

"That's just the ordinary human condition, Sandra. It's not often a great passion," he said, springing suddenly up to his feet. Then he turned to look at her—"Or it's because they need some extra cash to take a trip for their health," he added sarcastically. "I am now going to throw you in the river!" He leaned down as if to lift her in his arms.

She was on her feet in a second. "Come on. Let's explore this place."

"You think you can escape me like that?" He pretended to seize her, but then his eyes were fixed on her hair, and he began to stroke it instead.

"It's bright. There's fire behind it," he said, and he let himself down on the ground again and pulled her to him onto the grass. He knew he would never again be able to think of her without passion. *She is now a part of me, she throbs in me like my own heart.* He whispered to her, "Delicious, Sandra, your hair grows in funny, silly curls all

around your temples. Doesn't it tickle?"

She threw back her head, pushed him away, mockingly, "Yours is ridiculously stiff and thick and black like a hair-brush that no one would ever think of wanting."

"Why on earth did you come here with me? That's a miracle I cannot understand." He took her by the shoulders and shook her gently.

"You have, after all," she said primly, "A certain charm." She rumpled his offending hair with one hand. "Let me see your eyes."

"What's the matter with my eyes?"

She was solemn as she looked into them. "If they had been one sixteenth of an inch nearer the edge of your face, they would have fallen out."

"Sandra." He still had her shoulders. "I have noticed when you look right into my eyes you sometimes have a strange expression."

With a lithe movement she evaded his arms and fell back to the grass. "Scared? Perhaps..." Words failed her.

Marston thought she was being whimsical, but her expression alarmed him.

"Why are you scared?" he demanded.

"That they'll fall out."

They laughed and suddenly he asked, "Do you love anyone, except me of course?"

"Are we playing the truth game?" Sandra said.

"Yes, if you don't answer you pay a forfeit."

"Why do you want to know?"

It seemed a long time before he gave his answer. "Because you are like that path over there in the forest—

44

unexplored. Tell me something now. The rest I'll spend all my life exploring." He thought that he would never end his exploration of Sandra. Her affections, were they rich regions to penetrate? How little he really knew about her. He was constantly wanting to know more details of her life, and just when he thought she would lapse into silence, she said:

"Beatrice. You remember I told you I had a great friend—the only one I ever really needed."

He spoke quickly, seriously, gentleness in his manner. "Give me a picture of her. Is she fair or dark?"

"She can't be described," Sandra interrupted. "I don't know how people I love look. I want to tell you about her."

But she did not continue. At last he asked, "Would I like her?"

Sandra seemed unsure. "I am not sure that you would. You might. I don't know whom you like. Anyone would be impressed by her. She mystifies intuitive people."

"I am not sure that I like being mystified or impressed." He watched the sunlight on her hair.

"It might do you good," she said lightly.

They listened to the stream, the stir of air in the tops of the trees, the buzz of insects. The sun lulled him into peace, the warmth of their bodies, so close to the sweet-smelling earth, gave him a calm sense of well-being.

By the way she looked at him he knew that while she wanted to continue talking about her friend, she found it difficult to do so.

*She has touched on the one important fact of her life. Somehow I make it difficult for her*, he thought.

45

"It's like painting," she began. "You have a box of paints, a palette, brushes, canvas, all ready. Then you look at the apple—the thing you have to record. You know you're not going to express its meaning. Just yellow, a splurge of red—purple, and maybe green, too. But what makes that a particular apple will escape you."

Marston followed her words closely.

"Beatrice was married about the same time I was. You will have to take my word for the way she affects other people. Her charm is not always clear, it's too subtle. The people who know her well are either entranced by this mysterious quality or...or confused by it. She scarcely conceals the power that's in her, perhaps that's the reason."

Marston noticed that a mist covered Sandra's eyes.

"Bea never got the happiness she wanted," she went on. He said nothing.

"I admire her more than anyone I know. It's not just that I love her." She spoke slowly.

The tone of her voice arrested him. It was like an obbligato in a minor key. "And her husband?" he asked.

"Mismated." Sandra picked up a blade of grass, examined it as if it were of importance, and threw it away. "But they loved each other, and, in the beginning, at least, that was sufficient. She has always loved him,..."

Marston listened intently.

"She had so much to give, he simply wasn't capable of taking it. It wasn't long before she knew—knew she was utterly frustrated." She paused. "That's the only word. I hate it, but it's the only one that explains her." He saw she wanted him to understand, and kept his eyes on the droop

of her mouth. I make her sound unattractive, that's where my portrait of her has gone astray. How can I picture her?" She gave a wide gesture with her arms. "She is elemental, and elemental people do not belong in the world which she inhabits."

He looked again into her eyes and saw sadness there.

"She has everything to give," Sandra burst out. "Beauty, intelligence, and such love that one can only speculate as to its limits. All that, Marston. And all gone to waste."

"But you said she loved him."

"Yes, but she could have loved so much more."

"Was there ever another man?"

"I think so, but she chose loyalty to her husband, and she's a wonderful mother."

Suddenly Marston saw through Sandra's intensity. *You have my love*, he thought.

She went on, "Something has become sealed in her. She—"

Marston broke in, "He seems like a clod of a husband!"

"It's more complicated that just that."

"Usually it's called a fiasco, darling. But you say they love each other?"

Sandra groped for words. "Somehow it has nothing to do with sex."

Marston felt it had everything to do with sex, but he was quiet, waiting for her to go on.

"That is what makes it terrific," she said fiercely.

"What do you mean, 'Terrific'?"

They looked at each other, he yearned to understand.

"Marston," she hesitated. "Bea has so much to give. Most

people in this world have so little and take so little."

In the pause that followed, Beatrice was becoming flesh and blood to Marston. The story also brought out more facts of Sandra's life to him. He asked her, though it seemed an anticlimax, what Beatrice's name was and where she lived.

"Beatrice Graham. She lives in New York. Bob is the president of American Consolidated Trust."

"Has it been a long time since you've seen her?"

"Not since last summer when she and Bob came over and I took my holiday with them."

"Just three of you?" His voice was low.

"Oh, no, Bob had a friend."

"An American."

"Yes, he was great fun." She smiled at the memory.

He knew it was unreasonable to have a jealous pang because of some man whom Sandra had known before he knew her, but it did not make it any easier. He wanted for her to go on.

"Bea and Bob are coming back to Paris soon. Perhaps very soon."

"Will I meet her, do you think?"

She nodded, and then with finality said, "Now let's go exploring."

He touched his lips with his own fingers and pressed them to her lips. Sandra kissed them.

"In an odd way," she said, "Bea brought you to me. She is involved in our lives. Some day I will tell you more." She got up and shook the twigs from her dress. Marston wondered how this shadowy figure in Sandra's past would

48

affect their love affair.

They followed the path along the river. It closely followed the stream for a while, but then took a sharp turn to the left, leaving the water behind and passing through orchards. Suddenly Marston paused.

"We are coming to the stream again," he said. "Listen, I wonder if it's still ours?"

It had a different sound, invisible behind thick undergrowth, as though it were bigger and running faster.

"It's deeper...I think it must be," she said. They looked at each other, childishly thrilled.

A moment later they came upon a heavily overgrown bank hiding a wall fast crumbling into dust, but overflowing with vines planted long ago, on either side. The rampant shrubs, whose growth obscured the masonry, drew Sandra onward. Amid their luxuriance the remnant of two gateposts showed themselves. They had once been the entrance to a property. Now they clung falteringly to a certain dignity, an oddly formal look in spite of their pathetic down-at-the-heels condition.

Sandra put her arm around a post, patted its decaying stones and came quietly back onto the path. Beyond the wall, the road, passing through a wooded tract, still fairly trim, lapsed into a trail but the sound of the stream led them on until a twist in its meanderings brought them out at its banks.

"Look," Marston said, "A bridge!"

"Our stream has become a river."

He did not answer. Two images preoccupied him—the ruined gateposts and Beatrice, a girl with character

unwilling to accept love except from a man incapable of the love she needed. He found himself preoccupied with these thoughts.

Yet after a moment the dense woods through which they had passed, the slight wind fluttering over the fast moving current, brought a sense of release. It had just been the dark woods. The sense of life lost by frustration, and the decayed walls crumbling, described a new world.

"There's melancholy here," he said.

Sandra was probing the bridge with one foot and made no comment. Constructed of light timbers and decrepit planks, the bridge appeared perilously unsteady. There were gaps in it, and rotten piles in the water. She gave a laugh. "It's full of risks. Come with me." She sprang forward, but Marston caught her hand.

"Let me go first," she insisted. "I am lighter."

"Don't be foolish, I'll cross and see if it is safe for you." He pushed her back.

"You will break it down, you great hulk!" she said. "And we'll be on opposite sides of the river with no chance of ever meeting again."

"It's only eighty feet. I'll swim back to you, darling." He took a few steps on the rotten planks. "It's not so bad as it looks," he announced jubilantly, "I'll come back and get you."

Sandra waited obediently.

As he picked his way, decayed wood gave way and fell splashing into the water below. Then he sprang forward, his weight never resting at any time for more than a second on one spot. She watched him, fascinated. With one last

bound he reached the far side and turned, flushed and amused, to look at her.

She put up her hands on either side of her mouth and shouted at him, "Fearless hero!"

"I'm coming back to get you," he called.

But before his sentence was completed, Sandra was on her way. For a moment it appeared she might not find a foothold, but with one last well-calculated jump, panting and laughing, she reached the shore. Marston had watched her delightedly as she balanced herself over the big gaps and came leaping to his side.

They turned together to see what lay ahead. The path was wider now and showed signs of recent travel. It passed through a meadow, then abruptly plunged into a forest — tall pine trees with orderly undergrowth which the brush gatherers had cleared of all but shrubs and ferns. Sandra, who was walking ahead, stopped suddenly, put a finger to her lips and in mock fear hissed, "Hush! I see signs of the enemy."

She pointed dramatically up among the trees where a wavering line of smoke was rising.

They went on until they reached a clearing. There, hidden by the bushes, they saw a red cart covered with an orange hood. The red staves of the wagon stuck out straight and empty. Nearby a mangy horse browsed, tied by a halter which a stone anchored.

"Gypsies," whispered Sandra, her face pressing close to Marston's.

A fire burned by a half-charred stump, and a hanging kettle hissed over it. Sounds of voices came to them; then

out of the cart emerged two young figures. Their guttural dialogue and the glitter of their white teeth against their dark faces brought to the wood a sudden surprise—exotic color—that excited their imagination.

Marston and Sandra, close together, watched. Something began to stir in Sandra. An indefinable excitement.

The gypsy man was unshaven, almost black, and smiling. He had the keen gaze of an animal who must watch out for danger. The girl, handsome and untidy, with a bronze-tinted face and black hair, hanging in braids on either shoulder, was pleasant to look at, and alluring. Yellow beads hung around her neck and fell on one half-uncovered breast.

"Aren't they beautiful?" Sandra spoke low in Marston's ear.

"Yes," he whispered, "From a distance."

The gypsy girl moved away from her mate and Sandra became aware of a child lying on the ground half hidden by the wheels of the wagon. With swooping ease, the gypsy girl picked it up, threw it into the air, and then set it on her shoulder, where it rode clinging to her braids. Her hips swayed under the weight as she moved to the fire. The man watched her indolently, but his eyes glowed under his smooth, dark brows. He went near her and sat watching, while she lifted the lid of the kettle.

"Let's speak to them," Sandra said impulsively.

"No, we might spoil it," Marston restrained her. He knew her disillusionment would be intense. She followed him, hesitantly, but as they retraced their steps she was glad that Marston had not let her approach the gypsies. *He was right,* she thought. *The picture was impressionistic. It should be*

*seen from a distance.* They went back, half running through the forest. Marston crossed the meadow and stood for a moment on the edge of the stream.

Then he saw Sandra dart forward over the bridge. She took it quickly and turned to wave her arms at him from the farther bank.

"What will you bet I make it?" he shouted.

"A new hat," she called.

He considered this for a moment very seriously, then nodded. She watched him excitedly, as he came rapidly over the broken surface. She thought, *Just as a wild beast might move in the woods.* He had the power and stealthiness beautiful to look at. *He belongs out-of-doors,* she thought.

Suddenly over midstream a plank gave way under him. He sprang with easy agility to another, balancing with arms extended. He looked up to smile triumphantly. Then without sound, he stepped forward and dropped into the deep water. In a moment, first his head appeared, then a waving hand.

"It's grand," he called. "Come on in."

"Your hat— Now you have lost two," she called back, pointing to where it bobbed and was being carried away by the running stream.

He shook his fist at her.

"I wish you could have seen yourself, a tightrope walker. Where was your balance pole?"

"All right. Rub it in." He swam downstream, rescued his hat and turned back towards the bank. Sandra was glad he swam beautifully. She tingled with pleasure as she watched

him glide through the water.

He stood up to see how deep the stream was. "I can touch," he said. The water reached his armpits. The current was strong and it tugged at him, but he was immovable.

"I am never coming out." He vanished, came up shouting, as though she were very far away. "It's worth a hat, Sandra. Come on in."

She crouched on the bank and ran her fingers through her short hair.

He plunged again and came up closer to the shore where the trees hung over the river. He walked out, towards her. He wanted to be close to her. As he pushed back his wet hair he laughed.

Now the water scarcely touched his knees. He stretched up to the overhanging boughs, but they were out of his reach. He jumped into the air and caught them in both hands, pulling them down low so that they hid his face. He knew she was waiting for him on the bank.

The warm sun struck through the branches, seeming to perforate him with spots of green and yellow. He laughed again; the sound came to her through the trees as though he were far away. Gripping the branches, Marston felt a primitive, spontaneous reaction, like that of an animal. He wanted to cry out to her, *I love you*. He played with the leaves, letting them go, then pulled them back. He liked them close to him.

He would have loved to reach out and pull Sandra into the water beside him. The thought made him remember Biarritz once, bathing with a beautiful courtesan whose almost naked body had touched his body under the waves.

54

He threw back his head, peering through the leaves at the sky.

Then he saw Sandra take a step nearer the water's edge.

"What are you doing in the branches? Oh, Marston!" He caught an overtone of concern in her voice. He knew it was no longer a game. But he could not know that to Sandra his speckled face playing hide-and-seek with her among the branches, even while it delighted her fancy, had suddenly brought startlingly to her the suggestion of his temporary, fleeting place in her existence.

"Watch, Sandra, watch!" His hands opened, the young, green sprouts snapped back. Then he swung himself to the shore at her feet.

She threw her arms around his dripping body and hid her face against his shoulder.

"You're crazy," she said.

At dinner that evening, they laughed about the afternoon. Gaiety came easily to them. Marston invented details just to hear Sandra's infectious laugh.

Then he leaned across the table.

"Suppose sweet heart," he said, as if it were of the utmost importance, "We were wandering nomads, roaming the earth with only a canvas roof over our heads?"

Her radiant face flushed. "And only a decrepit horse to carry all our possessions, and we could go wherever the stars led us?"

"You wouldn't look bad with a red kerchief over your curls," he said.

"Or you with rings on your hands. But how about you in

earrings?'' she asked.

"I wouldn't work. You would tell fortunes and cook—"
He looked pleased, "And all the rest of it."

Sandra suggested they must go south at the right season
so that the swimming would be pleasant. "We would never
know what sort of place the next night would land us."

The dining table at the Château de Fleuris vanished in the
dream of gypsy life.

It was Sandra who broke the spell. "I suppose we shall
have to swim the river after this. You certainly did a good
job, breaking up someone else's bridge."

"Swimming across will get you in training for being a
gypsy," he said, rising from the table.

Maurice had gone. Marston brought two chairs to the
terrace.

The moon and the stars opened up the entire sky to
them. For a long time they did not speak. Sandra, letting her
head rest on the back of the chair, cut off all the earth, and
holding her breath and staring with unblinking eyes into
the blue, could imagine herself rising up into the sky. Each
second she was nearer the stars. They grew larger and
larger, and brighter and brighter.

She lowered her head to see if Marston also was still visi-
ble. To her suprise he was sitting very close to her.

"Where have you been?" Marston asked. He had been
watching her.

"Try it. It's fun. You can get right up into the stars."

She thought by the rigidity of his shoulders that he was
occupied by other thoughts. Marston smiled. "You like to
leave me now and then? Don't you?" He knew he had

briefly left her, too. He had been thinking about how busy he was going to be in the coming week—with so little time for her.

"It's all right," she said hastily. "Don't explain."

"But I want to explain." He was amused at her perception.

She continued quickly. "Am I conceited if I say that I believe you want to be with me as much as you can? My work takes up a lot of time, too. Not that it's important like yours. The Marquise, with all her kindness, expects the best from us." She paused, and added, "That's one of the reasons I like working for her."

He wished she had not spoken about her work, but he listened in silence, knowing she had more to say.

*It's good to get this off my mind*, she was thinking. *Besides, we must be able to talk about everything.* She balked. *Her and their children.*

"Marston."

"Yes, Sandra."

"I ought to tell you that after my husband died, there was very little left for me to live on in the way I wanted to. Besides I could not be idle, and also be happy. Now I earn a good salary and commissions from Feodor's on the orders I bring in. So I am financially independent and I always will be."

He knew. He had faced it all before. "I am not going to try to make you change your life, sweet heart. In the beginning I hoped I should have more of your life. I didn't understand. Now I do."

He moved in his chair restlessly, as if he had something

else on his mind. "Some day," he said with an effort, "I want to tell more about my life, but not tonight."

"Why not tonight?"

He shook his head and got up.

She thought, *Marston reveals himself in the things he does not say.* In the moonlight she saw his eyes were brooding. Pain passed through her as she sensed the difference which might grow between them if he shut her off from the things close to him. Things they could not directly share. *Balance seems the only possible course for both of us. But how to keep the balance, loving him as I do?*

That night, under Marston's caresses, love grew like a widening stream that gains beauty in its depths.

# 4

There was summer tumult in the air of Monday morning, a sky full of clouds chasing across blue spaces. Indoors the sashes of old windows rattled by the gusts, made bleakness in spite of flowers and freshness, that drove them into the darkening outdoors. They roamed the woods and orchards, coming in boisterous, hungry and disarranged.

Luncheon over, Marston and Sandra stood together, looking out from the library at the coming of the first showers. And when the rain came it drew them together in the intimacy of the fire-cheered room. The old cornice and ceiling and the fireplace had been left as Sandra found them, not because she particularly liked them but they had the character of the French provincial life of some fifty years ago, and painted ecru like the walls, made an unobtrusive setting for turkey-red curtains and armchairs of scarlet leather. It was in this intimacy that Marston drifted to the bookshelves with Sandra. She watched him finger the volumes, exploring the strange books in the library in a rented house, and noticed how those he could not have liked he handled with precision, as though he respected them—even the cheap novels. He would never, she knew, touch anything without regard

for its structure. She imagined his skillful handling of children.

Marston left the bookcase and settled in one of the deep chairs. He lit his pipe and his head sank on the red leather back. Through partly closed eyes he watched the fire. He was still, but his stillness suggested latent action.

*It was one of his charms,* she thought—*this sense of immediate action even when he was in repose.* She crossed the rug and stood between him and the fire. "I love seeing you do nothing."

"Let's always do nothing and stay here forever and ever," he said, looking up at her.

"Some profound writer says that doing nothing is the most difficult thing in the world, and I also think he says the most beneficial." She laughed as she said it, and leaning toward the blaze, adjusted a log with the toe of her shoe.

"It sounds like Oscar Wilde."

"You do read Wilde? How astonishing!" She turned to face him. "Do you read plays?" Then she added, "Do you mind being questioned?"

"Only if I have to. And only if you won't sit on the arm of my chair."

He reached up and drew her down to him.

"You are as secretive," she said, "As only a man without a secret can be."

"Give up Oscar," he pleaded.

He raised himself, as if seeking a way of escape, until, still struggling, she pulled him back. "I have you now." Settled back in his seat, he sighed.

"I want to know—" she proceeded, then paused. It was perfect to talk to him, but it was also perfect to be quiet.

Some time later he asked, "Know what? Sandra, stop strangling me."

She disengaged her arms from his neck. "—Things people know about you. I have my own facts about you, that's only my own. Do you sail or race yachts? What is your favorite flower or color, what movie actress appeals to you most?"

"Go away," he said. "I didn't expect an inquisition."

"And what about you and the arts? Do you collect Rembrandts or Modiglianis? Or sculpture? Or are you musical? You probably collect books, do you ever read them? Are you color-blind, blond-blind, or brunette-blind? That's all for the moment."

He reached up to rumple her hair. "I've never noticed, what are you?" He chuckled. "You should already know the answer to every one of those questions. I see you don't appreciate my deeper nature at all."

She evaded him, got up quickly and went to the window. He watched her study the sky. "When you begin to stab me with words, it's time we took a walk through the wet woods,...or *anything*."

In the pause they were both aware of the rain still beating against the panes. The room was a quiet place, its warm darkness holding above all an invitation to confidences.

They sat for sometime without speaking. At last Sandra murmured, "When you stroke my hair, I become a half-wit." She went on, "My darling, suppose you told me you had secret information how Crown Prince Rudolph died? That Shakespeare didn't write his own plays, who killed Mr. Mills and the gardener's wife, and why Elizabeth was called the 'Virgin Queen,' do you think I would hear a word of it?

He laughed as he held her closer.

"No, not a word."

"I don't even know if you have an awful vice," she continued, her head close to his, "Or a harmless hobby, a fondness for animals, or an aversion to caterpillars."

"I am not color-blind. I love horses and dogs."

"I'll skip your loves. Now your hobby!" She put her hand over his mouth. "Let me guess."

He kissed her fingers which she drew back quickly.

"You will never guess. I rather like caterpillars, but I can't stand cats."

She interrupted, "Keep still, we are talking about your hobby."

"You are like an old maid after a crumb of gossip."

She pulled his hair. "It's books. Or if not books, it's building models of boats."

Marston sighed. "So you put me in the obvious category. I promise to tell you some time, but now I want to tell you a story—"

She gave his hair an added jerk.

"Just a story, but a nice story. It has to do with us in a backhanded way. It is true and it's symbolic."

"In that case, I'll listen."

"It begins in China," he said. "Once upon a time."

"Is it really true?"

He nodded. "Once upon a time I went on a trip to the fabulous land of China. Mostly on business. But there was a dash of pleasure, too. Five of us were in the party and big interests were involved." He hesitated. "At the last moment before leaving," he went on, "My wife was taken ill and I almost gave up the trip, but..." He passed his hand over his

brow. "But doctors assured me I could leave. I don't know why I am bringing Eileen into this. She has nothing to do with the story. Yet it stands out in my mind."

Sandra realized that he had been thinking aloud. She prompted, "Had you been to China before?"

"Yes, but only once before on business."

There was a pause during which the fire cracked and a violent outburst of rain rattled against the windows.

He took up his story. "In Peking a noble of the highest caste, Li Ching Kong, entertained us in the fashion of the East. Opulent. A feast without beginning or end of mysterious delicacies. Exotic girls and insupportable music. Then the guests were shown the treasures of art for which Li was renowned."

Marston stretched his feet out nearer the fire. He relaxed so that Sandra was sure that what he was about to say was important only to themselves. Their closeness wiped away the memory of Marston's wife, cleared her mind of anything except a story she was listening to.

"We had gone to Japan first," Marston explained. "Then to Shanghai. One of our party had considerable knowledge of ancient Chinese art. Our host realized that, and showed his choicest possessions. By the time we journeyed into the interior to Peking, I, too, had learned to discriminate between worthless and priceless pieces of art. But I confess it was not till that evening that I had any particularly strong feeling about anything I had seen."

Sandra turned so that she could watch him as he spoke.

"There were ancient Chinese paintings in the monochrome of the Sung period, porcelains of Suan Ti, blackened lacquered wooden Boddhissatvas, and Hindu-Chinese

63

sculpture of creamy marble. Lacquer that wasn't banal, bronze encrusted with the patina of buried years. It was an endless revelation in Li's house." He stopped.

These few words roused in Sandra the feeling that she herself had visited China. She heard the constant rain on the windowpanes, but it might have been the beating of Oriental gongs. Outside was a French landscape dimmed by rain. Inside was a glamorous palace in Peking, and Marston's eyes saw it, too, as he picked his way among words with the masked intentions of an Oriental.

"The wrapped and boxed treasures of Li Ching Kong unfolded themselves, aloof and majestic, sometimes evasive, before our eyes. A spun thread of gold joined them one to the other, the unbelievable depths of porcelain colors, the fantastic bronze shapes, the unctious feeling of jade and marble, and jadeite and nephrite, the opulent grandeur of embroidered silks." As he elaborated the picture, names of stones, of fabrics unknown to her, brought alive new images. Then he stopped for a minute while the vision lasted. Falteringly, he continued:

"These treasures were a rare experience. Beauty, as you know, darling, leaves one rather silent. I felt grave as we left the rooms in which we had been shown all these things, and, not heeding where we were going, I found myself in a much smaller, simple room. I stopped in the doorway and suddenly my eyes were drawn to one single object on a low table. One object—afterwards I remembered it as standing beside its lacquered case; then I only knew that all my life I'd been waiting for the feeling it gave me. I wanted it, not just to own, but to be with."

He raised himself in his chair, unconscious that he had pushed Sandra aside.

"I wanted it," he said, "the way, maybe once in a lifetime, one looks at a woman and one's want is above the reach of lust." Now he rested one hand on her head and was silent.

"Yes, darling?"

When he spoke again his voice was soft. "I cannot describe the semiclear, crystal figure to you. To tell you it was lucid, but full of depths, that it was formed by the goddess of grace, that its carving was so simple, so slight, so delicate as to make one doubt the human origin of its craftsmanship and its bold design—all this as description means nothing."

Sandra's breath caught. She sat immobile.

His eyes were dark with concentration, his voice now deep. "It would have been absurd," he said, drawing her back with him against the chair, "had it not been a strangely intense moment for me when I realized that I desired a treasure belonging to one of the richest princes in China."

He was laughing now at himself, his mood lighter.

"It was like walking into Henri de Rothschild's house and setting your heart on one of his possessions, or trying to induce the King of the Islands to part with his youngest, most beautiful slave, for I could see the glint in the old prince's eyes when he looked at the crystal figure. He was as old as the world, he was power, and he held life cheap, and the treasure was his."

Marston paused to look at Sandra. She had not yet caught his secret meaning. It was a story, she had forgotten the symbolism.

"Go on," she said.

"The next week we went off into the interior. In the meanwhile I informed myself of Li's weaknesses," he said. "But apparently the great noble had no weaknesses not already catered to. Girls of unusual beauty surrounded him. Boys, beyond the dream of paradise, abounded in his palace. His every wish was fulfilled."

"But I still had one hope—that I should find some other crystal figure as moving, as appealing, as the one which had so stirred me. When it became known that a rich American was in search of distinguished *objets d'art*, dealers and impoverished nobles dispatched agents with their rare art objects. They brought some precious crystals—but I did not find anything to approach my adored figure."

His eyes were on the fire. After a while he continued, "On the return voyage, I passed through Peking and went to pay my respects to the great prince. I had given up any hope of ever equaling his treasure, but I could not leave without seeing it once more."

Sandra watched him, fascinated.

"I was almost afraid to see it," he said, his voice low. "You understand, I thought I might have exaggerated it in my mind. It might be better, I told myself, to go away and just remember what I felt about it. But when I was actually inside Li's palace, he received me in the room next to his most cherished possession. I could not resist."

A strained quality had come into Marston's voice. "Sandra, are you listening?"

"Of course, go on."

"He was a subtle old devil; I am sure he guessed my secret passion, for with great ceremony he led me to the

room in which it was enthroned. He watched me like an old eagle."

Marston stopped, then said abruptly, "I need not have been afraid. It was more beautiful than I had remembered, more touching."

"But—" she said hesitantly, "What happened?"

"Nothing happened. I went away. But the next time I desired something with all my heart, Sandra, life gave me what Li had withheld. I have my crystal goddess."

Sandra's head dropped. "Marston! Marston!"

Marston put both hands on her head and turned and raised her face to his.

Later, when the rain had stopped, they rambled through wet woods and meadows. The dripping trees, the soggy earth, the feel of wet on their faces, the laughter in their hearts drove them on. At the foot of the field below the château, Sandra threw back her head and called over her shoulder to Marston, "I will beat you to the house. I want a bath, flowers and fruit, cocktails, food."

They raced, and in the end he waited for her on the terrace, his arms outstretched.

## 5

Louise's holiday had been devoted to an orgy of cleaning. She polished, swept, and relentlessly hunted for imaginary specks of dust. This had always been, next to marketing, her greatest pleasure. Her husband had appeared on his usual Sunday but had been ostracized, until the following day, *le jour de fête*. Then Louise had settled him grudgingly in a kitchen chair to read the Sunday papers over again. To Fernand, with a bottle of Médoc and a carafe of water at his elbow, it had not been an unpleasant experience.

He had read a good article in the *Figaro*; he would now reread it. He was interested in a sensational murder case which had first appeared in the Saturday papers—*l'affaire Merrimée*. Ths morning's paper announced that the great hero had been arrested for the murder of his wife. It promised to be long-drawn-out and scandalous, a succulent bit on which to roll one's tongue. The popular idol, aviator, auto-racer, holding a world's record, flying ace of international fame, was now in the public eye in a new role. His wife, up to this moment not well known, had been murdered in their house on the Rue Debidour.

At four-thirty, Louise and her husband sat down over a *petit goûter* she had prepared. They had both been in good

spirits. But Louise, who during intervals of scrubbing and polishing, had ploughed her way through the newspaper account of the case, was not of the same opinion as Fernand. The aviator was a wild young man. Didn't he fly all over the world in aeroplanes, and drive fast racing cars, leaving his wife alone for weeks at a time? Such men cared nothing for domestic life. It was very probable that he had killed her.

"It was his business to race," Fernand had explained, "Just like any other business."

Louise had shaken her head dubiously. Her husband continued, "He took the trouble to go home the night before she was murdered, even though he had to leave early in the morning."

"He says he went out early, before she was murdered, but no one saw him," Louise said. Her concentration brought a deep furrow between Louise's eyes.

Fernand rose to his feet, a slice of cake in one hand, a glass of wine in the other. "Does someone always see *you* if you leave here at four in the morning?" he asked.

"I am not up at four in the morning. It's not respectable." She paused. "How did the murderer get in the house?"

"So you did not read about the ladder?" At his wife's bewildered stare he continued, "The gardener says the ladder which was always kept in the garden had been moved and—"

The telephone suddenly began to ring, and Louise went to the hall to answer it. "*Non, Monsieur,*" Fernand had heard her say, "Madame is not at home." After which there was a pause, then, "Ah! Monsieur Gram! Madame will be sorry. And Madame, your wife?"

Another pause, then in Louise's most approving voice, "Yes, I will give your message. *Merci, Monsieur.*"

Louise had an expression of satisfaction as she returned to the kitchen. Fernand again kicked the newspapers aside as he awaited her explanation. It had been slow in coming, for she had appeared lost in pleasant thoughts. "That nice Monsieur Gram (she could not pronounce Graham) has arrived from America. His wife is coming later," she said, at last. "You remember, last year Madame took an automobile trip with them and gave me a holiday."

"That was when we went to Lyon."

"He is a very handsome young man and so friendly, a real *gentilhomme*. Very rich, too."

"How do you know?"

"One sees those things."

"Where is his wife?" Fernand finished his drink and let himself down in the kitchen chair. "She was here last year, I remember, but you never said much about her."

"She is very quiet, very much the lady, one hardly notices her."

That had been last night. Today was Louise's marketing day. She went out with great pleasure, an empty string bag over one arm, a cotton umbrella (against the threat of a cloudless day) over the other. Her hat expressed her conservatism; it was perched high above her face, resting on a frizzled bang.

The art of finding the best food at the most reasonable prices was Louise's recreation. No Parisian chef possessed a keener eye for blemishes beneath surfaces, and no businessman a subtler method of consummating a bargain. The

bustle of the *marché*, the shrill clamor of excited voices, the sight and smell of food, acted as a stimulant to Louise's imagination. Le Veufe Pouget had the best fish in the *marché*. He has a hunchback. His trade was small and exclusive, his wares too expensive, Louise always told him, after they had been haggling for years, though they both knew in the end she would pay his price. She liked his wrinkled face with the hair that fell over his eyes like a Skye terrier. He was the only seller in the *marché* with whom she had even a remotely personal contact. Today he had news for her.

"I know," he said, "A girl who knows the cousin of the cook in Merrimée's house."

"Did she tell you who killed Madame Merrimée?" Louise asked?

"She said it was a *mariage exemplaire*. An *apache* got in through the garden."

Other clients appeared and Louise was pushed aside.

She knew she didn't have to hurry today, for Madame would not be home until lunch time. She would first settle her one remaining problem: flowers. On these, Madame's orders must be strictly carried out. It appeared that only certain colors could be put together; this quirk Louise could never fathom.

At half-past twelve, Sandra stood at the door of her apartment. She hesitated for a moment before putting her key into the lock. *Will I wake up and find I am not myself?* she thought, *Like the little lady in the nursery rhyme?*

But the door was opened for her, and Louise's impassive face greeted her.

"Good morning, Louise, how is everything today?"

71

"Good news, Madame. Monsieur Gram has arrived, he will be here for lunch today."

Sandra was genuinely surprised. "And has Madame Graham also arrived?"

"Louise's head moved from side to side. "Later," she announced, and disappeared into the dining room.

Sandra went to the table and picked up her mail.

*Bob without Bea!* That was her first thought. Until now she had not known how much she wanted to see her friend, but Bea's arrival would also bring her to a very grave decision. She let the letters drop unheeded on the table. She did not want to decide anything right now which might alter the strange situation in which her love had placed her.

Bob would be here, in a few minutes, bringing the full weight of reality. Work at Feodor's had been a half-reality all morning. Earlier, she had fled the château before Marston was up.

In the sitting room the usual array of vases filled with water reminded her that the flowers had not yet been arranged. The bluets and yellow girofles lay side by side. Automatically Sandra arranged the centerpiece for the luncheon table. "Low," she said, "so that they didn't have to dodge blossoms to see each other." Her fingers were agile; she finished the bowl quickly, and put it on the table. When she looked up, the hall door opened and Bob Graham strode toward her. He seized her hand, kissing it in the exaggerated French fashion.

"It's great to be in Paris." He tapped his chest and breathed in deeply. "Sandra, you really look like a million dollars!"

"When did you arrive, Bob?" For some odd reason she was on her guard.

"I stopped in London to pick up my clothes and flew over yesterday. Didn't know it was a holiday and dropped into an empty city. But you can always spend a half day on the boulevards and in the Tuileries." He laughed.

"I'm glad to see you. When is Bea arriving?"

Sandra resumed her flower arranging.

Bob lit a cigarette. "Bea's involved in the new addition to our country place. The boys are growing so fast, she's also re-equipping them. Easier than girls, though."

She looked at Bob with a sense of detachment. She really knew him intimately through Beatrice. She liked him well only because he was clever and kind. Arranging the flowers, she thought, *He is wholesome, that's what he is.* He brought her cigarettes and offered Sandra a light. *His eyes are candid, too. They have no secrets. Of course he really doesn't feel anything. That's Bea's bad luck.*

"I say, Sandra, you must dine with me tonight."

She smiled, still following her own thoughts. *His eyes are intelligent, but they don't seem alive.* Yet she couldn't help liking him. Such cheerful shallows, Bea's tragedy. Aloud she told him she never stayed out late during the week.

"There are some English people coming. I met them on the boat."

"I'm sure they're very nice, but I just can't do it."

"Sybil's beautiful. You've got to come, you'll see for yourself. What have you been up to?"

The flowers were now all in their vases, but her thoughts had been on other matters.

73

"Just the usual things," she said, without looking at him. "Some parties, a hectic life at Feodor's. Paris is full of Americans, who are running away from the depression." He looked at her incredulously. "I know you'll have a good time," she finished.

"I am only staying a few days; then I go to Carlsbad for the cure." He patted his stomach as he looked down at it. "My tailor is horrified."

"If you have an *embonpoint*, he's a skillful tailor." She went to the fireplace. Was there something in her expression to hide from Bob? She tried to reassure herself by looking in the mirror. "Bea hasn't written me often. Is she all right?"

"I think she wrote you about her work on the hospital drive. It's an uphill grade getting money out of people who have less and less for themselves. They say she's very good at it. She's good at anything she puts her hand to."

"You ought to change your politics, Bob. Democrats make everyone here rather bitter."

Bob's happy expression changed. "We hate it, but we can't help talking about it. If you want to know the truth, we are getting frightened. So far Roosevelt hasn't done a thing he said he would, except..."

They had cocktails and went in to lunch while he was still propounding his views. After a while he broke off to say he hadn't come to Paris to talk politics. "We had a wonderful crowd on the *Bremen*," he said, "Supper parties every night."

"Just what is Sybil's last name? I suppose she hasn't any husband?"

"Thank goodness, she has."

Bob's flirtations were notorious for their innocence. He loved being seen in the company of beautiful women. Yet if his attentions resulted in conquests, no one ever knew. His bland face now asumed a sly expression. "You must dine with me, there will be de la Roche, too. Do you know him?"

"That too good-looking man? Dark and a marvellous dancer? I don't know him, but I've seen him about a lot."

"That's the fellow. He's just as nice as he can be, in spite of his good looks. Jacques has been over to the States. He returned on the *Bremen*, too. You'd like him, especially dancing with him. The *demi-vierge* l'Aigle and that nice old Count Marbeau—I know he's a friend of yours—and the Dicksons are coming."

"I didn't know they were back. I heard they were in the Soviet Union."

"Now who is your latest, so I can ask him?"

"It sounds like a nice party without me."

Bob laughed. "Just as adroit as ever! You always have so many men, no one can pin anything on you."

"The Granvilles stole two of my dancing partners and took them to Brazil."

"Two! What about the rest? Enough! I'll stop for you at eight-fifteen—"

"I don't dine out during the week, Bob."

But he was off on another subject, and they gossipped until it was time for her return to the shop. It seemed simpler finally to accept Bob's overwhelming reasons why she should dine with him. Besides, that night, Marston had

an unbreakable business engagement.

When at eight-thirty they came into Clouzet's, the foyer was already crowded with guests. Those who had not been far-sighted enough to engage tables in advance, pushed their way through the hall to be courteously, but insistently, barred. Others were searching for their parties, some, vexed with the places alloted them, were being soothed by a suave, small maître d'hôtel.

Robert G. Graham experienced none of these difficulties. The best table in the foyer had been reserved for him, and Sandra was sure the best table in the dining room as well. He and Sandra sipped their cocktails as they surveyed the pandemonium. Then suddenly Bob was on his feet. From his smile she knew his English "flame" must be in sight. She looked up. Mrs. Mowbrey was a specimen of exotic English perfection. Sandra thought she should be pinned on a dark background like a mounted butterfly, in a lepidopterist's collection, but men thought she was a woman who had no right to be a lady. Her husband soon faded into insignificance though he towered above her.

They were closely followed by Mademoiselle l'Aigle's tall figure. Sandra watched its approach; she had watched it many times before in other restaurants. The technique the French woman had acquired of weaving her way through crowds, from left to right, always in profile, had given her the name of an Egyptian bas-relief, and the chiseling of her nose and mouth truthfully recalled the figures at the Temple of Aswan. Just behind her came Count Marbeau. It was the lively old Count who had said her semi-virginity was an attar. He stood there immaculate and compact; blasé

beneath the veneer of his easy manners; happy, as always, in his reputation of a distinguished *viveur*. Sandra saw him with pleasure. She always delighted in his combination of kindliness and wit. He basked in her beauty; and seemed genuinely mystified by what he called her purity. Had he been sure she was not pure, but only looked and acted the part, he would have been in love with her.

Upon the arrival of the Dicksons, Bob led the way to the dining room. To know one of the Dicksons was to know both. It appeared that they had been born alike some forty years previously; born to be cheerful and stocky, to dote on countries that were not their own, to disregard home ties and pick up acquaintances along the route of life as one would pick up souvenirs.

At the table Bob waved Mrs. Dickson to the seat at his right. Mrs. Mowbrey he placed on his left with Mr. Dickson next, then Mademoiselle l'Aigle, Count Marbeau, and Sandra. An empty seat was between her and Mrs. Dickson.

"Jacques is late," said Bob, "but I know he is coming. I saw him at the Travellers."

The restaurant was noisy and crowded and Sandra did not just know when Jacques de la Roche had taken his place, until the hors d'oeuvre were being served and she saw him out of the corner of her eye. The Count was telling her in his fluent, but un-English accent, that he had just returned from Biarritz where the weather had been vile and where he saw people thrown up on the sand from a shipwrecked immigrant boat like flotsam.

"Why did you stay?"

He looked at her slyly.

"There was a pearl in the flotsam, Madame."

"You are incorrigible."

"On the contrary, I am a good Samaritan. Even you do not understand me, my divine one. I rescued a stolen jewel and returned it to its rightful owner."

"You mean the Koh-i-noor, or the Hope Diamond?"

"An erring husband reinstated on the loving bosom of his wife," he said.

"How you must hate the man you restored," Sandra laughed, "And how he must hate you."

"I not only manipulated the guilty one back home, but also successfully hid the crime from his elderly and wealthy spouse." He finished with a sigh, "The digression was entirely understandable."

"So Paul Thibot has been at it again!"

"How ever did you guess?" asked Marbeau, his blue eyes twinkling.

"You are surprised, aren't you? You didn't want me to know!"

"Again correct. He went at it body and soul. Even at his age, you cannot permit yourself such total abandon. Thus, you see," he said with a glint in his eye, "I saved not only his reputation but probably his life."

Sandra knew the Thibots. She had stayed with them fairly often in their renovated château near Tours. They were the objects of much malicious talk.

Mademoiselle l'Aigle and been eavesdropping. Now eager to hear mundane gossip, she sacrificed her Egyptian profile by shifting her face to look at Sandra.

"Dora Thibot is giving a series of house parties. I am go-

ing next weekend, have you been asked, Mrs. Fane?"

Dickson said from across l'Aigle, "We have been asked, and have refused. It's disgusting the way that man treats his wife. He lives on her and makes her a laughingstock."

"If you are going to have principles about the people you stay with, where would you ever stay?" Mademoiselle l'Aigle observed.

Sandra was conscious of a movement on her left and De la Roche brought himself abruptly into the conversation.

"If a rich woman of a certain age chooses to marry an impecunious man, young enough to be her son, what can you expect?"

"It's what *she* expects that counts," said Dickson.

"*Elle a un tact superbe*," the Count said, "Provided the *convenances* are maintained."

Sandra looked at De la Roche. He was surveying her. "I think," she said, "Dora prefers a good-looking husband to any sort of husband she would otherwise have had. And that's that."

Jacques de la Roche's answer was meant exclusively for her. "You are a philosopher, Madame, although..." He held her eyes for a moment. "You don't look the part."

"If *I* wanted to be personal, I could say you think like a Frenchman, but look like an Italian."

"You don't like personal remarks?"

She hesitated, feeling foolishly annoyed. "Not obvious ones coming from strangers."

At this he smiled. "One has to be obvious to start."

"To start what?"

He laughed outright. "You are leading me on."

79

She recalled his reputation as a charmer and a superb dancer, and thought, *It's nice that when one meets him he has none of the regular signs.*

Nothing was said, and De la Roche waited for her to speak. He seemed unaware that the conversation at the table was animated and they alone were silent. It made Sandra feel an intimacy with him, which she resented. In these few moments of talk she had discovered that something of the romance of Italy survived in his eyes and in the contours of his face. His mouth was a contradictory force, a sensuous mouth with a noble curve.

When she spoke she had recovered her poise. "Bob said you crossed on the *Bremen* together. It was a fun trip, I gather."

He turned spontaneously to her, like a child who has been forgiven. "It was a riot. Don't you know? Mrs. Mowbrey was on board."

"He's flirting with her now."

"That's for my benefit."

"Nothing is more stimulating than competition."

"Crossing the ocean is a sort of condensed contest," He was mocking himself. "It's only then that all men and women are equal. Anything can happen."

"And did it?" Sandra asked disinterestedly.

Abruptly he said, "I have watched you dance."

She was accustomed to compliments about her dancing. He went on to say, "Perhaps you will think me personal again, and dislike it?"

"I have forgotten it. Be nice will you?"

"I'll try, but I meant to speak of your dancing."

"Be critical, I won't mind."

"Some day I'll tell you about it." .

She raised her eyebrows.

He continued, "You know, of course, that women reveal themselves when they dance."

Sandra laughed.

"Your figure is made for dancing." Had he dared she suspected he would have used another word. She might have been angry but she was only sorry that he had become what she thought he would be before she met him.

Quickly she asked him about his visit to America.

"Don't hand me out subjects," he said.

"Well, pick one of your own."

"It's better to have someone talk about you than to do the talking yourself."

"Are you truly part Italian?" she asked.

"My mother was pure Roman, but I am told my character is much more like my father's. He is French."

"You say you are in business?"

"Yes, automobiles. I went to America to get contracts for my company."

"Educated in England, I presume?"

"Eton and Oxford."

Sandra became aware of the buzz around the table. The conversation had become general. The usual political disagreements, rumors of war touched on, evaded, recalled. Depression and gold, the stupidity of people in high places.

Bob defended the Democratic party with tenacity. The Dicksons, having just returned from Russia, believed the dreams of internationalism. It was Sandra who furnished

the light touches and it was Mrs. Dickson who returned to Parisian interests. *L'affaire Merrimée* was an inevitable subject, because it was reported in every paper. The murder of Pauline was on the radio on Saturday and covered in the afternoon papers. The Monday newspapers announced the great aviator's arrest. It was a surprise to discover that De la Roche knew the aviator, and admired him.

Marbeau suggested most people's demon was iconoclasm. Tearing down idols was a favorite pastime and one which always insured listeners. For that reason the press would pursue the affair *ad nauseum*.

While the Count was talking, Sandra remembered that she, too, had met Merrimée once, very casually, at a reception given in his honor. They had had a few words together. But she remembered the words.

Then Mademoiselle l'Aigle broke into her train of thought. She was addressing Jacques across the table: "Do you think he did it?"

"I certainly do not, he is too decent. Daring, reckless when it comes to his own life, but in no sense vicious."

Marbeau's quiet voice interposed, "One doesn't have to be vicious to commit murder."

*How very, very like him*, Sandra thought. *Always calmly astounding.*

No one took his hook, but Bob rose to other bait. He enfolded Mrs. Mowbrey legitimately in his arms and danced away, a triumphant look on his face.

Since their passage about dancing, there had been no doubt in Sandra that De la Roche would be waiting to show her in what ways she did not deserve his praise. She turned

slightly in his direction. The chair beside her was vacant and suddenly he was on the dance floor with l'Aigle.

It was not until the party was about to move on that Jacques asked her to dance. They did not speak at all. When they sat down he gave her only a quick look. But he said nothing. She now managed to say to Bob, "I'll just sneak out. I'm sorry, but I have to get up early in the morning."

At the taxi door De la Roche suddenly appeared.

"Don't bother," she said, "I haven't far to go."

"But if you want to go alone, of course," he drew back.

She thought, *How ridiculous to make a point of it. He may think I'm afraid he will criticize my dancing.*

"Of course, come along," she gave him her address and he got in the taxi with her.

She felt alone in this homecoming. Marston, not Jacques de la Roche, had held her thoughts. Only Marston and herself really counted. She felt their experience was like an avalanche that had come crashing down from a glacier. It was an absurd image, because glaciers were cold and love was warm, yet both swept all before them.

She was interrupted by Jacques' voice. "Change your mind? Come somewhere and dance with me."

A passing streetlight showed how debonair he was.

"I remember tomorrow morning," she answered. Something inside her said, *Why do I remember tomorrow morning and forget the avalanche?* Aloud she remarked, and there was interest in her voice, "I should like that. A tango."

He started humming the bars of "Frenesi."

But at the door of the apartment, Sandra said good night. "Some other time." She immediately regretted it. "Some

83

other time then...soon." He seemed pleased, but left without suggesting a date.

When she was in her bedroom and alone with her thoughts, they were only of Marston. The casual events of her existence made her love sharper. Getting away from people was like an adventure. In spite of her memories, she was very sleepy. Yet as soon a she was in bed and the lights were out, every bit of her came awake. A *malaise* came over her, a tingling of her mind, a restlessness of her body. The room filled its blackness with recollections, some foolish, some irrelevant, others serious and fundamental, but confused, all out of sequence. Thoughts of Beatrice's arrival, and its significance.

A misty gleam from the streetlamps came disturbingly through the open window. Suddenly she seemed to be looking at herself and Bea in an unreal scene. They were in a boat on a lake at night. A moon hung in the background and tropic heat drifted across the water from the land yet, she knew it was real. It was the summer after her husband's death, when she had gone to visit the Grahams.

She did not want to relive it again, she wanted to sleep. But the vision was persistent. Their talk had started with Bea trying to take Sandra's mind away from her problems by talking about educational societies and group movements, with her typical cynical asides but yet not without refreshing enthusiasm.

*She hates that kind of thing just as much as I do*, Sandra had thought.

Sandra remembered how terrifying it had been then to find herself asking for a calm life. It was much more terrify-

ing than a longing to live excitedly. She had always known that she really wanted to build a palace and to adorn it inside and out. When a storm came and blew it down, it wouldn't really matter because she could always build another. Somehow these thoughts had seemed to fit into what Bea had said, although now she could not follow the connection. She could not get the wherefore of what her friend had gone on to say: "After all, there is no one truth, no one good."

Much as she wanted to break away from the memory of that evening, long ago, it proved to be impossible. Why had Bea felt that way? "You mean it isn't truth or good to you, when it is to me?" she had asked.

"Something like that. And all the high-sounding words, like Evil and Good and Time have no fixed meaning. We both know how hours can sometimes seem as long as days."

In the moonlight she had been able to see the twist of Bea's lips as she went on. "Why is it good for us to always see eye-to-eye?"

Then the smell òf pine trees had been with her and the translucence of light. The streetlamp outside was its feeble counterpart. But the unreal beauty of that distant night, with its utter discouragement, was now converted into the beauty of life. Sandra's thoughts had drifted to a film. Bea saying "The discipline of life is like a scale, weighing the things that are of value. Buy the weights are not the same for two people, who may see alike, but who live differently. The world is open-handed with its death to illusions, generous of its physical pains; why not grasp the joys we can?"

"You make me seem banal," Sandra had sighed. "I agree, of course."

The boat had scarcely moved on the calm of the lake. Then Beatrice had said, "Perhaps you don't know that I have forced myself to accept conventional standards, since I have no fixed standards of my own."

To Sandra, Beatrice's vivid face blurred, but her words remained. "*You* are starting fresh, you can make ordinary things beautiful. You wouldn't need to have conscious kindness, or..." her voice had trailed away while only soft water lapping against the boat was still audible in Sandra's memory. She could hear it clear and very far away.

## 6

The following Monday, Sandra rather languidly fenced with her dinner guests. While she was slightly amused by their chatter, she felt tired. The previous week had only two bright spots. Wednesday Marston had dined with her alone, obviously craving the privacy and freedom of Fleuris. Swept by his desire, she had sought to divert him. She told him of Bob's dinner and of Bea's imminent arrival. He was disturbed, which she was at a loss to fathom. Then he said, "We shall somehow be cut off."

She chided him gently, but with a smile. "Accept my ties. I accept yours."

"I need a long time to do that, perhaps forever," he said.

Later in the week there had been a stolen moment, amid his busy days.

"It's Thursday," she had said, "most of the week, thank heavens, is over."

"Yes. But I won't see you until late Saturday. Let me hold you, let me kiss you. Sweet heart, nothing is real without you."

Monday morning she returned from the château to Paris.

The memory of the short weekend seemed as though they and spent a day in paradise. The drabness of everyday existence disappeared for those twenty-five hours like smoke dispelled by a breeze.

The stillness of Fleuris seemed to hold its breath with the joy of their intimacy.

And now Archie Cummings was slumped on the sofa beside her, his whiskey and soda on a table at his elbow. He had obviously taken Sandra up. He had telephoned several times, and twice dropped in to see her the preceding week. Bob Graham in front of the tea table, was deciding which one of Louise's dainty morsels he would choose. Jacques de la Roche had come, and his arrival with Bob had not surprised her. She had observed his roving eyes take in the details of both her sitting room and herself, and she once again sensed his admiration.

He sat somewhat apart from the others in a low white satin chair which accentuated his slimness, and his black hair and dark eyes. The elegance of his long, lithe figure was agreeable to Sandra. Jacques de la Roche was without self-consciousness. She was once again struck by this. In one hand he held a glass of vermouth, in the other a cigarette.

They had been chattering about the Merrimée case, the races, polo, new plays, the rate of exchange. Now, abruptly, Archie Cummings said from the depths of his cushions: "Sandra, how's your American lawyer friend?"

"Marston Overstreet?" she questioned. "Malicious, I call you."

The man's eyes remained fixed on her. De la Roche alone was inscrutable.

Her look was unflinching. "If anyone ever had a one-track mind, you have, Archie." She smiled. Then turning to the others she said: "Archie saw me at dinner somewhere once. Marston Overstreet was at the party. I suppose I must look too interested in men, because Archie has never been able to forget it."

Jacques De la Roche slowly moved his chair nearer. "Does he attract you, Mrs. Fane? I should not have thought he was your type."

"Please tell me," she said, "what sort of person should attract me?"

Jacques suggested that a less obvious heartbreaker would appeal to her fastidious taste. This was another De la Roche. Not the Jacques de la Roche of Tuesday night.

Bob Graham, who claimed to have known her so much better than Archie, and far longer than De la Roche, hesitantly ventured that she would not fall easily for any man. To this Archie agreed: "She has had plenty of chances."

"I am amused you enjoy discussing me," Sandra said, "as though I were a famous *cocotte*, a great artist, or..."

Jacques, with the air of invading Sandra's inner thoughts, interrupted. "We all should be greatly interested to know about the type of man that has been wrong—for you." He smiled. "Or right for you. A man you would fall for."

"I agree with you," she said evenly and with a glance which covered them all. "I should hate to think of myself as incapable of weakness. An Amazon. But, for the sake of argument, I presume you're implying every woman faced with the right approach, falls. And now, Monsieur, do tell me..." Her voice was slightly sarcastic, "About this weakness." Then she added quickly, "Really, do we have to talk

about it as sex? Can't we explore sentiment?"

Archie chuckled. "Even Bea talks sex when she's here. Nice try, Sandra."

The Frenchman ignored these remarks. "It is a delicious study, probing into a woman's nature and finding her code."

"Code? Code of morals, do you mean?" Bob Graham asked, as he was pouring himself a drink.

Sandra watched Jacques de la Roche without wishing to do so, while Archie listened as if to a great authority.

"No, not of morals," said the Frenchman. "I was thinking of something in a woman as personal as her voice, for instance. A code is wider than morals. Great codes eliminate morals."

Bob came back and sat down opposite the sofa, his eyes fixed on his hostess. Then he turned to look at De la Roche. "How do you get so deep. Where do you find out things like that?"

Archie's sigh was audible, but under his nonchalance it was clear he was not bored.

Sandra, conscious that the evening was growing late, and with a persistent image of Marston, became exasperated with the turn of conversation. She scarcely heard Jacques' next words:

"Her code is a living thing," he went on. "It is her ideal, however unconscious of ideals she may be, and you must meet it, or break it, *really* to possess her."

A sudden vision haunted Sandra. The château, the image of her desires, of a full and secret life, bounded by the skies, something that could not die. Silently she drew herself up.

She looked from one man to the other. She was indignant. Jacques de la Roche had transformed all men into adversaries. She exerted all her force to calm her voice. "Possess! Why must you think of that?"

De la Roche remained silent. Archie said impatiently, "Love, Sandra. We are studying love. Everybody knows about that."

She tried now to hide the resentment aroused in her by the conversation.

Archie subsided into the cushions. He wanted to learn from a master, but he was finding Jacques' codes a little beyond his depth. "Be a good fellow, Bob," he called, looking at his empty glass, "If we are in for a dissertation. Make me another drink."

Before Bob had time to move, Jacques de la Roche was pouring him a drink. "Let me supply your wants. People are always thirsty when they are interested. May I pour for you Mrs. Fane?

"I'm not thirsty."

Jacques handed Archie his drink and moving towards the sofa put a cigarette into Sandra's hand. The cigarette lay on the table while his lighted match burned short till he blew it out.

De la Roche rejoined the group. "I bore you, Madame."

"You are really too obvious."

Bob Graham interrupted, "Oh, come now, Sandra, give him a chance to finish."

De la Roche stood in front of them. He was talking, but for a few moments she did not hear what he was saying.

Archie Cummings watched her. She was accustomed to

admiration. He knew besides that she had always accepted it without self-consciousness. There was something different here. And Sandra herself was feeling that some new quality in men's valuation of her was forcing her to notice that for no apparent reason their attitude was not simple to deal with. She was sure they knew nothing of her secret. Yet did they sense a difference in herself and reacted to it?

She thought, *Jacques thinks I am afraid. He must end this foolish game.*

But De la Roche went on, "Men and women are mortal enemies. I repeat myself but we must always remember this. It's only natural that I wish to help my sex, so I desire to have as many men as possible benefit from my system."

"I feel as if I ought to leave you," Sandra said. "It sounds as if you're going to lead Archie and Bob into one of those rooms in foreign museums kept for the eyes of men only."

"Men are at a disadvantage. Don't go away, Mrs. Fane."

Sandra interrupted, "What is your great disadvantage?"

"We are naturally too honest. Especially for modern women. So we have been forced to learn new tricks; we are fighting for our very existence. If we do not master them, women will rule the world."

Sandra lay back. "You poor innocents."

He ignored her, addressing himself to Bob Graham. "Every man must study women, learn their tricks, or how shall he make any progress among them?"

Bob groaned. "How do you find time to work on that?"

Jacques de la Roche turned to his hostess, his dark eyes glowing, "And there is, of course, the method to break that defense."

92

They all stared at him.

Sandra flinched.

"The method is to destroy her faith in someone to whom her loyalty forces her to cling."

Bob Graham said: "Oh, come on!"

Undisturbed, Jacques went on, "There is the principle of her chastity." He looked reflectively at the floor as though recalling some episode in his past. "A minor code. A woman holds on to her chastity, even though she may lose dignity, respect, and beauty in the process. Perhaps it's not entirely her own fault, because she's inherited it through conventional ethics. Chastity is an aim, not a possession. It is pathetic to see how a woman struggles to overcome her natural instincts, because she has been taught to preserve her chastity. She must be made to feel that love is more chaste than sacrifice."

He reached for a cigarette and lit it. Sandra studied him. She wondered, *was there something whimsical about the corners of his mouth? Did he mean what he was saying? Or was he disillusioned by his own experience?*

"Now we have the woman who is afraid of her reputation. What can she lose if found out?'

A groan escaped Archie from among his cushions.

Jacques, gazing at the top of Archie's head, remarked, "On the continent we all know that type. Women are aware that such men boast of their conquests. There is only one method to win such women" He dramatically paused for his effect. "It is by seduction of a brutal nature." His smile was so disarming that Sandra laughed nervously. " I have had enough of your lectures," she said.

93

When her guests had left, Sandra fell back on the couch, exhausted.

Jacques de la Roche had a horrid mind, and yet she recalled how nice he had been the first time she had met him. She remembered the kind whimsical twist to his lips. *He wanted today to interest me, he was feeling me out, describing me so that, from his standpoint, I might fit into any one of his categories. But he was hoping that I might be doing the same thing.*

She tried to read a book, but it did not hold her. The images of love and seduction stood between her and the page. She flung the book down on the sofa. *I am no longer a stuffed bird, my eyes are not glass.*

To be drawn irresistibly into the center of this discolored life, like a leaf sucked into the eddy of a moving stream, had been her destiny. No more now could she expect to look undisturbed on human weakness.

*Love is apart,* she thought, *a thing alone. It has nothing to do with the horrid things Jacques speaks of. It is what my lover and I feel.*

She went to a window, opened it wide and stood breathing in deep breaths. She wanted to go out and walk in the city, away from air laden with false ideas. She started for her bedroom to find her hat, then, remembering, let herself down on the sofa once more. It was too late for a woman to be alone in the streets of Paris. The eternal warfare between the sexes was once again brought home to her. She recognized that her nerves were overstrained, but it seemed to her true that all men in the world, except Marston, were against her. Suddenly this malevolent force about and

around her was all she could see. Men doing things against beauty; men being grotesque, being mistaken; men deliberately destroying themselves, and dragging women with them to destruction. All the wasted energy, the sham—when with Marston there was joy and loveliness to be taken.

And she wanted him. She knew that he too listened to the language of the spirit. Ugliness and disillusionment did not exist for him. "Marston!" she said aloud, "Nothing matters as long as I have you."

# 7

Before Sandra had finished her breakfast on the following Thursday, Louise brought a letter with the flowers. Sandra unwrapped the flowers, but held the envelope unopened in her hand. It was as though she were touching the edge of Marston's jacket. She had seen him only once since Monday morning. A rapid visit, tantalizing in its brevity.

*My precious one,* it ran, *I only feel a part myself without you. It seems impossible for me to stay away. You are beside me as I write. I see you. But when I reach out to you, you are not there for me to touch. I can't hold you. But sweet heart, I shall never be without your warmth again.*

*Tomorrow when you read this, it will only be until evening when I shall be with you. At this moment you seem in the air around me, so near, you come to all my thoughts.*

The letter fell from Sandra's hand onto the bed. She picked it up again and reread it. Outside sounds now made music with her memories. She got up feeling joyous and dressed hurriedly and left her apartment.

Today was surely to be an eternity at Maison Feodor. The *Prix d'Auteuil* was next Sunday. All the clients who had ordered new clothes would strut and preen themselves in the

enclosure, while she and her lover basked in the sun by the stream of Fleuris.

The streets exhilarated her, the roar of traffic, reflections in plate-glass windows—of herself and others, and the clean water in the sidewalk rivulets. For the first time she realized that the weather was close and dampish, an atmosphere unfavorable to her mood. The people she passed, most of them hurrying to work like herself, seemed without uplift, symbols of drudgery.

To step out into her role of Madame Nada gave her a sense of being no one at all, neither Sandra nor Nada. A flurry of annoyance dominated the salons of the old house, like some feminine ghost protesting in her ancestral home at its misuse. Shortly before noon Madame sent for Nada.

In the mirror-lined room, empty except for Feodor and two fitters trying a dress to the Marquise, Sandra sank into a chair.

"My reputation is gone!" The *couturière* waved a naked arm. "Last week at the races I wore a tired gown, a month old. This week is a week of folly, and next week will be the same. Clothes, clothes, clothes! I wish everyone were a nudist. I shall join one of their colonies for my vacation."

The two fitters pinned and cut. Nada gazed in admiration as Madame's silhouette emerged subtly changed. She looked from one mirror to another to catch all the angles. "The first of autumn! Aren't you afraid to wear it? That sleeve will be stolen."

The Marquise surveyed herself nonchalantly. "I want them to steal it. It's good, but it is not inspired. It's bait for the early buyers. I feed them a dry bone, and while they

quarrel over it like hungry dogs, I prepare the *glacé flambée.*"

Nada's fatigue disappeared. she threw back her head laughing. "You are incredible!"

Madame looked over her shoulder. "I sent for you, Sandra, because I have an idea. When I was at your apartment last winter, I was impressed with some of your paintings. Do you remember?"

"Yes, but I haven't painted recently."

"What mediums do you work in? The pictures I saw were in oils." There was a professional tone in her voice. Sandra was once again Nada, a member of the staff.

"I went to an art school in America but it was never just what I wanted. When I came over here and worked for you, I found myself more interested. Then I worked at libraries and museums. I copied plates from costume books, too. That was pretty dull—"

"Well, was that all?"

Madam's dress was being pulled over her head. As she emerged Nada continued: "Then I began studying old paintings. It's absorbing. How the old masters saw clothes."

Madame smoothed her rumped hair, lit a cigarette and sat down. "As you know, it's not a question of the next collection; that is practically ready now. But when trade settles definitely on what it wants, I shall make more models. You have talent. Would you like to try some designs?"

Nada seemed pleased, but doubtful. "It's a profession in itself. I realize that, and..."

Madame Feodor broke in, "Yes, yes, of course. Bring me some of your sketches and if I think you might work into it,

I will tell you what I am planning for later on." She paused, then continued, "For the moment I can't give you any time off. It would mean you would have to make your designs out of hours. With our South American trade this year, as well as the buyers, we are going to be rushed all the time. *Oh, la, la, les américaines du Sud!* It is just for them I make sleeves like *that*." She pointed to her dress which one of the fitters was carrying away.

When they were alone Feodor scrutinzed Sandra. *"Vous avez trouvé le bonheur.* You cannot deceive Feodor." She said this to Nada kindly and casually. Then the interview was terminated.

Back in her apartment Sandra found a stack of letters on the hall table; one she picked up hastily. It was from Beatrice. She read it standing in the grey-colored hall. She walked slowly into the sitting room and stood looking out of the window, but only the words she had read passed through her mind. *I'm planning to spend a couple of weeks in Paris before Bob gets back from his cure, and it's going to be wonderful being with you.*

It was strange how this letter made her feel: completely indifferent, even to Beatrice. All the security which Marston's letter had given her ebbed away. Her vision of him was clear.

In the shop later that afternoon, Sandra's depression grew. Thoughts of Beatrice were somewhere at the back of her mind, buried in among thoughts of Marston. *What shall I do?* It had seemed that after her decision to live with Marston all the other things in life would take their places naturally. But now Bea, her friend, simply by her arrival on the

99

scene, would become a problem. *I shall see him tonight,* she told herself, *and I shall know then what to do.*

A few minutes later, one of the girls came to say that there was a Monsieur to speak to her on the telephone.

*Marston would never call me here. It must be someone else.*

She went to answer the call in a gloomy corridor. It was his voice which spoke. His wife was ill, not seriously, he said, but he must leave for the Riviera soon. Backing away, she leaned against the opposite wall of the passageway. She moved to it again. "How soon do you go?"

He sounded very far away. "In half an hour. He gave her an address a few blocks from the Maison Feodor. "I will be in a taxi on the corner."

She felt annihilated. Getting out of the house and finding the corner was like climbing to the top of a high building when you were exhausted before your started. And through her mind ran only the dreary words: *He is going away. He is going away. Each hour of our separation has added to our sadness and now he is going away.*

The message which had come to Marston from his wife on the Riviera caused him to give his instructions to his secretary in a few sentences. A special plane to be ready in three-quarters of an hour. His chauffeur to meet him with his bags at the Porte de Villette, his appointments to be cancelled, his invitations regretted, flowers by telegraph from Cannes to the villa. In the street he hailed a taxi. In accordance with his order it had stopped at a nearby hotel, where he had telephoned Sandra, and gone to the address at which they were to meet.

100

He sat back in the taxi for a while and closed his eyes. Professional obligations had filled his days and obtruded into his nights. Only once during the endless week had he seen Sandra. He had to be careful about going to her apartment. Her street was out of the way, but there was always the danger of his being seen crossing the pavement from a taxi. Sandra's work was also demanding, and her free hours were limited. Marston's days had been crowded with thoughts of her and the nights filled with images of her loveliness. Alone now, driving through crowded streets, he realized how little of his emotion he had conveyed to her in his letter. There had been moments since he left her when longing had sapped his powers of concentration for work, haunted as he was by visions of her near their stream, her body relaxed on the grass, or close to him in the château. Did Sandra suffer as he did with separation? Was it possible that her passion, so like his own in their hours of ecstacy, tormented her when she was from him, just as he was tormented? He hardly dared hope so.

The taxi was held up in a traffic jam. He was afraid he would keep her waiting on the street corner. He hated the thought. Meeting on corners was outside his code, but actually it was unimportant, because all day a storm had been raging within him. He was to have seen Sandra tonight. Tonight of all times, he had looked forward to being with her. He had a new curiosity about her, a view of limitless fields of exploration. But now he must go away because of his wife's illness and her helplessness.

For the first time he felt resentful.

The taxi moved on. He looked out and saw that they had

only a few blocks to go. When it stopped, he searched the street. In a moment Sandra would appear. Had she been waiting for him?

The door of the car opened and he was aware that she was in the taxi. He shouted directions to the driver. The car sped forward. They were in each other's arms and the comfort of her embrace put an end to his pain.

"I shall be back on Saturday," he said.

"You are not worried?"

"No, I spoke to the doctor. It's not serious, just one of her attacks. It is a nervous condition, but I must go to her."

"Of course."

"I will telegraph." He kissed her again, sat close, his knee against hers. "Sandra, do you love me?"

"Darling, yes."

"Don't say it like that." He touched the hand from which she had removed her glove.

"Hide me somewhere. Take me with you!"

In a few moments he looked out the window. "We are almost there."

"Where are we going?"

"The taxi will take you back, sweet heart."

"Saturday is only day after tomorrow." It was hard for her to speak.

His breath came fast with a halt. "I will be sure to telegraph," he repeated.

They came to the Porte. Marston leaned over her, held her and kissed her lips. A moment later the taxi door slammed behind them. How short it had been, he thought. He was too full of passion. He would like to have given her some rational courage.

The rest of Sandra's day was lost in oblivion.

Friday, when she'd wakened, the sun shone through her window. She remembered at once that he had gone. But the sun was bright. It touched the geraniums and reflected some of their pinkness. She thought drowsily, *I like geraniums because everyone in France has them. They are ugly, stiff, little hardy plants, but thousands of people are looking at them just as I am now—and making up their minds to get up and go about their business.*

At first she did not know why she felt so overwhelmed. It was true he had gone, but only until tomorrow. It was an effort to move. Then she sat up in bed. "He will not be back on Saturday." She said it aloud.

Louise brought her tray. She saw the telegram on it, but did not open it. She looked again at the geraniums as if to fortify herself against possible disaster. At last she took it up, tore it open and read:

*Separation unbearable. Will be back Saturday.*

"This is the morning," she said excitedly, "When I must have an extra dash of heliotrope in my bath!" The scent gave her a country smell, it would make the château seem nearer.

Before she left for work, another telegram came:

*Arriving Saturday at five. Arrange to get Monday off.*

The air along her route smelled fresh from the newly watered streets. It smelled of bakeries, of flower bouquets

in the kiosks, of coffee with chicory. Everyone in the street was hurrying to work. She wondered if all these people loved their jobs as she loved hers. It would really be fun to take up her painting again. Once she had thought of it as a career, but later she knew she wasn't good enough for that. Her route was familiar; often when she was early she stopped to talk to the people in the boutiques. Today she only nodded to them and hurried on. They followed her with their eyes. *La belle américaine, elle est gentille.*

*I wouldn't dare to ask for a holiday on Monday. Marston still has a few things to learn*, she laughed to herself. *But Saturday is twenty-four hours away.*

Later in the morning Nada was involved in trying to prevent an elderly woman with badly dyed hair from choosing pale blue satin instead of black lace, when she looked up and saw Count Marbeau standing in the doorway. He was immaculate as usual. He entered the room with a buoyant dignity that proclaimed his distinguished past. She thought that there was elegance about the Count; it was beautiful, because it was served by the magic of courtliness and friendliness to hide the faraway turbulence of his youth.

He had come to ask her to dine with him that evening. It was very warm, the Bois was fresh, and as cool as one could expect these oppressive days. "Not a party, just ourselves."

How thoughtful he was, she would like dining with him. The elderly lady was beckoning.

"I will call for you." He kissed her hand and she hurried away."

"Who is that?" her client asked. "He looks like a big swell."

104

Nada smiled to herself, "He is one of the greatest men in Paris. He was just admiring the black lace dress."

"I like it much better than the blue. It's so refined."

The afternoon slid by easily. She was looking forward to Saturday.

That night as she dressed for dinner, she took care that every inch of her costume should be as meticulous as she could make it. *Count Marbeau is buying himself a little picture for the evening. I must be worthy of so great a connoisseur.* But he was beyond the age of turbulence and passion. Or was he?

In the Bois he caught Sandra's mood, which was quiet, and left her to her own thoughts, filling in her silences with adroit anecdotes. Sandra's thoughts were not only of Marston, but of Beatrice. Her own secret was not only her own, it was Marston's too, and she had no right to admit Beatrice without her lover's consent. *But how happy she would be to know of my happiness.*

Then on Saturday morning early a telegram arrived.

*My darling, I cannot leave today as patient is not so well. Nothing serious. Will surely get away Monday.*

There was more, but she could not read. She had been tacking against the wind but the wind had died. She was in a dead calm. How stiff and dull the geraniums looked. She would be late if she did not get up at once. She bathed because she had to bathe; she dressed because she could not go into the streets without dressing. She gave orders to Louise. It was Saturday. "Pack my bags on Saturday," she had

said. Of course she would not go to the château, but she could not yet face the question of what she would do. It didn't matter. She had been invited to the Thibots. She considered calling Dora up to ask if they still had room for her.

In the street, Paris seemed altered: pale and tired. It met her with bloodshot eyes. Tawdry. A Paris operated on strings, its soul gone. Rain began to fall, it fell quickly and put the finishing touches on her despondency.

At last noon finally came at the Maison Feodor. She saw the Saturday rite repeating itself. Could she be the only one heavy with disappointment? The sun had come out brightly; twittering girls poured into the street, like silly, senseless birds, cocking their heads and running about excitedly.

Men waited to meet them. Sandra paused to watch. It wasn't that she much cared. Actually, it was only that she felt rather critical of them. If she were happy, she knew she would not find them silly. Before Marston, on Saturdays she went back to her apartment and either went away with friends, or invited them to luncheon or dinner over the weekend. Yet that now seemed a long time ago. Was it only two weeks?

She turned to look at the sky and found it was golden as well as deep blue: the air was soft and bright.

How proud a city! Then suddenly it washed away her disappointment; the hunger of her love came back to make her happy.

She could scarcely wait to get home. "Louise, do you have room in my bags for an extra package?"

"*Mais certainement, Madame.*"

With paint box, brushes and pad, she darted off to catch the train for Dreux. But on the way to the station she re-

membered that, just off the Rue du Bac, her old friend Beaulier had his studio. *I'd like to see him, and his paintings*, she thought. *He might give me some help. I'm so out of practice. Once he helped me with a watercolor. How I have neglected my old friends.* But Beaulier was not at his studio and she missed the express to Dreux.

When the château finally came into view from the sudden turn in the drive, *It's lovely, but it hurts,* she thought.

Maurice appeared in the doorway. An expressionless figure. She told him that Monsieur was delayed. He bowed. "Would Madame like her dinner in the library near the fire? The night will be chilly."

It had been easy to feel happy in Paris, but here in their house all her spirits died. In the quiet of the library she looked despairingly at the books, at Marston's special chair. She was once again weary and lonely.

Upstairs her bags lay unpacked as usual, and on the table she found her artist's paraphernalia.

*I'm glad it's late*, she thought. *I just couldn't go out.* She spent the evening with her watercolors. First she cleaned her paint box and brushes. The paints were old and dry and she moistened them and finally began sketching a corner of the library. Marston's red leather chair against the ecru wall, and an end of the turkey-red curtain. Somehow she succeeded, and went to bed somewhat contented.

The warmth and sunlight came in through the open windows when she woke the next morning but her hand, automatically reaching across the bed, lay on Marston's pillow. It was a long time before she moved and her eyes did not leave the place where her hand rested. She was trying to

evoke his image, but it evaded her. She fancied she felt his breath on her lips as if he leaned over her, but she could not conjure his face or the outline of his figure under the bed-clothes. Raising herself on one elbow, she moved closer to where he might be lying. *He is asleep, I will waken him gently.* And she pressed her face down, down on the empty pillow. If he had been there, close, she would have begged him never to leave her.

After breakfast she looked at the painting of the previous evening and knew that while she had worked hard on it, its uncertain touch showed a lack of practice. *I should make quick sketches to limber up my fingers,* she said to herself.

The house was quiet and empty, so she rang for Maurice. "I will have a picnic today. Sandwiches, fruit in a little pack-age," she told him.

With her lunch, her paints and pad, she went down the path to the river.

She made believe that Marston was with her. And now that she was outside, it was not difficult. She imagined that he stood back of her, very close, wearing his country clothes and slouch hat she loved, the hat he saved from the river.

It was Marston's habit to make her walk ahead where the path narrowed so that he could watch her. He had said he liked to see her long strides, like a race horse. He said her hips swung free as she walked, and she cocked her head over one shoulder. An absurd thing to do! It made him laugh.

Now alone on the path, she spoke to him aloud over her shoulder as though he were there. "Where shall we go today, darling?"

She went on making remarks to him at intervals. "You see," she said, "I used to feel as though I were without roots. I was a tree growing out of nothing, so that if a wind blew I would have been blown right over, and all the other trees would have laughed at me."

Following the river beyond the bridge she came to the large wheat fields. Once green, they were just beginning to turn yellow. A narrow path skirted them along which she continued the imaginary conversation. "And now miraculously you have become my roots. I am now erect, so even when storms blow my roots will hold firm. I will know what it feels to be green and aglow."

He must have taken a quick step forward, for she imagined his hand on the nape of her neck. She lingered, her arms at her sides, and then went on. After a while, she began to think of Beatrice's message. It was like Beatrice not to tell anyone of her plans till the very last minute.

She came now to an avenue of young poplars. Their thin trunks rose like the bodies of young girls with delicate arms, in gowns, moving rhythmically in a tiny breeze.

"There is my dress!" she said suddenly. "How lovely!" She started to paint and she worked quickly. Her work came easily to the paper. It now had freshness, rapidity and point. Her hand raced to catch the thought. Then she sat still on a stump, her hands folded on her lap, waiting for the paint to dry.

Sometime, though when she could not guess, sometime like last night, she would stretch out her hand and he would not be there. She had the awful thought that he might never be there again.

The sky above the trees was so tender! She sat with her hands folded thinking about the one thing lacking in her

happiness. She had no illusion about the permanency of her love affair. Perhaps its very impermanence lent enchantment to it. The music of a violin which thrills for a moment, never to be made static, is more beautiful than mountains, more beautiful than sculpture, more beautiful than anything than that which may be twice seen.

The sketch was dry. Sandra gathered up her things and walked on. Without having noticed where she was going, she found herself once again at the bridge. *Are the gypsies still there?* she wondered. *If they are I'll talk to them and see if they like being gypsies.* The gap in the bridge Marston made was not, after all, very wide, but the broken saplings looked dangerous. She went forward, took a flying leap and landed on the farther side, listening for sounds, gazing through the trees for the smoke of gypsy fires. She heard a meadowlark and saw only the sky.

The clearing was empty, but traces of the gypsies' occupancy had been left behind. Where had they come from and on what road were they going? The rubbish they left behind offended Sandra. She cleared it away, hiding it under brown leaves in the woods. If they were going to leave anything they should have left bright beads and crimson scarves. Not rubbish.

The tracks of their cart led to the opposite side of the clearing and she followed them till they faded on the surface of a country road.

She remembered the first day they crossed the bridge when she and Marston spoke of being gypsies.

It was easy to picture gypsy life. Collecting sticks for open fires, cooking, no law ofice, no Maison Feodor. None

of the thousand-and-one objects, to say nothing of the responsibilities collected during the years. Each gypsy day of each gypsy year would take them to a new place. There would be no friends, only those acquaintances whom one met on the road.

Suddenly she was hungry, and she sat cross-legged on the ground, and lunched. Afterward she became drowsy and fell asleep. She dreamed that she and Marston were nomads with a brood of dirty, brown-faced, black-haired children tagging behind them. She seemed to spend a long time roaming the woods.

When she woke, she returned through the forest. When she reached the bridge once more the dusk, translucent and calm, was falling. She did not want to cross the bridge again. It would be delicious instead to jump into the water and swim. But she crossed as she had come, because of her paints and sketch. On the farther bank, these she deposited and then jumped into the cool chill, clothes and all, shaking her curls back from her face. Coming out, she ran until she reached the field in front of the château. There she lingered for a moment by the stream. She felt that she was waiting for something. Her clothes clung to her unpleasantly. But she did not know for what she was waiting, or why.

Yet when a star appeared over the château, she called it hers and knew it was for this that she had waited.

Lights brightened the windows as Maurice moved from room to room, and she ran up the path to the terrace and into the house.

There might be a telegram.

It was there on the table. She forgot her dripping clothes.

*Take Monday train to Moulins. Will meet you Tuesday morning at station. Don't fail me. Longings. Answer Hotel Miramar, Cannes. M.*

In spite of her wet clothes, a warmth spread through her. She had never taken a motor trip with him! Quickly she remembered that such a holiday meant all of Tuesday away from Feodor's. And there were three important clients coming. Feodor might want to see her sketches. With despair, she realized that she could not go.

She took the telegram upstairs with her, the mud in her shoes making squishing sounds.

In her hot bath she wondered how she could spend another night alone in the château. To order a car and get away was her first impulse. She was tormented by so many thoughts and seemed unable to bring them into coherence and harmony with her practical life.

But at last she began to laugh. *He will be back Tuesday, what an idiot I am, thinking only of Sandra, Sandra.*

It was ridiculous to feel lonely in their home, because he was close to her in every part of it. She would never leave the château, even though he stayed away forever.

After she had dressed, she went to the window in her room and cupped her chin in her hands to look out. The lights as she had seen them appearing in the darkness in the windows of the château were a symbol. For a long time she dreamed about them. Then she imagined she was traveling in space. A few clouds stained the sky, but a slowly rising crescent moon cleared them.

She wondered what it would feel like to be the evening star to see with its blinking eye right into people's homes

as though they were made of glass, and to be a part of the dwellers' existence. It was as though she had become the star and was moving through the sky. She saw palaces and slums jumbled together. It was midnight and because a magic harmony existed between herself and mankind, she could read the secrets of everyone.

In the houses she saw women, men, and children. The women were in the arms of their husbands or lovers; or alone, dreaming of love. Restless young men, and tired young men who slept, tired by overwork, or exhausted by pleasure. There were women in lying-in hospitals awaiting the birth of babies. Men seeking forbidden fruit. There were children, their rumpled heads lying on white linen or dirty pillow ticking. Life in all its phases passed before her. So real to her, so poignant.

It was lovely to kneel in front of the open window with her face in the evening air.

When she finally went down to dinner she discovered she was very hungry. After dinner she forgot about the star and wanted to paint a dress inspired by the poplar tree.

She propped the sketch up against the back of Marston's red chair in the library, and sat down opposite to study the tall grey and green trunk, and the wavering lines of feathered branches above. A tight, shaded skirt was obviously indicated, but the effect of branches, the changing green lights of the upper part seemed an insurmountable task. Without a pencil she could do nothing. With her pad on raised knees she sketched in the shape of the tree. After trying a dozen times she despaired of getting the right effect. It was neither a poplar nor a dress. Impatiently she discarded her pencils and worked with brush and paint. At last

she succeeded in accomplishing what she had in mind. A tiny scrawl on a corner of her pad. She moved her position to the table where she could work with greater freedom.

It was late when she had copied the little figure, enlarged and developed on a clean sheet. *How awkward and out of practice I am*, she thought as she got up and stretched. Leaving her paper in a safe place to dry, she switched off the lights and went upstairs. There on the threshold of the bedroom, a great loneliness swept over her.

Shadows lay in corners that she had never seen before, and wavering lines came from them extending over her, meeting as though for some strange motive. One single light flickered on the wall. It stretched into a darkness that seemed darker than black. She turned on the light by the door and all the room as alight. It had seemed, while there were shadows, she had companions, yet now that there was light, she knew she was alone. She switched off the light, going quickly back to darkness. It could be that a step would sound on the stairway. She listened for it: the silence was complete.

## 8

The following morning, Sandra composed numerous long telegrams to Marston on the train. But when in the crowded Bureau de Poste she faced a thin white sheet which threatened to tear at each stroke of the pointed, scratching pen, she scratched only:

*Sorry, impossible, will explain later. Love.*

After that the morning dragged on endlessly, until Madame said, "Bring your studies to me this afternoon, ma chère."

Arriving home for luncheon, she found Louise holding the door open. "I put Madame's mail in the salon," she said indifferently, and tramped away.

Life seemed to be a continual wait for telegrams. Quickly she opened the door to the sitting room and went in.

A figure rose from the sofa and a voice exclaimed, "Sandra!"

She veered in her course, her bag fell from her hand. "Bea!" she exclaimed.

They were in each other's arms.

Sandra was the first to speak. "You didn't tell me!" She stood back to get a better view of her friend. "I can't believe it."

"I'm here. I—" Beatrice's voice, which was always husky, broke off. Although her face was now bright with happiness, her large blue eyes had the same look of secret insistence which Sandra knew rarely left them.

"It's just like you, Bea, to never tell anybody anything." She laughed as she kissed Beatrice once more. Then she remembered her mail. It lay on the center table. If there had been a telegram, it would have been on top. A glance told her there was none.

Beatrice went back to the sofa, picked up her bag and lit a cigarette.

The shock of finding Beatrice gave Sandra a sudden, objective view of her friend. They had always been so close, it was like trying to discover what was right before your eyes. She looked at Bea with a detachment that for a moment surprised her. Suddenly she knew the reason for it: she wanted to see Beatrice through Marston's eyes. It never before had mattered how she saw her. She was Bea, she was beautiful and different, but in Marston's view, she was to be of special significance. So that standing there in the softened light which came through the Venetian blinds, framed by the mirror over the fireplace, she saw no longer the familiar image, but a person to observe.

The strong figure was slightly taller than herself, erect, without curves, but not angular. Her head, held proudly free, above a beautiful and full neck, was tightly fitted by a small turban, from which hair of *châtain* color descended

116

in a smart curve on fine high cheeks. Her face too broad for pure beauty, yet it was a small face, with, unexpectedly, a slightly tilted nose. Her eyes were amazing. Turquoise blue. So arresting. People, she remembered, always found Bea distinguished and distinctive. But it was her eyes that were unforgettable, not because of their upward slant, but because of their look from within. They were far apart and her lashes, much darker than her hair, gave them a mistiness, except when they were open wide.

While making these observations, Sandra realized that she was also being studied.

Beatrice now said, "I did tell you I was coming. Didn't you get my letter?"

"Of course, but you said soon . . . soon might mean anything. It's no use. I know you'll never reform. Now account for yourself. When did you arrive in Paris?"

They laughed.

"Sunday morning at something A.M. in the usual good humor of Cherbourg trains." Then abruptly, happily, "Sandra, you look wonderful."

"I'm fine," Sandra turned to pick up a letter, a different quality in her voice. "So do you," she said, facing Bea again. "You don't change. I like black on you, and the turquoise beads you wear are marvelous with your eyes. You are beautiful. I can't tell you how I feel about your being with me now. I'm excited. I won't ask questions—because I can't wait for answers." She left the table and sat down on the sofa.

"I have never wanted to come abroad as much as this year," Beatrice said, sitting down next to Sandra.

"So you are really glad?" Sandra said.

Beatrice's face brightened into a look of expectancy. "I don't think I was ever so excited getting on a boat. Who have you been seeing? I'm dying to meet new people."

"It happens my best friends are away. But, oh, I don't know where to begin."

There was silence for a few moments, then both started to speak at once. They laughed, stopped, laughed again.

"How's the work, Sandra?"

"Better than ever. How are the boys?"

"They are grown up. I hate it. They are on an dude ranch now. Is the Marquise as marvelous as ever?"

"Extraordinary! And you know her yearly extravaganza is Saturday night. Do you remember Archie Cummings? He's turned up here."

"Yes, Bob wrote me. Oh, Sandra," her look embraced her friend and the room, "this is really what I wanted."

Sandra's eyes were steady, but Sandra felt a qualm. If her secret were all her own she could tell it now. "It's funny," she said, watching her friend. "I always think of you as little, and when I see you and find you are tall and strong, I'm surprised."

"I don't feel big," Beatrice said ruefully." Before I got here, I felt like curling up into a ball and letting someone, anyone, roll me along."

"That's over now."

"It is. You must get a holiday and we must use it to go somewhere. Where shall we go?"

There it was again, that sharp feeling of uncertainty. *What shall I do?* She spoke quickly, "Yes, yes, tell me. I hear you

118

have become a public-spirited citizen." Her laugh was slightly forced.

"I can't tell you how stale and stodgy I was feeling," Beatrice said, leaning back. "Anything is better than hearing people call the government names, even though it deserves them, and then doing nothing about it. I'd be a nurse for the Italians, if I knew how, or a spy for the English, if they would let me." She laughed her deep laugh. "I was hounding people who had only a dollar, to give it to those who had only a cent."

"I was overcome by your sacrifice," Sandra said.

"Yes, isn't it noble of me? Don't let me ever think of it again, Sandra. I can't believe I am here. I am made over already. Now, what about you?"

"Rush work at Feodor's. The Granvilles are away, as you know, that means a lot to me. Emil owns property in Brazil. They took Stephanie and two of my best men friends with them. Nina wanted me to go and I like her so much I would have let her pay my way with pleasure, but it meant a couple of months away from work." And Sandra thought suddenly, *If I had gone I might never have met Marston.*

"That leaves quite a hole in your social life," Beatrice said.

"It certainly does. Besides, it's been so hot in town that people have stayed away much longer than they usually do. And the word *Ethiopia!* Well, we are certainly not going to talk politics. Anyway, I've been too busy to go out. Bob made me go out one night."

"I know. I had a letter from him when I got here. He said you looked amazing, and you do."

119

"Bob's crazy, everything in Paris looks amazing to him. Oh, Bea! It seems so long, longer than ever."

The door from the dining room opened, and Louise crossed the room with the apéritifs. Then, linked arm in arm, they went in to lunch to talk of friends, of their own personal interests, talking rapidly, interrupting each other, their words tumbling out. There was so much to say. They forgot to eat until Louise's scowl forced them to. For a while Sandra's mind was shut off from Marston. She was completely enjoying her reunion with Bea. In their rapt faces could be seen the unspoken pledge that had held them locked for so long. But presently other thoughts fought their way into Sandra's mind, and she was silent, thinking, *Here I am right in the midst of the problem without having asked Marston whether or not I should tell Bea.* Should she let Beatrice find out for herself and leave the great fact unmentioned between them? She had thought before Bea's arrival that this would be the best solution, but here facing her, she felt appalled by such an idea. For the first time in their friendship, she had a feeling of self-consciousness. It was not that she could resent her silence; she might even prefer it.

When Sandra spoke again she was aware of being unnecessarily expansive. She imagined that Bea's intense, but veiled, eyes sought her own less frequently. Lunch finished and back in the sitting room, she was suddenly sure that Bea knew her secret. She did not mind it, but minded the stab it gave her to think that she had seriously considered not telling her friend—it was this that was unbearable. And then spontaneously, her hand was over Bea's. She blurted,

almost fiercely, "I love someone."

Beatrice took and held Sandra's hand. She showed no surprise, only the intensity of her expression increased. Suddenly she smiled, "I am glad, at least I am if you are. I *felt* you were."

Sandra leaned forward to kiss her friend's cheek. "I am happy…very happy…so happy I am afraid."

Beatrice's voice was very low. "I knew something had happened to you. You are transparent…" She sat without moving. But although usually Sandra loved this quality of immobility, she now would have liked her to be demonstrative. She tried to break the tenseness. "I mustn't start to talk, darling. I must go back to Feodor's. If once I start telling you everything, I won't be able to stop."

"Just tell me one thing, is he a Frenchman?"

"Oh, American!"

Beatrice showed immediate relief.

"You didn't think a foreigner could … ?" Sandra's tone was grave.

"I heard from Bob there was a Frenchman," Beatrice said, looking up quizzically at Sandra.

"Bob gets very suspicious over here." She was on her feet looking down at Beatrice. "Come with me while I get my hat."

"Do you have to leave right away. I have our car, I'll take you."

"I'm afraid I do. It's your own fault, if you had told me when you were coming, I might have arranged to stay with you. Everything is all right, dear, I just can't tell you more now. We must have a long talk."

121

Beatrice knew immediately that Sandra was right. It was not their way. It was enough to know Sandra was in love. The rest could wait. She got up, followed her friend who was at the door. Before opening it, Sandra turned and, trying to speak lightly, said, "It is not all a bed of roses, there are miseries."

"Oh, Sandra!"

"They don't really matter." There was silence before Sandra continued. "He is married. His wife is a semi-invalid."

For a fleeting moment she regretted her confidence. Yet next second she knew she was wrong, and that it was absurd of her ever to have considered not telling Bea. "Dearest Bea," she said quickly, "Oh, dearest Bea, and to think I wasn't going to tell you."

"Will you let me meet him?" Beatrice asked, taking Sandra's hand.

"At the very first moment I can arrange it."

On their drive to Feodor's they did not speak again of Marston. Beatrice refused to come in and see the Marquise that day, so Sandra, her portfolio under her arm, went through the iron gates alone. They arranged to dine together that evening.

At fugitive moments in her afternoon's work, Sandra reviewed the impulse which had made her tell Bea about Marston. A shred of her reserve still lingered on their drive to Feodor's. Only yesterday the thought of Beatrice's arrival had filled her with vague regret, for fear it would add one more subterfuge to her pack of deceptions. Beatrice's abrupt appearance had brought home the realization that she was walking over the edge of life. Sandra knew that once

122

over the edge, all her senses had awakened into fulfillment of their destiny. She felt relief that with Beatrice there would be no more subterfuges. It was like a refrain from a happy song. The next verse would describe them acting in mutual understanding. Then the refrain would repeat itself.

*Beatrice will sidetrack Bob,* she thought. *She has evolved a friendly system with him sufficient to his limits.*

In the vortex of activity in the Maison Feodor, Madame sent for Sandra, telling her to bring her drawings. She was once again a pupil; a little girl, portfolio under right arm.

Madame looked over the old sketches rapidly and efficiently, paused with interest at the ones suggested by the old masters, making comments. When she came to Sandra's gown inspired by the poplar tree, she examined it with a gasp of surprise. The efficiency of the painting, its obvious grace, subtly expressed, its imagination and its beauty as a gown was an inspiration. Nada, looking at it, could not believe that it was her own creation. Feodor's hand rested for a second on Nada's shoulder, then she patted her head and the next second apparently forgot her. Feeling repaid, the *vendeuse* went back to her clients.

Girls from the cutting rooms came at the Marquise's call. Rapidly they were dispatched to bring materials of various textures, and few colors. Joséphine, Madame's favorite model, was sent for. Half an hour later, the floor of the mirror-lined room was completely covered with *liasses* of satin, chiffon, gauze, lamés. Joséphine, immobile, rose resplendent in their midst, while Madame, now kneeling, now standing or sitting, draped or undraped, retained or

discarded piece after piece of filmy substance.

Saucers of pins lay on the floor. Feodor filled her mouth with them and plucked them out like cherrystones. She fastened pleats, folds, tucks onto the model's white satin slip. The pins were forever being swamped by falling draperies and extracted by the work girls. Even when the pins pricked, Joséphine remained immobile. She knew she was assisting in a work of art.

At five Nada was sent for again. She stood entranced in the doorway. The spirit of the woods, the seizing of a moment of magic had been made permanent, and yet so fleeting as to suggest the movement of life.

"Walk," commanded Madame. The apparition swayed, her arms first moving tremulously. The action passed through her body, to the tree trunk, which gently moved forward. Its branches undulating, it sighed imperceptibly as she walked. It was as though Sandra had seen a stationary tree, except for a rustling of the wind in the branches. No one spoke until the spell was ended by a wave of Madame's arm.

Now the girls brushed aside the materials on the floor. They swept away the pins. Everyone stared at the new dress and thought it was a triumph of originality and loveliness. All eyes turned from it to Feodor, and Feodor looked at Nada. "It is Madame Nada's idea," she said. "I am happy to have her here. She will be our new designer."

"Perhaps it was my idea—but what a miracle you have made of it!" Sandra exclaimed.

Madame interrupted, "It is late. I have kept you after your hours. *Foutez le camp, mes enfants!*"

124

Her smile dismissed them all. An element of cheer infected everyone. *She makes one feel like a cog. It's nice to be a cog,* Sandra thought.

Instead of going straight home, she stopped at the Café de la Paix to enjoy the last hour of sunlight.

Crowded rows of tables stretched over the sidewalk. She had been taught that a lone woman must never take a front seat unless desirous of assiduous attention. After finding a table at the back, she ordered a mixed vermouth and a brioche.

The Rue de la Paix was a mass of humanity. Some of the real Parisian life still went on there, but much of the fake, too. People with themselves to sell, or people buying nefarious goods. People curious, expectant, despairing, or strangers who wanted to go back home and tell their friends about "The day I sat at the Café de la Paix."

The sidewalk beyond the tables was filled with a surging and ebbing flow of people. Alert, but tired, waiters pushed their way backward and forward. She wondered if they ever slept. At that moment Sandra became aware of a voice at her shoulder. Jacques de la Roche sat down at the table beside her.

"May I?" It was a perfunctory remark, for he was aready seated. "What are you doing here?" he asked. "I caught sight of you as I was passing."

"I am drinking a glass of vermouth and eating a brioche."

"You Americans are so surprising, you are probably not meeting anyone," De la Roche said.

Sandra sat back in her chair and looked at him lazily. "It's

so agreeable just being here and doing nothing and not having to be polite. It's nice letting other people push away your thoughts." She stopped, as though she had already forgotten what she was saying.

Jacques de la Roche ordered himself a *fine* and coffee. "That's a pretty hat you are wearing," he said.

"Thank you," Sandra said absent-mindedly. After a few minutes of silence, she roused herself. "How unexpected to meet you here among the bourgeois." She looked around at the mixture of types, the gesticulating arms, and the rapidly changing groups, and then back at him.

"The unexpected is always charming. Don't you think so?" he said.

She ignored his remark and said, "It's the third unexpected thing that has happened to me today."

There was something about the moving crowd, the warmth, the sound of voices and crockery, noises both homey and friendly, which produced a calming effect on Sandra. He seemed different sitting out here on the sidewalk, and the memory of their last unpleasant conversation almost vanished. She sipped her drink and looked out over the tables set with glasses and bottles, French cakes and white dishes, toward the pedestrians' faces beyond, thinking she had been rather absurd to be upset about what he had said about sex.

Abruptly he asked what the other unexpected things were, "Were they pleasant?"

"Yes, but they had strings attached," she said idly.

"What is the string attched to this one? I hope it won't take you away from dinner with me."

126

After his question De la Roche averted his eyes. He sat, his head bent, his eyes fixed on his coffee cup.

She thought dispassionately that it was not an unbecoming attitude.

Today he had the same ingenuous quality which had attracted her when they first met.

After a while he said, "So you are not going to tell me your unexpected incidents, with strings attached?"

His manner was so casual that she was scarcely aware of saying, "They are purely local. But you can have them if you wish: the arrival of a friend who could have been a complication, and the approval of my boss, who may not go on approving my work."

"It's worth trusting friends," he said, as if he had read her thoughts. "By the way, don't tell me if you don't want to, but why do you work? You don't have to, do you?"

"The work I am doing is becoming more creative and I do like that. Besides I couldn't afford certain luxuries if I didn't."

"But wouldn't you like other work just as well, maybe better?" He had straightened up in his chair and moved a little so that his figure cast a shadow over the table.

"If you mean being married or someone's mistress, I don't think I should want that as an occupation."

"And as a pastime?"

"I could be one of those and still work," she said smiling.

He drank his coffee and brandy in silence.

Sandra had already forgotten he had asked her to dine when suddenly he looked at her, and she realized that he was serious. "I do wish that I could rescue you," he said

the words appearing immediately irrelevant.

Sandra looked at him out of the corners of her eyes. "What is there to rescue me from? And besides I don't want to be rescued."

"It is easy to see you have a secret."

She returned his serious look. "If it comes to rescue, who needs a life preserver more than you?"

All his nonchalance now forgotten, he leaned forward eagerly. "If you will rescue me, that is another matter. I should adore being rescued. Nobody has ever cared enough to try. It doesn't matter at all what I am being rescued from. I give you *carte blanche*."

"And what, pray, will you rescue *me* from?" Sandra demanded with bravado. Or is this just an undiscriminating rescue party?"

Jacques drew back. "From the fictitious calm of your life."

Sandra detected the needle at once. When she spoke, the curve of her lip was obvious, "My life is a whirl of activity. I work, I sell clothes, I design, I play. And my nights are spent in riotous living. Don't insult me. You with your false talents as a psychoanalyst, even your boasting has not given you a fuller life than I have. I don't want to be saved." She got up. "I won't insult you by offering to pay for my drink, so thanks. I must go. My lover awaits me." And laughing at him over her shoulder, she wove her way out to the street and disappeared into the crowd beyond.

When she reached home it was to Sandra's surprise and disappointment that she discovered Beatrice had altered their anticipated tête-à-tête. It was now to be dinner at the

Crillon. A note advised her that Bea had run across friends and become involved. The last line read: *Darling, I'm happy because you are.*

Only Beatrice understood everything, Sandra thought, and she was now impatient for her lover and Bea to meet. It would mean far more than talking for hours about him.

A telegram from Marston came just as she was leaving the apartment. She felt both disappointment and love in each guarded word. He ended by saying he would come to her apartment at 6:30 the following day.

Beatrice's party at the Crillon was an impromptu affair that resolved itself into a summer *divertissement* which no planned entertainment could have achieved. The piazza outside Bea's rooms, where they dined, overlooked the Place de la Concorde and because it was not solely dependent on the kindness of nature, it was enchanting. Below and stretching out were the lights and playing fountains of the Place de la Concorde.

As a hostess, Beatrice was neither too attentive nor too casual. She made others appear at their best, shining only through their brilliance. She and Sandra had but one moment alone together. "I wish he were here tonight," she said, "to see you."

"Bea, I almost forgot to tell you that the Marquise wants me to design for her."

"Oh, Sandra, how splendid!"

"My paints were all dry."

"Let's go and buy some fresh ones tomorrow," suggested Beatrice laughing.

"In seventeen hours he will be back," was Sandra's irrelevant answer.

## 9

And when the seventeenth hour came, she heard a voice at the door of her room. *Entrez.* She thought, *Louise is announcing Marston.* She was ready, expectant, waiting for the knock.

Louise stood immobile just inside the room. Sandra could see her reflection in the mirror. "Yes?" Sandra questioned.

"I have everything prepared for a *petit dîner délicieux.*"

"Thank you." She turned smiling. Louise's broad back was disappearing behind the half-closed door.

It had been one of those days when one could not ignore constant annoyances. The inability of people to be punctual or polite, jangled Sandra's nerves and perspiring half-naked, middle-aged bodies depressed her. But it was all over now. Quickly she applied powder, rouge and lipstick, slipped into a tea gown, and regained some of her sense of well-being.

Marston always looked big in her living room. Today he seemed overpowering. For a moment they faced each other without words. The thrill of being together was enough. In

a world peopled only by themselves, they looked into each other's eyes, and drew closer, arms slowly rising—rising higher and higher till they clasped each other, with lips pressing together as though without end.

She was now free. As they moved to the sofa, he held a match to her cigarette while he asked her, in a solemn tone, why she had not met him that morning at Moulins.

He did not try to conceal his seriousness. To Sandra it seemed incomprehensible, but she feared that the hidden look which took him away from her would come into his eyes. Close to him she could feel the tenseness of his muscles as he braced himself against her. She did not want her physical nearness to influence him and moved away. "There is nothing I would have loved better," she said. "But, Marston, as long as I am working I must keep hours."

He was about to interrupt, but she stopped him with a gesture of her hand on his lips. "Sorry, dear, I know my part is a very small one, but I hold it intact."

There was a change in Marston's expression. He leaned over and held her almost fiercely against him.

She was not even then thinking wholly of him. It was Beatrice she was remembering with a shock. He was already disturbed. How would he feel when he heard she had shared their secret?

"Beatrice has arrived!" She said when she got her breath.

The secret look she had feared now came into his eyes. It hurt her. He sat back. "So that's the reason you did not come to meet me."

Instantly she knew he was hurt. Her only thought was to heal him. But she could not keep all the pain that went

132

through her. A physical wound. "That isn't generous of you," she said.

"Forgive me, sweet heart." He took her hands wishing their touch might give them security. "I am often wrong, and I'm hurting you."

With one hand she drew him closer to her on the sofa.

She didn't let go of his hands. Then his face cleared as though by the expression of her love.

Then she said, "Bea didn't let me know when she would arrive. When I came home for lunch, she was here. I found her sitting right on this very spot on the sofa."

They were silent. He was the first to speak. "I had dreamed of a day's motoring with you," he said. With a gesture of dismissal, he continued, "Tell me, I want to know all about you and Beatrice."

Sandra's hands were still in his, her voice was low, distinct, as if she wanted to impress him by what she said, "I told her about you. At first I was not sure what I should do, but when we were together it was the only way."

He looked at her, intent, "*All* about me?"

"Not your name, but I told her that we loved each other." The words were a caress. Silently they both lived in a sensual emotion born of the thought that someone knew of their love. It had become concrete, more real, now, even than when he possessed her.

He closed his eyes as if to hold it forever. It was an effort to speak, so intense was the moment. "What did she say? How does she feel?" And with his words, he prolonged the joy.

Sandra recovered more quickly; the thought of her

friend's words long ago on the lake jumped into her mind: *I have no standards of my own...*

Aloud she said, "I wonder how she feels? She doesn't like casual intimacies any more than I do. I am sure she understands." She finished lightly: "If you were a villain, she would be sorry."

"Did you tell her I was one?" he asked, smiling now.

"I told her everything in three short sentences."

Marston got up quickly from the sofa and stood in front of the fireplace, staring down at her. "Sandra, Sandra, I've brought this all on you. You should have fallen in love with a man your own age, and had a home and children." He came to the sofa again and put out his hand to her. She took it spontaneously and he pulled her to her feet. His voice changed, it was very quiet, very calm. He held her and kissed her. When they drew apart, she said, "Are you glad I told her?"

"Yes, very."

"She wants to meet you."

"Please, darling, arrange it soon." He pulled her down onto the sofa once more. "Would you have liked motoring with me?" he asked.

"We might have been on the road today, and the sun would have been shining. Are you a pleasant travelling companion?"

"It depends on what you want."

"No complaints, a thirsty curiosity, as much interest in people as in things, and a total disregard for time."

As he talked, he gave her the thrill and excitement of new places. Countries he had seen and those he longed to

see, leaped to life through his imaginative description.

Then, as though remembering something sad, he turned and looked at the clock. "Oh, darling, I forgot to tell you. I have to go in a few minutes."

"Oh, Marston!" Sandra's voice almost broke.

"How stupid of me not to tell you."

Sandra made an effort to smile. "I hoped you could stay."

"When I telegraphed you, I expected to have the evening free, but Clermont, my partner, just announced that we have a new client. It's a very pressing matter."

He stood very still, apparently absorbed in the pattern of the rug, until she touched his arm, when he looked at her. "I have to see him now and decide whether we'll take the case," he said.

Her disappointment won. She became cruel. "To hell with work!"

He covered her head with both his palms, pushed it back and smiled into her eyes. "Thursday I am going to drive you to the château."

"It can't be done," she moaned, shaking herself free.

"It shall be done."

"Oh, Marston, last week was bad enough and this one is going to be a repetition. I had to get up a party for Bea. You are *always* busy on Thursday, so I picked that day. Isn't it nerve-wracking? Foolish things coming between us!"

He looked at her with obvious disappointment.

"And, oh!" she went on, her voice trailing, "On Saturday there is the Marquise's ball. It is a royal command. Her big *soirée*, you know, that she has every year."

"Must you go?"

"I have to." She crumpled down on the sofa for a minute, then was on her feet again beside him. With a rapid gesture she took one of his hands in hers. "None of this matters *really*, my love, only there are times I would like to tear the world to pieces."

"It's horrible, and what's worse, I have to speak at a lawyer's dinner tomorrow, that's Wednesday, and Friday I am hopelessly involved with family. Are you sure, Sandra, it's worthwhile?" He asked the question but did not need the answer.

"You know, you *know*."

She broke away from his arms in a few moments, and smiled at him. "I am going to get me a new boy friend."

"And me a new girl," he answered.

Together they went out into the hall.

"Your new case. Is it going to be interesting?" she asked. "It's interfering with our evening together. At least you can tell me about it." If she broke the ice of his reticence concerning his work, another link would bind them together. This had often been on her mind, only to be pushed back by Marston's preconceived ideas of women. She was convinced that if he could have put it into words himself, it would have sounded like, "Women don't care about business, and don't understand it, anyway."

Now he said, as if it were a small matter, "It's Merrimée. He wants us to defend him."

"My heavens!"

The set of Marston's shoulders was evidence of involvement in the case which he so lightly mentioned.

"But he has his lawyers. I don't understand."

136

"He has chucked them." Then in a moment he added, "I hate seeing heroes destroyed."

"Do you know him?" she asked.

"I know a lot of people who do. I haven't met him."

They were silent for a moment, both occupied with the sadness of this popular figure thrown down abruptly from the height of success into the abyss of a murder charge.

"His alibi doesn't seem too good," Sandra's voice was sad.

Marston's expression changed. "That can often be the greatest sign of innocence."

"Why should he have wanted to kill her, Marston?"

"Why should anybody have wanted to kill her, except in the course of a theft, and there was none?"

"The gardener says someone could have gotten over the wall, the ladder had been moved. The murderer might have been scared after shooting her and run away. I hope Merrimée is not guilty."

"Do you think he is, Sandra?"

Sandra didn't answer right away.

She was suddenly drawn back into the memory of her meeting with him. "I met him once," she said thoughtfully.

"Did you? Oh, yes, I remember now your telling me when the case first came up. Did you have a chance to talk to him?"

"It was at one of those depressing official receptions given in his honor," Sandra said. "The line got clogged and I found myself stuck in front of him. Luckily for me, a funny old American woman gave me an opening. You know how much like a bird he looks, even in his pictures?"

"Go on." He was watching her almost impersonally.

"The woman seemed horrified," she continued, "and said in desperate French, 'Why you do look like a bird! I didn't believe it was possible that anyone could look like you.' He gave her an ingratiating smile: '*Oui, Madame, je regrette ça vous déplait.*' Of course, he and I had to laugh. 'Do you look like one because you fly, or do you fly because you look like one?' I asked."

"And what did he say to that?"

"He went on smiling as he answered, 'I had no beak as a little boy, it grew with my wings,' and I said something about his being obliged to keep those hidden under his uniform, and it was just as well, as they were surely ruffled now by having to be polite to so many people. He said, as if he had just thought of it, 'It's wonderful to think what patience people have in order to express their love of adventure.' He looked all excited and glowing, and his eyes were penetrating as if he saw something that wasn't there. And I said, 'You live for adventure,' and he said..." Sandra stopped short, then slowly repeated, "He said, 'No, not adventure, not flying. We are the gods. We have usurped their powers.'"

"He is not banal!"

Sandra put her hand on Marston's shoulder. "But, darling, why aren't you excited? What an opportunity! You don't often take criminal cases, do you? And such a striking one!"

"No, we don't." He paused, then continued, "It seems your friend Archie Cummings had a lot to do with Merrimée wanting me to take his case."

Neither spoke for a moment.

"Of course you will?"

"I am going to see Merrimée now. How can I decide until I see him?"

"You are going to see him now! Take me with you. Oh— if you only could!"

They laughed, then abruptly became serious.

"Naturally, you have followed the *affaire?*" he said.

"Like everyone else."

Marston stood looking at the carpet. With sudden determination Sandra pushed him towards the door. "Stop dawdling," she said.

"I don't want to go. I want to stay." He stood still, facing her. "I am going to resign from practice," he announced, with mock seriousness.

"I can't permit your sacrifice at so dramatic a moment," she said solemnly.

It was she who opened the door to let him out, and as he went down the stairs, all her happiness and something of her vitality went with him.

Unable to control herself, she closed the door fast. It slammed. She hoped it was not too late to keep more of her loneliness outside and more of her strength within. *I hope he did not hear it slam.*

There was no movement in the little grey hall, only an echo of something he had once said to her. She had asked him if he would take the case of a criminal under extenuating circumstances, which she had called "nice reasons," to love or to shelter someone else.

139

"That is nothing but ordinary human shabbiness," he had answered.

It took an effort to move back into the living room, but the heat drove her to an open window where the Venetian blinds were lowered. It was only possible to see the street by bending down. Her thought continued: *Louise will not come till she is rung for. Louise with her petit dîner délicieux, and no one to eat it.* She rebelled against being alone, her mind was too active to face an evening of solitude. She was excited by the idea of Marston taking the Merrimée case. A noisy argument came in on the stifling air from the street. There must be someone who would like to share her dinner. She laughed at herself. In the old days, if she spent an evening alone, it was because she had wished it so. You had to know someone fairly well to ask him to dine at the last moment, and lately she had dropped some of her men friends. Besides many people were out of town. If only the Granvilles hadn't gone to Brazil. In her present mood, she couldn't just invite anyone. Of course there was Jacques de la Roche, but after their conversation at the Café de la Paix, she dismissed him. Then there was Felix, Count Marbeau. He would be a correct solution. A man of reassuring traits.

As soon as she hung up, the telephone began to ring. It was Marston. "I am at the Club. I called to say goodnight."

"I am glad you called."

"Tomorrow night I am going to take you to the country."

"But don't you have a speech tomorrow?"

"I've cancelled it."

It reminded her of other moments of happiness.

"The Count is coming to dinner tonight."

"What an honor!"

"It isn't. You know perfectly well that otherwise I should be alone. I don't want to be alone."

"How perfect under those conditions that you want me," Count Marbeau had said.

There was still some time before dinner and Sandra went to fetch her drawing and painting materials. Today she would try something different from the poplar dress. Her talent had always been for pictorial scenes where action and characterization counted. She had the faculty to sketch rapidly descriptive events. An illustrator's aptitude. She had never wholly given up this pastime, as a pile of small sketch books, concealed in a bookcase, testified. She amused herself looking over them and was surprised at the memories they evoked. Her first experiences at Feodor's showed her bewildered and clumsy in the salon, clients whom she already had forgotten emerged from the pages. There were café scenes, some made on the spot, others from memory, a succession of incidents that now seemed spirited and clever. One book was half empty. She took up a pencil and drew a rough suggestion of Feodor's mirror-lined room, with Joséphine swaying in her tree dress, surrounded by a gaping crowd. Then on another page Jacques de la Roche and herself at the Café de la Paix. She thought it needed color and tinted it with the light of the setting sun.

Louise startled her by coming in to tidy the room to draw the curtains before dinner. She was slightly annoyed with herself that the work was not better, and she determined to

paint or sketch something every day in the future.

The Count, on his way to Sandra's, was immersed in his contemplation of her. He sensed that recently she had stepped into a new world and he knew that beautiful women only entered it by way of love. The crown of perfection had been placed on her head. It would be difficult to say if she had lacked it up to now. Perhaps she was afraid, or because she was cold. One could never tell with vital-looking women, particularly Americans. He thought it would be nice to go to America sometime, but he doubted he would like it. He pictured it as glittering and cool, best indicated by exclamation points and asterisks. It must certainly lack flavor. Yet some day he must go. Here he was getting older and vanishing from the scene, while Sandra was entering into the jeweled doorway of life. He sighed, yet smiled, remembering how few were the disappointments in his extensive career of good fortune. He had known long since that the age of his rapid conquests was over. He had glided into a period of agreeable makeshifts with a philosophy worthy of his intelligence. *My fastidiousness saved me,* he thought. *Sandra's florescence! How lovely and important.* Of course her lover must have disappointed her tonight.

The evening had become much cooler, and when they came out from dinner a small fire was lit. The coals snapped on the hearth. The flame-colored curtains were drawn at the windows, so that the room looked even gayer than in the day time. Marbeau stopped on the threshold to admire

the scene. As usual when alone they had been talking French. *"On est bien ici chez vous,"* he said, holding his cigar poised in the air. *"Cette chambre où vous avez su combiner l'art ancien avec le goût moderne.* I will not say it would have been better if you had withheld the modern."

"Don't you like anything modern?" she asked.

"Certainly. Bathrooms, telephones, aeroplanes and jazz."

They laughed as they went to sit in front of the fire.

"You are a sweet little girl to have thought of me tonight," he said. "I am glad that our Beatrice has arrived, for both of us. She affords me great pleasure."

"I know you have always liked her."

"Excuse me. But no. I have always admired both her appearance and her character. But when I first knew her, I did not find her as sympathetic as I do now." He paused. "She is well worth knowing. You must always keep her with you, *ma belle*. She adores you." He pulled at his long cigar in silence, while Sandra said, "It's mutual, you know that. One of the hardest things for me is that we are separated so much of the time." She had a qualm as she said it.

"But she misses you far more than you miss her," he declared with conviction. *"Il y en a toujours une qui baise et l'autre qui tend la joue."*

"No, no, you are mistaken."

"Indeed, I am not, pardon me, my lovely one. You have more to live for."

"But," Sandra was on the point of making a conventional mention of Bea's family when the Count added:

"You are thinking of that dear Bob and the children. They exist, to be sure, as physical relations in her life. She is

a good woman and it is not in her character to forget them. But it is you who are spiritually important."

Sandra did not speak and Count Marbeau continued: "She makes me sad. Perhaps that is the reason that when I first met her, two years ago, I did not much enjoy being with her."

"I wonder why she makes you sad?"

"It is my nature to be made sad by seeing powers not fully used," he said gently.

Sandra marvelled, as she had many times before, not only at his insight into character, but his knack of knowing the truth of how much this mattered to Bea herself, and how aware she was of all that she had missed. Even her close, old friends took it for granted that she had become reconciled to second best.

She felt drawn to the Count. "Don't you think," she said impulsively, "that you might call me by my first name?"

He raised himself on one elbow, smiled at her, "Sandra! It is always so that I think of you. And if you will, can you say to me, 'Felix'? On your tongue it sounds entrancing."

*"Mon cher Felix."*

"Ah, *ma chère*, you honor me." He let himself sit back on the cushions. "A beautiful woman when she says that word," he sighed, "brings back thoughts of rapture."

"You are happy, aren't you?" she asked impulsively. "You seem as...as though..."

"Tell me, Sandra, do not be afraid. I have passed the time when references to my age offend me."

"I was going to say," she went on, "As though you had enjoyed and appreciated life so much that every phase of it

144

has added to your zest for it."

He pondered before he spoke. "Everyone despises growing old." It came out with surprising vigor. "Some do it more gracefully, which is only a test of supreme self-control. Wrinkles and hollow cheeks are hideous to one who loves beauty. It is stupid to fight what is unfightable. Take every bit of your youth, *ma jolie*, and treasure it."

"But I am no longer young," she said. "The night before my thirtieth birthday I spent in tears, and that was seven years ago. My husband came in and found me sobbing."

"No doubt he did not understand. You should have spent that night with your lover. Then it would have been delicious. It is odd, isn't it: a woman just entering into the most consummate period of her youth and beauty, weeping for what she considered gone!"

"I think," said Sandra, smiling at the Count's obvious pleasure, "of the word 'turbulent' as synonymous with youth."

"With some people it comes late," he said.

"Is it true," she asked, leaning towards him, "That one can live in memory?"

He laughed scornfully. "It whets the appetite. But why should we dwell on such things. You have your energies, and you are young for your age."

"If only I could go back ten years!" she sighed.

"No, no. You would be another woman and would not have your great experience."

She would have liked to challenge the implication but instead brought the conversation around to one of his favorite themes: his library. He called it by the extremely grandi-

ose title: *Bibliotheque intime des amours du monde*.

He recounted to her anecdotes collected from obscure sources, while she sat curled in the corner of the sofa. Then he told her something he had never told anyone before. She had asked him if there was any one woman who stood out in his memory above all others.

Sandra seemed to him in that moment so warm and tender that he told her the truth. "She was a horrid, little creature, almost bedraggled."

"But she gave you something that no one else could?"

His shriveled face took on a gleam of reminiscent light. "She took me. She was the part of life I didn't know and didn't want to know. *Je l'avais dans la peau.*"

"I suppose there is someone for each of us, whom if we met, we never could be parted from," said Sandra slowly.

For a brief moment Paris and the apartment did not exist for the Count and Sandra.

After he had gone the things he had told her re-echoed in her mind and it was not until towards morning that she fell asleep.

With Louise's knock the following morning, she awoke to discover that she was mumbling into her pillow: *"Je l'avais dans la peau."* Laughing at herself, she jumped out of bed. *Luckily, Louise is slightly deaf,* she thought.

Sandra's first act was to look up the address of a clipping bureau. At lunch time she went to their office and ordered the past, present and future clippings on the *affaire Merrimée.* They could not and would not promise all the old newspaper pieces, but assured her that she would certainly

not be lacking in material.

Marston and Sandra left Paris in the late afternoon. She forced herself not to ask Marston about whether he would defend Merrimée.

She was so preoccupied she was surprised that it was raining. She was glad, because they had to close the car windows. Here in Marston's car they were shut in together. Although they were no closer than if the windows had been open, there was a marvelous feeling of intimacy with the windows closed and rain running down them in rivulets. She and Marston compressed into a tiny space. She was happy and found it cozy to ride with him in silence.

There were moments in the drive when she vividly remembered his first wooing. She had felt helpless and he had caressed her gently. His kisses were always controlled. One day he had stood close beside her and had said: "We can be happy together. It won't be a cloudless sky, my sweet heart. Are you ready to take a chance with me, Sandra?" He had moved away, leaving her alone. "If you love me and have faith in me, come with me."

She had drawn close to him. Since then theirs had been a feverish happiness, a satisfying happiness, a calm, protracted happiness.

When they arrived at the château, when Sandra got out of the car, Marston saw she was trembling. *Could it be possible*, he thought, *that she loved him in the same way he loved her?*

Maurice was on the terrace to meet them, an umbrella at

the ready in his hand. Marston took it away from him, closed it and put an arm around Sandra. The rain pelted down as they ran to the house together.

"Go upstairs. Get dry," he said. He was smiling, seeming oddly younger than his years.

A little later he burst into her room where she was standing half-dressed. "It is sweet to dance to violins," he said.

"But there are no violins," she laughed.

"I shall conjure them up at once," he said, wrapping his arms around her.

"At least we have love and life," she said. "You feel very substantial." She put both hands on his shoulders, freed herself and pushed him towards the door. "Would you mind getting out of my boudoir while I finish dressing?"

"I mind leaving you even for a single minute." He wanted to possess her, unexpectedly, completely, but Maurice knocked on the door, announcing dinner.

Marston swore, but Sandra sighed. So when she pushed him away again, he said, "To tempt men is your vocation."

"To resist temptation is..." He would not let her finish, "Is in the hands of Maurice."

Dinner was like a new experience. They changed from laughter to serious talk. Their conversation was inspired by their happiness, which made commonplace remarks sparkle.

His eyes did not leave her. Marston examined every detail of her dress and of her body, and he knew she valued herself the more for this appreciation of her. He believed that she told him about herself in successive revelations. He felt there was excitement and romance in everything they

did together. Nothing between them could be casual.

He was also glimpsing a new pleasure ahead. He knew Sandra had a deep interest in his work, yet it was his belief that his professional life and his personal life were two entities. He could not quite admit the fusion of the two, but the preceding day, linked as it was with tendrils of past thought, awoke a new feeling in him. Was it possible that a woman's sympathy could enrich a man's sphere of action? Sandra was not the sort of woman who could be carried away by the sensational aspect of the *affaire Merrimée*. She would, he knew, bring her clear, logical mind to the case.

Suddenly, he said, quite casually, "My new client is a character."

Sandra was excited. She leaned acaross the table, her eyes wide open. "Did you...?"

His lips were on the edge of a smile. "I accepted the case. I wanted you to know. But I can't talk about it tonight. It's better for me to see the facts as freshly as possible." Then he went on to speak of many other things. Trival, political, and later life in the Far East.

Very early in the morning they ran down the circular tower stairs, out of the house and got into the car. The rain had stopped, and a waning moon cast eerie shadows along the streets of the little towns they drove through. The road to Paris was filled with enchantment.

# 10

On her way to Sandra's apartment on Friday afternoon, Beatrice, sitting back in her car, was wondering whether Sandra would have any other guests besides Marston. Sandra had arranged this day for her to meet Marston. She thought, *It would be characteristic of her to make the occasion casual by bringing in other people, yet Sandra's spontaneity always left her in doubt.*

The evening before, she and Sandra had gone together to la Rue's where her friend was entertaining at dinner. Sandra had turned suddenly to her.

"I suppose the name Marston Overstreet doesn't mean much to you. But you may have heard of him."

"Marston Overstreet, the lawyer?"

"Yes."

"Will he be at dinner?"

"No, we never go out together."

"Oh." She understood.

It had been evident that Sandra did not wish to say anything more for the moment. She drew a scrap of paper from her bag. "Bea, whom do you want to sit next to?"

Beatrice remembered that she had not replied, and San-

150

dra seemed oblivious to the fact that she had not answered. While Sandra was seating her dinner party, Bea had dug into her memory to bring out all that she had heard about Marston Overstreet. She knew him only as a distinguished international lawyer who occasionally took criminal cases. As to his personallity, Bea knew very little about it. But it was a distinct pleasure to Bea that her Sandra's lover had brains.

The car slowed down, stopped, then sped on. Bea was thinking about last night. Archie Cummings had been sitting beside her. She had seen him staring at Sandra, and then turning to her, and suddenly ask, "Do you know Marston Overstreet?"

"The lawyer? Not personally. Of course by reputation. Why do you ask?"

He had looked at her mischievously, and said, "I think you'll meet him soon."

Beatrice felt it was disconcerting that Archie, so recently reinstated in Sandra's life, could speak to her that way.

Sandra forced herself to say casually: "What do you mean by that?"

He leaned his elbows on the table. "Quite a man with the women. I don't know him personally." He lolled back in his chair. "Marston Overstreet is one of those clever guys. I think he has a mystery in his life." And after a moment he had continued. "A neurotic wife. Always needing his attention, and very well-dressed and expensive. Isn't it lucky I never got married? I might have had one, too." He chuckled as though the thought amused him. "If I did, I'd leave her."

"Why doesn't *he*?" she asked.

151

"God, how could he?"

"I have just arrived in Paris," she said. "I don't know anything. Should I?"

Archie just looked superior.

Beatrice had changed the subject, thinking, *He connects them quite definitely.*

There had been another recollection of the evening. An elderly Frenchman had sat on Sandra's right. Her first impression of him was that of a distinguished individual who had probably been less interesting in his youth. His chin, mouth and nose were irregular, but it was evident that his thoughts and experiences endowed him with a nobility, irrespective, and had molded his features according to his character.

She had asked Jacques de la Roche at dinner who he was.

"You are the country cousin," De la Roche said.

"Well, who is he?"

"He is Monsieur le Juge Boissonier, known as the least corruptible of judges."

"A judge?" she remembered saying, "He looks as if he understood too much to be a judge."

"You are cynical, Madame. Judges are omniscient," De la Roche said.

"You still have some illusions then?" De la Roche raised his eyebrows. "Probably," she said. "More than you will admit having."

"So Mrs. Fane has been telling you about me?"

Beatrice looked at him squarely and laughingly. "She has never even mentioned your name."

He seemed crestfallen, sighing, "She is a lovely person.

Beatrice guessed he must be the man about whom Archie had written: *There is a very handsome Frenchman pursuing Sandra. Dangerous type.*

It had been the judge who, later in the evening, had drifted over to her. It was odd, she thought, to meet a judge in this rather inconsequential gathering. *Had Sandra met him through Marston Overstreet*, she wondered.

Now her car was held up by an incompetent-looking gendarme. While she was thinking of the vigor of the Judge's face, his keen eyes seemed actually to dominate her even here in the automobile. He had talked to her in French, very rapidly and with great precision, presuming her knowledge of public affairs: the Stresa meeting, Mussolini's address to the Italian Senate. He was wary in expressing his opinion of Great Britain. She could not remember her part of the conversation, but she sensed he liked her as a listener.

After a while he talked about his holiday, which he had spent at his *petit coin* on the Riviera, and suddenly, mixed with his rather verbose language, Marston Overstreet's name emerged.

"Marston Overstreet's estate—you know, the lawyer—is not far away. It is grand and I think excessively palatial, overlooking the sea. The estate produces every kind of unusual and exotic shrub and plant. Not just flowers which grow in great profusion and fill the gardens and cover the walls, but rare blossoms, brought from faraway places." •

"So he is interested in gardening?"

"No, no, that's Eileen's enthusiasm."

At mention of the third member of Sandra's triangle, Bea-

153

trice had felt intense interest. "Eileen? His wife, I presume."

He nodded. It was obvious that he liked Eileen.

"She actually attends the gardens?"

"I should not exactly say 'attends'," he answered with an indulgent look. "She is very proud of them, for it was her idea, originally, and she gets pleasure from the number of people who visit them. They are quite famous. Eileen is not at all strong, but she's very brave, so her interests are confined to aesthetic matters." He had sat pondering that thought for a moment, then when he spoke of Overstreet his enthusiasm rose: "But what a man! A great intellect, yet so simple! It is sad that he no longer belongs to America. You need such men today. When it comes to that, we all need them. Of course, it is true that America profits from him through the large field of his activity here, but he is more limited in his sphere." He had paused as though thinking. "You know him, of course?"

Beatrice said that unfortunately she did not.

"Ah, and I do not think that our hostess knows him either. I must arrange for you both to meet him," Judge Boissonier continued. "I speak of the limit of his sphere, but truly there is so little limit that it is scarcely of moment. He is so highly thought of in your country that he represents the French interests of many important firms and banks. His fees are collossal."

"I have heard that he was very rich, but I thought it might be inherited money."

"Oh, no. He once told me that he began making his fortune in negotiating for oil interests in China for some large American company."

154

"He sounds too good to be true."

The Judge hastened to reply, "He is a type which you Americans develop now and then, and when you do, they have a unique quality which transcends our stereotype."

She said something polite. And then, "But why is he limited?"

"He is a brilliant orator. Practicing law here, he has very few opportunities to exercise that gift."

"Although he is a member of the French bar, he can't try cases here."

"You see our laws are very restrictive. Except occasionally on an international case, Overstreet is not permitted to be a trial lawyer. But he has a powerful personality, and makes himself felt, no matter what he does."

"We all agree, he is a brilliant lawyer."

"Oh, yes, that is true, but he possesses a very rare gift. It is given only to few." He had gone on to enlarge on Marston Overstreet's qualities.

If Sandra could have listened to this beautiful old judge, she would have been very proud of Marston.

Beatrice was still mulling over this thought, when her car drew up in front of Sandra's apartment. Louise opened the door leading into Sandra's hall. The maid's Sunday appearance and the sound of voices told Bea that she was not to meet Marston Overstreet alone. She felt unexpectedly glad that there were other guests.

Sandra was sitting on the sofa. Nine or ten men and women, grouped about the table, or sitting at the farther end of the room, were talking, eating and drinking. The little

salon looked crowded and the atmosphere seemed hectic. Sandra, Bea thought, had a forced calm as she got up to greet her.

"You know everyone, I think," Sandra said, looking around. Paul Thibot came forward to seize Bea's hand on which he impressed an enthusiastic kiss. Then she remembered the Count's rescue party, and Paul's return to Dora's bosom. She saw Dora herself across the room deep in conversation with the artist Beaulier.

In a few moments, Jacques de la Roche and Count Marbeau came to say hello. Someone asked Bea what she would like to drink. Archie waved to her from where he sat talking indifferently to Mademoiselle l'Aigle. The room was full of chatter and as she glanced around she saw that Marston Overstreet had not yet arrived. She had hoped he'd be here before her. A vague desire not to see him meet Sandra in front of this roomful came over her. She disliked Paul Thibot and his self-satisfied air, his flirtatious impudence. And Archie's intuition put her on her guard. Suddenly she became conscious of a stir near the door and she knew without actually seeing him, that Marston had arrived. It was absurd of her to feel uncomfortable, but she did; more distressed than she thought she would. It had nothing to do with knowing Sandra's secret; but rather, she knew, it had to do with the fact that *no one should know.* She wished there had been just the three of them.

Bea found herself thinking that the table in front of the fireplace, where the refreshments were spread, would be the easiest vantage point for Sandra and Marston to find her.

A few moments later, Count Marbeau introduced Bea to

Marston. Sandra had been taken away by the arrival of another guest.

"Do you like sandwiches?" she asked him.

"Very much." He smiled at her as she advised him which one to choose.

Beatrice explored the room while Marston explored her. In a corner between two windows and against the wall, stood a small sofa. She had had it in mind, but was afraid there was someone there. On the table to the left of the sofa was a glass lamp, hung with icicles, and a flat dish of floating rose leaves beside it. To the right of the sofa a comfortable chair seemed to add intimacy to the corner, although it was unoccupied.

Marston noticed that Bea's blue dress was the color of her eyes. That she was totally unlike what he had imagined. Her poise, her erect figure and the clearness of her look produced anything but an impression of introspection and frustration. Her appearance attracted attention in any case, he thought.

Beatrice knew at once that Marston was not going to prove adept at arranging a tête-à-tête.

As they stood there together, Beatrice said, "There is only one spot in this room that is possible." She glanced at the corner.

"Stay here while I get a drink, or I am sure to lose you," he said.

At that moment an older woman with a youthful figure, smartly clothed in black crêpe de chine, bore down on them.

Bea said, "Hurry up."

"Why Mrs. Graham, you are just the person I was look-
ing for." Dora Thibot spoke with all of her accustomed
enthusiasm.

Marston remained close enough that he heard their con-
versation while he poured his drink.

"When is your husband getting back?" the older woman
asked. "Sandra tells me he has gone for a cure. I want you
both to come and stay with us."

"He says ten days," Beatrice was noncommittal. She was
guessing Bob might not want to go. "These cures some-
times take three weeks."

Madame Thibot leaned forward eagerly. "What's the mat-
ter with him? Why must he take a cure?"

Beatrice simulated mystery. "I have never asked," she
said in a stage whispser. "It is so much better not to know,
don't you think?"

"If Paul ever takes a cure," Madame Thibot declared firm-
ly, "I shall know everything."

"How brave of you!"

Dora had a way of forcing people into unexpected situa-
tions. "Bring anyone you like with you, if your husband
can't come. I keep open house."

"That's very kind of you."

Dora hurried on, "I have built an indoor tennis court so
that Paul can keep fit without going to Paris so often to get
his exercise," she went on.

With a gesture of goodbye in her nod, Beatrice moved to
the empty corner of the room with Marston.

She sat down on the sofa and set her glass of iced tea un-
der the lamp. He laughed as he took the chair to her right.

"Would you risk a confidence here?" He surveyed the room hopelessly.

Bea was almost solemn. "But I must. I can't just make conversation with you."

"Go ahead if you dare," he sounded doubtful.

"Well, I must," she said looking at him. "I couldn't be gladder that you and Sandra have happened." Her voice trembled. She added, "Do you know she had never had the real thing? What a foolish word to use. Of course you know it. If I get frightened about things, don't pay any attention."

"But you are not getting frightened, you *are* frightened," he said. He leaned forward to look at her more closely.

She sat back on the sofa and drank some of her tea. "Sandra is not adept. Are you?"

Marston was observing her closely. That Beatrice should take him into her confidence so naturally and so quickly have him real pleasure. He wondered if she had heard gossip about him and Sandra. If she had, she undoubtedly would tell him. He had found warmth where he had expected coolness. He now saw a change in her face.

"Thank goodness she told me," Beatrice looked at the rose leaves, "or else I might easily have been pestering her, perhaps even unconsciously forcing her into the same position all these other people force her into," she ended, almost angrily.

"That's not of any consequence," he said.

She liked his assurance, but she could not trust it. "But it is, I think," she said. "If it happened to these other people, it wouldn't matter, it's just civilized, but with you two it is different."

"It is very different." He was serious and felt a tension which he sought to dispel. "Perhaps Sandra and I were not intended to be civilized," he smiled.

"I am glad you are primitive, too," she said. "Being a lawyer doesn't suggest that."

"So you doubted me? Am I right?"

They smoked for a few moments in silence, while around them, but far away in spirit, the guests talked and laughed. Sounds from the street came up through the open windows. High-pitched voices of children grew louder and then as they passed, faded into insignificance.

Suddenly conscious of their silence Beatrice said, "You have a great admirer in Judge Boissonier. He spoke about you last night."

"He's a good friend and obviously prejudiced," Marston said. Then with a change of voice, he continued, "Sandra gave me no idea what you are like. She is not very good at description."

Beatrice was amused, "She was wiser about you. She attempted nothing. Three short sentences."

"Three?" he questioned, "I wish all these people weren't here. I wonder why Sandra asked them?"

"I don't know."

"Perhaps she thought it would be easier for me."

"Or subtler," Bea said, and, as though just now conscious of the guests, glanced around the room. She caught Mademoiselle l'Aigle watching Marston out of her slanting eyes. Discovered in the act, the French woman slowly revolved her head until only her "Egyptian" profile was visible. Dora Thibot was in conversation with Count Marbeau, while her

160

attention was fixed on her husband Paul, who was discreet-
ly flirting with a young girl who had come in unobserved.
She also cast furtive, longing looks in Marston's direction.
Sandra's back was turned. She chatted with a group in front
of the fireplace.

Beatrice's attention returned to Marston.

"And what were Sandra's three sentences?" he asked.

"She said she loved you. She said you were married. and
she told me your name."

"And so?"

"And so I was left to flounder, if you don't object to my
putting it that way?"

"Flounder? Where? Why?"

"I do not ask for a category of your virtues or your
vices," she said, "Nor a synopsis of your *Who's Who*, but if
it hadn't been for Judge Boissonier, Archie Cummings and
Jacques de la Roche, I wouldn't have known anything. I'd
have been completely in the dark."

"Surely they didn't connect my name with hers?" he
said, frowning.

"Only Archie. Archie connects names as a pastime."

"It couldn't have been he who frightened you?"

"I admit he put it into my head."

There was a pause.

"And yet you are frightened?"

"Can't you allow me my secret concern? Sandra does."

A quick look of interest came into his eyes to be followed
by one of severity. "It's my duty to protect her."

Her dark eyelashes disguised their expression. Her voice
was more husky than usual. "You can't possibly protect her,

that's the one thing you can't do. And how do you expect to escape being found out?"

Marston watched her. *How could she be direct one moment and subtle the next.*

"You think we can't escape," he said. "It's an exception being here today. I am never seen with her. My excuse is Archie Cummings."

Beatrice now opened her eyes wide to look at him. "So you are to silence Archie's gossip? Stop me if you wish. But you and Sandra are people who attract attention. Do you know these people?"

He shook his head. "Some of them."

She looked around the room and turned back to Marston. "Dora Thibot knows everyone, spreads information like a sieve, and, in meaning to be kind, has a genius for putting people in anomalous positions. Paul Thibot lives in tittle-tattle; Archie hatches amiable scandals; Count Marbeau craves gossip like the bee visiting each new flower. De la Roche is a dangerous flirt." She laughed. "That man," nodding her head toward a small, well-bred looking man, "Whom I know only slightly, looks innocuous. He comes of one of the best American families, knows everyone, goes everywhere, and writes for a newspaper. Wait, there is another—L'Aigle, who looks like an Egyptian *bas-relief*. I am sorry," she paused, "I had no intention of talking like this, but when I got here today, I was scared. You noticed."

Touched by what he now recognized as Beatrice's selfless anxiety, he said kindly, "We are really very discreet."

"I suppose you come here often. Isn't that risky?"

"The first month I knew her I came more often than now, but never in my car. Perhaps half a dozen times alone

162

for dinner and rarely in the afternoon. No one else was let in. This apartment is on an out-of-the-way street, you know. The chances of being seen are slight."

"And now?" she asked, "You are more discreet."

"It's been three weeks," he said slowly, "Since we've had a place of our own. I come here only now and then, and you know Sandra has many other visitors."

"What a grand inquisitor I am," Beatrice said.

He paused, then with a quick look at her said, "You may be sure she asked me to come today for a reason deeper than Cummings. Not to meet you either."

"I suppose as long as anyone knows you know her, it's better this way."

"After all, it would not be fatal if it were known that I am devoted," he said, looking at her disarmingly.

Beatrice got up. Now, for her, there was nothing more to say except as anticlimax.

"Give me a little longer," he pleaded, "And we may give them something else to talk about."

A moment later **they** joined Sandra's group where Marston was introduced and the discussion that was going on about their favorite race horses continued. Gradually it drifted to Geneva and became futile.

When Beatrice was about to leave, her friend gave her a look to which she responded lightly. "I've had a nice time, Sandra. You entertain extremely well, doesn't she, Count?"

Felix Marbeau sighed. "She does everything to perfection, only she does not allow me to see her as often as I would wish."

Judge Boissonier entering just escaped colliding with Beatrice, as she was leaving.

"Pardon, Madame. Don't go."

They stood on the threshold, laughing.

"I had hoped that you might be here. Do I want to see anyone else beyond Madame Fane?" His eyes swept the room and singled out Marston. *"Ah! Mon ami Marston!* What luck! So he too worships here? Please remain, we four shall enjoy ourselves."

"I'm sorry, I wish I could."

Beatrice had followed the Judge's look to where Marston stood, his eyes fixed on Sandra. Jacques de la Roche and she were genuinely enjoying some *potin*, evidently to Sandra's taste. The lawyer's face was expressionless. She wondered if he always held his shoulders so rigidly. It came over Bea that she liked Marston for himself, quite irrespective of his love for Sandra.

She left quickly.

In the hall she said to Louise, "It's been a nice party. The sandwiches were delicious."

*"Merci, Madame, j'espère que Monsieur revient bientôt?"*

*"Oui, bientôt."*

On leaving the apartment, Beatrice had told her driver to take her back by way of the Arc de Triomphe and down the Champs Elysées.

The sun was setting behind Beatrice and some reflection of the passionate harmony between the two lovers made her marvel.

As far as she was concerned, she felt that the sun was behind her. She turned to look over her shoulder at the loveliness of a real sun.

164

At some moment in her life, she too might have grasped her shining moment. A deep yearning seized her. As life had moved onward, she had gathered treasure from experience. She had grown with time, and life had become richer and deeper. But Bob had been unable to leave the shallows. Love in the beginning had blinded her to his limitations, but now she was alone because she had chosen to stand by him in their life together. There had been one man she had met in her life, after her disillusionment, whom she could have loved. She had given up the chance of a life enriched like Sandra's. She knew the cost to Bob would have been small compared with what she would have found, but she had stuck to her code. This helped her to understand what Sandra now possessed, and she felt herself recklessly ready to fight for her friend's happiness. *Those two must not lose what is theirs.* To help them preserve it gave her a sense of power.

The sun shone, Paris was prodigal in its beauty. *Who else knows or cares enough? All precious things are the envy of others and must be guarded.*

The car sped on down the avenue, then turned into the Place de la Concorde and drew up. With a flourish the porter ushered her into still another world. The lobby and crowded restaurant into which she peered had an atmosphere of luxurious, enervating life. She felt despairingly that no force would come from the surrounding of her present existence to assuage the riches of her desire.

# 11

"I don't see why I should torture myself unnecessarily," Marston told Sandra on Saturday afternoon. He had stopped in to make the arrangements for taking her to Dreux after the Marquise's party. "Seeing you dancing with other men and not being able to go near you would be torture. I am not made of the stuff of Christian martyrs. I've always thought if I had lived in the days of the Inquisition, I would have told every secret on the first twist of the screw."

"Oh, dear! So you are not going." She sighed, quickly trying to hide her disappointment. "It was just a horrid, conceited reason I had for wanting you to go," she confessed. "I knew I wouldn't be able to dance with you or talk to you."

"You wanted me to see you," he laughed.

"My dress."

"A new one, I suppose, from Feodor's."

"I designed it myself."

When she told him that she was now a designer and that this was the first effort, Marston seemed perplexed.

"How long have you been at it?"

"Only a week."

"Why didn't you tell me?" he asked.

"It's not very interesting," she said.

He could not leave it at that. "But sweet heart, it means a lot to you. Doesn't it mean a raise and a more important position?"

"It might lead to something," she said.

"You never even told me that you knew how to draw."

"Oh, didn't I?" She was too casual, enough to pique him.

"I suppose I shall find out by chance that you play the piano, have written books, and are leading an orchestra on your nights off."

Although he stung her, Sandra did not minimize the advantages of his perplexity. *I haven't been able to make him see that I mind he's shutting me out from his work.* Out loud she said, "Men are not interested in dressmaking."

"I am not 'men', Sandra."

They were standing by the door as he was leaving. He put his hands on her shoulders and shook her gently as if to enforce his point.

"It's just part of my work. I'll show you my dress some time."

He turned to pick up his briefcase which he had left on the hall table.

It had been an effort to treat the matter lightly, so she threw her arms around his neck and rested her head near his. "It won't be long, dearest, before you come for me here tonight. What are you going to do all evening?"

"I still have a couple of clients I ought to see. I think I'll go to the Club and get tight."

167

As the door closed behind him she noticed a bundle on the hall table. Her name and address were typewritten on a label which bore the printed insignia of a clipping bureau. Excitedly she carried the package to her room with the thought that her nine o'clock dinner, given before the Marquise's ball, would allow her ample time to rest, and, at the same time, to read the clippings. An hour later, she swept them to one side, with great reluctance, so absorbed had she become.

Later when she was dressed for the ball, she forgot everything except the thrill of being a designer. Madame had completed Nada's gown for Sandra. She called it *Feuilles d'été*, and its shaded greens were more like the greens in the ocean than the tones of trees.

When Marston reached the street, he was possessed by great restlessness. He walked fast, his shoulders squared. It was almost as if she had repulsed him, for he had seen her twice since she had become a designer at Feodor's and feeling as she did about her work, it seemed significant that she did not tell him about it. Designing dresses was a professional job. One did not acquire the ability overnight.

The narrow streets near Sandra's apartment receded behind him, when he suddenly remembered that he had to go and see old Madame Castelroix. Ahead, the wide avenue was lined with trees, the tree trunks making columns of shadows stretching away from him on the sidewalk. He felt a surge of his black moods. Of late, he had been free from them because of Sandra. If he could rush back to her now, he might forestall it, but he knew he must battle alone. In the old days work banished these moods. Now he was re-

lieved that duties lay ahead. In addition to Madame Castelroix, there was the old fool, Franklyn who had gotten himself blackmailed for the third time and whom he would surely waylay at the Club. And Merrimée's erstwhile lawyers were turning over their papers to him today.

Philippe, Madame's son, had told him this morning that his mother was in town, in good health, and finally willing to sign her will. When Madame Castelroix was ill, she refused to consider death; when she was well she felt there was no reason to draw a will.

Once at the entrance to the irascible Castelroix's ancient mansion, Marston fortified himself with persuasive arguments, knowing that he would need all of them. He was received in her boudoir, amid a delicious eighteenth-century *mise en scène*; herself in black rustling silk, with a wicked twinkle in her clever eyes. Obviously she was going to put up a fight. She aroused his professional keenness.

While the spirited old lady offered him tea, he allowed his mind to relax. He ruminated that second only to his concerns about the law, his concern had been the variations of Eileen's health and moods. He talked on to his client, but he also was thinking about his two children, Stanley and Helen. Why did they now mean so little to him? Had he been too engrossed with his work, or been too preoccupied in his relaxations? At times he felt close to them, but they had always preferred their mother. That pleased him, but why should he be excluded? Once he had asked his wife why the children were so evasive with him. He had not forgotten her answer: "Some men just don't get on with children," and after a pause that was devastating, "But,

of course, they love you." He knew they did not.

One summer, he had taken Stanley and Helen to Cabourg because of the heat and Eileen's unwillingness to move. Ten days later she and her companion had joined them. He had thought her too weak to travel, but she had made the effort. "I was afraid you might not be happy alone with the children," she had said. But during those days, swimming and playing with the kids on the beach, he had come to feel closer to them. There had been other such occasions, but something always happened to prevent him from spending time with them.

When he thought of his boy, Stanley, he also thought of his friend, Stanley Reed, after whom his son had been named. During his youth and much of his later life he had closely associated in intimate friendship with that rugged character. Even after coming to live in France, until Stanley Reed's death five years ago, no break had taken place in their friendship. Not even that terrible crisis when Stanley had risked his friendship to interfere in Marston's married life. Eileen had never forgiven Stanley for trying to keep Marston in America. "What does he care about my life," she had sobbed on Marston's shoulder, after a devastating scene. "He would prefer my death, he has always resented your having a wife." It was true, of course, that Stanley had not understood Eileen's illness, but he had given her, up to that moment, all the consideration and loyalty due her. Afterwards the subject had never again been mentioned between the two men.

He had been half-listening to his hostess when suddenly he was aware that she was saying in French: "You and I

shall talk no business today. I know Philippe has put you up to coming here. If you had wanted to catch me unaware, you should have left your briefcase downstairs."

He looked at it ruefully. If the will were to be signed, he must put aside his own problems. A clever balance of blandishment and reason had finally produced the witnessed signature of his client.

As he bade her good afternoon there was a brief bedimmed sparkle in her eyes. "I have retained you for years, but what woman in Paris would not make excuses to detain you?"

On the avenue, the crowds broke his musings. He beckoned a taxi and watched the far-off vistas of streaked crimson, orange and violet over the river and the trees toward the diverging streets.

Then he became aware of the distinctive music which Paris possessed. Charpentier had in *Louise* caught the heart of the city and interpreted it into actual cadence. The rebellion of youth, and *Louise* its symbol. Her headlong flight into this city of tumultuous joy, the freedom of *Paree, Paree!* With Sandra it had been neither the rebellion of youth, nor Paris, but there was an analogy. Had not she, too, thrown herself headlong into love and freedom?

When the taxi drew up in front of the Club, he was thrust reluctantly back into the present. *Now for Franklyn*, he said to himself. Yet it was of Sandra's daring on which his mind was filled.

Inside, the overstuffed *Cercle Français*, the air was oppressive and dull. Men were leaving, bound for dinner engagements. He found Franklyn consoling himself with a

drink in an obscure corner. In spite of his years, this ener-
getic American had a crop of bushy grey hair and a deplor-
able incapacity to grow old gracefully. One could not
concentrate on one's own thoughts during dinner while he
recounted the story of his lady blackmailer. It was so star-
tlingly alive. Franklyn's anger was tinged throughout by
delicious recollections. Later in the dark-green lounge into
which they moved, with its dreary hangings and sepulchre-
like atmosphere, he became almost human. Marston smiled.
Even here he thought of Sandra's changing hazel eyes. They
almost seemed to meet his. Her laughing mouth twitched at
the sallies of the old *roué*. What would she think of Frank-
lyn's Rabelaisian tale? How would she react to it? He knew
she wanted to share his professional experience. He knew
he had ignored her desire. *I've been a thick-headed ass*, he
thought.

He must have looked absent-minded because Franklyn's
voice brought him up short. He then repeated what he had
said earlier, and added, "Send me whatever papers you
have. It doesn't sound as bad as I had feared. Look here, old
man, how old are you?"

"I know I'm a fool. But, damn it, she was such a sweet
little snake!"

"They always are." Marston sighed. "Well, you can af-
ford the cure for a few more years."

*One phase of the evening is over,* he told himself. *Now
what?*

In a corner of the lounge a crumpled-up man sat dozing.
Under a bright lamp two Frenchmen with imposing beards
argued, waving their arms theatrically. He refused to be
drawn into their conversation.

As he entered into the card room, he said to himself, *Why didn't Sandra tell me that something important had happend to her? My fault.*

Four men sat drearily at a table, mumbling over their game.

He left the Club and went out into a gorgeous night. The young moon, hanging in the sky, gave him a sense of vagabond longings. Then his big house in the Avenue Henri Martin came to mind. With it he felt the wave of a black mood.

Many of his problems, largely professional, had been solved in lonely night prowls.

Lately, he had cherished his free moments, for then his thoughts were free to think freshly about his and Sandra's unique and disturbing relationship. He felt discomfiture in these memories, and though he knew he must face reality, he half hoped something would happen to put off the inevitable moment.

Suddenly he heard a voice behind him. He swung around to find one of his old friends, Holloway, facing him.

"Baying at the moon, Marston?"

An arm on the older man's shoulder, he said, "It's good to see you. How's Ben?"

Everyone asked him the same question because he never made the same response. "Stupendously gout-ridden at the moment, and writing unbelievably playful letters to young folks." His large body fell away and shrank, shaking slightly with laughter.

Both were drawn by a desire for company. Ben Holloway said with a glance into the star-flecked sky, "I've a short time, 'the moon with lifted wing invites us.'"

A taxi stood in front of the Club. They got in, the older man painfully. To the driver he admonished, "Proceed *doucement, gentiment,* we wish to rejoice in your city."

In silence Marston reflected on the many wonderful hours he had spent with the old historian. He had seen him recently, but Ben Holloway had no sense of time. He had come to Paris six years earlier for a few months to do research for his book on Benjamin Franklin. He had remained ever since under Franklin's charms.

Seated together in the taxi, Marston realized each time they met, his friend appeared more shrunken while the vividness of his imagination increased proportionately. Behind thick glasses, his eyes betrayed a mind given up to thoughtful study and lively conversation.

"I'm embarking," Holloway said, "into a deeper sense of my subject." There was no pompousness at all in his manner. He continued speaking, his tongue caustic whether in attack or acceptance.

Marston was thinking that one of Holloway's chief attractions lay in the fact that, though he possessed the facilities of a conversational prestidigitator, he rarely used it. Holloway was saying that the art of biography was in its infancy. "My other books were all written too literally. Morality in itself means nothing. It is the spirit of morality which, if I could make my reader feel it, would be my joy. It is not mere truth which I seek, but only to be lovable. To convince is important, to delight is vital."

When they parted Marston was refreshed. *How Sandra would love that old codger,* he thought.

He dismissed the cab and walked in the direction of the Avenue Gabriel. The set-back houses on the peaceful street

were spotted with moonlight. Seen across their grass plots, made shadowy by trees and shrubs, one mansion brought the memory of a woman who had once lived there. He had found relaxation in her beauty. Now he remembered other periods in his life, periods connected with delicious women, beautiful women who gave him surcease from physical restlessness, but nothing in the way of companionship. He did not want the residue of love. When love-making was over he had always held his women at arm's length. Those who were in love with him were sad that he shut them off, charmingly, but with finality.

As he walked past the American Embassy, the Crillon, and followed the rue Royale to the Madeleine, he thought that he would try to lose himself in the mysterious streets beyond. His head down, walking with long strides, he pushed on. His mind fled back to the day when Sandra had told him how changed she was since they met. And for the first time he realized what had happened to him, beyond falling in love. It was as if life were somehow frozen and each moment became like the whole of existence in microcosm. She shared in everything he did. He could not think of her as separate. She was too much a part of him.

He looked up to find himself now in a dimly lit empty street. The houses were shut, the people inside were insulated from him, just as Sandra often shut out the world.

And reaching fifty, Marston remembered how the exquisite Sandra had come into his life, and he had loved her at once. He had said to himself: *Do I really know anything about her? Am I charmed because I know nothing?* And he felt suddenly cold. He had reflected, *If I am ignorant, it's not because of the mystery that surrounds her. I am not to-*

*tally uncomprehending.* He had believed he had insight into people. *I am praised for this in the profession.* It had helped him with Sandra. Had he perhaps been looking at people through windows and not face to face? He wanted to analyze her tonight, but again suddenly aware of the night, he looked up into a sky which had no top. He liked the feeling that the sky had no top, it had something vaguely to do with Sandra's having no limit. *I must analyze,* he thought. *I can't do that by looking at the sky. Looking at the stars and planets one feels only like an atom. Being in love makes one feel like a god.*

So he looked down at the sidewalks where people were not passing. Increasingly they bore in on him, and soon something of both the pavements and the sky brought an equilibrium to his thoughts. He felt his love for Sandra complete. *There is imagination, there is the mind and comradeship. There is sentiment which is apart from desire and there is fierce desire.*

Now he was in a little park where night wrapped him in a bluish crypt. He wished he were out in one of those rugged, unknown lands about which he so often dreamed. He pictured Sandra walking beside him, loving the wilds as he loved them.

He searched for a taxi. *It's not too late. I might still go to the Marquise, to take care of Sandra.* And as he drove back into another quarter of Paris, the Paris of wide boulevards and splendor, he told himself, *That is the one thing I just can't do, take care of Sandra.* He stopped the taxi.

He found himself in front of the big house he had bought years ago because Eileen wanted it. He looked up surprised

to note that in the flattering moonlight its façade had a cer-
tain stateliness combined with a charming grace. It held
him. He did not want to go inside. He felt suddenly tired;
suddenly, without realizing it, he leaned up against the
grille. *Why hasn't my life given at least some intimacy to
my own house?* Lighting a cigarette, he thought dully,
*People ought to laugh inside these walls, and run through
the halls. I wonder why they never have.* He closed his
*briquet* and put it back in his pocket. *It's not only all those
everyday objects used by people, accumulated through the
moments and the years that do something to a house, it's
an indefinable atmosphere...* As he puffed smoke into the
night, it seemed to him that life should declare itself in each
room. There should be forgotten books, old illustrations
and reviews, pipes, needlework, toys, unrelated pieces of
furniture, left for comfort among the small *meubles de style*.
With hunched shoulders he turned to stare down the street,
another vision now before him. *It's not just the difference
of grandeur*, he told himself, *only three weekends*.

He unlocked and opened the heavy grilled door. To his
surprise the maître d'hôtel stepped forward to meet him in
the hall.

"What time is it?" Marston asked.

"*Onze heures quarante*, Monsieur."

"Bring whiskey and soda and coffee," he said. "I shall
work late."

"I have already prepared everything, Monsieur."

It was a cliché. He had no thought of working. His mind
was still far away, with Sandra.

In the library he stood staring at the bookcases. He was

177

not thinking of books. Absent-mindly he picked up his pipe. He felt that the self-communion which he had experienced exposed him to a pitiless light. The dim room was a relief.

He threw his pipe angrily onto the desk. *That's over with, Sandra, sweet heart, you take your place. Why have I kept you out? Take all of me. I need you.*

Unexpectedly and excitedly, his mind went straight to Louis Merrimée.

He poured himself a drink, sat down at his desk and took up the threads of the case at the point where he had left them.

It was three weeks now since Pauline Merrimée had been murdered. He would organize the facts in a form to show to Sandra tomorrow.

When he had left Sandra on Tuesday, he had been taken to prison by his partner Clermont. He had been led to a room where he and Clermont had been allowed to talk with their Merrimée alone. Marston was unused to such scenes. He had taken criminal cases only twice before. In spite of all that he knew of this famous prisoner, he was not prepared for the man confronting him.

Merrimée had been a dashing and picturesque figure, but that he should prove to be a delicately adjusted person came as a surprise. At their first meeting Marston had not cared for Merrimée's personality. He discovered Marston watching, trying to size him up. As a lawyer, this was his role. It was not until after a second talk alone with the aviator that he had decided to take the case.

When the prisoner was brought in on the second occasion, Marston had taken into account more of the details of

178

Merrimée's physical appearance and bearing; the bronzed, healthy look of his skin, his small bones, the cultured manner of his speech.

The racer on this occasion had been much more cordial. He had shown relief that Clermont had not come. Over a cigarette Marston had said, "Flying and motor racing. It must be the height of exhilaration! If I were younger, I'd take it up. It's a life's work like any other."

Louis' face had lit up. "Yes, you escape in it."

*Escape? Why escape?* he had thought. Aloud he said, "I find being a lawyer exhilarating—I suppose that strikes you as impossible?"

"I'd like getting a fellow out of a jam. That must be like having your motor go dead when you're five hundred feet from the ground, and doing the only thing that can save you from crashing. Only a lawyer is doing it to save someone's skin."

"Is speed fascinating in itself?"

Merrimée had considered this. "Speed has a lot to do with it, of course, but there is nothing I can compare with the *feel* of a car or a boat under you, answering every touch." His voice was crisp.

Marston, without a change of voice, had said, "You made a serious error once."

Merrimée had gotten up impulsively from his chair. "You mean on that race at *Orléans*. Yes, I did." And suddenly, "How do you know about it?"

Marston remembered that Merrimée had been trying to catch him. He veered. "I follow sporting events."

The man had sat down again. "I took a chance." He smiled engagingly. "You know we all do at times." It was

just one of those chances that went wrong."

Marston had avoided looking at the prisoner as he went on. "Perhaps you took a chance in the instance when..."

Merrimée rose again and stood looking down at Marston. "You mean I took a chance and killed my wife?"

"Yes, you mightn't have been charged with it, nor even suspected, you know." He looked at the prisoner.

Merrimée's expression changed to one of genuine sorrow. "But I didn't want her to die. We were happy." It was as if he were stating a fact which everyone must know. Since Marston had made no response, the prisoner asked, "Do you think I killed her?"

"If you did, I hope you will tell me."

"You wouldn't take my case if I told you I had," he answered calmly.

Marston now remembered being jolted by the remark. He said, "You'd get a lawyer better than I am to take it."

Merrimée had continued as if unaware of him. "The truth is, I did not shoot my wife."

This scene seemed startlingly real to Marston in his library now, so vivid that he wanted to go over all the evidence right away, to review in his mind its finer points. He went to his safe and took out the papers, sat back, and allowed the excitement of an intricate problem to take hold of him.

Merrimée had three servants: a cook; a man who did the heavy work and was the gardener. He slept out; Amélie the maid, who, the morning after the murder, had found her mistress shot through the heart. Pauline Merrimée was found on the floor of her bedroom. Monsieur's room ad-

joined. Horrified, half-fainting, Amélie had opened his door and rushed in. The room was empty. Later it had been discovered that the bed had been slept in and she saw evidence that Merrimée had dressed hurriedly.

The house in which they lived was rather small, situated in a somewhat isolated district of Paris. Monsieur's and Madame's rooms were on the *premier étage*, one flight up, overlooking a little garden at the back of the house. A large French window in Pauline's room gave out onto a balcony where she and her husband often sat in warm weather.

Pauline was shot in the back. There were no signs of a struggle. There were two absurd metal cats, which Madame Merrimée had used to regulate the opening in the French doors. The morning of the murder, the window was open and the cats had been pushed aside. They lay on the floor. Someone had searched Pauline's desk, her bureau and her closet. There were no fingerprints exept her own and those of the maid. Nothing had been taken. She had been shot by a pistol unlike Merrimée's own.

Marston sat back, poured himself a cup of coffee and considered the value of the fingerprint history. He was unaware of time. The lack of fingerprints gave reason to hope that it was a professional job. Pauline's dossier was as innocuous as one of the metal cats. She had valuable possessions on the premises. Merrimée himself might easily have had enemies, but superficially that fact could not seem to involve his wife. Three weeks had passed since the murder. It was unlikely fresh evidence would now come to light.

The police inquiry into Merrimée's life brought out only the fact that if he had anything to hide, he had been excep-

tionally discreet. The name of no particular girl was associated with him. Many girls followed popular heros with adulation. There were photographs among the mass of evidence, taken on airfields, of Louis Merrimée followed by admiring crowds.

Madame Merrimée had died at about five o'cock in the morning.

Marston now sat back and finished looking over his notes of his second conversation with the accused man.

"I came in between eleven and twelve," Merrimée had said. "My wife's door was closed. I went into my room looked into hers and saw her asleep. As I was getting up early in the morning to test a new car, I did not want to wake her, so I closed the door between our rooms."

Marston had asked, "Did you always occupy separate rooms?"

"Yes, usually, but this does not mean that I was not living with my wife. I was."

"Yes, go on."

His expression had shown concentration, but also calm. "It is my habit, as anyone could tell you, to take my car out early when I am tuning it up for a big race. I like to experiment on the roads as well as on the track. There's less traffic early in the morning."

"What time did you leave?"

"It was four-thirty."

"It must have been dark."

"The dawn was just coming. Unfortunately for me, I had forgotten to tell them at the garage that I wanted my car so early. I had to wait around for over an hour before someone

arrived to let me in."

Marston had said, "Then you have no alibi for the most important hour?"

Merrimée answered with no expression, "There are three men and a woman who swore they recognized me. But I spoke to no one." In a moment he continued impatiently. "This is all on the record, which naturally you have."

"Of course. But why didn't you stop somewhere for some coffee?"

He seemed bored, rather than exasperated. Then he pulled himself together. "I had coffee before leaving the house. I always have a thermos in my room."

Marston now shuffled the papers around on his desk. Next he examined the servant's evidence. No quarrels. The average life of a *petit bourgeois*. A kind mistress, nice friends and acquaintances. An ordinarily affectionate couple.

Now Marston was coming to the crux of the story, the core on which his case would be based. The garden had high walls surrounding it, but not insurmountably high, and luckily they rose on the outside from hard pavement. On the inside a gravel path came almost up to the wall. It would mean a marauder, with the help of a ladder or a rope, would leave no footprints.

The gardener's alibi had been airtight. His testimony might prove to be of the greatest value. A ladder was kept in the garden for use in pruning the four fruit trees which were Pauline's pride. It rested against the wall, and the gardener was as convinced as anyone could be, that on the morning of the murder the ladder was not in the position

he had left it the day before.

The Sûreté had not been impressed by the gardener's evidence. Pauline had been shot in the back. It seemed unlikely that she should have heard no unusual sounds, and to have been quietly walking around her bedroom in the early morning, her back turned to an assailant other than her husband. And Merrimée had no convincing alibi. Those who had shown up with accounts of having seen him, reported it a week or more after the event, when public sentiment was already running high. Their depositions were not above suspicion.

Marston attacked this challenging problem. Several hours slipped by. He made notes, read evidence and pondered.

Suddenly the telephone started ringing. It was Sandra's voice.

"Did you have a good time?" he asked.

"Horrible, nobody spoke to me."

"I'll be there in a few minutes. Did anyone flirt with you?"

"Everyone. I loved it."

"Are you trying to make me jealous?"

"I am? What have *you* been doing all evening? I suppose you just got home."

"I am not home. I'm at a dance hall."

"Well, dance over and pick me up."

# 12

"How about a drive—just to move around? It will be cooler." Marston got up slowly from the terrace, knocking the ashes from his pipe. He went to the door and looked out over the fields in the direction of the orchard. They had only been once in that direction; it was away from the river, and the river had always drawn them.

He was superb as he stood there, and unconscious of being so. Today he was not merely one person. He felt there were competing elements in him. Since last night the desire to bring Sandra closer, and the difficulty of overcoming the habit of years, had been central in his mind.

Sandra lazily agreed. "Anything would be nice today." She stretched her arms above her head, and sighed with content. "I love the heat."

"I'll bring the car around," he said. He was not moving.

"I'll go and get my hat," she said, equally languid.

When, a little later, they got into the car Sandra carried her hat in her hand. It was large and blue and flopped against her white dress. She had bathed and dressed and combed her hair, but its unruliness gave her a carefree look, as though she were starting off on an adventure.

185

### A Love Affair

On the road leading into the country, the slight breeze made by the speeding car blew in their faces. The sun was hot, and the motion and the breeze created a rhythm that soothed them. The smell of Marston's pipe clung to him. It gave her a sense that her dream was real, just as the touch of her scented scarf, blowing against his arm, gave him a sense of enchantment.

*Old platitudes are new truths when you are in love* he thought. *Love was beyond desire and yet was not love without desire.* He saw in his mind's eye Sandra in the center of all. Beside him, he saw her, too. A glow on her; it suffused her face, glistened in her eyes, smiled on her lips, and blossomed on her breasts. From out of the broad fields a sudden tenderness came over him filling the car.

It had been almost twelve when they started and neither had noticed direction or time.

When Sandra spoke, Marston jumped as though suddenly awakened. "I think we had better be going back. I am longing for something cool to drink."

"I'm hungry," he said. He looked out first on one side of the road and then on the other. There was no familiar landmark, only cultivated fields, poplar trees, clumps of pollard willow and, now and then, high stone walls over which peered French lindens and glimpses of ancient buildings. The distant spire of a solitary church broke the almost even horizon.

They went on faster until they came to a crossroad with signposts. Marston stopped the car to look at the directions: soft-sounding names read in unison, of distant villages lying on all quarters.

186

"I think," he said indifferently, "Home is behind us, but we have made so many turns it might be anywhere. Suppose we stop at a farmhouse and have some fresh milk and eggs, darling?"

An enthusiastic nod was his reply. The automobile went on quickly until they came to a sharp turn, then they bumped into a paved street. They were in the center of a tiny village. No inhabitants were visible, the doors of the houses and barns were closed against either intruders or the baking sun. Only a dog moved. He crossed the street, apparently for the sole purpose of forcing the car to veer off its course.

Sandra, who was searching for a farmhouse, caught sight of a placard attached to the wall of a corner house. "Stop," she directed.

A moment later she read aloud: *l'Hostellerie du Jardin Joli à trois kilomètres.*

They exchanged smiles. "It sounds lovely," she said. "It's to the left."

"I never heard of it."

The left-hand turn wound in and out, but as they progressed the trees appeared more tufted and signs of less simplicity were noticeable.

Sandra took her compact from her bag, and primped. Then she put on the big blue hat, facetiously twisting the little mirror from side to side, to see the effect. Then she flirted with Marston from under its brim.

A high paling fence covered with blossoming vines hid all but the roof of their destination. Smoke rose from the two old chimneys and lost itself in the treetops. The roof sagged

187

slightly in places. It was not until they were inside the gate that they could see the rather large sprawling house—it was partly old with a newer wing added onto it, which was the *Hostellerie*.

"It looks fascinating," Sandra said.

She gave him a quick, questioning look, one hand on the steering wheel as if in warning. He smiled at her reassuringly. "It couldn't be more romantic."

In the hall she saw through more big doors into the kitchen. A great stove jutted out from the opposite wall. Starched blue and white girls cooked, mixed ingredients in shining bowls and pots, carried plates of steaming food. They were intent, but smiling. The sounds of rattling dishes, clinking glasses, crisp voices, the odor of fresh fruits and vegetables were in the air.

Splashes of colorful clothes, among flowers and well-trimmed shrubs, beckoned from the garden. Smart women's hats, men's summer finery, all produced an animation more startling after the silence and emptiness of the road. It was a beehive with the aroma of many honeys.

She stood still, intoxicated at the sight of this other world, conceivably her own or Marston's, until a capable-looking French woman stepped to her side. "A little table for two, Monsieur?"

With a hurried step Sandra drew back into the shelter of the doorway, where, a few minutes later, Marston joined her.

She took a deep breath and found the air full of spring, though it was summer; full of longings and desires, sensuous and stirring, the air as provocative to their own mood.

188

Marston saw that her eyes were shining, that she was catching something from the atmosphere. She was transformed into a different mood from any in which he had seen her before. She seemed closer to him than when they had sat alone on the terrace of the château. He had wanted only to be himself; but with this newfound understanding and the sweet odors from the garden, and the rumors of life in the air around him, he had a sense of great joy.

Sandra was speaking. "Every American who comes over here says the same thing. I want to add my complaint. Why don't Gardens of Eden like this exist in America? You don't have to answer."

"It is because we don't have any Adams and Eves in America."

"Darling, did you ever think of going back to America?"

"Yes. I've often thought of unifying the Republican party. Yet Eileen couldn't change now, even if it weren't a matter of her health, which it is. She has given up almost all her ties to America. It would mean starting a new life. She hasn't the physical strength to do it."

The waitress had come into the *bosquet* with the first course. Marston gave her the attention which, with a toss of her head, she pertly enjoyed.

Meanwhile, Sandra disentangled herself from thoughts of Marston's life to look around her. Nearby a family party wholeheartedly and simultaneously applied themselves to food, and conversation. Mama, Papa, two daughters, suffering from their difficult age, and a pimply son, ate and talked, sensually. Beyond them an overdressed couple seemed bored with each other, but absorbed in the other guests, reeked of industrial money. On the other side, there was an

almost rowdy foursome: two young men with their *chères amies*. They were filled with bubbling life, laughing, poking fun at each other, affectionately.

There were other such groups scattered about the gardens, but too far away to be seen in detail. Another *bosquet* like their own inadequately sheltered a typical French scene: a rather frayed semismart elderly man with a tawdry, blonde young girl, intent on being well wined and dined.

Sandra looked over her shoulder in the direction Marston faced to see six people who, at first glance, looked dangerous. She did not know them, but Marston could have.

"Mademoiselle says they have a very fine *clientèle*, not just the American tourists. She thinks she is flattering me by doubting my nationality. She's a snob."

"There's a sort of excitement about the Jardin Joli," Sandra said, "Although it is like lots of other places."

"It's because you are sentimental, sweet heart."

"I am not sentimental," she said. "I'm worse, I'm positively entranced, Marston. I dote on every word you utter. Go on about America."

"Where was I?"

"You were reuniting the Republican Party. I see a melting pot with old brains and brash oil kings and the arms and legs of Young Hopes and Republican Youths stewing in their juices. Out of it comes a new brew, you are leading it!" she said triumphantly.

"It sounds horrible, darling. It reconciles me to the fact that I can't just step across and find that my place has been kept for me in the interim."

"That's one of the things you don't need in politics—

having your place kept. If you step out, you lose it completely, and the next time, if you can step back at all, it's way up on the ladder where you can make faces at everyone below.'' She laughed at herself.

"I am too old and too unknown to make a start," he said.

"Americans love a new figure, especially if he has a background of accomplishment."

"The world isn't made like that. Nothing matters, except that I have you." He put his hand over hers.

In a moment she gave him a half-smile. "You could take me with you."

"Would you come?"

"Walking, trotting, or galloping."

"What about Feodor's? No, I didn't mean that." He added hastily. "There would be plenty for you to do over there."

"I might be your publicity agent, or your secretary and help write your speeches. I should be very good at that, I know so much about politics. And I never could parse a sentence. My spelling is...I don't need to tell *you*! But, darling, you have a good war record that would help too."

"I didn't run away or commit atrocities."

"Stop being silly and tell me about your war experiences. I know you have medals because someone told me."

For a moment his thoughts were far away. "That time in my life was awfully unhappy."

He hardly dared hope he would go on. She knew, for that much he had told her, that it was about the time when his first child had died and his wife had been ill. Though he hesitated, she had the feeling again that he wanted to go on, that he would not be satisfied if she tried to pull a curtain

191

across the void. So she waited, as the intimacy of their silence deepened.

He looked into her face, smiling. "I got the chance of my life, Sandra, when I was thirty. That was luck for a lawyer."

"Were you interested in politics then?"

"On the side, yes. But I didn't get much time for fun." He paused and looked away. "Lawyers work like hell. I had had some lucky breaks and I had just married and we were comfortably settled in an apartment, when my real chance came."

"How did it come?" Sandra asked, as she leaned her elbows on the table and faced him.

He looked up quickly and threw away the cigarette he had been smoking. "From the firm where I worked. It was like this: One day the senior member sent for me, out of a clear sky, said he wanted me to go to China..."

She interrupted. "That was the time you saw the crystal figure?"

"No, no, darling." He put his hand over hers. "That was much later."

"Go on," she said.

"The firm's richest client had big interests in the oil fields. They asked me to go out and look after their interests and I did."

Suddenly she saw a connection between what he had told her when she first knew him. The child he had lost. That was it. His first child had died. Since then Eileen had been an invalid. In some way he had held himself responsible. That was what he was going to tell her. Abruptly she decided that she wanted to know, no matter how painful it

might be for Marston. "Where in China was it?" she asked, only eager that he should go on.

"I was sent to Shanghai. Nothing could be accomplished there. Then off into the wilds. I didn't know how rough it was going to be." His voice changed, "Or I shouldn't have taken on the work."

"Eileen was opposed to going in the first place," he said. "I knew it was a big opportunity for me so I persuaded her. Even my boss didn't think it would take more than a few months, and he had the idea the negotiations could be handled from Shanghai."

"What kind of work was it?"

"Manipulating Orientals is like catching eels with greased hands. Half my job was diplomacy. Fascinating stuff, Sandra, watching the eel when you mentally master his subtle mind. Mixed metaphor, but you don't mind that. God, I learned more than I ever did in law school and practice rolled into one."

"You had to feel your way!"

"It took me months to learn patience, and—anyway, Sandra, I ended by... but I must go back." He sat motionless, looking out over the little garden.

"That's why your face is so masklike sometimes," she said.

He went on: "The transactions turned out to be a gold mine for me. But to go back." His voice changed to its ordinary timbre. "Living conditions were not good where we settled, at least compared with what Eileen was used to. Besides, she was going to have a baby." He went straight on. "I had to be away a lot. There was a colony of English and

193

Americans where we lived, but not the kind of people she was used to. It was all pretty dreary. She was miserable, physically and mentally, then there were complications about her health. The baby only lived a few hours, and she did not recover as she should have."

His eyes were fixed on a distance in which she played no part. She would have liked to say something adequate, so she said nothing; since he did not look at her as he spoke, she could not show him how deeply touched she was. "And I suppose," she faltered, "the Chinese maneuvered behind their unfathomable faces while your firm wired long-distance tactics that would have wrecked your work. Anyway, pretty tragic."

He broke in, "Sandra, you are a marvel. How did you know? Snooky—that's what we called the high-mucker-mucker in New York—was proposing Wall Street methods, while I had to sit on my legs like a Chinese and make polite phrases for hours on end."

"Did you learn to smoke opium?"

"Yes. I also learned how to pretend to smoke it."

Suddenly the waitress stepped into their conversation. She gave Marston a flirtatious glance, cleared away their plates, and went off.

Sandra looked at the border of *millepedres* which encircled one of the grass plots. The golden flowers among the dense green leaves grew in abundance, about a foot high. She said: "And you won your points?"

"So many millions for the oil company that it laid the foundation for my own fortune. But, Sandra!" He straightened up to look at her.

She waited for him.

"When we got back home, it was a matter of weeks before America went into the war." He stopped, his head in the air as if conscious of something happening above him. Sandra looked up. The sky was cut in two. One half was blue, but the other half was a black mass of clouds.

There was the thunder in the distance. "We're going to have a storm," he said indifferently. Then he continued. "For a while Eileen seemed much better. I went to Plattsburgh for my military training, and emerged with the inevitable commission. I was ordered overseas to France almost immediately."

"Where were you stationed?"

"That's all immaterial," he said impatiently. "I'll tell you some time. I want to finish the other story, dear."

She looked up once more into the sky. The grey veil was flirting. It was higher over the far-off horizon.

"As soon as she was strong enough," he said, "she moved to France where I had a house for her at Versailles. I spent my leaves there."

Sandra listened, aware of his *malaise*.

"It was during that time I saw the greatest change in her. For the worse. We moved again, this time to the Riviera, and the climate immediately gave her new life."

Sandra's lips moved. She said nothing.

"The war was over and we tried once again going back to America. It didn't work. Her illness seemed unfathomable. There didn't seem to be an adequate medical explanation for it." He moved in his chair. "After that we came here to live."

195

Sandra saw that tidal wave of circumstance which had come down on him. So completely could she identify herself with him that it almost seemed to have happened to her. It was a long time before he spoke.

"Now about Merrimée."

He feigned a smile. Was he deliberately ridding himself of all his reticences, in order to please her? She could not bear the thought. A crisis of self-blame passed through her, but before she could speak, he said, "Darling, don't." A tone of tenderness of understanding was in his voice.

"When the floodgates open, you can't just turn off the water as though it were a faucet, my dear one. Yes, you have brought it about, not for the reason that came into your head, but because you are you. Now there is not even the width of a blade of grass between us."

A sudden look of distress passed over Marston's face. "That reminds me, darling," he said, "I have to take my family to Cabourg for the weekend. Eileen arrives in Paris with the children in a few days. I have arranged to return Tuesday for dinner and Thursday in the afternoon. Why don't you go to the Thibots', it will give you a chance to be with Beatrice."

Sandra felt a pain as though a knife had pierced her skin. She knew she could achieve calm, but he must not see her eyes. "I'll miss you. I understand. You don't have to say more. I will go to Dora's." She rambled on now, "I don't like her much, but the Marquise wants me to go around and show off her fine feathers. Besides Bob and Bea will be there. Oh, dear I have just remembered I am supposed to have a new design for her by tomorrow."

"When am I going to see the dress you wore last night?"

"Tuesday, when you come to dinner."

"It's bad about next week, but after that I'll have more time. One of my cases will be over. I have a very absorbing case of international law for which I must begin writing a very complicated brief. But that I can do anywhere."

"And I want something else now."

"What do you want, beloved?"

"I want to dance with you out on the lawn over there. I want always to dance when I am happy."

# 🌹13🌹

When they were ready to leave, Marston told Sandra to give him a few minutes to get the car. "Then come out where the cars are parked. I'll be watching for you."

Just as Marston was about to step out of the inn, he was stopped by a familiar feminine voice. "Hello, Marston, we saw you at lunch. You didn't even wave at us." He turned to face two old family friends, the Ashley Murrays.

"I didn't see you. Why didn't you come over and have coffee with us, Elsie?"

Elsie Murray was not slow to use her advantage. "I thought your companion looked familiar, but I can't place her." The upward inflection of the voice implied a question.

Marston had already put one hand on Ashley's shoulder. "How are you, old boy? Not staying in Paris? I suppose you are off to a cooler spot?"

"We were going to Italy." Ashley looked at his wife as though she had made a *faux pas*. "But it's too much of a mess. We stopped at your house the other day and were told Eileen would be passing through soon on her way to Cabourg. We—"

Elsie, an attractive-looking blonde, lacking style, inter-

rupted. "Yes, when will she be in town?"

There was no avoiding it. "I am taking the family to Cabourg the end of the week. She'll be there in a few days. Why don't you come and pay us a visit at the seashore? I have taken a small house near the hotel." He smiled, shook hands with Elsie and started out of the inn.

Mrs. Murray did not attempt to delay him. She wouldn't think of embarrassing him. But her husband was less tactful. "I say, Marston," he spoke hopefully, "it's a jolly sort of a place, why don't you bring your friend and we'll go back and have a drink?"

Since Ashley forced the situation, his wife's curiosity got the better of her. "Yes, I wish you would, unless you are in too much of a hurry."

"I am afraid we must be going along. We hope to beat the storm," Marston said, trying to appear regretful. "Some other time."

"Too bad," Ashley said with a grin. "So long."

*Damn,* thought Marston, *the Murrays, of all people. His wife is just ignorant enough to think it's her duty to tell Eileen.*

A few minutes later Sandra joined him near the car. His shoulders were square. His forehead was wrinkled.

"You met someone?" she said.

"Is it obvious?" He forced a smile.

"I met, would you believe it, family friends. And she is green enough to feel the urge to gossip." His tone brightened, but the effort was noticeable. "There is only one thing for it, sweet heart. I'll have to take a different girl out every day next week."

"It's the first time we've been seen alone together, as far as I know," Sandra said.

He did not attempt to argue her point. "We may not be punished for our recklessness. After all, I've lunched with women before."

He couldn't fool her. "It needs more than once, dearest, to be fatal," she said.

He was grateful for her effort, but he could not control the vague fears which Elsie's icy voice had started. He knew that his attentions could not fail to harm Sandra's reputation. *Martson does not waste his time with women unless he gets what he wants,* the words, which Elsie Murray had once spoken, intruded themselves. He and Sandra must certainly have appeared vastly different from casual acquaintances. Eileen was always suspicious. Perhaps now she was actively seeking information about Sandra. She had used the technique before. He could not dismiss the importance of what another humiliation might mean to her nervous condition. It could have serious consequences.

"It was inevitable," he said. "We were bound to be seen some time. You may hear of me stepping out with women galore. If you show any jealousy, which I doubt, you will be in torment. But don't be afraid, I shall be Parsifal and Lancelot rolled into one."

Sandra rose to the occasion, she patted his shoulder. "While you are being tested by the flower maidens, my one recourse is to prove my own fragility."

"You shall do nothing of the kind."

"Do you doubt my virtue?"

"You know your friends will talk."

He glanced at her, as he said, "I think they will tell Eileen, yes?"

The road seemed short to Sandra, and at the turn where Fleuris came into sight, she glanced at Marston. He gave her a quick look as they drove on in silence as if to say, *We are safe here.*

When they left the car at the door, the rays of the sun were still hot. Fleuris stood like a monument to peace and beauty.

Marston suggested now that they go down by the stream, under the trees, and she followed the path slowly, full of lassitude. She knew he was tumultuous about the Murray's. He said, almost unconsciously, "Elsie is such a fool." Then: "I'll bring some cushions and cold drinks."

She turned to find he had not moved. His face off guard, seemed older, with lines of resignation. It showed a new and unfamiliar mask. She watched the river. He must not know she had seen his face.

On the bank, she gazed at the water and the rocks. There were wasps circling in the air. His meeting the Ashley Murrays faded when Marston had talked about himself. It set her spirit on fire, broke through her lassitude. She thrilled in the knowledge of this new bond between them. That afternoon he established a link in their relations which she had missed.

She heard his step behind her on the path, and before she had time to turn he was beside her, piling cushions behind her back, setting cigarettes and drinks on the grass between them. She held out her arms to him. She noticed he was young again. His look of resignation had vanished.

201

When he lay back on his cushions, suddenly, unexpectedly, he began once again talking about the Merrimée case. He used brilliant phrases, words and clear sentences.

There were few facts that she did not know, but his deductions were built on another point of departure. They left her full of admiration.

Marston could feel her excitement as his story unfolded. She listened, carefully, asking questions, or commenting, from time to time. It dawned on Marston that she not only had read about the case, she had assimilated it. Her knowlledge added to his pleasure as he progressed with his recital.

Sandra lay on her side, watching him. So absorbed was she that she did not observe the gathering grey clouds until far-distant thunder caused her to look up into the sky.

While they lay there silently in the slowly declining light, Sandra felt herself involved in a new experience. But she also realized suddenly that there was an element in the Merrimée mystery which was too female for the masculine-mind to grasp. She no longer felt she was an onlooker in a man's world.

The thunder grew louder. Marston watched grey clusters of clouds fill the sky above them.

Something about the menacing sky added urgency as he summed up the basis of his defense. She listened proudly. She felt perhaps a vital point was lacking. One loophole that could be used by the State, which his conviction of Merrimée's innocence did not cover.

She was thinking of her paints. The information gleaned through the newpaper clippings, illustrated papers, and sensational articles, would now be available and useful to

him. The desire to express her thoughts by way of her usual jotted notes in picture form made her say, "I feel like sketching. I'll fetch my things."

He seemed not to hear her until, pausing a way off, she called to him, "I ate so much lunch. Shall I tell Maurice to give us a light meal tonight?"

He said: "Yes, very light, as far as I am concerned."

When she came back, he lay quite still on his side, with his back to her cushions. "Is that you, darling?"

She patted his shoulder. "I'm so happy."

Quickly she opened her box and took one of her soft pencils. The grey clouds still brooded, the air was ominously heavy. Her pencil slid over the paper guided by her thoughts: aviation fields in sharp, telling lines, glimpses of planes taking off, crowds held back by gendarmes. She was thinking of Louis Merrimée, conscious he was neither a hero, a martyr, nor a friend, he was flesh and blood. A guillotine stood poised over his head. She sketched a guillotine in vague outline with a birdman caught in its grasp.

In Marston was the power to save him.

She looked up at the river, the silver sunset and the grey storm clouds.

Now she tried a number of women's figures on another sheet intently searching to find the one which would fit her picture: a slim figure, with controlled, or perhaps reckless gestures.

As she drew them, her thoughts were always of Louis Merrimée, the man who had spoken to her for a few moments and smiled at her. An exponent of modernism, speed, recklessness, and with the power of the gods. What

had his gentle wife to give him? Affection, love, boredom, comfort—all of these—but not companionship, understanding or passionate love. And best of all, belief in his adventures. Had he someone to satisfy him?

"He is innocent," Marston said.

A number of sheets were covered with impressions. They lay scattered at her feet.

She knew that Marston had not moved. She saw his eyes were wide open, but focussed in the far distance.

She picked up the sheets and reviewed them hastily, then from these studies, she sketched a complete picture. With nervous concentration she took up her brushes and colored it. A blue-purple field, faint streaks of a rising sun, an aeroplane, crowds and a distinct yellow figure, detached, important. Merrimée's head turned as he rose. He was the birdman.

She laid the painting on the grass to dry, gathered up the pencil drawings, and waited.

She did not look at the sketch except to see that it was no longer wet, then she put it away in her portfolio with her other work.

"Sweet heart, you'll get cold," Marston said later. "Have you finished? May I see?"

"Not now, Marston. Later," she said.

"What fun we have had today, Sandra. Always something new."

The following morning very early, a clap of thunder like the firing of a gun resounded through the house. It had been rumbling for some time as though waiting to explode. Marston awoke thinking that he was under artillery fire.

The flash of lightning that followed revealed Sandra asleep at his side.

He waited for the next clap, wondering if it could be possible for her to remain unconscious through another blast. It came rumbling towards them once more and broke with a hideous crash. The figure beside him moved, turned from one side onto her back, her arm thrown wide, and lay still.

Marston raised on his elbow, waited for the flash that would bring her clearly into view. When it came, he saw the golden brown of her bare body and her head turned toward him with her hair pushed back from her face.

The storm brought a slight puff of cooler air into the room. He reached to pull the sheet over her.

At the next thunderclap she woke up.

"Don't be afraid, sweet heart," he said. "It's only a storm."

She stretched herself, shook her head as if to shake away cobwebs. "Shall we be struck?" she asked indifferently.

"Probably. Shall I put on a light?"

She was suddenly wide awake. "I know it would be much more feminine if I were scared, and hung on to you for comfort, but thunder doesn't frighten me in the least. I like it."

"Do you? I'd have guessed you hated it."

"The claps are so strong, just like you, darling," she confided. "But I wanted to sleep, and now I am wide-eyed."

"So am I," he said as another bomb exploded, it seemed directly over their room, "Besides I'm terribly hungry."

"I knew there was something the matter with me. It must be that." She sat up straight in bed, her elbows on her

205

knees. "Don't you think we could have something to eat, darling?"

"What a marvelous idea! A midnight supper in bed."

Marston switched on the night light. He swung his legs over the edge of the bed and stood looking at the open window. "You are sure you are not afraid of being left alone?"

"I'm too hungry to think about that. Bring something very rich. Wait a minute. It's a midnight supper, so don't forget champagne."

He leaned down to kiss her. "Heavens be praised for the storm, and a small dinner."

When Marston returned, Sandra was sitting up on the far side of the bed. She had brushed her hair and smoothed out her blue pajamas. Her eyes were sparkling.

"Put it all here," she said, patting the bed.

"It will spill, I'd better move up a table."

"No, no, it must be in bed. Darling, let me see what you've brought."

Sandra took dishes. With exclamations of delight, she put them down in the center of the bed. "Pàtisseri, lovely! Pàté, divine! Raspberries, luscious! Bread and butter. Cold duck, the *pièce de résistance*! Champagne! Wonderful! Let's begin with champagne!

"You haven't left much room for me," he said.

She moved the cakes to a safe spot. "Get in quickly. Where are the glasses?"

He produced them from the pockets of his bathrobe, and slipped under the sheet, carefuly skirting the platter of duck.

To the sounds of heavy rain, and the accompaniment of diminishing thunder and lightning, they laughed, talked, ate

and drank. Sandra said, "The gods are truly here: nectar and ambrosia!

When the meal was over, Marston cleared away the food and they kept the champagne to finish with their cigarettes. Sandra leaned back against her lover's shoulder. His arm was around her waist, his head against her head.

"I don't care if the bed is a forest of crumbs," he said. "Sweet heart, you have a genius for thinking up mad and wonderful situations."

"You have too, darling."

Imperceptibly they were swept into a current of intimate talk. Then there was a long silence. Sandra was thinking of her life before Marston. Marston was thinking of what she had told him of her life.

She hadn't told him very much. Her mother's death when she was still a child. School in Switzerland where she had met Bea. The thought of Bea brought Marston to say, as he pressed his face close to hers, "Beatrice was exquisite the other day. I didn't tell you how very touched I was by her confidence."

"She's a wonderful person, isn't she, darling?"

He stroked Sandra's hair. He recalled that she had told him that her father had taken her out of school to live with him when she was sixteen. Marston pictured him as an elderly dilettante in the arts and a master in the art of living life.

He said to her now, "Did you ever miss a real home before you came back to live in America, sweet heart?"

"Father had a genius for nesting. Whether we were in a place for three months, or eight months, it was home. There was Mademoiselle, with her thrift and her *petit point*

to complete my education and to leave father and me without worries." She smiled at the picture in her mind. "The war restricted our wandering, but Cairo, Stockholm, parts of Italy and France, all sheltered us. Usually he took a little house, and furnished it with our own belongings."

"You must tell me more about all the people you met sweet heart," he asked gently.

"I'd love to." She turned her face up to look at him. "The trouble is, we don't usually have time enough to talk about the past."

"We never have time enough for half the things I want to do with you," Marston said.

"You should have seen us in those days, moving out of one place and into a new one. Suddenly, we would pick up our books and the mass of objects Father had collected in his travels, dilapidated furniture, shabby label-covered trunks and valises, and deposit them in a new spot, chosen for love, or just because of a flight of fancy."

Marston sighed. "I would have loved your father. Did he have white curly hair and a long lanky body?"

"How did you know?" She nestled closer into the crook of his arm.

"Darling, if I'm not being indiscreet, how old were you when you went back to America to live?"

"I was twenty. Of course, during our travels we had stayed for a while in New York."

"So you did not feel like an alien when you and your father came back?"

"Oh no. Beatrice took me with her on two summer vacations from the school in Switzerland."

Marston abruptly sat up in bed. "Sandra, my dear one," he said, "I feel as though I were interrogating you."

She pushed him away onto his pillow and lay back herself and laughed.

But Marston wanted to know more about her youth and marriage. The years of youthful happiness and misery. From Sandra's own description he imagined Tony Fane and his rapid, violent courtship. She had drawn a portrait of a brilliant, versatile young man of exceptional good looks who had swept her off her feet. And in the end was the cause of disaster.

Just as Marston was about to speak, Sandra put an arm around his neck and her voice was serious. "What happens when the person you really love hurts you terribly?" she asked.

"There are many kinds of hurt."

"It wouldn't matter how you hurt me. I will always love you."

"But darling, it would depend on how and why I hurt you." He drew her to him again. "If I did it deliberately, it would be one thing. If I hurt you because I couldn't live up to your ideals, it would be another. And if I hurt you because I was a horrid person, you could never go on loving me."

She put her arms around him and lay her head down on his chest so that he could not see her face. "Darling," she said, "You may have to."

"Sweet heart, that possibility kills me."

"No matter what happens, darling, the only thing I couldn't bear is not to be able to love you."

He turned off the light as she clung to him. Only the buzzing of insects could now be heard. The thunder had gone. A faint line of sunrise shone through the curtains and was dissipated in the darkness of the room.

## 14

"Will you tell Madame Nada Mrs. Graham is here to see her?"

Beatrice was shown to a seat in the half-filled row of chairs that circled the largest salon of the Maison Feodor. She asked if they could make a couple of new dresses for the weekend at the Thibots'. It was already Monday and although she knew that the Marquise liked her because of Sandra, it was also the season for the execution of buyers' orders, and the workrooms would be busy and crowded.

A pretty young *vendeuse* appeared in a few minutes. "I am sorry," she said, "Madame has sent Nada to make some drawings. She designs for us now."

"Yes, I know. Will she be long? I can't choose anything without her."

"Madame asks if you will look at the collection. She will be in to see you soon. My name is Estelle. I will take notes for you until Nada returns."

The *mannequins* were starting their parade. Then suddenly the room was nearly filled with customers. The feverish excitement of the audience stimulated Beatrice's interest. It was just like going to the theatre, except both the

onlookers and models had roles. She realized that she played one, too.

The difference between ladies and *cocottes* is not easy to define. A smattering of fashionable-looking men were fascinated by *La Mode*.

She had always thought that it would be pleasanter to do any work rather than to fill Sandra's position, but perhaps she was mistaken. Clothes were so personal. A woman selecting a dress seemed more nude than a woman on a beach.

Mademoiselle Estelle stood between Beatrice and her other clients. She whispered confidentially, cooing words of praise, making careful suggestions. As she called Beatrice's attention to a particularly lovely cocktail gown, a commotion took place at the entrance to the salon, and the shrill voice of another saleswoman could be heard above the noise: "Mademoiselle Estelle, Mademoiselle Estelle!"

The *vendeuse* turned to the door where a striking-looking woman stood silently surveying the room. Estelle quickly excused herself and darted among the models toward the new arrival.

Only one chair remained unoccupied in the salon. It stood at an angle to the room, almost facing Beatrice. Estelle pointed it out to the customer, who, after an intent and disparaging survey of the scene, proceeded slowly toward it. Everybody in the room became aware of this arresting woman. She held herself regally. You did not observe that she was small or that she studied each movement and its effect. Her face was startlingly pale against her dark tightly curled hair. Her critical expression, as she stood in the doorway,

was now replaced by indifference. She took the empty seat as though it were just a chair to sit in.

Beatrice, who had watched the scene as part of the theatre, now realized that the new arrival was not alone. A chair was hastily wedged in next to hers, and a woman who was obviously a New England spinster, settled herself between the newcomer and a young man of eccentric appearance, sitting, pad in hand. So incongruous were the two women, that for a moment Beatrice thought she was mistaken in thinking that they had anything in common. But the latest arrival said, "Shall I move? I am crowding you?"

Beatrice thought, *No woman could wear a gray-brown dress, stylish but drab, accentuating a gaunt figure, unless she were the real thing: obviously Philadelphia.*

After a few minutes, during which the parade of models continued, the new customer ostentatiously pushed her chair farther away from a stout American buyer in an adjoining seat. This forced her friend to edge backward, and the eccentric young man now found himself almost directly in front of the tall woman. He stood up embarrassed, and took his chair dodging the models, in a futile attempt to make himself inconspicuous. Finally he went to the far end of the salon, amid a titter of laughter.

Estelle obviously wanted to please a new and distinguished client, but never lost interest in her former client, nor allowed the excitement to impair her efficiency. Beatrice, rather overpowered by the procession of dresses, was primarily interested in the newcomer. She wasn't sure of her nationality. She could be Russian. She waited to hear

213

her say something. Soon she found herself more curious about the woman than the collection. In spite of herself, she frequently glanced covertly at the incongruous pair.

The showing of day clothes came to an end. At this point, a great deal of talk and bustle began. Joséphine, Madame's favorite model, flashed alone into the salon. In the center of the room she stood poised in an attitude of studied grace, one hand extended into space, the other resting on her hip. Her evening dress was of sapphire blue, cut and modeled to emphasize a woman's desirability. With a snakelike movement she began the tour of the room.

Up to this time, the new customer's expression had been supercilious. Now a genuine interest animated her face. Beatrice read her thoughts: *She sees herself beautiful in that dress. She is right.*

The pale woman beckoned to Mademoiselle Estelle. Joséphine's appearance had caused a hush of admiration. The silence amplified the newcomer's words: "I like the dress. It is just what I want. Bring the girl here." Her French accent was almost perfect, her voice was surprisingly big and ringing for so small and delicate a person. Noises again filled the room, which prevented what else she said from being heard. Joséphine, blasé, patient, stood waiting in front of the new customer, while the tall, drab woman with folded hands paid superficial attention.

When Joséphine was dismissed, the *vendeuse* wrote something on a slip of paper. *The dress has been ordered,* Beatrice thought, and then suddenly became aware of the woman's eyes looking straight at her. She tried to look away, but her gaze did not waver.

214

Suddenly a veil of reticence covered the woman's face so completely she might as well have retreated from the room.

"You are very tired?" A lull in the salon caused the gaunt woman's words to be heard. "Perhaps we had better go." The tone and the look which accompanied it were *dégagé* yet polite.

"I'm exhausted, but I might as well stay until the end. I am thrilled to find the clothes so exciting." She rested her cheek on one ring-laden hand and closed her eyes.

Estelle suggested that Beatrice would like a cup of tea.

During the next half hour, the new client recuperated as rapidly as she had faded. She chose three more evening dresses, changed the color of one, the *décolleté* of another, and the fullness in the skirt of a third. Her orders were rather dictatorial, her criticisms condescending. There was now no doubt in Beatrice's mind that she was an American. She never consulted her companion. It was not only the beauty and arrogance of this woman which held Beatrice's attention, but also her mercurial personality. Her dark eyes were very penetrating when wide open. But she frequently looked at her feet, as though she were too indifferent or tired to lift her eyelids. When she spoke, the muscles of her face hardly moved, they were as controlled as the muscles of a dancer. Her hair was almost black, tightly curled under her small, smart hat. One could only guess at her natural coloring, because of her painted face. She made no gestures except to summon Estelle. Her smooth languid hands lay in her lap most of the time, as if her rings were too heavy for them.

As the last *mannequin* disappeared behind the curtain

215

leading to the dressing room again another slight commotion took place at the entrance of the salon.

The Marquise stood for a moment in the doorway. Something about the well-timed pause, the insouciance of her expression reminded Beatrice of the arrival of the newcomer.

*She is an actress*, Beatrice said to herself.

Madame slowly came into the salon, while everyone gazed spellbound, as if her entry were the big scene of a play. She first went to Beatrice with soft words of regret for Sandra's absence, then she said aloud, "Won't you come to tea in my rooms?" Smiling, she did not wait for an answer, but said, "Come if you can." Then she went over to the small, pale woman.

"Madame is tired," Estelle explained to Feodor, "She is feeling very weak."

"I hope you will have tea with me, it will refresh you." After some words which Beatrice could not hear, the Marquise circulated among her clients.

When Beatrice looked once more in the direction of the American, she had moved to a more comfortable chair, and lay with her head resting on its back. Her friend stood beside her. In one hand she extended a bottle of smelling salts.

*That gesture is a common one*, Beatrice thought. *Could the bleak-looking woman be a trained nurse?*

A boring tea at Feodor's had been Beatrice's first reaction to the Marquise's invitation. Yet when she heard that the mysterious woman was staying, she knew she had to be there.

Beatrice stood apart, waiting for something to happen. Abruptly, a young American girl, whom she had noticed

216

earlier in the afternoon, spoke to her. "Shall I bring you a cup of tea or a cocktail?" she asked. "I often come to the Marquise's parties. I am a kind of part-time hostess. I saw that you were alone. Aren't her clothes beautiful? Would you like to meet anyone here? I'm an official introducer." She laughed.

"Why yes, there is someone I should like to meet. She is a new client. You may not know her."

"That doesn't matter. Where is she?"

It took a few moments to locate the pale woman. As Beatrice nodded her head towards her, the younger girl raised arched eyebrows. "I am positive she has never been here before. Judging from the way she behaved this afternoon, I think she is sure to snub us. It makes it easier." She was still smiling. "Beatrice Graham."

"Come along while my courage lasts or we'll lose her."

Beatrice now saw that the Marquise was also approaching the object of her interest. She was followed by a Frenchman and as they all edged closer to the pale woman, the smiling girl announced: "There, Madame will do it for me. What a relief!" And disappeared in the crowd.

Beatrice could just hear Feodor's voice above the din: "The Vicomte de Crepigny." She stood behind the Vicomte. "And Mrs. Robert Graham..." The other name was lost. The Marquise spoke at once to the Vicomte, leaving Beatrice facing the very pale woman. A glimmer of recognition appeared in her eyes, which were now wide open.

"It's so crowded," said Beatrice, "wouldn't you like to move back a little? I noticed you were not feeling well. There are some chairs against the wall."

217

The woman sighed. "The heat. Yes. Pat, where are you?" She turned her head to look for her companion who was just behind her. "See if you can't get me a drink," she said irritably. Pat promptly disappeared. "I saw you in the salon. Some of the clothes were really quite nice." Her condescension was striking.

Madame was within easy earshot. She gave no sign of having heard the woman's remark, but moved on leaving the Vicomte who turned to the pale woman and said in French, "Allow me to get you a drink. What will you have? Tea? A martini? Whiskey and soda?"

"Don't bother. My companion, Miss Patterson, has gone for it. I am badly in need of a pick-up. What an extraordinary party! It's nice of course. How do you happen to be here? How do you like it?"

"I dislike it very much. It makes me feel how unimportant a mere man is. When it comes to fashion, the beautiful ladies never give us a thought."

"Not at all, we go through all this effort so that we please men. Isn't that enough?"

"You must permit me to see you in that exquisite sapphire dress!" His eyes did not leave her.

Obviously she enjoyed the compliment and brightened. "There was only one thing I didn't like about it."

"The buckle, I suppose," Beatrice said.

The pale, white-faced woman looked at her approvingly. "Imitations are all right, if they don't try to imitate the real thing. Worth would never do that."

The Vicomte agreed. And Bea found herself saying the most absurd things about imitation buckles. The pale wo-

man appeared suddenly irritated. "Where on earth has Pat gone? I feel ill. Vicomte, you go and see if you can't find me a martini."

He bowed and said, "At once, Madame, I should have gone myself."

When they were alone, the woman looked weary. Beatrice led the way to two empty chairs and they sat down.

A good-looking man passed them. He bowed formally to Bea's companion, but did not speak to her. She seemed bored and nodded in answer when Beatrice said: "The Marquise has gone modern in her apartment. I wouldn't have expected it."

When her remark was ignored, Beatrice decided it was up to the pale woman to make the next move.

At last she heard the metallic voice beside her: "Who is the Vicomte de Crepigny?"

"I have no idea. I know very few French viscounts," Bea said. "It's a relief to see a modern room in an old house," she added.

"It's atrocious."

"It's fashionable, I think," Beatrice said.

"Among certain people—perhaps." The small woman's lip curled. "It casts doubt on Feodor's taste in clothes."

"I noticed that you ordered some dresses," Bea said.

"She probably goes in for this modern décor as a fad. Certainly I would not tolerate it in my house."

"Or perhaps to appeal to the uninitiated?"

"What could possibly be more beautiful than Louis XV," said the pale lady.

"Possibly Louis XVI," Beatrice said. She hid her smile.

"No, I don't think so," the woman remarked thoughtfully. "But I admit that is a matter of taste."

"And what is taste?" Bea feared she had gone too far, but apparently not, because the pale woman roused herself to look around the room. "Do you know any of these people? They are smart looking, but I wonder who they are?"

Beatrice wanted to say they were all her intimate friends, instead she asked, "Why did you change the color of that evening dress you chose?"

"Imagine *me* in pink!"

She was quite right. "Exactly what color are you going to order?"

"Crimson. My husband likes me in crimson."

Beatrice guessed that the woman was older than she had at first supposed. She guessed forty-five. Yet her face was amazingly smooth. Though she had at first thought she was an actress, she knew that an actress would have not mentioned her husband. On the other hand she was obviously a prima donna. She went on about French furniture, about Worth and his perfections. It was easy to pretend to listen, and make the proper answers. But it was not easy to control her growing irritation. There is a peculiar coldness behind the woman's words that chilled Beatrice. She imagined a pyramid of ice.

In the midst of their vapid talk, Miss Patterson and the Vicomte returned together. They both held one cocktail in each hand and were followed by a waiter with sandwiches and cakes. Beatrice got up delighted that she was being rescued. The angular woman offered her the cocktail in her right hand.

"Thank you, how nice of you. Are you sure you don't want both?"

"I don't really want any, but the tea table was too crowded," Pat murmured. "Drinks go to my head. You are American. From New York, I think? I come from Philadelphia. I'm Pat."

"I thought so. You were not much interested in the models. I couldn't help noticing because you were sitting right opposite me."

The drab woman spoke almost heatedly. "What's the use of buying so many dresses you never wear? Her closets are full of them."

From where Beatrice stood, she could hear as well as see the other couple. Crepigny appeared fawningly absorbed; he was complimenting his companion on her taste. She heard him say something about "Your husband..." Then he laughed. "He is not the sort to have time for dressmakers."

Someone Beatrice knew came over to say hello. Later she again heard the pale woman's metallic voice. "Come, Pat, I am going now. The cocktail helped a little, but it's been a very long afternoon."

The drab woman spoke automatically. "You *are* tired."

"I will take you to your car," the Vicomte insisted.

It was late when she reached the street. She had sent her car away, and decided to walk to the Crillon. She actually liked the city lights winking into life against the coming of night. *I wonder why Sandra was not there? Perhaps she went to meet Marston. I hope so.*

She went back to the Crillon. In the sitting room she

found a letter from Bob on the table. She tore it open, impatiently.

*My dear old best girl,*

*Thank heavens the cure is almost over. They have filled me full of water, vegetables and ham. I can never look stewed fruit in the face again. I'm sick of baths and everyone's symptoms, including my own. When I think of Paris, I get palpitations of the heart. As to the Thibots', it sounds O.K. My golf and tennis have improved. My waistline is something to boast about. You will be delighted! I had a letter from Bob, Jr., who says he wants to be a cowboy for the rest of his life. He'll bring home a bucking horse if he can buy one for the $6.55 he has saved up. The beautiful women I wrote you about don't look as good-looking as they did. A new group of ugly fat ones have just arrived. It's high time I got out. I miss you and it's going to be great to be back. Meet me Thursday morning. I have to dine with Jerry that night. He's just arrived from America, so get yourself a date. As they say in France* Je t'embrasse. A bientôt.*

*Bob*

*P.S. Let's drive to the Thibots' and stop at Blois for lunch.*

She wanted to telegraph him at once that it seemed a glorious idea, then a ring on the telephone interrupted her. It was Sandra.

"I'm devastated that I missed you this afternoon."

"I'm disgusted."

"I'm going to the Thibots'."

"That's good luck. Drive down with us, will you?"

"Wonderful. When do you want to see your new dresses?"

"I'm extremely busy until Thursday. Can you dine with me tonight?"

Sandra said she had a stupid engagement, and they made a date to meet at Feodor's on Thursday and dine somewhere in the country afterwards. Then Bea telegraphed Bob that she had read *The Lives of French Kings*, was fascinated by their wives and mistresses, and that she awaited his return to Paris.

## 15

For Marston and Sandra, the week passed no less unhappily than the last one. They met only twice. She imagined herself as a wound clock, ticking out the minutes, chiming the hours, until she saw him. When they were together there were no ticks. Time stood still. But when Marston left, the ticking clock began again.

Tuesday he had asked her to have dinner. Instead he stopped briefly before a dinner engagement with his wife who had just arrived in Paris.

He came to lunch on Thursday to say goodbye until Monday. Even the pretense of bravery deserted them.

And when the door closed on Marston, Sandra collapsed on the sofa, sad and alone.

At last she arose. She went through the usual motions of brushing her hair, putting on her hat, and ringing for Louise. Beatrice was coming to Feodor's to choose clothes. Then dinner in the country, as planned.

They dined at a tiny restaurant, discovered accidentally by Beatrice. It was unknown to tourists, and its courtyard sheltered only a few tables around which pink ramblers grew in profusion. They sat in the growing dusk, oblivious to what went on all around them, sharing each other's

224

thoughts, lulled by a companionship whose roots had grown deep.

When the sputtering candles had been lit and the coffee cups removed, Sandra noticed that Bea seemed somewhat preoccupied.

"When it comes to clothes, you know how I have to concentrate. Even now I can't be sure I won't look like an overdecorated Christmas tree in that silver dress you made me order."

Sandra said, "You can be really dressed up and not look it, my darling. That's one of your greatest assets. I wish that you had ordered it sooner, so that you could have worn it at the Thibots'."

"Let's give a Bohemian party some night," Beatrice said suddenly. "We had such fun last year with Beaulier and all that crowd."

Sandra wrinkled her brow. "Hang going to the Thibots'. I'd chuck it, except Madame insists. She's given me Friday and Saturday off."

Sandra filled their liqueur glasses from the bottle of Cointreau. "I suppose it will be all right. I hope Jacques de la Roche isn't going," she said.

"Is it as bad as that?"

"It's nothing." Sandra sounded slightly irritated. "It's just that he's been sending me flowers and books." She grimaced. "Books of poems. I just glanced at them. Very sentimental. I don't have time to read poetry."

"Do you like Jacques?"

"Yes and no. Mostly no. Sometimes he seems like a great black threat hanging over me. At others he's a nice kid. In any case, he's extremely easy to handle. The truth of the

matter is that only Marston really exists for me."

"I know." Beatrice smiled.

They were silent for a while. "I was telling you about a woman I saw the day I went to your workshop, who made a strange impression on me. She may have returned to Feodor's since Monday. She was a new customer."

"What did she look like?"

"I'll try to give you a picture of the whole scene. I won't give you my own reactions, I'll just give you the facts."

Bea saw that from the moment when she told of the pale woman entering the door of the Marquise's salon, she held Sandra's attention.

There was a pause. Sandra had scarcely moved or taken her eyes off Beatrice.

"I shouldn't have gone to tea," Bea added with a shiver. "Do you recognize her?"

Sandra made a gesture of extreme distaste. "She sounds poisonous."

"As I said, she was very good-looking, especially when she was in repose. Her lips were thin."

"You never found out whether she was an actress?"

"I didn't find out anything except that she was a bore."

"Let's forget her."

Beatrice paid the check and Sandra asked, "When do we start in the morning?"

"We'll pick you up at ten, go as far as Blois for lunch, and get to the Thibots' around tea time. Does that suit you?"

"Perfectly. Now I must hurry. I promised Madame a sketch for tomorrow."

"I have to drop in at Feodor's in the morning to see a

sample, so we can leave your sketch at the same time," Beatrice said.

The following morning the Grahams arrived at Sandra's apartment on the stroke of ten. Bob, who had returned, was in exuberant spirits. Sandra was dressed in a light grey suit with emerald green accessories.

Bob talked continuously as her bags were being strapped to the back of the car. He patted his stomach with pride and insisted on describing his daily regime at the spa.

They must stop at Blois for lunch and by all means see the château. It was *the* thing to do. Bob Graham was sure they would enjoy it no matter how many times they had seen it before. He was eager to point out to François that I had a mistress named Diane de Poitiers.

"Will it make us late if I drop off my sketch?" Sandra asked.

"And see my sample?" Beatrice said.

At the door of the Maison Feodor, Bea got out and took Sandra's flat paper package with her into the building.

Bob leaned back and said, "I wish Mrs. Mowbrey was going to be at Dora's."

"Why didn't you tell Dora? She would have invited her," Sandra said.

"I feel like having a flirtation," Bob said.

"If you feel that way, you will."

"I hope you're right."

"What about the Egyptian profile?"

"They say she's no longer in profile," he said.

Sandra laughed. Bea reappeared and climbed into the back seat next to her.

Bob said he guessed he would let Gustave, his chauffeur, drive until they got out of Paris. He sat next to Gustave.

Sandra noticed that Beatrice seemed upset. Sandra said nothing. Something must have happened at Feodor's. She and Bob chatted about the route. After a pause, she asked, "Who is going to Loirine, do you know?"

Beatrice spoke for the first time since they had left. She said that Archie had told her that he was going despite the fact that Dora refused to invite his latest flame.

"He is so very tiresome about ladies." Sandra observed, "Nearly as bad as a woman boasting of her conquests."

"Most likely he will bring one anyway," Bob said. "I have never known a refusal to stop him."

Beatrice said that Mademoiselle l'Aigle was coming, in her new role.

"If only she *had* one!" Sandra laughed.

"I liked the old one best," Beatrice said.

Bob wished he had as many lives as l'Aigle had. She was nothing but a cat anyway. He was sure she had told him she was going to be at Deauville over Sunday.

Beatrice went on: "Count Marbeau is coming down with some friends, I believe. I don't know who they are."

"Probably someone to amuse Paul Thibot—but not *too* much." Bob flashed a sly smile.

At first it seemed to Beatrice to promise a rather special day. She would have like to dwell on the surroundings, linked to so much of the history of France, which she had studied. She wanted to be impersonal and objective, but she could not. A secret was burning a hole in her mind.

She looked at the passing scene once more. The grass of the fields was not like grass anywhere else, she thought.

Even the flat expanse of the Loire has a faint muddiness all its own.

They approached Blois, at the workmen's lunch hour. The laborers who had been repairing small flaws in the road, sat now in groups, munching chunks of bread, while their discarded tools lay beside them. The faded blue of their loose trousers made designs along the roadside. Some of them had tied red handkerchiefs around their necks. Each had a bottle of wine from which he drank.

The car passed them slowly for there were obstructions where the repairs were being made. Some of the road crew waved at the car, and shouted words that were unintelligible to the passengers.

After luncheon at a pleasant restaurant, the Grahams and Sandra became tourists. Bob was the leader. He insisted on citing passages from the guide book while they stood in front of a castle. He could not look and read at the same time, so he saw little of the monuments. Yet he seemed to be enjoying himself.

Loirine was only an hour away. They had been there before, but were once again struck by the painfully obvious fact that a lovely ruin had been renovated to the point of deformity.

Tea, drinks, refreshments of all kinds, were spread in the large salon. Dora, in pink chiffon, presided, while servants, oversupplied with silver buttons and pompous manners, moved about amid the tapestried furniture and the guests. The assemblage consisted largely of neighbors who had the air of settling in for a protracted visit.

Suddenly Jacques de la Roche detached himself from them. Sandra's first thought was *That's the reason he sent*

*me flowers. If I had known he was going to be here, perhaps I wouldn't have come.* But a moment later she realized it was pleasant to see him among so many strangers. Oddly, their meeting at the Café de la Paix, which had made her so angry, was now forgotten. She had seen him again at the Marquise's ball, where his behavior had been faultless. She had thanked him for the flowers and the book.

"Do you like poetry?"

"No, not very much, but I think French poetry is best. Monsieur de la Roche, please don't send me presents. Flowers are very expensive and poetry is too intense."

"Perhaps you ought to cultivate the taste," he said with an intimacy which disturbed her. Then he left to mingle with the other houseguests.

The neighbors withdrew reluctantly, abandoning hope of an invitation for dinner. The houseparty were alone briefly, before going to their rooms to dress.

Aside from her old friends, Sandra met the Balliols, he with a portfolio in the Cabinet, his wife so insignificant she cast no shadow.

Newcomers also were the Gordons, as *nouveau riche* as they were English. Mrs. Gordon, common and pretty, had obviously pulled them into society by her bootstraps.

During the evening, everyone had a great many pronouncements on irrelevant subjects. Archie's trivial conversation got away from him as usual. Later Jacques de la Roche singled out Beatrice to play backgammon.

The party was typical, Sandra thought. From where she sat at the bridge table she could not help seeing Jacques de la Roche and her friend. It was Bea's face that drew her eyes.

230

She shook the dice and went through the motions of moving her men with the profound indifference of one whose thoughts were far away. When Jacques paused to consider a play, Beatrice sat looking at the board, but judging from her expression, she was looking beyond what her eyes saw. *If she were in love*, Sandra fancied, *she would look like that.*

Sandra was the dummy at the moment. She watched Bea and De la Roche. Sandra knew that Jacques had the power of making women conscious of themselves, usually of their physical selves. But Bea showed only aloofness, neither rude nor obvious, unless one knew her very well.

De la Roche by some method, which Sandra could not figure, had, in singling out Mrs. Graham as his partner, established a tension between himself and Sandra. She could not escape it. He did not look in her direction. He seemed interested only in Bea as an opponent in backgammon.

When the party started to break up for the evening, Archie strolled with Sandra into the great hall of Loirine. Beatrice and Jacques joined them. Archie was saying, "You are talking now just like any woman."

"I am any woman. Except *that* kind."

"Don't tell me you have no ruses of your own?" he laughed.

"Of course I have."

"And what are they, Sandra?"

"The kind that other women don't see," Sandra said.

The next morning, Paul Thibot and Bob showed off their tennis against Sandra and Jacques de la Roche. Then more neighbors came for lunch. It was not until the guests formed into tight groups that Jacques' actions toward San-

dra began to change. He maneuvered her into a corner. "It's obviously a day for a walk in the country. I know it is *the* perfect day, and I feel it in my bones. Meet me in half an hour at the front door." Then he said, "I've been *so* good." And he was gone.

She had no intention of refusing him even though he did not stay for an answer. Upstairs, she hesitated. He was dangerous. She was annoyed by the flowers and books he had sent her. Yet she found herself realizing that she could handle Jacques. It was, after all, just a walk in the country. She decided to go.

As they started off, Jacques' face was composed. His real interest seemed to be in the quality of the day.

"The gardens are so quiet," she said. "Which way shall we go?"

He pointed to the path on the right.

Jacques said nothing for a few minutes. Then he said, "Have you forgiven me my offending remarks when I came to call?" Sandra did not answer.

"You won't accept other people's definitions, I think you want your own."

"I made no objection to yours," she said.

"You are more civilized than I am. I am less controlled than you," Jacques said.

"Are you always forward?" she said. She did not look at him. "Perhaps it's your Italian blood."

"You could be as desperate as I am, but you won't allow yourself to be."

"Are these thoughts always with you?"

With a gesture of his shoulders, he indicated Sandra was right. "I will stop at once." Then he plunged into contem-

232

porary Italian art, and the new ambitions of Italy. He appeared to have an understanding of Italian peasants, as well, speaking refreshingly of their modes of life and the old customs that they still observed in certain sections of the country. Then he smiled engagingly and said, "You spoke of my Italian blood but really I have the blood of a dilettante, which has no nationality. We always have time for leisure. I'm a business man but I have time to read poetry, go to art galleries, and time for love-making—the greatest of the arts. Most busy people are so banal in their pleasures."

"Are you trying to be clever?" Sandra asked.

"I would do anything to be clever. Except improve my mind."

She detected the upward curve of Jacques' mouth, as she look at him with amusement.

Then he said seriously, "You like to defer pleasure, don't you?"

"Do I?"

"Yes, despite what you say."

"You want to think you are complicated. Right?"

Sandra did not answer.

Then he said, "Your friend, Mrs. Graham, for example. *There* is a complicated character," Jacques said.

"What made you think of Beatrice?"

He went on thoughtfully, "All people are complicated, Sandra, and people who have no sex lives are the most complicated of all."

"Jacques, don't be an ass. How do you know?"

He smiled. "How do I know the bush to our right is a hawthorne and not a lilac?" After a slight hesitation Jacques continued. "If she had had any sex life at all, it would have

233

been so tremendous that it would show." He paused. "A really tragic case."

"Why must you always be categorizing people?" Sandra was angry.

"Why do you want life to be so simple?"

"I don't want life made more complicated than it is, that's all," she said.

When their tour of the park ended toward the close of the afternoon, he told her more about his work as an automobile agent. It appealed to him, because the hours were not fixed and he could arrange to be away often. Besides, he met important business people. He also made a good living. "It's the mixture of business and society that I love," he said.

As they entered the house, De la Roche whispered to Sandra. Anyone seeing them would have guessed that what he said was of an intimate character. But his words might have been shouted through the air: "Let us pray that Socialism will never prevail. What an awful world it would be without luxury and beauty."

Dinner was a more formal occasion that evening, a number of guests having driven from their *châteaux* to Loirine. The company was so large that at midnight Sandra and Beatrice escaped to Sandra's bedroom.

"You have seemed rather absent-minded, Bea. Are you having a good time?"

"Fairly. You went out with De la Roche. Was it amusing?"

"It was entertaining. Jacques is an amazing person. He can't possibly be a simple character, but sometimes he behaves like an irresponsible boy." She leaned back luxuriously on a sofa.

"I suppose that's a trick out of his bag of tricks." Beatrice blew the smoke out from her cigarette.

"Are you warning me?" Sandra said.

"Sometimes you need warnings in spite of your experience." Beatrice stroked her friend's hand affectionately. "But, speaking of warnings." She was suddenly very serious. "I have to warn you about something else, darling."

"You remember the pale woman I described to you the other day, whom I met at Feodor's? She ordered a lot of clothes. She's coming back to try them on. She told Estelle she didn't want an appointment for a few weeks, but you are sure to meet her, Sandra. She's Marston Overstreet's wife."

Sandra did not move. Her eyes were out of focus. She did not realize that Beatrice had put her arms around her. They sat motionless for what seemed a long time. Then, with a rather violent gesture, Sandra stood up.

"It can't be true. It *can't*. How can she be such an awful creature?" She trembled.

Beatrice took one arm which lay inert at her side and pulled Sandra back onto the sofa. "It is true."

Sandra interrupted. "How can she be Marston's wife? You must have given me a wrong description. I know you didn't mean to."

Sandra's pain made Beatrice realize her own inadequacy. *I did not guess what this would do to her.* It struck Beatrice like a blow that she had never loved as Sandra loved. She had failed to prepare for her reaction. *She is not thinking about herself. She is only conscious of what Marston's suffering has been and will be.* She was now aware of the fact that the woman who barred Marston's freedom was a ruth-

235

less antagonist. *Sandra is as nothing and her lover is her only concern.* This touched Beatrice deeply as a realization of her own limitations. It never had been a vital fact of her life before this moment.

They sat close together.

"Now I know why he needs me." She spoke softly.

Beatrice felt the unreal shadow of her own life in which colors and forms might never touch her in reality. But she saw them now in Sandra.

Quickly she kissed Sandra and left her alone.

# 16

It rained continuously for the last two weeks of August. Marston was a part of each hour, although they had spent only two short weekends together.

Last Monday morning she stood at the dining room window, looking out over the rain-drenched meadow. In a moment the car would arrive to take her alone to the railroad station. Marston had said the night before that he would remain behind all day at Fleuris to work. He wanted uninterrupted hours of concentration that were available only at the château.

He left his table and came to stand behind her. Then his arms encircled her.

Out of the window she was watching the violence of the wind. It was like a brutal animal tearing away at the bloom of summer. She felt the bitter pain of leaving him for her own work.

*If he asked me, I would stay.* But he simply said, "Here is the car, sweet heart. It's dreadful that you're going. I'll come to lunch tomorrow. It's better than last week."

Still she stood staring into the rain. The meadows stretched before her, burned in spots by the summer's ar-

dent heat, now wet and lifeless. The river beyond was high, swollen, and ugly. "I must go," she said.

"I'll take you to the station."

"No, no. I couldn't say goodbye with people looking at us."

When she was alone she thought she saw signs of clearing. She remembered how happy Sunday had been.

On Wednesday, in the half-light of the afternoon, she walked from Feodor's towards her apartment. She was used to the sunsets of Paris. The miracle of the city was never a casual thing. The world seemed to have regained its equilibrium. She remembered with a mixture of reluctance and interest that tonight she was going to dine with Jacques de la Roche. She described it with a word she disliked, *intriguing*. He continued sending her flowers and books of poems ever since the Thibots' houseparty. The flowers had been beautiful, but she did not read the poetry, though she noticed that lines were marked and there was writing in the margins in pencil. Her notes of thanks had been succinct. They were followed by invitations to dine with him. She had refused all of them. She kept most evenings free in case Marston might be free at the last moment. But there was no chance for tonight. The rest of the week also looked bleak. The weekend was doubtful. Marston planned to go to the seashore.

She stood on the curb letting traffic pass, her face flushing in the irritating wind. She was glad she had a definite engagement tonight. Jacques was to take her somewhere for dinner that would be fun, and afterwards to a friend's studio where there would be music. She had met him at

other parties several times since Loirine, and they had danced together.

The crossing of streets seemed to Sandra like traversing the whole world. She saw buoyant people who obviously believed in tomorrow. She felt no certainty of tomorrow. *It's foolish that that exasperates me,* she thought. *Marston chafes just as I do, not knowing where nor when we will next meet.*

She arrived home late. Now she must hurry, because Jacques was coming at eight. There were more flowers from him. And a book. She laid the latter aside. She would remind him again not to send any more books. The first was about flowers and moonlight. It had bored her.

When she was dressed, she pinned the corsage of little white orchids to her belt and admired it in the mirror. She was wearing a new dress that Feodor had made for the Thibot weekend. It was a draped affair of yellow crêpe, sleeveless, with low back. She slipped on a sheer short jacked of the same color. Her soft brown hair with gold glints lay in curls about her small head and her hazel eyes took on a grey quality in contrast to the yellow of the dress. She picked up her wrap and bag and went into the sitting room.

Jacques arrived and she let him kiss her hands. *How good-looking he is*, she thought, *A strange, complex man.*

She put a hand on his orchids. "You spoil me," she said. *"Merci, monsieur."*

On their way to dinner, Sandra asked, "Where are we going?"

"To a place where I can dance with you and no one can cut in."

"It sounds nice."

He caught her mood. "It's nice, but it's rather intimate."

"Am I going to be compromised?"

"I should like nothing better, but we're going to a discreet place."

The entrance to the restaurant was narrow and dimly lit. It had a furtive atmosphere, but not a shoddy one. The liveried servant who admitted them was both dignified and indifferent. If he knew De la Roche, he did not show it.

Jacques preceded Sandra through a narrow hall to a small staircase. At the top a waiter met them and led the way through a long passage lined on one side by many doors. Behind some were voices and laughter, others were silent.

At the end of the corridor he led them into a small dining room.

Sandra knew, before she reached the top of the stairs, that she was going into a *cabinet particulier.* She was not frightened, although she had not expected it. Obviously this was just what De la Roche would do. She had been far too occupied by her own affairs to anticipate it. She was positive, however, that Jacques would never make a fool of himself.

Inside the room she was struck by the sound of music. It came from below, for one glance showed that to the right was a large window, cut in the wall, overlooking a restaurant from which the strains of an orchestra wafted up. Curtains on either side were looped back with cords, and the room had dark brown draperies. Against the wall was a sofa. In front of it a table was sparkling, set for two. There was a large mirror above it.

From behind the curtains, she peeped over a railing. The dining room was crowded with men and women sitting at tables, which lined the sides, or dancing in the center.

Most of the draperies, which acted as barriers to the other rooms on the balcony, were closed. The few that were drawn back showed lights beyond and she assumed that these were occupied. But the open curtains did not reveal the occupants.

There was a lugubriousness in the room. Was it in spite of, or because of the lights, the music and the nearness of people? It was secretive and suggestive. The most intimate relationship could have taken place with the most complete discretion.

She held her cloak more tightly about her.

"What a devilish idea," she said calmly, as he took her wrap.

"Devilish?" He looked surprised. "One can dine and dance privately and also be a part of the life below," he said. "No one can see us unless we stand at the rail."

"Let's dance," Jacques said.

A knock at the door, then De la Roche said, "*Entrez,*" and the maître d'hôtel appeared. They stopped dancing.

"I have already ordered. Bring the cocktails." He turned to Sandra as the door closed. "Do you like it?"

"It's unusual," she said.

He searched her face, assessing her mood.

"The orchestra is excellent," she said, "And all those doors that we passed? Is everyone doing the same thing we are?"

"More or less," he said.

241

She ignored him.

He bowed, "Shall we dance?"

"Is this a very popular place?" she asked. "I mean, might I meet friends going in and coming out?"

"Possibly, but it's the least compromising of its kind. Do you mind, Sandra?"

"I don't think so." She was sure that he would be more circumspect here than in a garden at the Marquise's.

They danced in silence until another knock sounded on the door, and cocktails were brought in. Jacques' conversation became light and amusing.

As dinner progressed she felt disarmed. The food was excellent, the dance floor inviting, and the musical program, alternating between arias from operas and dance music, was pleasantly varied.

De la Roche avoided being too personal. He was as ingenuous as he had been on their walk at the Thibots', not as insinuating as he had been at her house. *Of course*, she thought, *he knows all the approaches, and probably when not to approach too near.* Her first revulsion of the room almost vanished. Obviously he had no sinister motives. It was not of him she had been afraid. She knew he was too much of an artist to allow an absurd situation to arise. Yet it was like playing with fire.

He switched suddenly from an absurd anecdote he was telling about the Thibots to ask, "How is Marston Overstreet getting along with the Merrimée case?"

"I don't know. Lawyers don't talk much about their cases."

"I hear Louis likes him. I don't. I'm jealous of him." His eyes darkened as he spoke.

242

She laid down her fork to look up. "Why are men so jealous of him?"

"In the first place we envy his brains, his courage, and we can't help acknowledging the power he has over women. I guess that's why."

"I imagine Merrimée must be attractive to women," she said.

De la Roche permitted himself to be led. "He is. Very. He always has lots of girls running after him. Now that you suggest it, he and Overstreet probably have much the same methods with women."

"All men have methods. Who is spontaneous?"

He looked crestfallen.

She continued, "You have the knack of fitting into a situation, as if you were made for the part."

"What makes you say that? Did you know I wanted to be an actor once?" he said.

She could not resist laughing. "A kid is what you really are," she remarked. "With a terrific desire to be a—wolf!"

He was obviously amused. "You give me the sense of having had all my protective coloring stripped off."

"At least you admit you have it," Sandra said.

She looked at him as she drew back her arm, and said, "We are going to hear some music tonight at your friend's? Tell me, singing, piano, or what?"

He studied her intently before answering.

"You are changing the subject," he said. Later he smiled as if to say, *Have it your own way.*

"We have exhausted the subject, don't you think?"

He nodded his head. "Come, let's dance."

It was as though having made a point, he now complete-

ly abandoned it, and when they sat down again he spoke as he had at Loirine of his mother and her Italy. Then he said suddenly, "These days no one expects to pay a penalty for ruthlessness."

She was at a loss to catch the connection. "Do you mean neither countries nor people?"

He threw back his head and laughed. "The modern woman doesn't even expect us to foot the bills."

A waiter knocked, bringing in the next course.

For a moment De la Roche watched Sandra as though in doubt, but when they were alone again, he said, "You think that because a girl goes to bed with a man, she is giving way to her feelings? On the contrary, what she is really seeking is experience."

"You don't know that experience without emotion means nothing." She felt a little tired.

This elaborate place for romance and intrigue, was becoming a parody. For lovers who could have no Fleuris, it might suffice as a corner of paradise, or a place for indiscriminate flirtations, but not for Sandra.

It was only a dance floor. She felt a restlessness to move on, where there would be people and other music. Dinner was not yet over. With an effort she turned to Jacques. He looked thoughtful.

"You said you had once wanted to be an actor?"

"I did, but I soon gave up that delusion. But I went to a rehearsal this afternoon."

"Was it good?" She sought a truce.

"It's either going to be a great flop or a great success."

"What is it called?"

"No one can decide on the name. They just can't think of anything that means nothing at all. To me every suggestion they made meant nothing."

"What's it about?"

"That would be hard to say," he said perplexed, as he handed Sandra the desert. "It's ultramodern, you see. Everyone suffers from internal pains. They might, as far as you can see, all be happy and contented, but then there wouldn't be any play. It's so elusive that you are sure you are missing something, unless you find a double meaning in each sentence. Of course, there isn't, but no one will admit it for fear of being thought stupid."

"That's rather cleverly put," she said.

He was very frank. "It's not my way of putting it. I went with a critic. It's what he said."

He turned to her with an impulsive movement as if he had something to say and must say it at once.

Quickly she went on. "You don't seem conceited. Are you?"

"Are you going to fence with me all evening?" He seemed angry. "I shall be getting conceited, dear Sandra."

"You decided what my true type was that evening at my house. No matter what I say, you won't believe me."

"You have no inhibitions when you dance," he said.

"The only trouble is I do have them *most* of the time."

"At least we can dance now." He rose to his feet.

The orchestra could be heard tuning its instruments, then came the intoxicating notes of a tango.

There was no beginning to their movement; they drifted into voluptuous rhythm, two bodies as one.

Jacques looked into Sandra's face now and then, their eyes were almost level. The rest of the time he followed their figures in the mirror. She was far away, unconscious of him, unconscious of anyone, impersonal, lost only in the rapture of the movement.

After a time, she became conscious of herself. She saw their coupled figures in the mirror. When she faced it, Jacques' back appeared, the muscular shoulders and arms in his evening jacket; the tapering of his waist accentuated by his tailor, the slimness of his hips. They were exaggerated in the reflection. Now as they turned, his profile appeared—the head, smooth black hair, straight brow, rather large nose, clear-cut mouth and chin, and an intense look.

When the last bar ended they stood without moving. He made a motion as if to draw her closer, but a distant look in her eyes stopped him. A slight tremor passed over her, then she relaxed as if tired, went and stood in front of the glass and absent-mindedly stroked her hair.

They sat down again in a moment, but they did not look at each other. He filled her glass and handed it to her. "How lovely you are," he said. "One of your greatest charms is that you are innocent of it."

"Where are we going?" she asked suddenly. "Is it far?"

He leaned towards her, his eyes dreamy. "Shall we go, now?" he asked.

"Where is it?"

"Ramon's studio; it's in rather an out-of-the-way part of Paris," he said vaguely.

She wanted to say that she was tired and preferred going home.

"There's not hurry. Let's stay and dance some more," he said.

He was thinking that some women were like high-spirited horses and needed light hands. But with all his control, he could not prevent his eyes from following the lines of her figure nor from resting on the curves of her breasts. She became self-conscious and moved away from him.

"You wore this dress at the Thibots'. It's very becoming." He touched the skirt of her dress. "Your gown at the Marquise's *affaire* was perfection."

During the next half hour they hardly spoke. They danced or listened to the music. Once De la Roche attempted to take her hand. He muttered something in French which sounded like poetry. She withdrew herself from him.

Later he asked, and she thought quite irrelevantly, "Did you like the poems I sent you?"

She was embarrassed and said, "Oh, yes, very much. The French language lends itself to poetry."

They were sitting beside each other on the sofa. Suddenly she was conscious of a tenseness in him. There was something ominous in the change. She sensed aggression she could not measure.

"I think we had better go. Your artist friend must be expecting us by now." She tried to speak calmly.

Without a word he rang the bell.

She hoped the drive would not be long, but an out-of-the-way part of Paris did not sound encouraging.

When De la Roche followed her into the taxi, Sandra spoke immediately of the first thing that came into her

head, "I told you I was designing for Feodor's didn't I?"

"Do give up being a *vendeuse!*" He turned to look at her. "It will give us more time to be together."

"You can't bear to think of a working woman, can you?" She said: "You work yourself."

"Yes, but I *have* to."

"You are old-fashioned at bottom, but you admit it," Sandra said.

He sat immobile in his corner of the car, still gazing at her while she watched the lights from electric advertisements throw street scenes into relief. A strolling crowd moved from light into shadow.

She talked rapidly now, recounting the funny everyday incidents which took place at Feodor's. He listened, but did not speak.

They had left the gay lights behind and were threading their way through a part of Paris Sandra did not know. The driver was looking out on either side of the car for the number.

De la Roche directed him. Slowly they drew up in front of the stately old façade of an eighteenth-century grey stone house. It stood almost intact amid a long shabby growth of newer buildings, on either side of the street.

Sandra peered out through the window of the taxi in surprise. The house, she saw, was set back from the sidewalk and in the intervening area a number of antique statues faced the sidewalk. An imposing doorway, with coupled pilasters on either side, had been filled in temporarily with wooden panels, in which a smaller door served now as an entrance. The blinds of the large windows were drawn.

As they left the taxi, Sandra said, "How amusing. Among all this rubbish. To whom did it once belong?

"The Montmarts."

Jacques led the way to the entrance where a sleepy *concierge* stuck her slatternly head out of a cubbyhole in the door.

*"Bonsoir, Monsieur,"* her voice was less rude than Sandra expected. There was a click of the latch and the door opened. *"La porte est ouverte en haut, Monsieur."* She added something which Sandra could not hear.

Inside the apartment was none too clean nor attractive. *Shoddy,* was Sandra's impression. The ancient hall had been divided into rooms, but a passageway had been left open leading to the staircase. A sputtering gas jet lit the formal wide steps and cast feeble reflections on the handsome iron balustrade.

"Sorry, there's no lift."

"You must tell me the history of this house."

They walked up while Jacques explained why this old mansion still existed.

"It's on the *premier,*" he said.

Another burner flickered more brightly in the hall of the *premier étage*, showing two high doors. The one at the back stood slightly ajar. A light beyond indicated signs of life, but there were no sounds. Jacques led the way into a small entry hall. Over his shoulder he laughed as he said, "We are early. No one is here yet." Another door confronted them. He opened it and Sandra stepped into what she could just distinguish as a pale-colored studio.

"Trust Ramon not to waste gas." It was Jacques' voice be-

hind her. It did not sound quite like his voice. Evidently he knew his way around, for in a moment he found matches and almost disappeared into the left-hand corner of space. He lit a lamp, a ray of yellow light fell on a grand piano. It was just what she would have expected, but somehow it came as a surprise. A faded piece of red velvet partially covered the piano. But it was the vase of white flowers standing there which in their whiteness gave her a shock. Hurriedly, obviously, they had been placed to bedeck where no bedecking was needing.

De la Roche moved to the fireplace where no fire burned. It was in the center of the right wall, at the other end of the room from the piano. Over it a deep shelf traversed the length. He lit a lamp on the shelf and there appeared a medley of objects. She was attracted by the variety: vases, books, a statue of a nude woman showed pallid beside an African idol, a picture propped against the wall, and a Tanagra figure revealed themselves shabbily. They were all slightly covered with dust and looked neglected. As her eyes became accustomed to the light, she distinguished in front of the fireplace a deep, low-backed upholstered sofa. It was covered with incongruous black satin and bright-colored cushions, and in front of it stood a table, untidily crowded with packages of cigarettes, ash trays, matches and knicknacks.

De la Roche now lit another lamp on the opposite side of the room. He seemed too busy to speak, and she remained silent, looking around. The lamp burned brightly on its brass tripod. All the other lights were dim. This one cast reflections on a big table in the center of the room. She went

250

over to this table. In contrast to everything else she had seen in the room, it was strictly in order. In the center were candelabra of *bronze doré*, and on either side two deep-blue Persian pottery jars. Their blue made her realize that the walls of the room were pale blue, tinged with green. Between the jars and candelabra stood two terra cotta busts. Sandra now observed that some modern pictures hung on the pale blue walls, without any special regard to symmetry, but they were not haphazard. A few ugly and shabby sofas, chairs and tables completed the furnishings of the room. She felt an abrupt sense of distrust of the owner of this ill-matched studio.

She moved towards the sofa. "I judge here is where he lives," she said, and going back to the big table, "Here is where he is formal." She examined the vases appreciatively. Her apprehension was somewhat lessened.

De la Roche was about to light the last lamp, then abruptly left it unlit and strode over to the fireplace. He put a match to the kindling.

Sandra went to join him, suddenly aware of something amiss. "What's the matter with this Ramon anyway, and what about his guests?" she asked. She searched Jacques' face.

An uncomfortable feeling stirred within her. She had sized up the room and its appointments. Her eyes fastened on a side table with bottles, glasses, and several covered dishes. At least there was some preparation for a party.

"Ramon is very casual," said De la Roche. He seemed amused as he said it, as though he were playing a game.

"He hasn't forgotten people are coming." She pointed

251

at the table of refreshments. "He obviously is a pianist," she said.

"Yes, didn't I tell you?"

Sandra was gazing at the piano where, in the added light of the room, even the white flowers looked flamboyant. "Funny, putting that heavy weight on the piano. You or I might do it, but a musician wouldn't." Her own words startled her. Was Ramon a musician? And, if not, what was he? Perhaps it was a borrowed studio, and he did not want anyone to know.

Jacques' voice broke into her thoughts. "Let's sit down and have a drink. These artists are so vague," he said.

Sandra was interested in what Ramon was like.

"What a funny combination he must be. Look at the junk with no significance except as an indication of his character, and then those exquisite Persian vases." She turned, wondering, to Jacques. "What kind of person is he?"

De la Roche had gone to the buffet and come back with two glasses. "Just that," he said with an indifferent smile. "Junk and beauty."

Something in his voice arrested Sandra. "Do you like him?" she asked.

There was a slightly cynical twist to his lips. "I love him some times, hate him at others. You'll see for yourself. Do you mind him being late? He's vague, but I'm sure he'll put in an appearance." There was a strained quality in Jacques' voice.

They sat down on the sofa and he set their drinks on the crowded, dusty table.

"Just for fun of it," she said, "let me be Philo Vance, the

252

modern Sherlock Holmes."

Without warning, Jacques changed completely. "Stop playing," he said suddenly furious. She leaned away from him, terrified.

"I've stood it long enough. I have been a good sport," he shouted. "You know damn well no one is coming here tonight."

Somehow she struggled to her feet, perhaps because he had not expected it. Then he was beside her, holding her with both arms. The anger in her face stopped him, even in his frenzy.

"What do you mean?" she demanded. "I don't understand." With both hands pressed against him and with all her strength, she pushed him away.

She held her arms rigidly stiff in front of her, while he stared at the horror in her face.

Then furiously he said, "You don't understand? What do you mean 'you don't understand'? I let you play your game all evening. You knew what would happen when you came here. You must have known. You read my poetry." He stepped nearer.

She stood looking dazed while he went on, his voice loud and angry.

"You let me see you so seldom. I had to woo you that way. You said you liked the poems I sent you. You came here with me tonight. You—"

"Jacques—" He did not hear though his face almost touched hers. She called louder, "Jacques! Listen. You must listen."

He was now beside himself. He seized her brutally, held

253

her while he spoke. "You want to play your own little game until the end." He laughed excitedly. "Even now. But it's lasted long enough. I've had enough of control."

It was impossible to get away from his iron grip. "I never read your poems. Do you hear? I don't know anything about them. I—" She kept repeating the words, when she could push her lips far enough from his mouth to utter them. He began tearing her dress.

After his first fury, and the kisses which he pressed on her lips, on her eyes, on her back and shoulders, and which she could not escape, he began to hear what she said. He still clasped her against him. "You never—read—the poems?" he asked, making an effort to control himself.

She seized the moment. "No, Jacques."

But he crushed her to him again. "What does that matter? What does anything matter? You do love me. I feel it when we dance. I will make you a lover such as you have never had. I—"

Amid her struggles it all flashed through her. He was Ramon. He thought she had come here voluntarily. If only she could make him understand. "I am not in love with you," she gasped, wildly trying to fight him off, "I never could be," and as his hold strengthened, "Jacques, don't. You mustn't." She felt strength failing. "You must listsen!" she gasped. He was pushing her closer to the sofa. "…you must listen! I belong to someone I love. You mean nothing to me—nothing!"

A quick vehement knocking was heard at the door. She fought him. The knocking was insistent. Suddenly he seemed to hear it, and suddenly he released her. She almost

fell to the floor, but recovered and steadied herself against the back of a chair. Her breath came in uneven throbs.

He must have locked the door, for in a moment she heard the key turn. He went out into the antechamber, half-closing the door. Voices came through to her. The voice of a woman, French words in loud, excited tones. Automatically she smoothed her hair, righted her torn dress. Then she heard an exclamation of surprised anger from Jacques de la Roche. He backed up against the door, opening it wide, and Sandra saw into the little hall.

Marston had pushed aside the *concierge* who cringed, still voluble, in a corner. He stood confronting Jacques. She caught his eyes over Jacques' shoulder. With a forward movement, he swept De la Roche to one side and strode into the studio.

Sandra stumbled to meet him. She held out one trembling hand. He took it and turned back to face De la Roche.

Jacques had followed him, and stood near the door, looking from one to the other. Some of his usual *sang-froid* had returned, but his hair was disarranged, his tie askew. "Why didn't you tell me, Sandra?" he asked. His voice was harsh and impersonal.

Suddenly aware of her disheveled aspect, she dropped the hand she had been holding and struggled to keep back her tears.

Marston, his fists doubled, grew paler. He took a menacing step toward Jacques.

Sandra saw his tensed shoulders and knew that he would spring. Jacques was gathered together for defense. With the speed of desperation, she caught both Marston's arms from

255

behind. "Get out, Jacques. Quick! Marston, please," she shouted. "I've been a fool. Wait!"

In the second that Marston hesitated, Jacques backed into the anteroom. The expression of his face did not change. He kept his eyes fixed on Marston's. There was no fear in them. Only vigilance.

She took an instant advantage of her maneuver. "Marston, let me tell you. I must. It wasn't all his fault."

The hard arms she held relaxed and Marston turned on her a look of compassion. But she only saw that Jacques had gone. Suddenly the whole scene dimmed as if behind a misty glass.

She hardly knew how her wrap came to be around her shoulders. She huddled into it, her teeth chattering. She felt Marston's quiver as they started half-blindly down the stairs. They walked down in silence. A sputtering gas jet wavered and almost went out in the lower hall. Then the heavy door closed behind them and the noisy bolts brought her to life.

She now felt Marston's rigid body beside her, felt it with the intensity of her awakened senses.

A taxi waited at the curb. The door, held open by the driver, gave her some reassurance. Inside was a place in which to hide. She sank into the shiny leather seat.

Marston thought she had reached the end of her endurance. He saw her shiver, even though the air in the car was hot and stuffy with stagnant cigarette smoke. He realized that she could not talk to him now. "Sandra, not a word till we get home." His voice sounded to him expressionless. He knew that she was waiting for him to guide her.

A street lamp fell for an instant on her face. The look he saw there was one he had never seen before: it was a very

256

young look, almost a bewilderment, and aroused sorrow and pity. To turn and stare out into the streets where he saw nothing was his only refuge. He must not speak, and he could no longer see her. He was imprisoned by the necessity to think. A chaos of ideas fought within him, while his heart felt contracted, painfully bound, tremulous. What stood out distinctly above this turmoil in him was the image of Sandra, exposed to the desires and importunities of men. His own place in her life was one which gave her no protection. He must stand aside, or himself bring on her the destructive gossip of their world. Already his headlong conduct might have been enough to start whispers. De la Roche was not the sort to hide his conquests, and to have got Mrs. Fane alone in his rooms at such an hour might be his boast tomorrow. To couple Marston's name with the scene would begin an inevitable train of scandal.

The only way in which she could be shielded was a road he had determined never to take. Marston drew a deep breath, for suddenly he imagined a vision of Eileen. She lay stretched before him in his mind's eyes, as he so often had seen her in times of stress, propped up by satin pillows, languid. The rings under her eyes were so black they might have been painted on the smoothness of her white face, and he thought of his own role in the origin of her constant illness. Could the passage of years of sacrifice and devotion wipe away his obligation? She had needed his protection; another kind of protection than Sandra unconsciously called for; but a responsibililty that was his forever. Duty was a sin against nature, but Eileen had once been strong and he had made her weak.

A sudden madness arose from Marston's depths.

Hungrily he looked at Sandra. The heaviest burdens of his married life, which had seemed to him inert, had, at the edge of a precipice, dropped out of sight in its depths. It was Sandra who really needed him. Eileen was safe on her peak of isolation. He had served his time. It was Sandra who was essential, and she to him. When the taxi stopped and he helped her out, he remembered how long it had taken him to get to De la Roche's earlier that night, and how they must have flown back to be here so soon.

She left him in the grey hall, before even turning on the light. A gleam came in through the door into the corridor, sufficient for her to find the way to her bedroom.

For the first time since they had left the studio, Sandra spoke, "Will you light up? I will be there in a minute."

Inside her room, alone, she stood pressing her hands to her heart. Her lover had not trusted her. He had followed her. Quickly she turned on the electric button, flooding the room with light. She saw her anguish in the mirror. Her cloak dropped unnoticed to the floor. She threw herself on a chair, her hands over her face. She wanted to run to him even though he might accuse her, and yet she wanted to hide from him. With an effort she dragged herself up, looked again in the mirror where she seemed to wear the imprint of Jacques' kisses. Her dress was torn, her hair mussed. She repaired the damage with awkward fingers, feeling naked and defenseless. If only they need not talk, just sit in the same room, and far from each other's bodies. She felt herself contaminated by lustful hands and shrank from the thought of all physical contacts. She did not want to be touched; but it might be that Marston did not want to

touch her, that he might never want to touch her again.

She could not sit there forever, but how was she to get into the other room? And when she was there, the brightness would glare in her eyes and she might perhaps see the look she feared to see.

She must hurry. What was he thinking, there alone? She forced herself to walk into the salon.

Marston stood in the center of the room. In his whole bearing there was a cast of strength and sureness. Sandra closed the door, though there was no one likely to come home at that hour.

He spoke in a moment. "I want to tell you why I followed you, my dear one. It started by chance..."

Sandra interrupted. "I think my story should come first."

He accepted in silence. He did not move. Sandra went from the door to the back of the sofa where she turned to face him. She supported her arms against the sofa back, as she spoke.

At first Marston's face showed no reactions. He looked at her steadily without expression. There were no personal remarks or embellishments in Sandra's recital. It might have been an account by a disinterested observer trying to tell a story of someone else's doings. Sandra sounded as though she were half dazed. Her eyes were on his. Then she looked over his head.

He asked her no questions and it was not until she reached the incident when De la Roche seized her that he moved. His arms grew taut then, and his eyes burned with fire, but she could not tell what it was, only it was not the look she dreaded. Her lips twisted when she told him about

the poetry. He listened with surprise, but there was no suggestion of incredulity. "You never read the poems?"

"No, when he asked me if I liked the poetry he sent me, I was embarrassed and said, 'Yes'."

"So when you went with him to the studio, he thought that you were prepared to give yourself to him?"

She said evenly, "Yes. I see that now. He had every reason to think so."

"And thinking that, how did he behave himself all the evening?"

"He thought I was playing a part. He likes acting and was willing to play, presuming always that in the end..." With an effort she said, "He was going to be rewarded."

Marston took a step nearer to Sandra. "And suppose I had not come just when I did? What would have happened?"

He made a gesture as if to put his arms around her, but instead took one hand and led her round the sofa, gently pushing her down on the cushions. "Sit down, Sandra," he said, and sat down beside her.

She had told him her story. She buried her face in the pillows until Marston's voice stirred her into attention.

"I found myself unexpectedly free for the evening," he said.

Her head was erect again, her eyes followed his lips. Her strength began to come back. He leaned into his corner of the sofa, his voice gentle. "I didn't stop to telephone you, but hurried here. Halfway down the block I saw you getting into the taxi with De la Roche. I wanted at least a word with you, hoping that I could see you later. I yelled to my driver to follow. He almost lost you twice, but finally

landed me right behind your car at the side entrance of—"
She thought he met her eyes unwillingly as he paused. "I
was about to rush out and stop you when I realized where
you were. Then I pushed myself back into the farthest cor-
ner." He stopped. "Taxi drivers are used to such situations,
and after giving me what I presume was a sympathetic
glance, he sat there in the front seat watching the meter
tick. I couldn't think just what to do. After a while, I told
him to go around to the public entrance."

It was dawning on Sandra that Marston had never sus-
pected her. She was too deeply moved to speak. A wave of
comprehension broke over her. One hand crept out to
touch his. He held it for a moment in silence. She drew it
back gently and he took a cigarette out of his case and lit it
quickly, absently putting it in Sandra's mouth. He then lit
another for himself.

"I have never entirely trusted De la Roche," he said
quickly. "I couldn't go off and leave you there. That was
the only thought I had when I went in. I realized he could
do you no harm in the place."

He stopped. "That is, unless you wanted him to. And I
knew you didn't." He was looking straight ahead of him,
absorbed in his story. "I was jealous in a way. I was jealous
because he was spending the kind of evening with you that
I would have loved to spend, and I felt cheated. There was
a party of people at a nearby table whom I knew, and after
I had dined, I sat with them. I danced, too. I knew the lights
would be turned on when you left your dining room and
when they were, I went out and took a taxi to your apart-
ment. For some reason it had not come into my mind that

261

you might be going elsewhere. I still had a chance of seeing you." He leaned over to the table and crushed out his cigarette in an ash tray with an angry gesture; then turned to look at her. "I was told you had not come in. That was when I first was really frightened. I ran and overtook the taxi that had brought me. I told the chauffeur to go back to the side entrance." Sandra edged closer.

"I am known by the doorman. He knows De la Roche and I are acquaintances. I asked him when Jacques had left. I was going to the same party, I said, and had lost the address. I made it worth his while to believe me. The rest you know."

"I made you suffer," Sandra said.

He interrupted, "If you mean from jealousy—there were only just a few minutes of that when the old hag *concierge* wouldn't let me in. I threatened her and bribed her. I was frightened then, and more angry than I've ever been. Besides, I knew as I went up those stairs that I was compromising you by giving you my protection. Even my rage didn't make me forget that. I was putting your reputation into the hands of a scoundrel."

"Oh, darling, what a fool I was."

"You don't understand men," he said. "In one way I am glad you don't, sweet heart. There is a beast in us that has the power to seize us in its grip. Sometimes it makes us ruthless."

She cried out, "You never could be like that!"

He scoffed at himself. "Oh, but I could. And I have. Not with you, because I love you."

"No, no, Marston, you really couldn't." She saw him get

up abruptly from beside her, saw a look come over his face which said: *I am no better than other men.* Then he said sternly, "No man can say what he will do if he physically desires a woman."

Seeing the little table with drinks set out, she nodded towards it. He came near and passed his hand over her hair. "Now, beloved, there is only *you*," he said.

She saw him move, it seemed to her in inexplicable triumph. Then he seemed to vanish until she felt the touch of his hand again against hers. He gave her a glass and she drank from it. There was something she wanted to say.

"Jacques won't say anything, it doesn't do him credit." With an effort she went on. "He did vanish very neatly It was wise of him not to get his handsome face smashed for nothing."

Marston was silent. He saw she was confused. The evening seemed to have begun long ago in the dim past.

Sandra softly said, "Get some rest, these next two days are full of Merrimée."

"I only rest with you. But you are very right," he said. "Jacques won't tell. Even in his best version of the story, it will be hard for him to explain leaving the room gracefully."

"That horrible place."

"Darling, go to bed and to sleep. Those are my orders."

At the door he took her hand and pressed it against his lips. "Goodnight, sweet heart." In his secret thoughts he envisioned days without partings.

# 17

When Sandra awoke the next morning, the memory of the preceding night returned, not with a brutal shock, but rather with a sense of a final bond with Marston.

Yet her emotions were still in turmoil when she arrived at Maison Feodor. A remark of Estelle's served to arouse a sequence of thoughts in her mind, which pursued her all morning. "We need more material dyed for *Midnight Blue*, Nada, so please don't promise the dress for a rush order."

It was the dress Eileen Overstreet had ordered. For over two weeks she had dreaded the possibility of Eileen's appearance in the salon. A close watch over the engagement book had given her a feeling of security. And she knew Eileen was at the seashore. But Sandra feared that she might come back unexpectedly.

Not until Beatrice arrived at lunch time and whisked her off into the street, could Sandra rid herself of her anxiety.

"You are worried about something, Sandra. I got a glimpse of you before you knew I was here."

"I had the most ghastly feeling all morning: a premonition that Eileen Overstreet was going to appear at any moment," Sandra said.

264

"What will you do then? I happen to know she plans to be in town tomorrow."

"If I only knew *when* she's coming. But I'll worry about that later. Where shall we lunch?"

"I don't care," said Bea. "Unless you are famished, why don't we go to Sherry's and have a really feminine lunch of salad and an ice cream soda. Afterwards, we might go and look at some shops."

"All right. I have no ambition today, I'm in your hands."

On the way to Sherry's, Bea kept chattering. They sat down at a table, and ordered The Feminine Lunch.

Beatrice was thinking about that pale and exotic woman who at any moment could come face to face with Sandra. With such a woman one could never be sure. Bea knew Sandra's work was essential to her happiness. It meant, too, progression in Sandra's career. She was apprehensive that Eileen Overstreet might have the power to see that Sandra's job was placed in jeopardy.

Looking back, her own actions during the last three weeks surprised her. Since the afternoon when Eileen appeared at Feodor's, she had met her twice.

On the Tuesday after her return from the Thibots', she had been coming out of the Ritz late in the afternoon when she found herself on the Rue de Rivoli standing next to Marston's wife and Miss Patterson. Their driver had made the mistake of stranding the two women. Suddenly, she was seated a few minutes later in her own car with Eileen Overstreet beside her, and the companion stiffly upright in the jump seat in front of her.

In trying to recall what had taken place during the drive

265

which ensued, Bea recalled the substance of their talk as light and dull. Vexations had provided Eileen with a bundle of recent grievances, from which she had moved to a ponderous monologue of her summer existence. Then she spoke of the Riviera and Judge Boissonier. Finally, she discussed the inadequacy of Paris in summer.

Beatrice realized that she had encouraged Eileen to prattle. Mrs. Overstreet had suggested a drive before going home. Eileen, she discovered, had a way of expecting you to indulge her whims, or else she could be very rude.

On the drive, Bea tried to bring Pat into the conversation without threatening Eileen. She had felt Pat's silences were less a sign of boredom or humility, than antagonism toward her employer.

When Eileen told the driver to go to the Bois, Pat's awkward figure had turned and she had given Bea a deeply communicative look: *Now it's your turn; how do you like it?* And Beatrice said aloud, "The very nicest time of day for a drive in the Bois, don't you agree Miss Patterson? Do you like motoring?"

"It depends. It's a lovely day," she had said.

Bea's thoughts had instantly been, *Poor thing, how she must dislike her duty to have dared make that remark.* Bea then suggest that Eileen and she have lunch the day after tomorrow, providing circumstances permitted. To her surprise, Marston's wife had almost jumped at the idea. A rendezvous was immediately made for one o'clock

*I have left myself a keyhole to run away through,* Sandra said to herself. "You understand I'll certainly be there unless something unavoidable comes up. Eileen Overstreet knew

I'd go. She didn't have to say "Come if you can."

In thinking of it here at Sherry's with Sandra beside her, she knew that in making the engagement she had wanted to meet Eileen again, without Pat.

They finished their luncheon, but so intent had each been in her own preoccupation that they had not noticed the long silence.

"Where are you going to take me?" Sandra asked, rousing herself.

"Wait and you'll see," Bea said. She hoped Sandra wouldn't suggest leaving quite yet, for she wanted to debate how much she would tell her.

While Sandra contrived to make the luncheon her treat, Beatrice sat reflecting how intense her curiosity was to see Eileen again. But now the memory of that hour spent together, alone, resolved itself into a clearer picture of Marston's wife. A picture based more on intuition than fact.

At Eileen's suggestion they had walked in the shady *allies* near the lake, or stood about among the trees, partly out of reach of the glaring sunlight. Eileen, in a flimsy white dress, less white than her own face, gave the impression of a restless wraith. She had revealed many details about her superior children, the handicap of bad health, and of Marston. When she paused, with the air of having completely unburdened herself, neither a colorful nor a genuine confidence was revealed.

"Come out of your eclipse, dear," Sandra touched her lightly on the arm.

They walked back to the Crillon to pick up Beatrice's car. They took the Rue de Rivoli, following the Seine until they

reached the bridge leading to the Ile de la Cité. The poplar trees which edged its banks already showed the results of a dry summer. Their sparse leaves lent a slightly melancholy aspect to the Rive. Behind them, on the higher ground, rose a colony of fairly new houses. They had been wedged into existence rather than usurping the prerogatives of other neighbors.

"It's the Hôtel de Biron," Bea told Sandra. "We'll just skim through it to decorate our eyes."

"I don't know if the Baroque can do that," Sandra laughed.

"A few curlicues may stay in the corners, but that doesn't matter."

"It's fun doing anything with you, Bea. You're a *chaise longue* and an electric spark rolled into one."

As they went into the overwhelming interior, Sandra looked about with a sigh. "How did they ever manage to live up to it?"

"It's been left complete. Furniture, furbelows, everything," Bea said.

"And ghosts," Sandra said looking over her shoulder.

A few old guards moved slowly about the rooms. Sandra and Bea were the only visitors.

"The exuberance suggests tortured minds," Sandra said.

"I like it—sometimes," said Bea. "It seems so unreal."

In one of the upstairs rooms a window had been opened.

"How dangerous," commented Sandra, going to it. "The air might make all this vanish into dust."

Beatrice followed. "The Birons were partial to paint, weren't they?"

"I bet the sun never got in far enough to fade it. My, but it's nice to know there is an outside world with things happening in it."

"Yes," said Bea, 'the Hôtel de Ville. Look over there, what a contrast. And the Tour St. Jacques. Solid. They bring you down to earth."

"One can never escape Montmartre," Sandra said, turning to look at the dim outlines of the Romanesque church, fading like a Monet into the soft sky. "Not that I want to. It's fun, this rather decadent taste, right in the midst of the new, and the green of shoddy trees."

They stood silent at the window for a while.

Bea's usually level blue eyes looked out in perplexity. "It's nothing of any importance."

"What isn't of any importance, dear? You haven't said a word." Sandra touched Bea's arm lightly.

"It's about Eileen."

Sandra's expression changed.

"It has nothing to do with you and Marston," she said hastily.

"What about her. Have you seen her again?" she asked.

Bea nodded. She turned her back to the window and Sandra moved a step into the room to face her. "A week after I saw her at Feodor's, I was coming out of the Ritz and met her. Her car wasn't there, and I offered her a lift. You know the impression she had made on me. It was the last thing I wanted to do."

"You must have disliked it!"

"But it turned out it did not matter," Bea said.

Behind Beatrice, Sandra watched the early afternoon

269

light beating down on the city, it made the Seine a shimmering radiance that shone among the buildings and under the bridges like a golden snake.

"It mattered all right. It mattered a great deal— because to keep from being rude, I had to take her for a drive. She seemed to want to talk. Her companion, Pat, who turns out to be a Miss Patterson, came with us. I met her again the other day. I have asked her to lunch with me tomorrow."

Sandra appeared to be fascinated rather than surprised. "Really?"

"Not if you have any objections."

"I have none dear. Why should I?"

"I don't know. That's why I asked."

"I am really surprised. I admit it."

"I want to go, Sandra." she spoke hastily, leaned her hands on the window sill and stared straight down into the river below.

"I hope you've found out that she's not as awful as she seemed the first time." Sandra spoke very slowly. Then a sudden panic seized her, perhaps because of Bea's silence. "You're positive she's not trying to find out about Marston and me?"

"I don't think she knows anything about you." Beatrice was keenly aware that what she was going to say was only partially true. "I want to be *sure*," she said.

Sandra took Beatrice's hand and squeezed it. "Is that all? You know, Marston is positive she's never heard of me."

"Does he think she is jealous?"

"He's never mentioned it."

Beatrice finally said, "You know that Marston has a great reputation as a womanizer. I think it's this reputation that

occassionally makes her suspicious."

"I heard that long before I ever met him," said Sandra. She couldn't see the Tour St. Jacques, and Bea's voice came from a distance. For, once more she re-lived the drive to Fleuris on the day her honeymoon was to start. Her eyes had been open as she walked over the edge of security and no frailty of Marston's, and of her own, could ever force her to go back. Love was like the city below them, with its fabulous risks, its tortuous ways, its pillars of light, its almost too bright radiance. Only those who could feel its beauty could understand it.

"You said you had something to talk about, darling?" Bea's voice interrupted her thoughts.

Sandra put one arm on Bea's shoulder. They stood looking at a city that was now clear and lovely to their sight.

"Last night something happened, which has brought Marston and me closer than ever together." Sandra went on, "If that is possible. He's wanted me to give up Feodor's all along." Her breathing came quickly.

"I know. But I understand why you don't."

"Now things will be different Bea," she spoke earnestly. "Marston is going to do more of his work in the country. He has a brief to write that can be done at the château. Then, there is Eileen."

Beatrice did not take her eyes from Sandra.

"Since Marston first took for granted that I would give up my work we decided to have Fleuris—I explained to him at the time why I could not give up Feodor's. He has never mentioned it again. But we can be together if I don't have to come to town. I am quite sure Madame will let me work on designs at Dreux, so I'll still be able to make a little

money." She paused. "When the courts open in November, we'll be separated much of the time. We will never know when we can see each other. Life is not life without him. And Bea, life is awfully short."

Beatrice leaned to kiss her. "And youth is shorter," she said.

Sandra felt a pang for Beatrice, so intense that she could only cling to her friend. *Nothing in all the world is so desperate as waste.* For Bea it was the waste of precious youth and beauty, and the capacity for love. Unfulfilled. Sandra saw this in all its cruelty.

They left the Hôtel de Biron arm in arm. "Some day," Beatrice said, "when Marston is away, will you take me to the château? I wnat to visualize you at Fleuris."

"Darling, of course. Any time." Her voice was calm, but her pain had not gone away.

At the door of Feodor's Beatrice wished Sandra luck.

"It will seem strange having nothing to do all day, every day."

"Don't worry about that," Bea said. "It's going to be magnificent. Oh, Sandra, I forgot. The Dicksons' cocktail party is this afternoon."

"I have to go, too," Sandra said.

"I'll come back for you. I want to hear what the Marquise has to say."

Later Sandra reported that the Marquise had a lot to say. "She was very understanding. She refused to let me just be a designer. She suggested that I be a designer without pay, but if she liked my clothes she would buy the sketches."

"That won't bring you much money, I'm afraid."

"But she will pay me commission on every new customer whom I send to her."

Beatrice looked worried.

Sandra continued: "She said I must say I'm taking a vacation as a favor to her. Put this way 'It is always so much better not to explain anything; unless you want to say you have come into an inheritance, which no one will believe anyway. You are far too attractive to lie. Keep your position, my dear. It's lucky for me it hasn't happened before. Try to be a *soupçon* more worldly.'"

"What do you suppose she meant by that? Bea asked. "Does she think you've been indiscreet?" Bea asked.

Sandra shrugged her shoulders, but her friend insisted, "Did she say any more?"

"No, she just looked wise."

The Dicksons lived in an apartment in the Trocadéro area, and their party seethed to overflowing with men and women from all over the world, caught like fish in widespread nets.

Sandra and Beatrice talked with a few people on their way through the crowd, larcly unfamiliar faces, and finally, coming across some of their own set in one of the smaller rooms, they joined them.

Dora Thibot and Mrs. Mowbrey sat on a sofa with Judge Boissonier; Archie and Bob stood nearby. Mademoiselle l'Aigle, Paul and Mr. Mowbrey faced them in two antique armchairs. Dora and Paul Thibot had been over to Deauville

and to Cabourg for lunch, she said. The only excitement there was Marston Overstreet's wife. Marston's wife always produced attention, a fact which Beatrice had noted before. Now the listeners looked at Dora, except Bea who watched Sandra's apparent indifference with relief. Archie's cunning eyes darted to Sandra, as he said, "I don't see how it could have been exciting. She's an invalid, isn't she?"

"No one *ever* sees her," said L'Aigle. In a voice full of meaning she went on. "I've noticed that Marston doesn't go to her as much as he used to."

"I know her only very slightly," Jacques de la Roche responded in his easy way. "She's rather pathetic and sweet."

Bea noticed that Sandra was very relaxed. So Jacques knew something about Marston.

"She's very striking-looking," Dora went on, "But it was her household that made people talk. You know how conventional the people at Cabourg are."

"I know her well," Judge Boissonier said in French. "She is a very brave woman."

"Why does she have to be brave?" Bob Graham asked.

"She is in very poor health, but manages to do things for the sake of her husband and children."

"How noble," said Archie wearily. "Don't tell me any more, Judge."

"There were so many of them and they were so exclusive," Dora Thibot explained, rather flatly. "She looked white and faint—you know, as if she were being eaten by some awful disease, and she was surrounded by a retinue of servants. They had a cottage, but on their way to the beach the parade always came through the hall of the hotel after

lunch, when everyone was sitting over. It wasn't necessary. She could go around the other way."

"She's picturesque," Count Marbeau said. "I know her very slightly. She's always exquisitely overdressed."

"Is she good-looking? L'Aigle asked. "What a waste for a sick woman to have Marston Overstreet for a husband. It must be exciting to be his wife." Her tone was suggestive.

"Don't worry about that fellow," said Paul Thibot. "He has lots of consolation."

Dora continued, "Yes, she's beautiful in a way. She wears the most beautiful jewelry."

"I'd hate to be married to her," Felix Marbeau said. "Illness has not improved her disposition."

"She is very gentle," said Jacques de la Roche. He was watching Sandra. "She makes you want to protect her." It did not sound like Jacques, and Bea thought that this was his way of telling Sandra not to be frightened.

"She's more like a corpse than a woman," Dora Thibot continued. "I can't believe she needs your protection."

Archie laughed. His eyes surveyed the room and hung a moment on Sandra. "Perhaps she needs protection from theft. She has possessions besides her jewels. Her children, for instance—"

"She always has a detective with her," Dora Thibot said.

Beatrice regretted coming to the Dicksons' party. Yet Sandra would always be seeing people and she would always be subject to exposure, danger. Today she seemed very vulnerable. Beatrice's heart ached for her.

"Who else did she have in her retinue?" L'Aigle asked.

Dora Thibot was lighting a cigarette and there was a

275

pause before she answered. "You are right when you call it a retinue." Dora obviously liked the attention she was receiving and continued slowly. "There was a companion. She looked distinguished, very expensively dressed, but acting as if she hated the publicity. If you wanted to impress a lot of respectable old ladies, you would dig her out of your past and use her. She looked very safe, no possible temptation for a husband."

Everybody laughed. The joke was at Paul Thibot's expense. Dora appeared to enjoy the joke. "Even Paul," she added. "She had two maids, a manservant carrying thermos bottles, parasols, cushions, and rugs; the detective, I mentioned; two big good-looking children with their governess and tutor. I think that was the complete entourage."

"Cabourg must have been dull if that was all the excitement you had." Mrs. Mowbrey said. "And where was her husband?"

"He wasn't there," Dora said.

The conversation turned to the Louis Merrimée casse. Everyone had an opinion.

Beatrice felt Sandra's eyes. They had the same thought: *A man who looked like a bird and had said, 'We are usurpers of the powers of the gods!'*

"I believe Madame Merrimée had no redeeming qualities," Judge Boissonier said. "No wit, no nothing." He seemed only half-serious.

"If I knew Louis," said L'Aigle, "I would visit him behind bars."

De la Roche suddenly threw aside the cigarette he had been smoking. "Mrs. Fane, you have met him, haven't

you?" he said.

Everyone looked at Sandra, who was surprised.

"For only two minutes at a reception, yes."

"You never *told* me!" Archie said.

"I certainly would have, if there was anything to tell."

Count Marbeau said, "I could never trust someone I knew was a murderer, but I rather think I've known a few without knowing it."

Archie slumped back in his chair. "Merrimée is not the type."

Archie pulled himself out of his chair, and said, "I had something to do with Marston Oversteet being Merrimée's lawyer. He thinks I've done him a good turn. I have." He looked surreptitiously at Sandra.

The party was both winding up, and winding down.

"Come along, Bea and Sandra," said Bob. "I am going to take you home, away from this mad conversation. You will both be having theories if we stay another five minutes."

# 18

Beatrice Graham entered the vast hall of the house of Avenue Henri Martin the next day. She was the first to arrive. Eileen Overstreet came forward to meet her. Bea noticed she was in her "alert mood."

The room was richly furnished in an antique Italian style. Carved walnut choir stalls had been covered with ancient red velvet and the *portières* were also red velvet. It was a room far too heavy and dark for the season, but provided Marston's wife with a background she liked. Eileen looked very small and dominant. She resembled a lady of the Medici family as they might have appeared in the sixteenth century. Even her dress seemed tight and medieval, as did the formal curls of her hair, that were now combed forward to soften the contours of her face.

Later two women came to share her hostess' hospitality. One was an old countess, born to the French aristocracy. The rigidity of her figure, the fashionless mode of her clothes, and her poise stressed an exalted tradition.

The other woman was American. Beatrice knew she was alien in the company, but obviously not disconcerted by it. Her clothes seemed strangers to her, as though she had

278

gone to the best dressmaker in Paris, yet afterwards lost interest in the result. Bea came to the conclusion that Mrs. Reed dated, in Eileen's calendar, from the days of her youth in America. Mrs. Reed, attractive in appearance, had a casual manner. She had entertaining small talk, but she was also a good listener.

At the table with the guests widely separated, conversation became impersonal as it was bound to do with three people, none of whom knew the others at all.

Mrs. Reed asked Beatrice a disconcerting question. "Do you know Eileen well? I have never met you here before, but then she doesn't ask me very often. You see, we went to school together, and came out the same year. My husband was a great friend of Marston's. That's why I always make a point of seeing them when I'm in Paris." This remark was made within earshot of Eileen. Bea was appalled.

Mrs. Reed went on in her low voice, "My husband died five years ago. Ever since his school days, he worshipped Marston. He never lost it."

After observing that Eileen was attentive only to her own conversation, Beatrice continued, "You asked if I knew Eileen well? Actually, I've only met her three times."

Mrs. Reed brushed aside this answer as if it were unworthy of Bea's intelligence. "You haven't answered my question. No matter. Since she bacame an invalid I scarcely know her myself."

Beatrice suspected that Mrs. Reed raised her voice deliberately when she pronounced "invalid."

Eileen heard it. "are you talking about me, Frances?" she asked.

"Yes. I was telling Mrs. Graham that since you became an invalid, I didn't feel as if I still knew you."

Did Mrs. Reed practice rudeness, calling it frankness?

The countess gave Mrs. Reed a withering look.

Luncheon was now over, the maître d'hôtel drew back Eileen's high-backed chair as she stood up. As they were leaving the dining room the countess said, "You have, I have been told," she said, "A room from the Château de Cerf. The château was once owned by a very dear friend of mine. I have visited her many times in my life." She straightened her shoulders as if for an ordeal.

"How awful," Frances Reed said. "Do you mean to tell me they had to sell it?"

"But certainly," the countess said, sadly.

They went slowly down towards a double doorway at the end of the hall. She was suddenly aware of what the countess was saying to Mrs. Reed: "I am told that most babies born in the States now are by Caesarean delivery."

"Just as American women are divorced five times," Frances Reed said.

The countess wagged her finger at her companion. "My religion does not permit divorce."

"I am not a Catholic," said Eileen abruptly. "But I consider divorce a disgrace. The guilty party should suffer for it."

A silence followed, then Beatrice said, "If someone makes a mistake, he deserves a fresh start?"

Before the countess could answer, Eileen's metallic voice filled the hall. "You don't have to be Catholic to believe that divorce is evil."

Bea watched Eileen, who walked beside her. She noticed that her lips were compressed. Then she heard Frances say,

"If holding a husband involves elaborate play-acting and hypocrisy, I could never manage it."

Their steps echoed on the marble floor. Beatrice felt that Eileen was struggling to control herself. She was relieved when the countess spoke. "It is the children and the home that are the most important. You are right, Eileen."

They had now reached the end of the hall and the countess stopped for a moment at the door. Beatrice felt as if she were about to genuflect. The others followed her in.

The room proved an exquisite oak salon, but it was vaguely cold and over-decorated.

"You see, they would not sell the fireplace, so I had to fill it with another and a panel over it. Jacquelin made it. It's very good, don't you think? How do you like this set of Boucher furniture. My husband gave it to me for Christmas. Do you remember if they arranged the *fauteuils* like this, Countess?"

"Oh, *non*. They followed their traditions, different from yours. And what a lovely room it is," she said. "You have adapted it beautifully. There were to be three windows on that side."

After a moment the countess led Eileen toward an open door at the end of the oblong room. Mrs. Reed hung back. The others went in alone.

"Can't we get out of this?" Frances whispered.

"I don't know her well enough to be rude," she said, and so they went into Eileen's bedroom.

It was empty and immaculate. A blue-grey room, strictly Louis XV, old *boiserie*, old *meubles*. Eileen seemed not to have collected the usual objects that litter women's bedrooms. The lack of personality gave one the feeling that it

should have a cord strung around it to keep sightseers from touching the furniture. On a dressing table in front of the middle window, the *repoussé* mirror was supported on either side by *bronze doré* brackets. On the left was a large photograph of Marston, in a gilt frame. It was an old picture. He looked younger, but his expression was stern. *It's before Sandra,* Bea thought.

Beatrice soon discovered two other photographs. They stood on a console opposite the windows, in the shadow of a Chinese porcelain bowl, mounted on a bronze pedestal. One was of a girl about sixteen, with wide-set eyes like Marston's. The other was a picture of a boy, a year or so younger. He resembled Eileen. He sat trying to survive life in an Eton suit. He looked tall and rangy for his age.

Now the countess and Eileen had moved on into the bathroom where the former gazed at the latest gadgets, particularly the sunken tub.

Frances Reed put her hand on Bea's shoulder, and drew her aside. "My husband, Stanley Reed, loved me," she said wistfully. "But he loved Marston more. He did *everything* to try to keep Marston in the States."

"I thought he left because of Eileen's health?" Bea said.

"No," Frances said.

"Was there another reason?"

Mrs. Reed raised her voice, "No, no," she said. "He believed what his wife told him. But it created bad feelling between Eileen and Stanley. My husband risked his friendship with Marston by using his influence against Eileen."

"But it hasn't ruined Marston's life, just changed it."

"He would have had a role in running the country now. Heaven knows we really need brilliant men now."

"Your husband risked his friendship with Marston?"

"He never hesitated."

"Did Marston ever want to divorce her?"

"No, but she was petrified that she couldn't hold him. *That's* how it happened."

"I don't understand."

"It started after they came back from China. She knew then that he was slipping away from her."

"But why come to France?"

"Each of us has his own weapons," Frances Reed said.

"What could she possibly do to hurt him now? He is firmly established."

"She would love his downfall."

"She might love it, but she couldn't manage it..." Beatrice said.

Mrs. Reed gave her a pitying look. "Remember that men who reach the top, as Marston did, arouse intense jealousy. He is an American practicing law over here. Naturally everyone knows that husbands have affairs in this part of the world. Yet if Eileen chose to exhibit herself as a wronged and suffering wife, invalided by her husband early in his career, with two children just at the age where they needed a father's guidance—in France where the family conventions are so rigidly observed, she could conceivably ruin his career."

"Mrs. Graham," Frances Reed said softly, "I must say goodbye. I have to go."

"So must I."

They chatted at the hallway door. On the way back to the salon the countess and Eileen could be overheard talking. On the way downstairs neither Frances nor Beatrice spoke.

283

François and a footman let them out into the afternoon sunlight. When they parted Beatrice walked for a while before going to see Sandra.

# 19

"Yes, hello, I hear you. Will I see you today, darling?"

"I'm sorry, sweet heart. Not until tomorrow."

Sandra wanted to tell him in person, but she couldn't wait until tomorrow. "I resigned my position yesterday."

"What do you mean?"

"Feodor's."

"I don't believe it. Oh, Sandra! Really?" His voice sounded loud and rumbling. "I'm...I can't tell you how I feel."

"Why did you do it?"

"A lot of reasons. I'm going on designing for her at home."

"Sweet heart, why do you tell me when I can't take you in my arms?"

"Maybe that's why."

"I can't wait to see you. Do you know what it means? Listen...hello?...I'll be able to do most of my work in the country now. I am going to bring a pile of law books to Dreux. Do you mind."

"Marston, shall we really be able to live there? ...Where will we put all your books?"

285

"In the bookcase, silly."

"There's no room. But I'll fix that."

"Sandra? Is there any money left in the Fleuris account?"

"Not a *sou*."

"I must get some cash. How can I manage to get it to you? I am tied up here all day."

"Could we meet somewhere near your office, so you can slip me some tainted money?"

"Let me think—"

Sandra saw, in her mind's eye, Marston at the château, immersed in law books, his legal bookcase in a rearranged library.

"Are you there?" He gave her the address of a bookstore close to his office. "I'll meet you at two-thirty. That's exactly an hour from now. Darling, is that all right?"

"I'll be there. You can recognize me by my avaricious look."

She reached the dusty bookshop early and opened the door which rang a cowbell.

In the corner, crouched a pale youth with a doughy complexion and horn-rimmed spectacles, poring over a book. Two customers were being waited on by a middle-aged woman. She turned to look at the new arrival and called loudly to the crumpled figure, "Sebastian, *réveille toi!*"

He carefully slipped a bit of paper between the pages of his book, laid it aside behind some large volumes, and came to wait on Sandra.

"Good afternoon," the young man said.

She couldn't think of a single French book. "Good afternoon, it's a lovely day," she said amiably.

"May I help you?"

She collected herself. "Yes, I was looking for *La Vie de Bohème*." It was the only book she could think of.

"By Murger?" He was pleased with himself.

The cowbell rang at the door. Sandra did not at first look at the newcomer. Then she saw Marston and heard him say, *"Bonjour, Madame."* He continued in French, "I see you are busy. I will look around a moment." Then he said to Sandra, in English, "Why how do you do? What a surprise to bump into you in this unlikely spot." He offered his hand in a formal gesture.

Because she felt she shouldn't laugh, her tone was equally ceremonious. "It's a beautiful day. I came to buy a very special book. When I got here I couldn't remember the name of it. Do you think I have amnesia, or hardening of the arteries?"

"Undoubtedly both," Marston said solemnly.

"Then I am a fascinating case." She looked into his eyes.

"Unique," he said.

"I can't come for a consultation, doctor," she said. "How about day after tomorrow. It's a Saturday."

"The Society for the Prevention of Boredom meets at four," he said formally.

"I'll be there," Sandra said.

The young man returned with a paper-covered edition. Marston intervened in French. "Madame wishes the book in cloth." With a sigh, the youth went back to look among the bookshelves.

Marston took a package the size of a small book from his pocket.

"That will be very helpful," she murmured. He scribbled on the paper package.

She paid for *La Vie de Bohème*, but Marston took the package. When she reached the door he gave her both the book and the bundle. "Goodbye. I am obliged to leave town this afternoon on a matter of business, or I would offer to escort you."

"Shall you be away long?" Sandra asked.

"I shall be back just in time for our meeting, which, by the way, will be a long one. There are a great many propositions to be considered."

"And acted on," she said.

In the street she looked quickly at the pencilled words:

*Your hat is saucy, beloved idiot.*
*Can't call you before I see you.*

*I know what it means to walk on air,* she thought. *I always forget how handsome he is.*

If she attended to it at once, she realized, the new bookcase could be at Fleuris by Saturday afternoon. She took a taxi and told the chauffeur to go to the Trois Quartiers. She found a quiet corner where she could open her parcel. First, she carefully tore away the square of wrapping paper on which Marston had written and put it in her bag.

*I can buy enough bookcases for a full library,* she thought. *But I shan't. A desk is going to be essential, a scrap basket, two more lamps, a light picnic basket, paper plates and cups, some yellow foolscap for his notes, and— a glass-topped iron table for meals on the terrace.*

She began to rearrange the library in her mind's eye. *The books must be near his big leather chair, over there in the corner. I've got an idea. It must be round.*

But how could she ever find a circular, revolving bookcase in Paris such as she had seen in old-fashioned homes in America? Only at a secondhand furniture dealer's. The desk would be her extravagance. Then she remembered that lawyers usually had big, business desks with roll tops and horrible grained surfaces. Was that the only way briefs could be written? She couldn't see Marston sitting in front of one. The desk would be like one she had seen at Doucet's, of noble proportions and suited to his dignity.

She found everything except the bookcase and the exalted desk in the Trois Quartiers. She had them sent to the mover who had transported her previous house furnishings. A kindly old man in the furniture department gave her the address of a secondhand dealer in the Faubourg St. Antoine.

Picardy's was a vast junk house, sprawling in room after room and spilling out over the sidewalk. There was every kind of a bookcase she did not want. Low, ornate ones, or high aggressive ones with glass doors. See saw one pseudo-Louis XV, and a rather pleasant English one in a final state of decrepitude.

They sent her from one place to another, junkier and junkier. But she wanted that particular kind of bookcase.

It was not until she reached the fifth shop that she finally spied the coveted object, mostly hidden behind the remains of a decapitated angel.

"Oh, *that!*" said the salesman. "That is a very rare piece."

"You've said a mouthful," Sandra murmured in English.

It looked as though it could have come from her old aunt's house on Washington Square. *Marston must have had an old aunt, too,* she thought.

After driving a bargain, she was tired. But if she didn't buy the desk today, it wouldn't reach its destination by Saturday.

A look at the Doucet-like desk proved that it wasn't too large for the space between the windows in the library, and Sandra bought it at a reasonable price in cash.

Once out in the street, she knew she did not want to go home. A kind of lonesomeness invaded her, a vague nostalgia for Feodor's with its familiar sounds and feminine bustle. She even missed its irritations. And she had only been away from it for a day. Would she miss the tension of that life? For over three years, it had occupied seven hours of her day. Now, she realized how many interests had been sacrificed. But she felt humble, wondering if she still possessed the capacity to develop. *I shall have time to stock my mind with Marston's life. Will I be able to? How ignorant I must really be.* She knew Marston loved her. It was her comfort that leaving the Maison Feodor would not end her development and the broadening of her outlook.

The following afternoon was spent with Beatrice who had just come from luncheon with Eileen Overstreet. Beatrice's mood was belligerent. She violently discussed irrelevant subjects, and was angry over the present day lack of idealism. Finally she referred to lunch. "There were two other women at Eileen's," she said, "One was an American whom I liked. Has Marston ever spoken to you about

Frances Reed? She's quite a grand person."

"No, I don't think so."

"Her husband died some time ago. He was a great friend of Marston's."

"If Eileen has that kind of a friend—" Sandra spoke with evident relief.

Beatrice blurted out the truth. "I don't expect to see Eileen again."

Her brevity ended the subject. It registered more clearly than if expressed in violent speech. Then Beatrice said, "I'll tell you more about Mrs. Reed some time."

Early on Saturday after lunch, the truck with Sandra's new possessions had just arrived as she drove up to the château.

She kept the moving men to place the furniture. The desk between the two windows gave a cachet to the library which delighted her. She gathered together some papers he had left behind, took the writing set from the living room and, with a new lamp installed, the room lost its gloom and became friendly. The standing lamp, with reflector, was put next to Marston's special red leather chair, which always fronted the fireplace. Her own chair occupied the other side. She saw themselves seated there, the turkey-red curtains closed. It gave her a sense of newness. The old bookcase in the corner beyond Marston's chair was oddly attractive. She placed a bronze bowl on top of it, stolen from the dining room. A table which stood between the windows before, was moved with its magazines, flowers and odds and ends to the wall opposite the fireplace. She had also brought a desk chair and a small upholstered sofa. With the

sofa placed against the wall opposite the desk, the bookcase became easily accessible from it, as well as from Marston's own chair.

She was exhilarated by her arrangement. It was akin to the thrill of packing for a trip to a new place. As she surveyed the room, it seemed the symbol of their new life.

At four o'clock she waited for him, her pad and paints resting against her raised knees. She was so busy working on a sketch of his arrival in the new room that she did not know he had arrived until he was beside her.

He was eyeing the room. "You're a magician," he said, "and the desk! It's beautiful. I've brought some of my books. How convenient that old bookcase is next to my chair. And what's this? A new sofa?"

He tilted her head to look into her eyes. "Where's your red hat?"

"I left it on the train."

"Careless."

Maurice suddenly appeared with a pile of books.

"It seems I shall have to go to work." He spoke in English to the maître d'hôtel. "Throw them in the fire!"

They spent the evening in the library.

After two days at the château, Sandra had an uneasy feeling. She detected a slight difference in Marston's manner. At first it seemed only natural that the prospect of a long, almost unbroken companionship would be sufficient reason for his subtle change. Yet she thought she knew what it was. She waited anxiously for him to finish his afternoon's work, to find out whether she was right.

Sitting on the terrace, she heard him come out of the château, whistling noisily. It was unlike him.

"School out?" she asked.

"My brief is writing itself," he said. He seemed pleased with his work. "What shall we do?"

"Go for a swim! See if we can find the gypsies! Anything." She got up, stretched herself, and hid the law book she had been reading behind her back.

"I need some exercise. Let's explore."

It was not until just before dinner, when she was dressing, that she found the opportunity. But then she was sure that she was right. She had taken a bath after their long walk and was sitting in front of her dressing table in a white gown, brushing her hair, when Marston came in. He wore a dark blue smoking jacket and was smiling.

"Funny how the woods and roads can turn into romance, and climbing a fence can be a breath-catching adventure," he said. He threw himself into an armchair near Sandra.

"The glamour of imagination," she said. "Dusty lanes are golden pavements."

He watched her in silence.

*He's thinking of it now,* she thought. *How shall I get there?* Aloud she asked, "No snags yet in the brief?"

"They will come, don't worry."

"Are you going to work tonight? I don't mind reading.

Suddenly he said, "Sandra, darling, I have been thinking about you and Jacques."

She was on her feet at once, turned and took a step nearer to him, still holding her hairbrush. "You think I can't take care of myself?"

"Why, sweet heart," he looked surprised, "I love protecting you."

293

"Marston," she broke out, "I believe that getting myself into that mess with Jacques has made you..." She stopped because of his uncomprehending look, and went back to the dressing table. There she looked into the three-sided glass and saw reflected his blank face. The brush dropped with a little rap on the table.

"Made me what?" he asked.

"Do you think I can't take care of myself?" Sandra was intense.

"No, I don't think *that*," he said.

"Yes, you do, dearest. I think you're taking this altogether too seriously."

At last, he saw what she was driving at. "But, my sweet heart, I want to protect—"

She interrupted, turning to confront him. "You can't put me in that position, just because I was a silly idiot once, you can't, Marston. It's not fair."

Only amusement showed now on his face. "Sandra, what's the matter? You don't understand. I..."

Again she broke in, "It can't be true."

He saw her standing there in front of him, erect, her hair tossed back, dismay on her face. "You don't understand," he repeated gently, and reached for her hand.

"But I am afraid I do understand," she said.

He got up, staring at her.

She went on quickly, "Just because I did a foolish, silly thing, you...you want to break up your life." Tears were near the surface.

"But, Sandra," he gasped.

"Just because I was a fool," she continued hotheadedly, "You want to chuck your career, throw away all the things

294

I love you for, your ambitions and your brains. You can't...Oh, darling..." Her voice suddenly broke.

"But," he said in surprised incredulity, "But I can still work. It's no sacrifice. Think what it would mean."

"You are at the height of your career, Marston," Sandra recovered herself. Her words now came fast in her conviction. "You would never have any chance at politics. And what about the Merrimée case? Marston, are you crazy? What about Eileen? Don't you suppose that I know what you owe her, don't you suppose I respect and admire you for your sense of responsibility to your family? What about your children?" Her feelings were so intense that she was forced to stop.

Marston was too amazed and stunned to speak. "You are you. It's all mixed up with your brains and accomplishments. You must see it."

"Darling, it's no sacrifice. I'm sure you need me more than anyone else."

"I do, of course I do. But not that way. I need you the way you are, the way *we* are. Oh, Marston..."

He leaned to take her hands. She was trembling now more than she did a few nights ago when he sat beside her on the sofa at her apartment.

He wanted to tell her what their life together would become, what it would mean. What difference would it make if he was no longer given big cases? And as for politics, he would probably never have that opportunity anyway. But when he began to talk, she grew vehement once more.

"We have almost everything," she exclaimed, excitedly. "A month here alone now, evenings and nights together. No, no, you don't understand what you mean to me."

He was still for a short while, all his thoughts concentrated on their problem. Then suddenly his eyes were opened and he felt how misplaced his judgment and desire had been how much fuller their present life was. Sandra was a never-ending surprise to him. She wanted her independence and she was right. She treasured it more than he had realized and her resolution to keep it intact filled him with admiration. She accepted part-time loneliness willingly, he now understood, for him. He had visualized the future as one great horrible break, and then perfect happiness. Now he saw that his vision had been smaller than Sandra's. She loved him for what he was, with all the restrictions and the obligations his life imposed on him. His career was more important to her than anything else, and nothing should hinder him from exercising his full powers.

In the next few days, life at the château took on a routine. But to Marston and Sandra, it presented no such formula. Each act blossomed from a special inspiration which could only have been conceived by their joint desire.

She knew he was a great worker, but she had not realized the concentration with which he applied himself to the smallest detail. He explained to her that already several young lawyers had spent days in the preparation of voluminous notes of precedents from law books citing cases similar to the international case for which his brief was being written. The new interpretations of the cases and interpretation of the law he must make alone.

Often Sandra asked Maurice to prepare a tray which he put down on the table of the library and silently left. She

lunched alone, a book propped against the centerpiece from which she read between mouthfuls.

Other days were ordinary. The mornings were largely spent by Marston in writing his brief or attending to some other law business. Sandra painted. Sometimes she surreptitiously read his law books.

Then often they had lunch together in the orchard or beside the river, or they would walk farther afield. At these times, Sandra felt herself in a pact with nature, alien to such conventions as houses and clothes.

Some afternoons they rambled far from Fleuris, for they liked walking the narrow dirt roads, where they met peasants bringing their farm produce to town, in carts that clanked and rattled and squeaked drawn by sleepy horses. Sometimes they met a peddler, moving at a snail's pace beside his merchandise, who accosted them. They often stopped to talk to their comrades of the road. Usually they assumed that their car had broken down.

"We have no car. We know where we are," Sandra would inform such people. "We like the road, don't you?"

"*Tiens, c'est curieux quand même.*"

These simple folks were more at home with Sandra than with Marston, because he forgot everything in the pleasure of watching her as she chatted with them and saw their excitement.

In the evenings, usually they put aside their work, and sat close together. There were evenings when Sandra lay stretched on the sofa with a book, her feet crossed. Hour after hour went by silently, interrupted only by Marston

rising to fetch another book, or to pace the room like a prisoner. She found herself remembering her father, whose bent, white head, so unlike Marston's but oddly similar in its total absorption, had remained stationary for hours at a time. Many nights she fell asleep on the sofa, only to be awakened by his kiss, and other nights she went off to bed alone without Marston realizing that she had even left the room.

Some mornings he got up early without waking her, and went to Paris to show up at the office. She knew he called his wife on the telephone. Sandra accepted his work on the Merrimée case as the cause of his long absence.

Some days he was back by noon with flowers and fruit, which he had selected. He always had a clever gift for Sandra. There was a time when expensive presents had made her frown. She had accepted only one from him without protest. It was a bracelet of six strands of beautifully matched pearls. They were not too large to be worn appropriately in the day time, and Sandra was seldom without them.

Twice Marston had flown to Cannes for quick visits. Sandra and Marston planned to go to town for a few days at the end of September.

Leaning against one of the old gates the afternoon before they were to leave, Sandra noticed that summer was beginning to desert the country side. She had scarcely noticed that the trees were losing their summer foliage. She remembered their first morning at Fleuris when she had stepped off the woodland path to stroke the crumbling masonry. Those days seemed long ago.

*A Love Affair*

That night they sat up very late, as though they could not finish all the things they had to say to each other. They would not be back at Fleuris for four days. Sandra realized what the four weeks of uninterrupted intimacy had brought them. Since the day they had lunched at the Jardin Joli, with its danger of scandal, and the shock of her experience with De la Roche, Sandra's life had fused with Marston's more completely. Their continuous proximity, physical and mental, added a further bond.

His work was not so complicated that he couldn't discuss it with her. Their dreams were shared with each other.

Though they had often guessed each other's thoughts before they had expressed them, they took joy in words, and shades of meaning.

"What will you do away from me, poor darling?" he said that evening.

He pulled her off the sofa.

"If you want me to go to bed with you, you'll have to carry me upstairs."

When he awakened in the morning, Sandra was gone. He was alone. It reminded him of the day after their first weekend at the château.

Marston had said he would come to lunch with her at the apartment in two days. Sandra asked Beatrice to come to luncheon that day.

During lunch Bea spoke to Marston about their first and only meeting. "I plunged right in, didn't I? Talked about you and Sandra right off. You must have been terrified."

His eyes said to her, "I won't tell Sandra that you were the one that was terrified."

299

She reassured him with her next words. "I never saw any one so indifferent-looking as you, Marston."

Marston smiled at Sandra. "Bea'll always be a flirt. She flirts with every farmer and peddler on the road, to the point of making eyes at flowers and birds and even inanimate objects. Nothing is safe." Then he said to Beatrice, "The truth of it was that I was bowled over by your confidence in me. That you took me in as you did, was something I'll never forget."

"I liked you from the first," Bea said.

"What if you had hated each other?"

Bea made a face, then she smiled. "It wouldn't have mattered in the least to either of you. You never would have known it. By the way, Sandra, do you really want to take a trip with us this year?"

"Of course I do. When are you going?"

"Almost any time. I suppose the sooner the better. It will be getting cold soon."

Sandra turned to Marston. "Darling, what are your plans?"

"I thought I would take a week off just before the opening of the Court, November first. I must be back the middle of the preceding week."

"How does that fit in, Bea?"

"Wonderful. Don't you think Felix Marbeau would be an outstanding fourth? Nothing for you to worry about there, Marston!"

"His mind is very dangerous," Marston said.

"I am as tame as a Cheshire cat, and shall soon fade into oblivion just as it did," Sandra said.

"Then it's settled," said Beatrice. "Guess who I met yesterday? Mrs. Mowbrey, Bob's old flame. She wants us to visit them in England."

"Do you *dare* go, Bea?" Sandra asked. She was smiling.

"Bob likes his partridge shooting ornamented with pretty faces. I think I'll get him to go it alone, and amuse myself in London seeing new plays and wandering around."

Marston had to leave early. "What are you two girls doing this afternoon?"

Sandra looked at Beatrice who shook her head.

"Let's go and see my friend Beaulier," Sandra suggested.

"Oh, I'd like to," Bea said.

"Where shall I pick you up tomorrow, darling?" Marston asked.

"I think it had better be at the Porte."

"I can't get away till seven, you know."

Sandra went into the hall to say goodbye. When she came back Beatrice was staring at the unlit fire. Sandra thought she appeared rather dispirited at lunch. Now her expression was thoughtful. "Not getting homesick for the boys?" Sandra asked.

Bea seemed as though her thoughts had been far away. "Perhaps I am, without knowing it."

"It can't be really bad then."

"I feel depressed. It's probably an ominous feeling about what's going to happen in the world. We just aimlessly rush about, knowing that there could be another big war, and more horrible depressions. It gets on my nerves."

It was obvious to Sandra that all was not well with Beatrice. She wanted to be reassuring, but Bea's mood did not

invite that. She hoped the amusing Beaulier might cheer her up. When they separated, late in the afternoon, she knew that at least temporarily, Bea had soared this way and that, on a kite of Beaulier's imaginary flights.

At the Crillon, Beatrice realized that she and Bob had a free evening. It was nice. She wanted to adjust to her husband's reality and forget the interludes of worry that had recently become more and more frequent.

Beatrice was on her way to Feodor's, for Madame had been kind and said she could try on her dresses during the lunch hour, when it would be quiet.

In the fitting room she sat waiting for the fitters, when an imperious knock sounded on the door, and, before she could answer, it was pulled open, and on the threshold stood Eileen Overstreet.

"They said you were here," Eileen said, closing the door rapidly. She walked slowly toward Beatrice's chair. Beatrice had the sensation that something important was about to happen.

Eileen's appearance was amazing. She wore the sensational midnight blue dress which she had chosen the first day Beatrice saw her. Her makeup gave her a warm, clear complexion enhanced by the reflected blue. Every curve of her body seemed perfect. The rather studied disorder of her dark brown hair softened her features.

A strange premonition left Beatrice icy cold.

In the ghastly light, Bea looked at Eileen as though seeing her for the first time.

Suddenly Eileen's expression changed to one of petty annoyance. "I took the night train from Cannes last night. I'm

here for the day. My maid forgot all the things I wanted, and Pat has been beastly. I wanted to talk to someone."

Beatrice was shocked by the new Eileen, who had been hidden up until now. She spoke quickly. "You are going back tonight?"

"Yes, I am. I love to sleep on trains. Never take a sleeping pill. Pat wouldn't come with me."

Beatrice interrupted, "Your dress is beautiful, Eileen, and very becoming."

"I suggested some changes which have improved it. It's the fourth dress I've tried on this morning. The tiresome fitters know I want my clothes in a hurry, and they're as slow as snails. I ordered them six weeks ago. Everything has gone wrong today." Her voice, more metallic than ever, grated on Bea's nerves, and she could no longer look at her. She would prefer no fitting at all to having one with Eileen present.

Eileen went on. "I really can't imagine what has come over Pat. She mopes all day. She actually *refused* to come to town today."

"It's a long trip for one day."

"She *never* feels well when there is work to be done. She said she wasn't coming. I made the trip alone. She has no conception of gratitude."

"Gratitude?" she said. "What should she be grateful for? She is a lonely old woman, with no personal life."

"You know nothing about her," Eileen said coldly. "I saved her from a disastrous marriage, and gave her all the luxuries of my house. I pay her handsomely."

Eileen stopped talking, as though the subject no longer interested her. "I want to have lunch early. Don't be late.

One o'clock sharp at the Ritz."

Beatrice was on her feet. "I can't lunch with you. I'm busy."

"You must. I am all alone and I want you to help me with Pat. She is becoming tiresome."

"Give her a holiday."

Eileen had been looking at herself in the mirror. "A holiday!" She quickly turned to Beatrice and laughed. "Don't you call being on the Riviera with absolutely nothing to do, a holiday?"

"She struck me as needing a change of scene, since you asked me."

"Has she been complaining?" Eileen said. There was anger in her eyes.

"I have never had two words with her in my life. Now, if you'll excuse me, I'll have my fitting."

Eileen turned again to the full-length mirror. Her reflection, her entire expression changed. The corners of her mouth turned down, her shoulders sagged. She opened her bag and took out a small bottle and a piece of cotton. With a quick movement she covered her face with a white lotion. Bea could see the metamorphosis in the mirror. Eileen was too absorbed to notice. She then clasped both hands over her heart with the finished gesture of a superior actress, and walked weakly to a chair. "I won't have the strength to take the train back tonight."

Beatrice quickly opened the door into the hall. If she stayed in the room another moment, she would lose her temper. Her fitters stood outside. Estelle was leaning against the wall of the corridor, waiting.

"Madame wants to rest. Will you help her to a fitting room, Mademoiselle Estelle?" she said.

Eileen, with a slight gasp, allowed herself to be led away. Estelle and the fitters would never have guessed at Mrs. Graham's sudden and rather excited interest in the details of her dresses, where before she had been oblivious to colors, materials and details of what she was trying on. The glitter in her eyes was ascribed to faraway thought—far from the quiet dampness of the fitting room at Feodor's.

Sandra, sauntering in the Tuileries, enjoying a walk without duty or responsibility, was thinking about city people and their schemes to further their own interests.

A young girl crossed her path. The pure freedom of her carriage and the swing of her skirt reminded Sandra of the gypsies at Fleuris. They had a private world created by themselves, a circle within a circle. A man, a woman, a baby, with the open road ahead and freedom.

At the Crillon, Sandra discovered that Madame Graham was out. Sandra did not realize till then how much she had wanted to see Bea. Surprisingly, Bob almost bumped into her. He insisted on taking her to lunch. Beatrice had gone off somewhere. He was alone.

He took her to a happy restaurant in which the raffish proprietor personally served them.

Sandra did not enjoy Bob's company. He either complained about Bea or talked of trivial matters. After lunch they went back to the Crillon where they found Beatrice in the sitting room. They talked as though they hadn't seen each other for a long time. As Sandra was leaving, Beatrice

said, "I'll be in Paris only a little longer. Would you let me come to Fleuris?"

# ❧❧❧ 20 ❧❧❧

Sandra was sitting on the steps of the château terrace, waiting for Beatrice. They had just arrived from Paris. Bea had gone to Marston's room to put on walking shoes.

Sandra thought, this is the hour for Marston's racing car to pull up in front of the door. But he wasn't coming today. He was flying to Cannes. Bea and Sandra drove to Dreux.

Sandra was excited about sharing the river with Bea. The broken bridge, the orchard, the winding paths, Marston's and Sandra's domain.

She heard Bea humming as she came down the circular staircase. Several minutes passed before Bea came downstairs. She arrived smiling.

Maurice emerged suddenly from the dining room. "Madame is wanted on the telephone."

"I think it's Marston. Follow the path." She waved in the direction of the orchard. "I'll catch up with you."

Just fifty yards away, Beatrice saw the gnarled branches of fruit trees, grotesque against the sky. A small animal scuttled away in the long grass at her approch. Yet she was among the trees when she saw the ripe, golden-green apples hang-

307

ing within easy reach. *Pommes d'or*, she thought. One of the trees, its branches loaded with fruit, seemed to spread its branches in invitation. There were two ready-made steps and a natural reclining seat in the branches. She climbed up, leaned back, and closed her eyes.

Why must thoughts never stop? Is it because nature abhors a vacuum? With eyes closed, her thoughts raced faster than ever. She opened them now, hoping that the view would divert her.

Summer was over. Autumn was here. Bea had the fancy that only a little while ago Primavera had finished her spring dance through the countryside. She recklessly shed her seed, was profuse in her generosity, joyful in her abundance. Now her luxuriant course was tangible proof of her passage. She skipped away, leaving the fruits of her gaiety— Summer.

Beatrice imagined the trees as a pack of growing children. Now the children were overgrown. But death would come, and then resurrection. Spring would come again.

Nature and human nature obeyed the same laws. Bea felt, as a woman, she had an advantage over the flora. Not only could she reproduce her kind, but she was capable of acts and thoughts. For a moment she felt superior. Then she thought, *What have I ever produced except my children?* A part of her was still barren.

A sudden breeze blew leaves away from the apple trees. Bea heard the thud of falling fruit, and then the crack of a snapped bough. She made a face. Nothing was permanent. She always yearned for one durable thing to lean on. A confusion of feelings passed over her. Vanity and age. She knew

another spring would come as beautiful as the last. Yet with people, each spring left the scars and pains inflicted by life. If only every year could retrieve the loveliness of youth, just for a few short months! You could always hibernate for the rest of the year, until spring returned.

She leaned her hand against the big tree branch and sadness seemed to seep into her from the gnarled old limbs. Impermanence was everywhere: in the weather, in buildings, in feelings. The Château de Fleuris had crumbling steps. Then with a sharp realization, she knew why this thought of impermanence struck her with such sadness. She was thinking of Sandra. She would never be perpetually young. Neither could her happiness stand still. Sandra simply had no security.

Yet Bea's own world was all wrong. Her self-analysis convinced her that she was deficient in both accomplishment and fulfillment. She could not bury the *it might have beens*. The ghosts of lost opportunities haunted her thoughts.

*Where was Sandra? How long had she been here? Did Marston have bad news?*

Rapidly she slid down from the tree. Her stocking caught and tore against the bark. It made her smile. *Silk stockings are impermanent, too.*

She hurried back to the château. At the edge of the orchard she saw Sandra coming towards her. Sandra waved triumphantly. Beatrice watched the figure which came forward, fast, swinging a basket. She thought, *Everything is all right.*

Sandra called out. "He didn't have to go away. He'll be down for a late dinner." And as she drew close, "At first,

when he heard you were here, he said he would leave us alone, but. . ." She stopped to laugh, "I told him we would be talked out by then. I've brought some sandwiches and tea. We can pick apples and take them with us."

Bea worried about Sandra. Yet, with her friend beside her, she was lighthearted. "What fun! I've been lying in a tree like a salamander. I was afraid you wouldn't find me, I was so much a part of the tree."

In the orchard, they picked the ripe fruit from under the trees and set about selecting the perfect spot for tea.

Beatrice felt as happy as she had when they left Paris early in the afternoon: she knew the day would present her with particularly lovely things to look at.

"We'll make a loop and strike the river beyond the bridge," Sandra said. She led the way. "I'll show you the tree that helped me to be a dress designer, and other landmarks of outstanding events!"

"Winter will come fast now," Beatrice said. "Marston will be back in Paris, Sandra. What are you going to do then? Do you know?"

"I have no idea. *Chi lo sa*. If Eileen stays on the Riviera during the winter, Marston may have to stay with her there on weekends."

*If? May?* Bea thought.

Sandra broke out suddenly. "By the way, have you heard any gossip about us?"

"Not about you and Marston. Do you really mean Jacques de la Roche?"

"I do, Bea. Have you heard any stories?"

"None. Except that he tells everyone who will listen that he admires you. I can't believe there hasn't been more gos-

310

sip. You live alone in Paris, and beautiful single women are not undesirable. Is Jacques still pestering you?"

"He never will again." Sandra looked at Beatrice, who seemed worried.

"You don't know his type," Bea said.

Those had been Marston's exact words. She felt stupid. "Apparently not." Then laughing, "But how is it that you do?"

"Bob told me a lot of drivel about you and Jacques. What actually happened?"

They walked along the path side by side. Sandra felt sordid telling the story. Yet she was proud of Marston's part in it. Beatrice's reaction was unexpected. She took Marston's understanding for granted, and, Bea thought, was unnecessarily preoccupied by implications that Sandra did not immediately grasp.

Bea's mouth showed a downward twist of the lips. "Men don't interfere in such scenes, unless they have a right to," she said.

"It worried Marston."

"Of course Jacques learned all about you and Marston." Sandra was silent.

Beatrice was thinking. "Now I understand," she said. "Jacques was trying to tell me at the Dicksons that he intends to keep his mouth shut."

Sandra turned to look at Bea. "Am I an ostrich?" She was very serious.

"I will never stop worrying about you, Sandra."

The path was narrow ahead and Sandra led the way in silence. She was almost drawn to the shadowed woods. The crimsons, the yellows and pinks of the autumn foliage, the

puffy clouds changing places in the sky, the sounds of birds
among the underbrush, and their own footsteps, rustling
the dry leaves—it was a magic world.

Sandra's anticipation of her lover's arrival completely
changed her mood. It was wonderful that Beatrice was
here, too. Life would enter a regular phase. After dinner she
and Marston would go upstairs to their room together. San-
dra had already told Maurice to lay out his master's clothes
in her room, for there were only two livable bedrooms in
the house. She suddenly had the thought that they would
always be lovers, but would never be man and wife. The
prospect struck her with great power. Her thoughts turned
to Beatrice, who had missed the full measure of love. She
had not subliminated her sadness in a career.

Sandra paused and stepped off the path. She did not want
to lose sight of Beatrice. She waved her ahead so that she
could see the long line of her neck as she held her head
erect, and the movement of her hips. Sandra was surprised
as she watched, that where latent strength had been, now a
new force existed. She had observed an intangible change
in her friend when they had gone to the Hôtel Biron, and
again more noticeable a few days ago when they lunched
and spent the afternoon together. But until the metamor-
phosis, it had been too subtle to pin down.

Was there a purpose in the tilt of her head, and the new
sureness in her walk?

Bea turned to look back at Sandra. "Is Marston still sorry
he can't go back to America?" she asked.

"Sometimes," Sandra said, linking arms with Bea as they
walked on. "You know he had a deep feeling of responsibil-

ity for the illness of his wife. She *must* live in France. He accepts that and has made the most of it."

"But, Sandra..."

"He feels that way, Bea. It must be terrible to have an invalid wife, and especially..." she hesitated, "...someone like Eileen Overstreet."

Arm in arm on the narrow path, they were very close and Sandra could feel Bea tremble. "What's the matter?"

"Nothing."

Then Sandra asked, "Do you ever hear anything about Marston's children?"

"I saw their photographs the day I lunched there. The older one, the girl, looks like him. I think she is going to be beautiful."

"What does his boy look like?"

"He looks like his mother. He's very manly for his age." Then Bea said, "Why does Marston feel he's responsible for Eileen's illness? I heard one story, but wondered if it were true?"

"He took her to some place in the Far East when they were first married. She didn't want to go. He had business there. She got very ill, and lost her first child."

"They have other children," Beatrice said. "He loves his children, doesn't he?"

"Oh, yes!"

Beatrice nodded.

"I think he worries about them a good deal. He doesn't seem to be as close to them as he wants to."

"A lawyer who is very busy, whose children are away to school? It's not easy."

"Even during the holidays, when Marston visited them, when he returned and spoke of them, I had the feeling..." Sandra had been looking ahead. "Oh, here is our bridge."

Beatrice seemed inattentive. "What *sort* of feeling did he give you?"

"That he did not have much chance to see the children."

Bea now could see the bridge clearly. "What's on the other side?" she asked.

"There used to be gypsies. Shall we look for them?"

"Let's have tea first."

Sandra sat down on the bank where she had watched Marston on his adventurous swim. She was opening the picnic basket. Beatrice, next to her, sat on the slope close by. Sandra turned to put her arm around her. "Are you tired?" She put her head near Bea's and whispered, "Having you here is like...like, I don't know what it's like...it's like a home."

Sandra intensely·wanted good things to happen to Beatrice, yet she had no idea of how to get them for her. She wanted only the fulfillment of Bea's dreams. She wanted Bea to have a great passion that would give her the same fulfillment that she had found with Marston.

When they finished their tea, they realized it was getting late. Sandra led the way back to the house, knowing Bea had bottled up powerful emotions. *Was it possible that I have less friendship to give Bea because of Marston? Have I selfishly withdrawn a part of myself? Why this doubt.* Her worries seemed to vanish in the château, where the lights were bright, and their footsteps clattered happily on the stone steps of the circular staircase as they went upstairs to

dress. Sandra would wear the tea gown she had worn the first night at the château. No matter what flowers were on the table, she would just imagine they were anemones.

When Marston arrived, he found Sandra and Beatrice in the lamplight of the library, laughing over their cocktails. They were a fresh, entrancing sight. He went straight to Sandra, kissed her, held her with one arm and took Beatrice's hand with the other. "What fun to find you two here. I was so excited driving down that I almost ran into all the slow old cars that wouldn't get out of my way. I am glad I didn't kill anyone or was arrested. I see you are ahead of me on cocktails." He looked at Sandra's glass.

She carefully brought it to his mouth and he drank what remained of it.

"How cozy you both look in my library. What have you been doing?"

"Beatrice pretended she was a salamander. We had tea by the bridge, and—"

Bea broke in, "Sandra wanted me to tramp the woods in search of gypsies, and she was sorry for me because I don't have a château or an attractive man to go with it." With Marston here, Sandra was very animated.

"You had better look out for that woman tonight, darling," Sandra said, pointing a finger at Bea. "There's a dangerous glint in her eye."

"I'm terrified of you both. Nevertheless, sweet heart, I'll need ten minutes in a bath to fortify myself."

"Not a minute longer."

When Marston reappeared, they went in to dinner. New impressions registered on his mind. Voices and laughter

which had been a duet, now became a trio.

Coffee was served in the salon. She loved its blue-grey walls and bright blue chairs and cushions. A gala setting. The lamps and firelight gave the room a friendly glow. Three arm chairs were drawn up to the chimney and Beatrice settled into the one on the left. She had just finished a story about some mutual friends who had disappeared beyond Sandra's horizon. They now lived in medieval elegance on an island somewhere off the West Coast of the United States.

Sandra moved the chair next to Bea so that she could face the fire. She reclined against the cushions, and her long slim figure relaxed immediately.

"I like the island concept," Marston said. From his chair he could see both women without turning his head. He could look at Sandra with the intimacy of love. He went on lazily, "Have they something to hide, Bea?" Or something to guard?" Beatrice had impressed him tonight, even more than when he first met her at Sandra's. Beatrice was taking her tapestry work out of a bag, her eyes fixed on it. *She has discarded her personality,* he thought, *and found another.*

The two women talked while Marston was thinking about his new theory about Beatrice. He wondered if she were unconsciously seeing though Sandra, as if she were invisible. He barely listened as they continued.

"Nobody understands why they do it," Beatrice said.

"I wouldn't like guards lying on the floor outside my door," Bea said, searching among her strands of bright silk. "If you pressed the wrong button, flashlights appearing, or guns exploding, or iron gates clanking together."

"Don't you suppose they are hopelessly bored," s
Sandra, "So bored that they create dangers for themselve
just for amusement?"

"Perhaps they *are* just dull," Bea said. "They require cra-
zy dreams."

Marston, deep in thought, no longer heard what they
were saying. He was conscious only of the pleasant sounds
of their alternating voices. The circle of his life had widened
now. The full pleasure of the world rose about him like fra-
grance. Sandra's every gesture shone with an inner grace.

These three people in the blue room relaxed Marston.
His recent days in Paris had been trying ones. Merrimée's
self-assurance was faltering slightly. Eileen's unexpected ar-
rival exacerbated matters.

During dinner no one had spoken seriously. Marston had
been surprised at the amusing twists Beatrice gave to ordi-
nary stories. He watched her sitting across the hearth from
him now, working on her tapestry and chatting with San-
dra. Since dinner she had changed. He watched the glances
she gave Sandra, a solicitude which did not match her
cheerfulness. It was a fleeting concern that, had Bea not
piqued his curiosity, he would not have observed.

Sandra was unaware that Beatrice was looking at her.
Marston was exhilarated by Beatrice's radiance. "How
much they love each other," he thought.

He heard Sandra's laugh and was aware, once again, of
their conversation.

Bea had been making light of the problems of children,
so tragically stressed in a recent novel. She was beautiful to-
night in a soft yellow dress that brought out the deepest

e of her eyes, and the lights in her hair. He liked the outhfulness of her looks, combined with the maturity of ner mind. He understood Sandra's pride in her.

He was about to join the argument when Maurice came in to announce that he was wanted on the telephone. He got up, went to Sandra's chair and rested his hand on her arm. "It's only Doriot. I'm expecting news about a case, sweet heart. I won't be a moment." Then he left the room quickly, followed by the servant.

Sandra was tense. She said, "Doriot is his secretary. But it is the first time he's ever called here."

Then she continued. "Only Doriot has this telephone number."

A few minutes later, when Marston came back, he leaned over Sandra, smiling.

"An important cablegram. Doriot thought I might want it tonight. Tomorrow will do just as well."

Bea didn't smile. Neither noticed her sudden limpness. She picked up her work and sat back in her chair. She resumed their conversation about children.

"Your children, Marston," Bea said, reflectively, "must be discouraged trying to live up to you."

"What an odd way of putting it," Marston said. "I don't believe, no matter how well we succeed in getting close to children, that it's never possible for the barriers between children and parents to be let down. I don't care what other people say."

Beatrice nodded. Then Marston leaned forward and said, "Don't you want any barriers between you and your children, Bea?"

318

"I think so. Yet, I'm not sure that if there were *no* barriers, that I'd like it, or any parent would."

Marston remained silent. He got up from the arm of Sandra's chair and stood in front of the fire.

He put another log on the coals.

"You must run up into some ethical problems in your legal practice, Marston," Beatrice said.

"Politics is worse," he said.

"You would like to be in politics, wouldn't you?"

"It's a wonderful feeling to fight for something worthwhile, Bea."

When he sat down again in his own chair, he began telling them stories about law cases. One leg crossed over the other, admitting them into his confidence. They did not know how long he talked, because they were transported into another world. His last anecdote involved a question of ethics, and Marston, not being able to see eye to eye with his client, dropped the case. "He had his own standards, and I had mine. We were both sincere. Perhaps we were both right. But it would be a very topsy-turvy world if everyone stuck to his own principles."

"What a copybook remark, darling," Sandra said.

"If you had to get people out of muddles they got themselves into, because they imagined they were a law unto themselves, you wouldn't scoff."

"Do you remember," said Sandra, abruptly turning to her friend, "saying to me once, ages ago, that you had no fixed standards of your own?"

"Did I?" Bea asked.

"I've never forgotten it. In fact, thinking about it kept me

awake one night. Remember? We were in a boat on a moonlit lake."

"Yes, I remember," Bea said.

"No remark could have been less like you. But you meant it."

The embroidery dropped from Bea's hands. "Yes, I did mean it."

"You meant man-made laws are not meant for everyone?" Marston asked.

She gazed into the fire. "Lots of things that are considered to be wrong, don't seem wrong to me. I would not hesitate to break any law, if I saw a good reason to do it," Beatrice said.

"What about the Ten Commandments? Those are God-made," Sandra said. "Let's see what are they about, besides adultery? Worshiping graven images, covetousness, theft, murder, loving your neighbor. I can't remember any more. Is that all you meant, Bea?" She laughed, looking from one to the other. "If so, your remark was conservative."

With a sudden spontaneous movement, she got up from her chair and stood with her back to the fire. "I want to show you a picture," Sandra said, looking at Marston. "It's one of my sketches." She went to the corner of the room where her portfolio stood propped against the wall.

While Sandra searched for the sketch, Bea remarked, "I said that, but after all, the world is pretty topsy-turvy as it is, Marston. Half of us conform to a pattern which we loathe; the other half is struggling to destroy it."

Sandra came back to the fireplace, a sheet of paper in her hand. She held up the picture for them. It was the sketch

she had made by the stream, two months ago, of an airfield at the start of a race, with Merrimée in his plane.

For a second there was silence, then in the same breathless tone Marston and Bea exclaimed, "Merrimée!"

To all of them it was no longer a picture. It was an event, a moment when people feel the excitement of something about to happen. Movement swayed in the crowd, held back by ropes, by uniformed men, and by awe. Their interest centered on an aeroplane about to begin its flight. The propeller was already whirling, making strange shadows on the grass as it gained velocity. The crowd pushed forward in uneven lines. Here and there were figures, upraised arms and legs pushed forward, who detached themselves from the purplish crowd. The purple had almost pink and blue highlights because it was early morning and the distant mist had not quite dissipated.

Louis Merrimée's head and shoulders showed above the cockpit of his plane. His bird-like face with its pushed-back goggles was too small to express more than raw intensity. But as he reached forward to look down at a figure below him, a figure in movement, something was noteworthy. A woman had escaped from the crowd and pushed her way close to the plane, her arms outstretched. Her yellow dress, the red handkerchief around her neck, were brighter than the sun. It seemed two figures were being parted from their greatest desire. The aeroplane moved. Marston, Bea and Sandra imagined they saw it moving on the static paper. A gendarme seemed to pull the girl back, as the arms of the aviator descended to the controls. Then they seemed in the stillness of the room to hear shouts from the crowd.

"Sandra!" Marston shouted at her; he must make her hear above the noise.

Her arm that held the picture dropped. She looked from one to the other.

Marston seized the sketch as she slowly sank into a near-by chair.

"I had forgotten. I didn't remember it was like that," she said. She was recalling Merrimée's words to her: *It makes me feel like the gods. We are usurpers of their power.* Abruptly she looked up and realized that neither Marston nor Beatrice were horrified. Yet Marston, she knew, was in shock.

In the moment's silence which followed, it was Beatrice who recognized the full import of the sketch, and its importance to Marston's principles and to Merrimée's fate.

Suddenly Marston laid the sketch on the table. Beatrice noticed the seriousness of his look, but it revealed nothing. He turned to Sandra, "Sweet heart," he said, "Dufy would be jealous. As for journalism, you're wasted at Feodor's." Marston's effort at casualness was obvious. "I have to leave very early in the morning," he said. "I am sorry I can't take you both with me. I'll order a car for you."

Upstairs, they said goodnight to Beatrice at the door of Marston's room. Then they walked together to Sandra's room and closed the door. Marston looked at Sandra, seeing she was exhausted. She reached a hand to his shoulder. His need of her had never been so pressing. Passionately he wanted her flesh, her lips that clung to his in ecstasy. He closed his eyes. He could not bear to see her move. It awoke in him, in a crescendo, the memory of when he held

her close—then closer—giving her his love, her acceptance of it. No, Sandra giving him the rhythm of love.

He sank into a chair. Then Sandra's arms were around him. "My dear, oh, Marston! Do you remember once I told you that Bea had brought you to me, that she was in our lives?"

He hesitated, looked at her, and suddenly he imagined Sandra in the blue dress, under their tree, and he heard her saying, *Now, let's go exploring!*

Now in the room, he asked, "How did Beatrice bring you to me?"

"She gave up a man who would have meant happiness for her. If I had not seen the sadness of her sacrifice, I would not have had the courage to take your love."

He reached to her. "Sandra, won't you take me, utterly?"

She stroked his arm. "I want you as you are," she said. "To me you are perfect, complete. I am happy. Can't we leave it at that?"

"But—"

"There is no but. This world is one thing and we are certainly another."

Beatrice, across the hall in her room, slowly approached the bed. She sat down on it without noticing what she was doing, and her eyes travelled over the fittings of the room. It was white and dark blue, modern Italian, appropriate in detail for a man, but without intimacy. Two novels had been placed on the table by the lamp. She touched them but did not look at the titles. She undid the snaps of her dress, stood up to slip it over her head, and sat down again. It seemed to her strange that because of some disassociation

323

in herself with life that she was unable to do anything for Sandra. Her own problems were settled. She had accepted that. They might rise to confound her at times, but that was unimportant. It was only for Sandra that she despaired.

## 21

For hours during the timeless night, Beatrice's thoughts stumbled on. Through uncut silences she was conscious of a current of thought which separated itself into a double stream. One ran audibly, carrying the actual words which she would speak to Marston. The other was unfortunately working itself toward dark places.

When she slept, it was from exhaustion. She awoke and sat up. The air in the room seemed too thick to breathe. She felt she was suffocating. She opened the window and, resting her arms on the sill, let her head sink on them.

She was then aware a strange thing was happening to her. A trap door in her mind opened and everything within it seemed to fall out. She drank in gulps of fresh air and went back to bed. The sheets felt cool, the atmosphere clear. Then utter darkness.

She awoke early. She heard the chirping of birds and the special silence of a house before anyone stirs. She rushed through her bath, dressed slowly, and packed her suitcase without regard for neatness. She stood silent for a moment at the window. Then she went quickly down the circular staircase, taking her bag and coat into the hall below.

The door to the dining room was open. Marston was sitting at the table, scribbling on a piece of yellow foolscap, a cup of coffee at his side.

She was in the room before he heard her.

"I woke early," she said. "Will you take me back to Paris with you? I won't make you late."

Maurice appeared with more coffee.

"How nice for me," he smiled.

He glanced at her some ten minutes later to see if she had finished her breakfast. She sat rather stiffly in her chair.

"Shall we go?" he said, getting up.

"Will you have Maurice tell Sandra that I have gone to town with you, and that I will telephone her at lunch time?" Beatrice said.

When she was in the car next to Marston, she was aware that dark thoughts she had had during the night were back again.

He was saying something. She ought to listen, she realized. It might give her an opening.

"You know, I've always been sophomoric enough to think women useless to a man's work. You know, I thought they should be just sympathetic."

"Sandra is an exception."

He took his eyes off the road long enough to give her an approving glance. "In a strange, fascinating way that sketch tells the whole story. Who the woman was, basically makes no difference."

This was leading her off the trail. She must return. "Did your wife tell you that she knows me?"

The car swerved slightly. "Why no." And, with a quick

look at her, "My God, does she know about Sandra?"

"No."

He seemed very relieved and, after a moment's hesitation, continued. "Where did you meet her? Long ago?"

"About two months ago. I met her at Feodor's. We were both ordering clothes."

"You mean you talked to her?"

"The Marquise asked us both to tea afterwards. I didn't know who she was then. I hadn't heard her name."

"She goes out very little," he said. "Does Sandra know you met her?"

"Yes, she knows." Beatrice hesitated, then straightened herself in the seat. "Your wife seemed to like me. She asked me to come and see her."

Marston slowed the car. It was his only reaction.

She went on. "I stayed away on purpose, but about a week later we met on the Rue de Rivoli. Her car—wasn't around."

He was running the automobile slowly on the far side of the road, and turned to look at her. "Bea, why are you telling me all this? Your seem worried about something. What are you leading up to? Does she know about Sandra? Tell me at once."

"No. I'm positive she doesn't. It isn't that."

"Then why are you acting so strangely about meeting my wife?"

"I'm curious that she didn't tell you."

"How nervous you are. Why *should* she tell me? She doesn't tell me about everyone she meets. Are you sure she isn't using you to find out about Sandra and me?"

327

"It's possible, but unlikely, Marston."

"Well, I've been stupid. I thought you had some special point." His foot pressed the accelerator. They moved on again much faster.

Words caught in her throat, caught and then came with a rush. "Well, I have a point, and you have to listen." She was trembling.

He slowed the car again. Marston took one hand from the steering wheel and touched her arm. "I am still at sea. I can't see the importance. But go on."

"Where was I?" she began. Her voice was steady. "I remember now. Your wife suggested that day that we take a drive before going home. So we did. I didn't want to. She made me uncomfortable. But we did."

She noticed that Marston wanted her to speak faster, in order to reach her point more quickly. *It doesn't matter how worried or upset I make him*, she thought to herself, *and besides I don't know how far I can go. I have to feel my way.*

"Why did you go for a drive if you didn't want to?" he asked.

"She wanted me to go. I did wonder why. But I found out that there was no reason, only that she was bored with Miss Patterson."

"What did you talk about?"

Beatrice spoke faster. "About her. Your houses, the children, woman talk..."

"She's ill. Stong women don't realize what a handicap poor health is."

After a pause, she said, "Of course bad health is a tre-

328

mendous handicap. You see, I have known people who were semi-invalids." She stopped. "It did not end there," she said.

He frowned. "You say you have a point, Bea. I'm not getting it. Shall we drop it?"

Bea spoke faster. "I met her again by appointment."

"Well?"

"I met her in the Bois. She said she liked to sit by the lake. Actually, we took a walk—a rather strenuous one, I thought. It was hot. I would have been exhausted if I'd walked as much as that. Later she wrote me a note asking me to lunch. I wanted to go."

"Why not?" He was on the defensive.

"We have nothing in common, Marston. But I was interested in something I had to know about. I went there to spy." She watched him start and grip the wheel as if to relieve his feelings. "I know you can't fathom what I'm saying. I am coming to that."

A horn sounded behind them. Beatrice looked back. She felt as though someone had spoken, telling her not to go on, warning her that what she was trying to do was hopeless. The car slipped by.

He no longer tried to stop her, but said, "Does Sandra know all this?"

"She knows I was seeing her. She knows only what happened at Feodor's."

He steeled himself. "Did she want to know?"

"No."

"I don't have to ask you if Sandra had any idea you were going to talk to me." I was an out-loud thought, not a ques-

tion. "Were you and Eileen alone at lunch?"

"No, an old friend of yours, Frances Reed was there, and a French countess. Miss Patterson didn't come down. We went to see her afterwards."

"All this seems to me very ordinary, Bea."

They were moving very slowly and he felt in his coat pocket for a cigarette, took out a package and passed it to her.

Then Beatrice said, "I have seen her since, quite by accident. We met at Feodor's. She had come up from Cannes on the night train. It was that awfully bad day, humid, damp and enervating. She tried on a lot of dresses. She was going back that evening on the *Train Bleu.*"

"I wish she wouldn't do such foolish things, yet I know she does them," he said. "I expected to be with her last night. She was ill. Then she telephoned that she was better, so I was free to go to Fleuris."

Beatrice clasped her hands tight. "When I saw her at twelve o'clock in the morning, she had travelled all night. It was humid, exhausting, and she had already tried on four or five dresses. The overheated fitting rooms had made her so hot that most of her makeup was washed off. Her skin was glowing. She was much fresher than I was. Marston, Eileen is as strong as a panther."

Marston brought the automobile to a jerked stop on the side of the road. His expression had been one of rigid control as he listened. It showed the coldness she had foreseen.

Beatrice did not try to look away from him. She wanted to fathom the frozen face, and know if there was any flaw in his armor. She saw the change when it came—a look

which could have been sympathy for her delusions, or acceptance of a truth that was of no importance to him.

Very gently, he turned towards her. She told herself: *I might almost be Sandra. Now he is going to be absurdly generous.*

He spoke fast, and again she felt that he was utilizing an adroit defense. "You see, you don't live with an invalid. You can't understand it," he said. "They have their spurts of energy, then afterwards they collapse. Eileen has been ill in bed since that day you saw her in Paris. What you've been saying counts a lot with me. You know how I feel about you. I am not angry. I don't think for an instant that you are malicious or unintelligent, or that you aren't influenced by your love for Sandra. You told me simply because you think I'm an ass. Believe me, my dear, Eileen is ill. I know it. I have lived with her." He paused for a second. "Maybe I have not studied her; but I have gone though agonies with her."

She saw the foundation of her belief becoming a lost cause. She spoke quickly, struggling for calm, for reason. "That's just what you don't do," she said dispassionately. "You are right when you say you have not studied her. You have simply taken her at her word. You don't know the type." He seemed on the edge of stopping her, but Bea continued insistently, sitting bolt upright beside him. "Marston, she is a type that victimizes everyone around her. People like Eileen deceive everyone, especially their husbands. The Miss Pattersons are harder to break, but they can be broken. You are not the sort of man who could possibly suspect the lengths to which a woman will go who wants to

keep the man she loves. She can always pay doctors to deceive others. She can defraud her closest women friends—if it's worth her while. As for a very busy man, what can he know? She simply has to give a performance for a few hours a day."

"Are you proposing that I should *ignore* her doctors, her household, the governesses, and the tutors—all of them? Even Pat, who has been helping her for years?"

"Miss Patterson's spirit is broken," Beatrice said. "You must see that. I doubt she would dare tell you of her despair." She turned in her seat so that she faced him, one hand on the steering wheel. "Marston, look at it from another angle. You must not be apologetic for having philandered with other women or feel so guilty for having taken her to China. You did her no harm."

"What conceivable motive would Eileen have in revealing a secret personality to you?"

Beatrice sat back.

"She had no motive. She did it unconsciously. You see, I don't belong in her life. The deception she was engaged in was not meant to influence me. I wanted only to examine the third side of your triangle. As I said, I stayed to spy." Her voice was more husky than usual, but clear. "She represents Sandra's greatest danger. I had to know how great that danger was. I wanted to discover if she suspected Sandra. I found out not that she suspects Sandra, but that she owns you. She has Sandra's future in her hands, because she has you in her grasp." Bea fell silent. "And now," she stared ahead. "And now—I am in too deep."

She slumped back in her seat. When she spoke again, it was as though she were finishing what she had to say in a

soliloquy. "If you think back, you will remember that there had been times when you were suspicious. Repeat to yourself the seeds she has sown in your mind, about invalids having sudden spurts of energy. She's told you so often, you think you originated the idea."

Marston's hands were tense. He waited for Bea to finish. "Oh, Marston, how often she must have reminded you of your baby's death." Beatrice continued, "How generous she was about it, wasn't she? You wrecked her. She said you were both so young, and ignorant. She never blamed you, did she? But she has had two perfectly healthy children since. What do you make of that?"

Suddenly Marston spoke. "Bea, I think I am stupid," he said. "Has Sandra told you that she would not think of marrying me?"

"Have you asked her?"

"Yes. She almost took my head off. She won't have me as a husband."

*Of course,* she thought, *Sandra did not want him as a husband. But that was not the point.* "I am not particularly interested in whether she marries you," Bea said. She spoke slowly to be sure he understood. "It's what Eileen can do to you in either case that interests me."

He did not reply. She was thinking of Eileen's power for evil, her vindictiveness that could wreck Sandra. And that Marston would be powerless to protect her as long as Eileen was alive. Scandal would destroy Sandra. She recalled her talk with Frances Reed. The moment Eileen identified Marston's mistress, his career was finished. It would be Eileen Overstreet's sweet revenge.

Beatrice leaned one elbow on the arm of her seat, and her

333

head sank on her raised palm. "Here is the sum of it," she said wearily. "You can be ruined because of Eileen, and this is the only way you can be ruined."

"What's my career?" he said. "It's not worth Sandra's happiness. But I can't change Sandra."

"Why should you change her? She needs you, your career and your full power."

There was a finality in Beatrice's words. Instinctively Marston started the car. She scarcely noticed that they were once again speeding along the road.

Gradually, the sense of defeat that had nearly crushed her gave way to what she had felt in the solitude of her room last night: the same double flow of thought, the dark, inarticulate stream. But her depths of indescribable confusion merged with the first stream. And now she was filled with the terrors of conflict. Her body rested immobile against the side of the car. She was fighting an interior battle.

Marston sat like a useless bulwark beside her. *He can't help Sandra. He does not believe that Eileen is a roadblock standing in their way. She is armed with her weapons, and I am here alone with mine.*

It was as if an exquisitely sensitive nerve in her body had been touched. She thought, *I wonder what it feels like to fear oneself?* Marston could not help her. If only she convinced him of his wife's true character, but, since she had failed, a strange, primitive impulse drove Beatrice to go ahead alone.

Only as they turned into the Place de la Concorde did Bea become aware of her surroundings. How strong Marston was. It was not just his strength that she saw, but great tenderness and understanding.

334

He must have sensed her eyes on him, because he turned his head. "Bea," he said, softly, "Sandra and I have a life that is beautiful. Nobody has perfection, but we get very close to it. Now, I have something more to be greatful for—your love for Sandra, and your courage and honesty with me."

He drove her to the side entrance of the Crillon. She was immobile until Marston gave her a little pat on the shoulder to remind her where she was.

"Thanks for the lift," she said. She leaned forward to speak to him. "That sketch of Sandra's, is it going to make a difference?"

"Perhaps a great deal. But in any case, I'm going to stay with Merrimée's case."

"Good luck."

In the rue Boissy d'Anglais and through the congested traffic on his way to the office, Marston's thoughts dwelled on what she had told him. Had he not loved her because of Sandra and respected and admired her, he would have ended their talk immediately. He was determined to make an end to an intolerable marriage. Sandra wanted him as he was. Now his part lay in her protection.

At the office he went over his mail and then called for Clermont.

It was lunch time when they emerged from the building together. Clermont had received precise orders for the handling of the Merrimée case.

"I'm flying to Cannes this afternoon," Marston said. "And when you have looked into the matters I have suggested, please give me a ring."

His chauffeur stood at the curb, waiting with the car. "I'll pick you up here at four," Marston explained. "Get my bag

from François. I shall be away for a couple of days."

When he reached Sandra's apartment, she was sitting on the floor with sketches spread around her. She rose to meet him. "Apologize," she said, laughing. "For deserting me. Bea runs away with you. I am left to struggle to Paris as best I can."

"Didn't you hear us arrange our assignation last night? We thought it rather clever of us. What are you doing? Admiring your work?"

She gathered the sketches, and replaced them slowly in her portfolio. "Clermont is covering the points we discussed last night, sweet heart." He was going to tell her he was going to the Riviera this afternoon, but not just yet. "It took some arguing to make him change his point of view. I don't think that he has now, but it doesn't really affect the case. We have always had to face Merrimée's possible guilt. But if the State believes the girl exists, they will play it big. It's possible that they have evidence we don't. We have to guard against that."

"The woman must have been thoroughly researched," she said.

"By both sides. I'm convinced there is a girl, but I must find solid reasons to show there isn't."

"Marston, you sound positively unscrupulous."

"Today is the seventh," he said. "In a month it will be all over. Now that I see Merrimée in a new light, I think he has extraordinary poise. I still believe that we'll get him off."

Marston took the apéritif which Louise had just handed him. There seems to be no evil in Merrimée. Yet it stands to reason that murder cannot be permitted by law any more

336

than adultery can. If I had chucked him, no lawyer could do justice to the case with only a month to prepare, even if we turned over all our evidence. I can't leave him flat. Since the day that you asked me if I would take the case if he were guilty, I have changed. I admit it."

They were at lunch when Louise lumbered up to Sandra to say that Madame Gram was on the telephone.

"Sandra," Marston said hastily, "I shall be going to Cannes this afternoon to visit the family, in case you want to make a date."

When she had gone, he thought, *The longer I put off going, the harder it will be*. And, waiting there for her, he went back in his mind to his talk with Beatrice. He followed it step by step. What a friend she was! He would, of course, make the usual effort to see his wife. It was a pilgrimage. Then he shook himself and spoke to Louise, "What do you and your husband think about Merrimée? Is he guilty?"

"Monsieur knows." She said it with finality.

"I am going to prove that he is innocent, Louise."

"A postman would not be satisfied with such a wife. My husband says that it was his business he was attending to when he left her for weeks at a time," she sniffed.

"So you think..."

"*Ah, les gars!* They will always find excuses."

Sandra returned to find an amused expression on Marston's face.

"What did Bea say?" he asked.

"She called to reassure me that she didn't sleep with you. I told her I was going back to the country tonight."

"And are you?"

337

"Of course. There are your new books to be arranged. They arrived this morning."

"Each time it becomes more difficult to leave. I'll get back to Fleuris as fast as I can, sweet heart."

"It can't be soon enough."

He stood holding both her hands and looking at her. Then half-smiling, he said, "Will you live on a desert island with me, Sandra?"

"Certainly. Find one," Sandra said.

She looked down at their locked hands. "They don't have islands for us. We're too old."

"You don't know my capacity for youth." He smiled.

"I have no qualms about living with you," she said. "But not to run away from life! Think what we'd be missing. But I want balance."

Marston said, "Balance is not for a love like ours."

"We have our own passion, my dearest."

When Marston had left she surrendered to melancholy.

Then they were at Fleuris again. There were long talks, and silences while Marston concentrated on his brief, which had become exciting to them both.

"It's the best I have ever done," Marston said on the morning he took it to Paris to be typed.

The only shadows in the brilliance of her days, since they had been living at the château, came when she detected a tiredness in his eyes and a slight droop of his shoulders. His fatigue came, she knew, from the person about whom they never spoke. She deeply resented Eileen's influence on him. *How can it be that she has such power over him that she can make him sad even when he is away from her?*

## A Love Affair

The week of complete rest that Marston neeeded before Court opened was approaching. "Rather than have any discussion, I am going to Cannes," he had announced.

Beatrice had written Sandra from London:

> *Bob thinks, since we only have ten days for our trip, we should take the night train to Clermont-Ferand and have the car meet us there. It will cover a lot of ground new to all of us. I often think of my night with you in the country. Do be careful, Sandra, darling. I dreamed the other night of Jacques whispering horrid things to Eileen! He was laughing like Mephistopheles in Faust! We get back on the 18th.*

The day Marston was leaving for the Riviera, he drove Sandra as far as the Porte de Villette. He waited until she had found a taxi. She threw him a sad smile and a wave as she was driven away, craning to look out of the rear window for a last glimpse of him.

*Paris is indifferent*, Sandra thought, as she turned to confront what was still, even without Feodor's and its binding hours, the long day to fill.

Felix Marbeau reported ten days later that the Grahams' automobile trip had been an extraordinary experience. Now, sitting in his library, it disturbed him not to be able to say exactly *why*. He was a connoisseur of feminine impulses and psychology. To be mystified by the behavior of two women was a poor reflection on his power of analysis. It gave him a pang of discomfort.

## A Love Affair

It was very well for Sandra to have a love affair, or for Beatrice to be restlessly preoccupied, but that it should create an atmosphere of distress seemed inexplicable to him.

Despite his efforts, and Bob Graham's, to dispel the clouds of gloom, they had grown darker.

A single incident during the trip had given him pure pleasure. Count Marbeau judged himself a connoisseur of women's clothes, yet even he was genuinely startled and ravished by Bea's appearance when she came down to dinner the night they spent at Carcassonne. She wore a simple black gown, which very few women could have worn with such grace, so straight in line and so austere in effect. A gold belt and bracelet gave off shimmers of light. A necklace of twisted coral beads encircled her neck and fell halfway to her waist. Their clasp, consisting of three rather large filigree gold balls, lay close to the side of her throat, on the inner strand.

As the evening went on, Count Marbeau realized her costume was a foil for her personality. Beatrice constantly launched into spontaneous outbursts of stories and opinions. She was often joking and effervescent, certainly pagan, but pure. Count Marbeau often thought of a galloping filly in a green pasture. Bob had also been delighted with Bea, but Sandra seemed not to respond. In the turn of a phrase, Bea could envision emancipation without expressing it. *If I had never known her before,* the Count thought, *I would have attributed to her extraordinary knowledge of the mœurs of ancient times as well as of today. But with only an impish comprehension of their meaning, she danced on the tightrope of fantasy as though she were standing on solid ground.*

Remembering Bea from a distance, Count Marbeau was convinced that something fundamental had been awakened in her. Yet Sandra stood apart, listened to Bea, distracted, almost hostile.

Then there had been the Cathedral of Albi; all morning Beatrice had been silent, but a friendly silence, which they had enjoyed sharing, but a stillness from which Felix felt she longed to escape. Her efforts to do so were hopeless exhibitions of failure. At Albi, she embraced the solitude of the chapel, and Count Marbeau, finally wandering alone, met Sandra there, perplexed and sad. The shadowy vastness of the Cathedral exaggerated his puzzlement. Bea had said, "Do you ever have days when you feel as though you were looking through distorted glasses?"

Later, Sandra confessed to him that she hadn't been able to interest herself in the beautiful things they had seen on the trip. Marbeau had guessed then that her lover was not responsible for her mood. Beatrice was the source of it, feeding on some half-understood experience too unclear to comprehend.

The next day when a telegram had come for Sandra, summoning her back to Paris, Count Marbeau felt sure that somehow she had instigated it herself and he resented the fact that Bea had spoiled Sandra's holiday. After she had gone, Beatrice suddenly became talkative and altogether inconsequential, much like she had been at dinner at Carcassonne. Bob seemed relieved at her lightheartedness. But it did not add to Felix Marbeau's pleasure. It was too reckless to be comfortable.

*I am a foolish old man*, he told himself, as he stood now in front of his books. *I take my friends as I find them, enjoy*

*their foibles and make light of their moods.* He passed a loving hand over some of the volumes. *They look nice,* he thought, *they feel nice. But it is what is within that counts, and so it is with friends.* He picked out a green bound volume, and taking it with him to the old upholstered chair near the lamp, sat down wearily. *My legs are no longer strong. My liver has seen better days, and my heart beats too fast at times. I cannot love as once I did. Dieu soit béni, that I have still the capacity for sympathy, yet the longer I live the less I understand women.*

## 22

Beatrice walked from her car towards the large stone house on the Avenue Henri Martin. She betrayed a certain reluctance, as if she were unwilling to leave the sunlight. Yesterday the weather had turned unseasonably warm and sultry. Now the heat was luminous with memories of summer. Bea remembered the last time she walked through that door she had been with Mrs. Reed. It was just two months ago. "I am not ever going back again," she had said, and the American woman had smilingly replied, "I've said that, too. You'll be just like me. If you ever get to be Marston Overstreet's friend, you'll overlook Eileen."

Now Beatrice was returning because she was Marston Overstreet's friend. But she could not overlook Eileen.

When Bea returned from her trip two days ago, Eileen's invitation to a cocktail party for this afternoon was waiting for her. Beatrice had sent a prompt acceptance. Bea guessed that the party was to celebrate Marston's victory in the affair Merrimée, which was now almost a *fait accompli.*

A pair of well-creased grey-and-white striped trousers preceded her through the door into the house. A few people were scattered in the hall. But the main party was

343

taking place in a room at the end of the hall. Bea could see beyond open double doors figures against a red damask background. The sound of voices came to her ears.

Brilliant lights, a profusion of flowers and an excess of liveried footmen lent an air of festivity to the scene, yet it was hardly sustained by the impression she had at looking toward the great Italian salon.

Her first thought was that the news, which they had been invited to hear, had just come in, and would be bad. Marston had been defeated. But a look at François' benign face told her that this was not the case.

She approached the open doors from which the entire room became visible, and suddenly the scene appeared to change before Bea's eyes. Eileen became the only conspicuous object in it. Everything else had vanished. The room seemed strange and silent.

A crimson-covered *chaise longue* extended in front of the fireplace. It formed part of a semicircle of chairs occupied by unidentified human forms.

Eileen, half reclining on the crimson cushions of the sofa, was wearing a clinging gold satin gown, high-necked, long-sleeved and very sophisticated. The light was adjusted for theatrical effect. Added to this was the glow from the fire. The arrangement, studied or otherwise, was in dramatic contrast to Eileen's white, masklike face, her crimson lips, and the purple shadows of her eye makeup. Eileen seemed grotesque yet fascinating to Beatrice. She forced herself to look farther into the room, becoming aware of buzzing voices. She saw several men standing in the group around the mantel who were talking to the mummies sitting in the

circle of chairs. The figures came to life now. She recognized Judge Boissonier talking to Eileen. Two other men whom she did not know had joined the others.

At the farther end of the room, a long tea table was set as though for dinner. It was covered with flowers, with gold baskets of fruit, platters of delicacies of all kinds. Most of the chairs were occupied by chattering men and women, while other liveried servants circulated with trays of liquid refreshments.

Behind a large silver urn at the end of the table a surprising figure was seated. Miss Patterson, upright, was obviously suffering, but she was pouring tea with determination. Bea concentrated on present reality. She noticed that the flowers in the room were adjusted charmingly to their background, and that two handsome Italian cabinets between the windows looked perfect there.

Bea watched Miss Patterson, behind whom the wall glowed in the incongruous gold of a primitive saint.

There were perhaps fifty or sixty people scattered about. Everyone was talking in low voices, she thought.

She made a forward movement. "Madame Graham," François announced. In a moment she was next to Marston's wife.

From the pose Eileen had assumed, she now made a gesture of greeting unlike what Bea had seen before. *Her society manner*, she thought. Eileen's voice was also unfamiliar. It was lower, unmetallic and appealing.

"Not a word," Eileen said. "The jury is still out."

Judge Boissonier addressed Bea. "I was telling Eileen she need not worry," he said in French. "Her husband will win,

345

without a shadow of a doubt." He leaned over toward Eileen solicitously.

Eileen sank back on her cushions, both hands clasped to her heart. "The waiting. The anxiety," she murmured. "I have been so worried all day."

"How brave you are!" the Judge murmured.

Beatrice turned away quickly. The thought which had been foremost in her mind when she arrived came rushing back. The room receded, then flashed back. She wanted to go and speak to Pat at once, but the next moment she began to feel an element of excitement in the crimson-hung salon. She had felt some of it in the hall. Merrimée's name, the familiar characters in the drama, references to the summing up of the case, and the Judge's recommendations, bits of it came to her from several conversations she overhead. Excitement electrified the room. She found herself in conversation with people she did not know. Guests were moving around. Confusion reigned as they changed their seats or walked from place to place. A number of tea drinkers joined the group in front of the fire. Others took their places at the table or helped themselves to cocktails. A Frenchman named Tessier joined her and asked her to have tea with him. For a few minutes she forgot Miss Patterson. Now she imagined that Eileen was chastising her by forcing her into a subservient role.

She smiled at Tessier and her eyes sought the farther end of the room. She was shocked again by the incongruous figure in black against its background of a golden saint, which breathed the beauty and sanctity of complete indifference.

Beatrice led the way to the back of Pat's chair where the

346

haggard woman, who had seen her approach, raised her head to listen to the half-whispered words: "Let someone else do this. Come and sit with me."

Miss Patterson threw a furtive glance toward the other end of the room, then murmured, "Let me go on now. No, I mustn't stop just yet. In a little while." Her hands fumbled along the cups. Something out of the ordinary must have happened. Bea knew that the greatest kindness would be to leave her for the present. Immediately she felt anger sweep over her. She drew herself erect and heard Tessier speaking:

"Here are two seats, Madame, not far from your friend. Shall we sit down?"

They took the chairs while she struggled to control herself. The general conversation was loud so that her silence passed unnoticed. Everyone was speaking about Merrimée in French.

Bea heard a pretty young woman nearby saying, "Louis wasn't as good a witness as everyone expected, don't you agree?"

A man next to Tessier, who looked like a government official, answered, "His testimony reads well, but if you had been there to see and hear him, you'd think otherwise."

Tessier leaned forward, joining in the conversation. "Clermont's strategy in handling the 'mysterious woman' was a consummate maneuver. He could scarcely have known, considering the lack of evidence, that the State was going to play it up so big, yet he was thoroughly prepared."

"What motive could Merrimée have had?" asked another strange voice.

"Ambition, a quick temper, and a desire to better himself

347

in the world," Tessier said. "Any number of things."

"The alibi didn't wash," the pretty woman suggested.

Beatrice roused herself. "Who can remember exactly what had happened," she said, "If you did not really have to remember?"

The man who looked like an official smiled at her. "You are right, Madame. This made an impression on thinking people."

"It must be a great strain on Overstreet," Tessier put in, "sitting there running the case yet being unable to argue it himself."

A pretty woman announced that Marston Oversteet was more effective off his feet than most men on theirs.

"Young women line the sidewalks on which he passes," a woman said, intimating that she was yet another one of his victims.

Bea heard a familiar voice come from behind her chair. "I feel as if my own life were at stake," Count Marbeau said. She looked up to see him leaning over.

"The jury has been out for more than three hours," Beatrice said.

"The smart rascals are undoubtedly playing *trente-et-un* and waiting for a discreet amount of time to elapse before coming back to the court with their great opinion," Marbeau said sarcastically.

"Excuse me," Bea said to Tessier. And with a quick movement she rose and took a chair next to Pat. Beatrice could not resist her unspoken call for help. "What's the matter?" she whispered.

From the frozen aspect of her face, Beatrice knew she'd made a mistake.

"It's my nephew," Pat faltered. "He is very ill."

Beatrice remembered the story of her nephew, Pat's only living relative, who was travelling somewhere abroad.

She drew her chair closer. "Where is he?" she asked.

"He's at Fontainebleau. He's been staying on a pension there. He has pneumonia." She slumped in her chair. "He had a cold. I only heard after lunch that... that it's a crisis." She stared at Beatrice helplessly.

"But you must go to him at once." Beatrice was on her feet.

Pat seized her convulsively, pulling her down. Her eyes darted from Bea's face to the other end of the room where Eileen now sat up on her sofa, propped by cushions, a cocktail glass held in one hand. Even at this distance, she stood out.

"She said she needed me to pour tea this afternoon."

"Come," Bea interrupted. "She doesn't need you anymore. Hurry, Pat." She unconsciously called her Pat for the first time.

"You don't understand." Pat didn't move. She was unable to take her eyes away from Eileen. "She is going to be alone tonight. Marston has to be with a client somewhere out of town. She won't let me leave her."

"I'll fix that." Bea sat down again and put one hand over Miss Patterson's bony fngers. She spoke to her gently. "You know he needs you. You come with me. We'll get your hat and coat." She was stifling her anger, intent on her task. "You can take my car. It's waiting outside. I'll go with you, if you like. Hurry!"

Miss Patterson got up awkwardly. She was upset by the noisy room.

Beatrice took her arm. She saw Tessier rise as though to join them, but one look at Pat's face sent him back to his chair.

Half way across the room, Pat stopped. "You don't understand," she said. "She refuses to be left alone at night."

"I understand. We will just walk out. A lot of people are here. She won't notice."

"No, no, I can't," Pat said. She was trembling.

"Then I'll ask her myself."

"Please don't. She'll be very upset."

"Miss Patterson, you are being absurd. She can't do anything to *me*," Bea said angrily. "And you don't owe her anything. Come."

It's no use," Pat persisted. "She *can't* be left alone." Then with a sudden fury she said, "I want to walk out and never see her again."

"You wait here," Bea commanded. "I'll go."

And then a sudden electric wave of excitement seemed to pass through the room.

*"Les nouvelles! Ecoutez! On va nous apprendre les nouvelles!"*

There was nervous laughter and suppressed voices, followed by silence.

A minute later a sharp, strident French voice filled the silence. It was the radio announcer:

The verdict in the affair of the State versus Louis Merrimée has just come to us from the Court of Assizes.

After a short dramatic pause, the voice then continued:

## A Love Affair

The verdict is not guilty. The decision—unanimous.

No one waited to hear more. The sedate quality of the party vanished in an outburst of enthusiasm. Exclamations, laughter, and loud conversation all exploded at once. It swept through the ancient room like a storm. Beatrice was carried along in its wake. In its midst she felt Pat's hand on hers. Her face was transformed, "Oh, how happy I am for Mr. Overstreet. He *deserves* this," she said.

The first uproar subsided like a breaking wave, and people now listened to what others had to say. Then the next wave broke. It seemed everyone had known the upshot before. "I told you so!" echoed on all sides. Each revealed his own inside information.

Beatrice stood beside Miss Patterson. It was now impossible to approach Eileen. Everyone was heading in her direction. She was hidden from view. "Let's go. No one will see us."

Pat gasped. "She'll work herself into hysterics. I can't go."

They stood isolated by gesticulating people.

"If you won't go without telling her, you'd better sit down. I can't reach her with that mob around."

"Anyway, Mrs. Graham," Pat said in a changed voice, "I must wait. I want to see Marston." There was a spark in her tired eyes.

For almost half an hour, Bea watched Eileen, waiting for an opening, but the crowd was still dense. Her rising impatience became suppressed anger that was almost unbearable. Then just as she was about to force her way through

the noisy crowd, she heard a commotion in the big open doorway.

Into the tumultuous scene strode the figure of Marston. She saw his straight shoulders for just an instant.

*"Le voilà le hèro!"*

She gave Miss Patterson's arm an encouraging squeeze and edged her way nearer the fireplace, where she could see him more closely. He was pushing his way toward Eileen, laughing, polite, but firm in his intent. Those nearest realized and made way for him. A little empty space suddenly appeared around her as if it had been cleared.

As Marston reached the *chaise longue*, he stretched out his hand. He took her hand with both of his and leaned down to kiss her. She fell back with an exclamation. He straightened up.

Immediately he was surrounded, bombarded with questions. Through the crowd Beatrice could only get glimpses of his face. He looked tired, but he had the look of triumph. The youthful simplicity of his pleasure touched her.

People began to ask him questions. The room grew quiet awaiting his answers.

Bea was not listening to what he said, but she felt his charm. It was a palpable thing, more real than the Italian cabinets. Yet his power was the power of life. She envisioned him as a leader of men, as an influence for sanity in a world gone mad with bankrupt theories. She remembered Judge Boissonier's words: "America needs him."

She saw that one of the damask curtains blew into the room, but she could not feel the breeze that was moving it. The room was warm and airless.

Looking up, she noticed that an exquisite pale blue ceiling was overhead. It had square designs in arabesques, outlined in gold, painted on it. Then, it seemed, the great Italian salon was gone as if by magic, and she was moving along a road in a car with Marston beside her. What she had hoped for had not happened. He could not actually, concretely, help her. It wasn't his fault. But here he was. This was the life he had chosen to honor. The effigy on the *chaise longue* was the reality, the chain that bound him, that held him, that kept Eileen under a painted ceiling, instead of his own boundless sky.

Eileen's gold figure against crimson cushions with Marston near her hit Beatrice like a blow. She closed her eyes. With the strength of her inner vision, she saw Sandra and her lover in the library at Fleuris. "Darling, I'll be with you in a minute," he said. Sandra had smiled.

When she opened her eyes, she saw that Marston had discovered her. Quickly she turned and went back to sit with Miss Patterson.

People had begun to leave. She realized a long time must have passed.

"I'll ask her now," she said to Pat. Marston was moving away from his wife's side.

Pat was saying something. Bea leaned closer to hear. "If she could get someone to dine with her, then, you see, I could come back before she went to bed."

"I'll try. Who is there? I don't know her friends."

Miss Patterson stood slightly swaying, as though at the end of her strength, while Beatrice felt her own courage ebbing away. Objects in the room and people became

353

bright and very close to her as though she had lost her depth perception.

Wherever she looked, she saw Eileen's face. She saw her yellow swathed figure as a flame, extinguishing all other light. When Marston had gone, Beatrice went up to her. She forgot everyone else in the room.

"Miss Patterson is very much upset," she said. "Her nephew is ill. My car can take her to him..."

Eileen looked as though a stranger had gone suddenly mad. She stared at Beatrice without speaking.

"I'll see her on her way," Bea finished.

Eileen's reclining figure came abruptly to life. "What do you mean? Pat can't leave me. I have had a terrible day. Can't you see that I am ill?"

"But her nephew has pneumonia."

"What about me? I can't be left alone. My husband has to be out of town. He won't be back tonight."

Beatrice stood beside her very erect, her blue eyes looking right through Eileen. "Couldn't you arrange for a friend to dine with you? She could be back before you go to bed." She noticed Eileen's expression change, as though she suddenly recognized Bea.

A wistful smile crossed Eileen's controlled features, as though some pleasant new toy had been offered to a spoiled child.

"If *you* could come," she said. "Could you?"

This was a stupefying thought. "Oh, I couldn't. I have an engagement, but why not one of your friends?"

Beatrice saw Eileen's displeasure.

She spoke abruptly, harshly. "Tell Pat she can wait until

tomorrow. Then I will see." She turned away to say good-
bye to a guest.

Beatrice flinched, then thought, *I will have to dine with
her if Pat is to get away.* Returning to Eileen, she said,
"What time do you dine?"

"Half past eight. That will give me time to rest. Will you
tell François to order my car for Pat? She must be back be-
fore I go to bed."

Bea drew away. Her place next to Eileen was immediately
filled.

"Quick," Bea said, "Go get your things. I'll tell François
to bring the car at once, before Mrs. Overstreet has time to
change her mind."

Miss Patterson could scarcely speak. She held Bea's arm,
squeezing it with her strong, bony fingers.

"It's all right. I am coming to dinner. You'll have plenty of
time. She wants you back when she goes to bed, but you
telephone me here if your nephew isn't better."

"Do you have to have dinner?" Pat said in dismay. "You
will hate it."

"It doesn't matter."

Beatrice hurried Pat out through the hall. Guests were
still talking and gesticulating aimlessly.

Marston was gone. The faces of the guests looked differ-
ent under the bright lights. The flowers had wilted in the
heat. Beatrice was angry, and sank into deep thought. Then
she realized that she must leave. She would return to dine.
Marston's wife and she would spend hours together.

After saying goodbye to Pat through the wrought-iron
door of the lift, she reminded François to order the car, and

followed the flow of departing guests.

Outside she thought, *Pat is free, but I am trapped.* The late afternoon was opalescent with soft colors—St. Martin's summer. *Let me be strong*, she said to herself. *I'm going back. I must go.*

Then she remembered Bob. He wouldn't like her not showing up tonight, because they were dining with some people who were interesting only to her. He hadn't wanted to accept. *He's so good to me*, she said to herself. *He understood my moodiness on the trip. I wasn't so bad after Sandra left, but how devastated I was! I wish I had seen her after we got back, but she stayed away at the château. It won't be long before Marston is there with her. That's where he is going, of course. It seems dangerous, somehow, their being there tonight, but really, there's never any difference. It's always terrifyingly dangerous.*

When she entered her sitting room, Bob was there with two of his American men friends. They were waiting for her to make a fourth at bridge, and talking excitedly about the Merrimée verdict. She tried to remember something Marston had said, but failing that, remembered Eileen falling back on the cushions.

"I have to make a telephone call before we play," she said. She told Bob about Miss Patterson.

"Do you mean she wouldn't let the old lady go?"

"I had to promise to dine with her."

Bob took it very well.

"What sort of a woman is she?" one of Bob's friends asked. "If she's an invalid, why doesn't she just go to bed and stay there?"

"You are too damn nice, Mrs. Graham," the other man said.

"Bob, I'll get away in time to join you after dinner."

They sat down at the bridge table. The windows had been open all day, so that the room was cooler now. A slice of blue sky was over the Place de la Concorde. They could hear the newsboys below, shouting out Merrimée's acquittal, punctuated by the roar of traffic and horns. The thrill of the city was below them.

It was comfortable in the big sitting room. It did not feel like a hotel apartment because of photographs and odds and ends. Their own books were spread untidily about. Bob had been investing in bright Charvet dressing gowns. He had brought them in to show his friends. They lay across two chairs, sprawling like limp figures.

When the men had gone, Beatrice went in to dress. It was late and she must hurry. It seemed unreal that she was going to dine alone with Eileen. A physical repugnance swept over her as she put on the dress laid out on the bed by her maid. It was not until she looked at herself in the mirror that she noticed it was the black gown with coral and gold trimmings—the same dress she had worn that night at Carcassonne.

Bob stuck his head in through the door and said he could drop her off and still have time to take the car to the Ritz. "What time do you want it back?" he asked.

"Ten o'clock, I think. And, Bob? Leave word with Marcel where you'll be. If I get away early, I promise to join you."

At the iron grille door in the Avenue Henri Martin, Beatrice

said: "Now Pat's gone, I'd like to leave Eileen flat."

But then she trembled. *Eileen alone. If she has any sus-picions, she will talk about Sandra tonight.* Then she went into the stone house.

# 23

"When did Miss Patterson leave?" Beatrice asked François, as he closed the elevator door.

"FIfteen minutes after you left, Madame. Press one, please."

Now she felt completely isolated. A few minutes ago before she had entered the hall, she sensed she was being driven by the power of an alien will. Had she left her own identity at the entrance?

It was a relief a minute later to be out of the cab and in the second-story hall. The lights, she observed, were somewhat dim, but a brighter triangle came from the end of the hall where lurked another distasteful image: a portrait of the old countess.

A serving table stood near the door to the salon, suggesting that dinner would be served in the panelled room.

She paused to look through the open door into Miss Patterson's room, then, with a slight shiver, walked on.

François, who must have walked up the marble stairway, met her at the head of the stairs. He informed her that he had been fortunate in reaching the Pension Marguerite on the telephone before Mademoiselle left. The young nephew was no worse.

359

"What's the matter with him, François?" she asked, just to make conversation.

"Pneumonia. But I hear that there is a good doctor at Fontainebleau."

Beatrice felt strange. *Oh, yes, of course. That is the reason I came.*

"Madame is very agitated. I think she may keep you waiting," said François. He gave her an inscrutable look which she did not understand. "I will bring Madame an apéritif and some canapés now."

The rather dim salon had been changed since her last visit. A twelve-fold Coromandel screen had been placed to form a quiet roomy enclosure, and it was from behind the screen that she now saw the bright light. The maître d'hôtel led her to an open space which served as an entrance to the corner. Directly opposite was the closed door to Eileen's bedroom. It seemed very silent.

In the center of the temporary dining room, a small round table was set for two. It glistened with highly polished silver, the unshaded candles adding highlights to beautifully thin glass, damask linen, and, in the center, a low bowl of red roses reflected in a mirror underneath.

In a far corner was a sofa, next to which stood a table with a lamp shining down on an assemblage of china animals. Armchairs and smaller tables gave this corner a rather informal comfort. The screen with its old gold Chinese script formed the third side of the room. It blended agreeably with the oak *boiseries*. The bright cerise curtains and furniture upholstery, the very red roses, of which there were more on a small table, made bright accents in the room.

360

Other lamps gave out soft light, one lonely yellow-covered novel lay on a little walnut console.

François must have left her and come back without her realizing it. He stood beside her with a tray and some newspapers. She took the glass he offered, and he put down the tray and the papers on a table next to a large armchair. He was wordlessly telling her to sit there, indicating that she might have a long wait. She crossed the room and sat down on the sofa instead. She was full of rebellious thoughts. Eileen's possessiveness seemed to permeate the whole house. It reached François, and imposed itself on this ancient salon. The countess' ancestors, for whom it had been built, would have resented its partitioning, and have been appalled by Eileen's taste.

How suffocating the autumn night felt! She had already been here a long time. The window near the sofa where she sat was slightly open, but only a breath of warm air seeped through the damask curtains.

*If Eileen suddenly appears*, Bea thought, *there won't be enough air in the room for us.* She did not like this hostile house. She then had a fantastic vision of herself violently upsetting the room. Oddly, she could not remember her reason for being here. To control herself from disturbing her hostess' dining room was not very difficult. But she had lost power over her thoughts, and they rebuilt a vision of the Italian salon of that afternoon, rebuilt it with such faithful exactitude that it seemed she stood once more at the door looking in. The languishing golden figure, the proficient lighting, the sophistication of every detail, appeared before her on one side to be rapidly followed on the other by the wilted form of Pat, like a creature broken in harness,

unable to help herself. Two months ago Miss Patterson had shown signs of rebellion. Perhaps Eileen had given another twist of the screw.

Beatrice felt oppressed. Recklessly, she went to the window, pushing it wide open. A whiff of air came in, but not enough. She leaned out, looking down at the almost silent street. A car was coming, the sound of its motor becoming louder. But even as it raced by, its sounds were discreet in the sobriety of this residential section.

Pulsing, throbbing Paris might just as well have been miles away. Only faint rumblings of traffic, like echoes of dim thunder, could be heard. Nothing happened on this somnolent avenue.

Beatrice had no idea what time it was. It could have been only ten minutes since she arrived, or it might have been an hour. *Probably,* Bea thought, as she turned away from the window, *at this moment Eileen is decorating herself for another tableau vivant.* She was aware suddenly of real thunder. She looked back and saw a pale flash of lightning low in the sky. It lasted only a second and she walked to the dining table. As she came into the candlelight, the blackness of her own dress and the coral beads which hung around her neck interested her. It had been chosen by her maid and put on thoughtlessly, but now it had a significance, associated as it was with the dinner at Carcassonne, when she had been carried by flights of fancy into entertaining and bewildering Bob, and astounding Count Felix Marbeau. And Sandra. Sandra had not liked her mood. It was probably because she did not understand it. But, neither had she, entirely comprehended her own feelings. In a misty way, she

recognized that it had something to do with worrying about Sandra. Later, after Sandra had left them, one day they had been near the ocean and she had felt as if she had broken loose from some anchorage and was setting sail for a port too far distant to be on the chart.

Suddenly, out of the muteness of the house, the door from Eileen's room was thrown open. It swung straight out into the room, and jarred loudly against the panelling. If Eileen had not stretched out her left hand to stop it, it would have struck her on the rebound.

Eileen stood there immobile.

Beatrice instinctively reached for the back of a chair. She clung to it as she stared at Eileen.

Eileen's naked arm still rigidly held back the door. With her right hand she clutched a frilled pink garment over her chest. It seemed as if she had shrunk, for the tasteless wrapper trailed all about on the floor. She had not taken off her makeup. Beatrice could see on her neck and parts of her shoulders a healthy, natural color. By contrast, her masklike face gave the appearance of being severed from her body by the boundary of white makeup, which now defined what had earlier been the neckline of the golden dress.

Whatever happened between the afternoon and now, had ravaged the purple shadow of the lids and under the eyes, shamelessly smudged the cheeks and left uneven ridges on the drawn-down mouth. The face was set and angry, and her expression remained unchanged as her gaze was fixed on Beatrice. She nodded perfunctorily, but at the same time she was speaking rapidly over her shoulder in French to someone in her room. "Take away all those

clothes! Take everything away! Do you hear me? Take it all away. I hate it!" Her voice was metallic, high. "You damn imbecile! Take it all away. Take everything away. Do you understand?"

Beatrice had recovered, and stood watching as Eileen took a few steps into the room. She watched her distraught face, saw her turn, reach back for the door, and quickly, but silently, close it behind her.

"François," she called, her voice still high, "Where are the cocktails? Bring them, bring them."

She sat down abruptly in a nearby chair, and then, as if remembering her guest, said, "I couldn't help keeping you waiting. I've had a dreadful time."

Beatrice said nothing. She walked out from behind the screen and met the maître d'hôtel as he was crossing the big salon. He must have heard his mistress' voice. Eileen Overstreet didn't try any explanation, but took the tray from him. "Wait outside," she said.

She poured out two cocktails, handed one to Eileen and brought the plate of canapés from the table where François had left it.

Eileen sank deeper into the cushions. She took something from the plate with her right hand and her wrapper fell apart revealing a silk lace-trimmed slip.

Beatrice refilled Eileen's glass again. Eileen looked steadily ahead of her. She drank and ate mechanically. Beatrice went back through the dim salon to the door.

Two footmen were approaching along the hall with trays of covered dishes. François stood nearby. Bea spoke to him: "I really think Madame is quite ill. Will you leave some cold food for us on a tray here, in case we want to eat later?"

He showed no surprise. Only a slightly pained look showed on his benign face. "I will do as you say. If you do not mind taking this decanter, I think it will benefit Madame. I will leave the tray here and close the doors. The bell next to Madame's bed calls her maid, the one near the door is for me."

He started closing the side of the door near him. Beatrice saw him wave the other servants away. They went back to the lift. She saw that François was studying her face.

"Something took place," he said respectfully, as he handed her the decanter. "After you left this afternoon, two of Madame's friends remained when everyone else had gone. Monsieur had also departed in his car."

"Yes, François, thank you. Will you let me know if Miss Patterson telephones, or when she comes in?"

As she came from behind the screen, she put the decanter down on the table. She saw that Eileen had not moved. It was strange, how totally abject she was. Undoubtedly, Bea thought, Eileen has made the right choice in the selection of her role. Bedecked and immaculately preened, her languorous manner and her efforts at courage had been a masterful deception.

Beatrice sat down in an armchair nearby and quietly drank her cocktail. *It's time,* she said to herself, *to light the fuse. There is a bomb here, I'm sure. What the length of the fuse may be, I can only guess.*

She put down the glass and spoke casually. "All the evening papers and everyone says that if it had not been for your husband's handling of the case, it would never have been such a great—"

She could not finish, for, with a violent gesture, Eileen

365

was on her feet and a hoarse sound came from her. Her
empty glass smashed on the rug. She made a lunged step
forward, tripped on the edge of her wrapper and clutched
at the dining table to steady herself. There was a rattling of
plates and glass. In a moment, she had regained control. She
was firm and rigid, leaning against the table, her hands
spread over the cloth, her eyes fixed on Beatrice as if she
were about to attack her.

Bea remained immobile in her chair. She struggled to
conceal the fear that Eileen's anger might soon be dirccted
against her, as a friend of Sandra's.

Eileen started to speak. It was with difficulty that words
came through her crookedly painted mouth. "I suppose
you saw that everyone here this afternoon was laughing at
me." She leaned further across the table. The candle flick-
ered perilously near her disordered hair.

Bea grasped the candlestick, held it at arm's length, then
slowly, carefully changed its position. She was sure at that
moment that Eileen was thinking only of herself. "I don't
follow you," Beatrice said, and sat down.

"Then you haven't *heard?"Eileen demanded. Her face
was a study of wary cunning.*

*"Heard what?"*

*Eileen relaxed her hold of the table and dropped into the
chair beside it, her eyes fixed on the red roses. She took up
a fork and began tracing lines on the damask cover. "I
wondered," she look at Bea, "I wondered why he was
away so much of the summer. He left me alone most of the
time," she said bitterly. "'Working on that damn case,' he
said. And to think I was fool enough to believe it!"*

366

Her uncovered neck grew red with anger. She passed a hand through her hair. Then suddenly her head sank, her eyes fixed on the fork which she had continued to move automatically backward and forward. There was only rage in her look. Beatrice could read no sign of sorrow or hurt.

Could it be possible that Marston's wife did not love her husband? Did her possessive instinct make love impossible for her? Her pride! Only her pride was important to her. Later she might discover she had a broken heart. Beatrice shuddered at the thought.

Without looking up, Eileen said, in her metallic voice, "It appears that he was coming to town to see some woman." She threw the fork. It hit the table and bounced onto the floor. Then she laughed, a shrill laugh of disdain. "It appears," she went on, "that there is a woman, not a whore, a nice respectable woman, whom he visits in town and in the country, not very far away. He *keeps* her.

It was Beatrice who now stared at Eileen. She fixed her in her gaze until Eileen raised her head and saw her blank expression across the table.

"Do you mean really that you haven't *heard* about it?" Eileen asked. There was incredulity in her voice.

"I have never heard your husband's name coupled with any woman," Beatrice said calmly.

"Well, perhaps it isn't so bad then. Perhaps what I was told is true after all. He's been careful." She stopped, somewhat calmer. But some other thought must have struck her for Beatrice saw a menacing shadow move across her mottled face.

"Careful! Perhaps this woman and my husband aren't

367

common gossip. Then," she blurted, "who are the people you know in Paris?"

"I just happen to know a lot of people you know," Bea answered smoothly. Marston's wife must be made to minimize her suspicions. "My husband goes to the Travellers a lot and he's always put up at the Jockey Club. We have a lot of friends among the diplomatic corps. I assure you, your husband's name is mentioned very often—" She stopped, in fear she had said too much.

A canny look came into Eileen's eyes. Now, perhaps, the direct accusation was going to come. Would she say, *You are protecting her?*

But Eileen's strength abruptly left her. She fell back into a chair. "It's true, of course, it's true. After all I have sacrificed. Men are all alike. They love to humiliate their wives. And after all I've done for him. But perhaps the gossip isn't all over Paris. When he gives her up, as he shall, it—Quick! Give me something to drink. I feel faint."

Eileen's head sagged just below the white ridge on her neck. A few beads of perspiration showed on her forehead. Her hands were limp.

Beatrice filled a wine glass from the decanter and held it to her lips. Eileen could smell that it was whiskey.

Eileen swallowed a little and her neck resumed its natural color. The whirlwind of rage into which she had worked herself was subsiding.

"Would you like something to eat?" Beatrice asked.

Eileen was perfectly conscious, but she made no answer. Her face was frozen in hard, immovable lines. Beatrice crossed the partitioned room, went out into the salon and

opened one of the doors leading into the hall. She felt like a perfectly equipped machine with the power to think, reason, and act, irrespective of emotion. It was exciting to feel that way. She needed her strength. And she needed it more than she ever had in her life.

She had been right about Eileen. A deceiver, who did not love her husband. She believed only in possession. She was also a bully. A destroyer. As Bea picked up the tray in the hall, she wondered what time it was. It must be late. There was one more thing she must know. She must find out if Eileen had any knowledge of where Martson's mistress lived. She was now convinced that the couple who had seen Sandra at the Jardin Joli had been responsible for telling Eileen. If one started with the fact that restaurant was close to Dreux as a pivot of information, Fleuris could be discovered in no time. Yet with no control over her husband, how could she force him to give up his mistress? But there were other avenues of approch. De la Roche, who could have become vindictive. Archie, who only half-innocently might have said something to the wrong person.

When she came back, she straightened the dishes on the dining table, picked up the fork, and pushed the bits of broken glass under the chair from which they had fallen. After replacing the candlestick, she put some food on a plate and put it in front of her hostess. While doing this, Bea saw that Eileen was revolting. She couldn't sit here at a table with her.

Eileen suddenly began to speak. It was in sing-song, like an oft-repeated lesson. "You don't know what he did to me, of course. How could you? I was nothing more than a

child, just married, innocent, loving. He was always absorbed in his business. Then came a chance for his advancement—I was going to have a baby. He took me to rural China." She waited for her effect. Beatrice had heard the story from Sandra. She moved to the window and looked down into the almost deserted street. After a short pause she went back.

"Eileen, don't you think if you bathed your face, you would feel better? Some eau de cologne, perhaps? You will find it easier to eat, and you really should eat something."

She went to the door of the bedroom and opened it.

"I know I am a sight. Yes, he took me to a place in China. It was where he worked, a terrible place. I wanted to be with him, and..."

"Do go and wash your face."

Eileen was enjoying the story. She wanted to go on. But Beatrice did not move from the door. "If one of the servants came in," she added quickly, "they might gossip."

The older woman got up. Something in Beatrice's attitude forced her to go. Then she remembered her open wrapper, pulled it around her and hiked it up in front, so that she could walk without stepping on it. She crossed to the open door. In the bedroom the lights were dim. The brightest of them was the lamp on the table by the bed. It reflected the knickknacks and bottles. On a chair nearby, Eileen's flimsy nightgown lay over another wrapper, and below on the floor a pair of mules lay side by side.

Beatrice stood in the doorway, not looking at Eileen's progress across the room, but conscious of her every step. When she disappeared into the bathroom, Beatrice looked

370

at the table by the bed. There was a thermos, a few small bottles, cigarettes, matches, a book, and a travelling clock. She picked out Marston's photograph on the dressing table, and the children's pictures on the console next to the porcelain vase. The bed had not been turned down. Her glance fell on the draperies on either side of the bed. They hung in straight folds, slightly beyond the posts. She saw the ecru lace spread.

Then she went back to the open window in the other room and waited. She felt as though she were out of her body, watching an alien body and mind at work.

Eileen called from the bedroom: "Mrs. Graham? Mrs. Graham?"

She took her bag from the sofa where she had left it before dinner and went back. The older woman stood near the bed. She had taken off the frilled robe and was standing in her slip, her head bent, as if in thought.

She had hastily cleaned her face, removing her makeup. The white line on her neck now shone pink from rubbing. Her brows were drawn together, her eyes were brooding.

"Can I do anything for you?" She thought to herself, *I mustn't let the maid come in before I find out...*"

"I shall need three Nembutals tonight to make me sleep," Eileen said as she sat down on the edge of the bed, "and a little whiskey. Will you bring me a drink? I wonder where Pat is? It's half past ten. She should be back by now. How many of my guests this afternoon knew about my husband? What were they saying behind my back? I'm going to stop that story. Are you *sure* you didn't hear anything?"

Her voice rose with each staccato sentence. She looked

over her shoulder at Beatrice, who was slowly returning to the room.

"Of course it may not be true. You know how people gossip in Paris. I've heard nothing," Beatrice said slowly.

"I have ways," Eileen shrugged and nodded her head wisely.

Beatrice was silent.

"It's easy once you have a clue."

"Shall I ring for your maid?" Beatrice asked. She stood under the unlit chandelier, and drew a long breath. It seemed that a heavy weight was slowly descending on her. She thought: *It isn't the chandelier, but it seems as though it were. Everybody is alone,* she went on thinking. *Even in the closest of human relations you are alone. Emptiness is all around. I might just as well be suspended in the sky or in a vast hall of statues that are hard and cold. I am the only thing here that breathes and feels.*

She unconsciously stretched out her arms. *They touch nothing,* she thought, *nor have they ever, nor ever will.*

She shook the thought from her mind, to leave room for what she must now face.

Eileen had put on her nightgown and was in bed. "I have rung for Jeannette," She said.

Beatrice remembered that she had asked for whiskey. But she did not move. In the few moments during which Eileen was silent, a plain young woman came into the room with a glass of milk on a tray. It was covered to keep it warm. She put it on the table next to the bed, and began to pick up Eileen's discarded clothes.

372

Beatrice sat on a chair near the table. Jeannette now brought her mistress' brush and comb and a hand mirror from the dressing table.

"You didn't bring my whiskey," Eileen said.

"I forgot. Do you want it now?"

"I take it with the hot milk," Eileen explained.

Beatrice pretended she had not heard.

"Jeannette, bring the whiskey from the other room." Eileen spoke in French. "And, where is Pat?"

"The door of her room is open, Madame."

"After you have brought me the decanter, go and see."

Eileen's voice grated on Beatrice's nerves.

Eileen gave her hair a few careless strokes, tossed the brush and comb on the floor and lay back. "Don't leave me till Pat comes," she said.

"I will wait for her."

Jeannette returned with the decanter, then left the room again. While she was gone, Bea looked at Eileen's face against the pillow. Her every hard line showed in the light which came from the nearby lamp. Bea could not stand the sight of her. She looked away and across the room once more. Her eyes fastened on the window nearest the bed, which she could see through the gap in the slightly open curtains. Then she heard the maid's voice: "Mademoiselle has just arrived, Madame."

"I don't want to see her now," Eileen said sharply. "She will want to talk and I can't bear to listen to her. I just wanted to know she was in."

The girl stooped to the floor as if to remove the brush

373

and comb. Beatrice trembled with disgust.

Eileen said irritatingly, "Stop fussing. Tell Pat to come in and say goodnight after Madame Graham leaves. Here, take these away. And fix the window. It's suffocating in here. That will be all."

In a moment, she spoke to Jeannette again, "Wait! When Monsieur comes in tomorrow morning, inform me at once. Now, hurry. Put out the lights outside."

Silently the girl obeyed her orders.

Beatrice watched while she opened the window, and followed her with her eyes as she crossed the room, hastily taking a last look around, opened the door into the hall, and left.

The only light in the room was now the one near Eileen's bed. When the maid had gone, Eileen sank deeper into the pillows. A wrinkle appeared between her brows. Then with a jerky movement, she raised herself on her right elbow and reached for the small table, where she fumbled among the bottles.

Beatrice got up and took a step towards the table and opened her bag. "Do you take sleeping pills every night?" she asked.

"No, only sometimes." She found the bottle. It was half full. She picked it up and sat back against her pillows. The curtain fell into place.

Eileen's expression was suddenly bitter. "I suppose he won't be back very early." She jerked the cork out of the bottle with her right hand.

Beatrice knew that Eileen must not put the cork back. She took a hasty step nearer the bed and spoke excitedly, "You are not going to do anything silly?"

374

It served its purpose. Eileen made an angry gesture with her right hand, and the cork fell onto the bedspread.

"Not do anything!" she exclaimed. "Not do anything—" The words choked in her throat as she raised herself to look more closely at Beatrice. The cork slipped from the bedspread onto the floor.

Bea took a chiffon handkerchief from her bag and raised it to her face. She wanted to smell its perfume.

Over her handkerchief she saw Eileen in the bed examine the bottle which she still held. She spilled two of the white tablets into the palm of her right hand and reached to return the bottle to the table. She took the cover off the glass of milk and then picked it up. "I'll drink some of it," she said, "to make room for the whiskey."

When almost half of it had been swallowed, Eileen dropped in the tablets, after which she held out the glass towards Bea. "Now put in the whiskey."

"You had better put it down," Bea said. "I might spill some of it on the bedspread." Her arms hung at her sides now; in one she held the bag, in the other the handkerchief. She turned to put the bag on the nearby chair and in that moment Eileen reached for the decanter. With a swift movement Bea intercepted her by taking it herself.

"Hurry up, I want to get to sleep. I mustn't look a sight tomorrow."

"Put the glass down," Bea said.

Suddenly Eileen laughed disagreeably. She set the glass on the table. "As if my life wasn't hard enough," she said.

"Have you ever loved him?" Beatrice asked. She put the decanter down.

Eileen started bolt upright. The draperies fell forward in-

to their accustomed place. Bea saw that it afforded a little protection.

"Loved him?" she demanded. "What do you mean? I have always loved him."

Beatrice looked towards the window where the curtain blew out a little into the room. "Won't that light keep you awake in the morning?" she asked. "Look how the curtain blows." She pointed at the window. "I think the rain is coming in."

Eileen turned and leaned forward to look. Beatrice's handkerchief slipped over the medicinal bottle. She spilled its contents into the milk, put it down and reached for the decanter. It was the work of a second. Eileen Overstreet turned back impatiently. "It's all right," she said. "Tell Pat to come and see me. But tell her not to stay."

Beatrice thought, *People always slip up somewhere. Have I slipped?* Then she remembered, she took a step away from the table to the chair so that Eileen picked up the decanter and filled the glass with whiskey. *If it comes to fingerprints,* she thought. She took her bag off the chair, her back to Eileen. When she looked around again, the empty glass was on the table.

She walked towards the door. Over her shoulder she said, "I think I'll go."

At the door she paused wondering if Eileen would say anything. She went out into the hall, in silence.

She became immediately aware that she was not alone. Halfway between the door and Pat's room a large man was seated on one of the big chairs.

He got up and stood, as if waiting for her approach.

*A detective*, she thought.

"I am sending Miss Patterson in to say goodnight," she remarked in French.

The man had a small moustache and very black hair. He bowed and said *"On me dit que Madame ne se sent pas bien ce soir.*

*"Madame est souffrante.* She said she would take something to make her sleep."

She met Pat at the door of her room. "How is your nephew?" Bea asked.

"A little better, thank you. My dear, I'll never be able to thank you enough..."

Beatrice interrupted. "Don't *thank* me. I wanted to."

Miss Patterson noticed that Beatrice looked very tired. "I'm afraid you have had a bad time. Jeannette tells me—"

"I expect you have had to suffer it often enough. Tell me, why have you stayed with Eileen so long?"

A strange expression came over the old maid's face. "I would do more than that for Mr. Overstreet."

Beatrice now knew she had better leave quickly. She couldn't be certain how soon the sleeping pills would act. "She wants to see you. I'll go now. Good night." She put a hand on Miss Patterson's arm. "I understand."

Quickly she walked down the stairs. François waited below. He gave her a worried look.

*"Bonsoir, François. Madame va un peu mieux."*

*"Bonsoir, Madame, et merci beaucoup."*

# 24

Sandra realized vaguely that someone had been knocking on the door of their bedroom at Château Fleuris. She turned over sleepily. The next knock was louder.

Marston heard it, too. "What is it? Who is there?"

They heard the indistinct voice of Maurice. "It is Maurice, Monsieur."

Marston went to the door and opened it. He stepped hastily into the hall and pulled the door to behind him.

Maurice was trying to speak, but his voice was shaky. It took a few minutes for his master to understand him.

"Monsieur is wanted on the telephone."

He went back into the room and said to Sandra, "It's Doriot. I can't imagine why he is calling me so early."

Sandra raised herself sleepily on one elbow to look at the clock. "It's after nine, darling," she said. "I'm still very sleepy."

Marston slipped on his dressing gown and slippers and joined Maurice who was clasping and unclasping his hands and mumbling, *"C'est épouvantable, c'est épouvantable."*

Marston pushed by him and ran down the stairs and into the hall where the telephone was installed.

When Maurice reached the ground floor, he had recovered himself and went into the dining room. He began hastily to set the breakfast table. *"Monsieur will want breakfast at once."* He went to the kitchen for the coffee, thinking, *I hope it is all for the best. I pray this establishment is not involved—Monsieur is always very careful.*

Indistinctly he heard the one-sided conversation still going on when he came back.

Then Monsieur called out in a voice unlike his own: "Maurice, my car *at once.*"

In the hall he saw that his master had replaced the receiver and stood with one hand resting on the table, so immobile that he fled into the dining room and brought a cup of coffee, into which he had poured some brandy.

Marston's head was down and he had started across to the stairs when the maître d'hôtel overtook him. He took the cup and swallowed the contents. The servant reached for it when it was empty and removed it from his hand.

Marston's actions were scarcely conscious. He seemed separated from his body. His brain was beating against the inside of his head. After the first moment at the telephone, which had stunned him, he felt entirely lucid, and aware of how lucid he was.

*She has killed herself.* He kept repeating it. *How extraordinary that she should have done such a thing. She had such a great desire to live.*

He stood in the hall for a moment. *I must get there at once.* And, with a forward plunge, he rushed up the circular staircase, two steps at a time.

Just in front of their room he came to a standstill. *My*

*God, she must have wanted to die. I'll never get to the bottom of that. Jeannette found her. She'd taken too many sleeping pills. The doctor said it was not an accident. It's the last thing I would have imagined.* The hand that went to the door dropped at his side. *She was sick. Or was she? She didn't suffer. It's strange. I don't seem to feel broken up. I must do something. I wonder if Sandra is asleep? If she were asleep, I could get away without telling her. It might make it easier for her.* He reached again for the knob, and his mind blurred. He opened the door very gently and looked in.

Sandra was awake, disturbed by Marston's absence. She was sitting on the edge of the bed in yellow pajamas.

Marston came in and closed the door.

She sensed at once that something bad had happened and jumped up to meet him She was silently waiting at his side.

"Eileen has done for us," he said, staring down at the rug. He steadied himself on the back of a chair.

She put an arm around his shoulders. "Whatever she has done for you, she has done for me, too."

He went on staring down as if he didn't see anything. Then he suddenly moved to a chair and sat down heavily. Sandra waited motionless.

"This morning she was found dead in her bed."

She knelt beside him. "Marston, you must leave now. They'll need you."

"I'll try to be there before the papers get it. I'll stop any stories. No one knows exept Doriot. They telephoned him from the house. I must get dressed." He did not move.

380

"How did she do it?" Sandra asked. She still knelt in front of him.

"She took an overdose of sleeping pills."

Sandra's heart beat so rapidly that for a moment she could not move. Then she was on her feet and pushed his arm to hurry him. "Get dressed. Have you told Maurice to bring the car?"

He forced himself out of the chair. "I'll get dressed while I wait for the Chef de Sûreté to call me. I've told Doriot to have him call here. I should speak to him myself. I know him well."

His energy seemed to return. He hurried out of the room. Sandra picked up her dressing gown and put it on.

Standing, waiting in the doorway, she thought, *She must have wanted to die. How terrible for Marston that she wanted to die, and for us. Was it physical or mental suffering, or did she go crazy? I wonder why it takes him so long to dress. Perhaps I had better go and see.*

When Marston came out of his room, they walked together to the stairs. He went down ahead of her and stumbled. She groped against the stone walls, eyes closed, feeling that the dreams and reality of their united lives were with each tread dropping away like the hollow echoes of their footsteps.

In the hall he turned and said to her, "I may not be able to get word to you right away, Sandra. What are you going to do?"

"I'll go right back to the apartment where I can be in touch. Don't worry about me."

He looked out across the little terrace and saw the car by

the door. He was leaving the house when Sandra caught his arm. "Wait a minute—the Chef de Sûreté."

He suddenly remembered that he was waiting for a call. He had had a feeling since he went upstairs to speak to Sandra that something was wrong with the house. The feeling was growing on him, taking concrete form. From where he stood, he could see a part of his desk in the library. It was piled with papers and a few books. But it didn't look the same. It seemed shabby, tarnished. The turkey-red curtains were dim and hung limply. Quickly he noticed where the usually bright red chairs grouped around the hearth had taken on a musty, dull look. The hall was darkened by ugly shadow. It seemed shoddy. Fleuris, the emblem of his love, his happiness and relaxation, had lost spiritual nobility. Out through the door and across the fields to their trees and the river, lay a light mist.

He must find Sandra. She was unchangeable. He heard her behind him coming out of the dining room. He saw her bringing him a cup of coffee, her gaze fixed on him. Their eyes met, clear, though frightened, and his mind suddenly became acutely alive to the moment. He knew, as he touched her cheek with one hand, that she sensed the same mockery in Fleuris. He saw it in the way she avoided looking at anything but at him. He took the cup from her, set it down on the table, turned back. She up her arms around his neck in a sudden movement, and he held her close to him. They clung together, their eyes closed to the scene around them.

Then he pulled himself back and she motioned to the cup of coffee. Before he had finished it, the telephone rang.

382

He took up the receiver.

"Yes, I have just been told. I am leaving at once."

A pause.

"Thank you. I shall be in town in less than two hours. Will you see to the press until I arrive? Have you talked to Dr. du Berger? He has been our family physician for years now."

A pause.

"I see. He is there now...You say he told you that my wife is a semi-invalid?"

A pause.

"You are very kind, *mon ami*. I am just leaving."

He walked from the telephone to Sandra and looked at her. They were alone in the hall.

"Sandra," he said abruptly, "You know I can't believe that Eileen could have killed herself. On my way in, I am going to try to think that out."

"Marston, you mean it wasn't an accident?"

"The doctor doesn't think so."

All his energy seemed to have returned. She followed him from the house and into the car. His shoulders were braced and he drove away very fast.

Sandra hurried to her room. *I must get to Paris as quietly as I can,* she thought.

Invisible hands had again been at work. She shuddered to find her bags packed, her clothes folded on a chair.

The door of the dress closet had been left ajar. She covered her eyes to hide the dresses inside. She closed the door, her head turned away.

After a while she heard the toot of a station car. Maurice

stood outside in the hall to take her bags. She tried not to notice anything.

The morning mist was almost gone but the air was still heavy. Other mornings, back in the summer, she remembered hurrying off to get to Feodor's. Then, though she had been leaving, all the countryside seemed to wave *au revoir.* Now it seemed to scowl goodbye. The naked, gaunt fingers of trees stretched menacingly overhead, a profound melancholy lay over the land. Dead leaves rustled beneath the wheels of the car, and, as she turned the corner for a last look at Fleuris, she saw only its naked aspect. Its grace had vanished, blanketed in gloom.

The station master put her into a compartment with her bags beside her.

After a time her apathy passed and slowly she revisited the morning nightmare. *Eileen has done for us.* Marston's marble face. And Fleuris now a hollow shell. As the late autumn landscape crawled past the window of the car, she remembered his last words: *I can't believe that Eileen could have killed herself.*

Then it was an accident. Doriot was wrong, because if she hadn't killed herself and Doriot was right, then she had been killed. Who would want to kill Eileen?

She lay back in her seat, closed her eyes and tried to reason out just what Marston had meant. If only there had been no suicide, then Eileen would not have done for them. There were, she knew, the kinds of people who could kill themselves and the kinds who never could. It was possible to live with a person for years and years and never be certain in which category that person belonged. You

might be deceived by your wife in many ways, and Marston must have been, but this was a fundamental matter. He had said he could not believe it.

Who would want to kill Eileen? Poor Miss Patterson might have had her revenge, but Sandra could not fit Bea's portrait of the gaunt Philadelphian in the role of avenger.

The train was slowing down, gliding into the station, when Sandra emerged from her concentration. She hoped to find an extra, or a later edition of a newspaper that would furnish her with more news, but she found nothing at the Gare Montparnasse, and feeling lost in the pushing crowds, she went straight back to what she thought of now as her only home. Louise's cold greeting, although customary, affected her out of all proportion.

"I wasn't expecting you, Madame."

Sandra felt like leaving at once. "I will be out for lunch. Has anyone telephoned?"

"Count Marbeau called last evening."

The apartment looked gloomy. She had only been away since last night, but Louise must have been cleaning.

"Get some fresh flowers, Louise," she said.

Then she changed her clothes and went down into the street where she took a taxi, explaining to the driver that she must find the lastest edition of some paper.

He advised the Boulevard des Italiens, and started at top speed.

Travelling so fast along the streets soothed her. She noticed that the sidewalks wre crowded with *midinettes*, workmen and *flâneurs*. The cafés overflowed almost to the curbs. It must be lunch time.

When they reached the office of the *Petit Parisien*, the driver swung to the edge of the sidewalk in front of the bulletin board and jammed on his brakes.

The news she was in search of was displayed in large black letters.

On the very day after Marston's great victory in the Merrimée affair, he had suffered an overwhelming sorrow. His wife had committed suicide. Newsboys were leaving the building with papers slung from their shoulders. She leaned out of the car to reach for one.

Under the headlines there were a few short paragraphs. She read them, bent over the page. Her mind grasped and held four items: Marston and his wife had received friends at a cocktail party in the afternoon. Miss Patterson had gone away for the evening and Marston's wife, in excellent spirits, had entertained an American friend, Madame Robert Graham, for dinner. Marston had left Paris on business.

The taxi seemed to sway. *I've got a drunken driver. I had better get out,* she thought.

She looked at the paper again. Now she saw only one statement. Bea had dined with Eileen the night of the suicide. Who else had been there? Why had Bea dined with her? She had told Sandra she was through with her.

The taxi seemed to sway again. It would be better to get out before the drunken driver hit something. What difference did it make who else had dined with Marston's wife? But it must say in the paper. Leaning over the sheet she could find nothing more about the evening. Her mind was searching for something. What was it she was trying to re-

member? Now she remembered. He had said: *I can't believe that Eileen could have killed herself.*

She felt giddy with the monstrous flash of suspicion that came to her. The paper dropped from her hands. "I must be going crazy to think of such a thing," she said aloud.

The driver asked her something through the front window. He noticed that she was very pale and drove on slowly when she did not answer.

She did not know how long a time had passed before she was conscious of being far up on the Boulevard. Her senses had returned. She tapped on one of the windows and said, "Crillon."

*Bea was with Eileen last night. She could be in lots of trouble,* she thought.

The Grahams were both out. The concierge knew her well and he confided in her. Madame had dined with the lady who committed suicide last night. She had been called by the police to attend the coroner's inquest which was to take place today at two o'clock. A mere formality, of course. Monsieur accompanied her.

Sandra's and Beatrice's notes crossed the next day.

> *Please, Bea dear, come to my apartment this evening. Bob told me on the telephone that you would be busy until then. I shall be alone. I want to see you.*
>
> *Love, S.*

She found her friend's note when she came back from

Feodor's, where she had gone to deliver some designs.

Sandra took it into her bedroom and stood near the window to read it. The geraniums had gone and little evergreen bushes had taken their place.

*Sandra, dearest,* it read,

> *When may I come and see you? The inquest is over. It was just a formality. You will have seen by the papers what happened. I should like to come today, if you are free.*
>
> <div align="right">*Bea*</div>

Bea now knew she was waiting for her.

She dressed carefully and went in to dinner. She ate only because Louise had prepared a meal.

In the sitting room, she tried to bring order to her mind. All day it had been in chaos. Now, sitting on a chair in the corner of the room, she laboriously began to reconstruct the sequence of events since yesterday when she had returned from the Crillon.

The apartment had been empty. It had been Louise's afternoon out.

She remembered that she had doubled up on her bed, unable to think consecutively. Her mind had jumped from one irrational instinct to another. Long before the concierge had brought her a late edition of the evening paper, she had known, though without realizing it, that her surmise of the early afternoon, however unbelievable, was true. With the added details, her instinct seemed fact. The paper had dropped from her hands and a deathly blackness walled her

in. It was a horror that had no outlet.

Finally, she saw herself as another person, a person who had gotten up from the bed, picked up the paper, and gone with it into the sitting room where she had turned on the lights and lit a fire. There she had reread the article. Its salient points stood out now in her mind:

> A reception had been held in the Avenue Henri Martin the previous afternoon, during which the hostess had been in the best of spirits. Later, Mrs. Graham, the wife of, etc., had dined with the unfortunate lady, as her companion, Miss Patterson, was called away because of the illness of a relative.
>
> Mrs. Graham after leaving her hostess' bedroom at approximately ten forty, had stopped a moment to speak to Miss Patterson, who had just returned from Fontainebleau, after which she had been let out by the maître d'hôtel, and driven away in her car.
>
> Mademoiselle had been the last person to see her employer, as her husband had left town before dinner to attend a business conference.
>
> It was an unfortunate case of suicide, much to be regretted, etc., etc.

Of the remainder of last evening, Sandra had now no distinct vision. She remembered she had not expected to sleep and suddenly it had been morning, and now it was another night and she was sitting alone waiting for Beatrice. She had filled in the day with insignificant activity. She had gone to the Crillon again to find the Grahams out.

Suddenly Sandra became conscious that someone was in the room. She was on her feet. But it was only Louise, who having finished her work, was asking about tomorrow.

"Tomorrow?" Sandra said. "Oh, yes, tomorrow, I shall be out for lunch and alone for dinner."

The maid held an evening paper in her hand. "Did Madame see that the two children of the unfortunate lady are in Paris? A lady with children should not kill herself."

"But she was an invalid. She suffered great pain."

"God takes when He is ready," Louise said lugubriously. "And she had many friends to cheer her, Madame Graham and many more, no doubt."

"One might think so, but with sick people, one never knows."

Louise's sigh was deep, but obviously her remote connection with the tragedy was affording her a certain excitement. "My husband says invalids are always liable to commit suicide."

"Your husband is right. But it is very sad just the same."

"Of course. Are there any more orders for tomorrow?"

"No, but...wait a minute...I should like my trunks. I want to look them over. It's getting cooler tonight."

"I will fix a fire."

"No, no, it's all right. I don't need anything more. Thank you, Louise. Goodnight."

Impatiently Sandra waited for the door to close behind Louise. She shuddered, went back to her chair, and took up the reconstruction of the day. She had accepted Count Marbeau's invitation to lunch at Fouquet's. She had sorted sketches and designs, taking the last ones to the Marquise at

Feodor's. Everywhere people talked of Marston Overstreet and the unfortunate suicide of his wife. Sandra forced herself to listen. Everyone seemed both to admire and to sympathize with him. Suicide was an unpleasant affair, but there was no suggestion of foul play. The cause of Eileen's death was determined by the coroner, and his word was accepted. Sandra remembered Bea's growing fear for her safety and happiness. Did she discover that Eileen knew her husband's secret? She set hastily to work, adjusting the furniture and moving the smaller objects to exactly where she liked them.

Bea must be on her way now. *Has she made up her mind what she is going to say to me?*

Sandra began to tremble. She crossed to one of the windows, pulled back the flame-colored curtains and opened it and looked out.

There were voices in the street below. The world had not stopped for her. In the house opposite some of the shades had not been drawn, and forms moved. *They can see in here,* she thought, and then half-frightened, *No one must see in here.* Hastily she closed the window and pulled the curtains.

Sandra made an effort to be calm. She sat down on the sofa. Then the bell rang, neither loud nor soft, just like any bell. For a second Sandra felt weak. She couldn't move. Finally, she walked to the door, and opened it for Bea.

A casual, erect and controlled Beatrice—the usual Beatrice—moved past her to the sitting room. Sandra followed her.

Bea said, "I got your letter." she removed her hat. "I've

had it on all day. We've had a lot of arranging to do... Everybody has been *so* kind, but Bob wants to sail back to the States Saturday."

She put her small hat on the table. Then she walked over to the mirror and combed her hair with both hands. Sandra saw that the strong, straight lines of her blue-clad back stood out against the reflection of the pink wall; and, beside it, a view of her head and shoulders appeared in the mirror.

*I wish she had not worn her blue dress. It is the color of her eyes when she is happy,* Sandra thought.

Sandra spoke as though she were out of breath. "I've been trying to get you, but I suppose there is nothing I could have done. What would you like to drink? You must be tired."

"I don't want anything, thanks. But I *am* tired," Bea said.

Sandra saw that her dark lashes gave her eyes the shadowy look which she knew so well.

"Why don't you sit down on the sofa?"

"I'll just sit here. It's so peaceful." She lit a cigarette, staring into the cold fireplace. Sandra looked down at the table where Bea's hat lay among the books and odds and ends. In her mind's eye she still saw the long line of Bea's neck and the way it held her head, erect on a column. She saw, too, her calm, white hands, and the firm curve of her resolute mouth. *She wasn't born like that. She's been made like that,* she thought.

Beatrice was talking about the inquest and how easy it was because of Marston. But Sandra only half-heard her words. She was trying to forget Beatrice's physical presence. Her moral strength was easier to bear. Sandra's

thoughts flew back to her memories of the motor trip.

Sandra was very conscious that Beatrice was occupied trying to figure out just how far Sandra's intuition had taken her. *She passionately wants me to be ignorant, but she is not absolutely sure. She is as sensitive to me as I am to her. I must hide what I know, for her sake.*

Beatrice fell silent. It filled her with panic. Yet she reminded herself that they were often quiet together. Now she must stop the communion of their thoughts.

How often they had sat in the corners of the sofa, talking or not talking, as the mood struck them.

Sandra braced herself and moved to take the vacant seat. She reached to the small table at her elbow, took a cigarette, lit it with steady fingers. "You will sail on Saturday? That's very soon." She forced herself to look at Bea who nodded without turning her face from the cold fireplace.

"Yes."

In that moment all Sandra's thoughts were conditioned by one vital point: *I must hide.* And her emotions were torn by the realization that Bea was fighting a nightmarish secret hidden in her soul. In a moment she answered. "I haven't been able to get used to it."

"I understand," Bea said. "Bob wants to go home and so do I, much as I hate leaving you." She suddenly turned her head to face Sandra. She looked directly at her with a smile that was profound, captivating and loving.

Sandra was stricken. She accepted the smile. It would last her a long time. She put it away reverently, tremblingly, into the innermost part of her memory. It was a magnificent lie. With terrifying speed, Sandra was deluged by the memory

of all that Bea had been to her and all that she had been to Bea. It came in a flood: their understanding and instinctive intimacies, their closeness.

In the silences, Sandra thought, *For such a sacrifice, I have no strength.*

But her sorrow grew like a noise in the room, so loud she thought the walls would echo with it. Yet Beatrice sat silently, a symbol of force, sufficient unto herself. Sandra saw her as a lonely woman, whose robes of pride would forever cover her secret thoughts.

Sandra rose with a fugitive movement. She must move or lose her self-control. She couldn't bear Bea's serenity, a nobility which came from a secret source. As Bea came in the apartment, her shadowed unchanged eyes showed total control—how could her eyes seem the same?

"Oh, Bea, Bea!" Sandra sobbed. A fleeting expression of sorrow crossed her face, almost instantaneously followed by an inner light, more brilliant than any light Sandra had ever seen in her face before.

She crumpled on the floor at Bea's feet. Her hands passionately clasped her friend's knees, her head sank till it lay despairingly on her arms. "Oh, darling," she cried. "Bea, Bea."

Beatrice bent and her head rested on Sandra's. She made no sound until her friend was quiet. Then she lifted Sandra's face close to look into her eyes. "It has always been painfully difficult before to leave you when I went back to America," she said. "It's not so hard this time. Life is richer than I have ever known it to be."

Sandra felt awe. She clasped Beatrice's hands in adoration. Beatrice spoke agian. "I am free for the first time in my life, darling." Her voice was deep, her eyes very blue. "Don't write. I shan't either. Nothing in the physical world is possible between us. Perhaps you don't know that yet, but I do. And I want you to leave it here, my dear."

Both women rose together and walked side by side to the door. Then Bea walked into the grey hall.

She turned back and looked over her shoulder at Sandra and smiled a profound and captivating smile.

Sandra accepted it, but she knew that without her, Bea's smile would never have been born. And she was now part of it forever.

# 25

The *Normandie* was on her homeward passage to France.

For four days Sandra sat in the same chair on the promenade deck, reading herself into the lives of other people. She was now tired of that. She wanted to stop and find a quiet spot between the past and the future. Her one-week visit to America had filled her with happiness.

Now she put down her book and remembered her small, neat package of facts. Tomorrow she would arrive at Le Havre. Her apartment, after being rented for the winter, was free. The Marquise wanted her to return to Feodor's.

A shadow fell on her, and she looked up to see a small, distinguished figure standing above her. "Why, Felix," she exclaimed. "Where on earth have you come from?"

"I have found you," Count Marbeau said with triumph.

"You have been lost," she said.

"Oh, my dearest Sandra, let me sit next to you. I have been so lonely, a prisoner, and sick. I thought I should die."

In a few minutes the Count was established at her side. A steward appeared with champagne and caviar, which Count Marbeau insisted she share with him. He was bubbling with talk. He gave her a full account of his voyage.

"Let me give you all the answers," he said, sipping his champagne.

"What answers?"

"There is only one permanent thing in your country," he proceeded solemnly. "Your divorce courts. The most impermanent is your *Social Register.*"

"Felix," Sandra said, laughing. "I am not a reporter."

"Then what good has all my suffering been?" His face was comically disappointed.

"If you enjoy telling me, of course, go ahead."

"I do. American women are indecently triumphant in their conquests, promiscuously modest in public kissing, blatant about publically exposing their bodies, and secretive about their dressmakers."

Sandra laughed. The Count's wizened face remained unchangeable. "Don't forget the American husband."

"We used to hear of the luxuries they gave their wives. Now they give them to other men's wives."

"Where do the *cocottes* come in, Felix?"

"They are other men's wives, or daughters."

"How cynical!"

"I didn't presume you want a category of virtues from *me.*"

"Praise is so dull," Sandra suggested. "The people you met are just like others in the world. What about art?"

The Count stretched himself on his chair. "Americans are so very new at it that they attribute great significance to every painter, as though the lowest scoundrel could paint the most delicious canvas. And he does. And your tall majestic buildings shelter miserable little minds intent on

pursuing occupations leading them nowhere."

Sandra egged him on. He cheerfully launched into a still further account of his impressions and surprises. Then, he said, "And you, beautiful Sandra, while I was sampling your truly wonderful American hospitality, what were you doing with your adorable self? Is it a secret?"

Sandra explained that she had been in Florence all winter, in an effort to improve her painting, and selling sketches to Feodor "in order to pay for my trip to America."

The Count looked puzzled. "I understand. . .a little. . .women of all nationalities, but the American woman—*nom de Dieu*, she is too simple to be comprehended. You look lovely, are you thinner? Ah, la, la! The lover will come and you will blossom once more. Like last summer."

"As poetic as ever. But, Felix, I don't want to blossom."

"It does not matter, you will. But how is it that I did not see you in New York?"

"I was only there for a week, on business."

"A week! Then you missed Beatrice?" He took another drink of champagne.

"Tell me, how are Bea and Bob? Did you see a lot of them?"

"I saw the boys during their vacation. And dear Bob. One does not realize in Paris what a big man he is in the American business world. And Beatrice was as delightful as ever. I used to find something a little *triste* in her, something elusive, you know. Especially on our trip to Carcassonne last summer. You remember how distraught, almost unkind she was," Marbeau said. "Not that she meant to be. But at home I found her completely charming. They were both so kind

to me. I met interesting guests at their dinners, artistic and political people. She is very active in city politics. Would you ever guess it?''

When Marbeau wandered off somewhere, she remembered what a very long winter it had been in Florence. There were countless times when she fought to suppress the desire to go back to Fleuris. She knew that was open to her at any time, and that Marston wanted and needed her. But she always won her battles. There had been only one crisis back in November. She had to get away. *We must both have time,* she had written him. *It may be true that we shall never change for each other, but there is something else. Our relation to Bea. I want you to have a free life for a while,* she wrote on. *You have never been free. We should both be. Perhaps you need it more than I do.*

She had already sailed by the time he got the letter. She did not tell him how to reach her until a week later. Then he wrote pleading with her. In the end, she acquiesced.

When she wrote again, she said, *Please just answer my letters.* And her letters had not been very frequent or very long, but they had said a lot in a few words and no essentials of her thoughts were lacking.

Very late that night, someone knocked on the door of her cabin. She hadn't slept well during the voyage. She had been reading late. The knock came as she was filled with drowsiness. A sleepy cabin boy handed her a radio message. She signed the receipt for the envelope and handed it back through the door. She returned to her bed and sat down with it. She held it a moment before opening it. Then she started to draw it from the envelope. It stuck at one cor-

ner. She tore it apart, making it difficult to read the clearly typed words:

*Will meet you at Fleuris tomorrow afternoon as soon as you can get there, Darling Sweet heart.*

There was no signature.

The next morning Count Marbeau arranged it that their seats were together on the boat train. During disembarking, and on the way to the railroad coach, he sat immobile, allowing porters and stewards to wait on him. Settled and muffled in a white silk scarf, he supervised everything.

To Sandra, the hedgebound fields, the rolling hills, the fresh, tidy orchards which lay between vegetable gardens and pastures in which cattle browsed, were pure joy. Prosperity and orderliness were apparent on all sides.

When they reached Paris, the Count disengaged himself with embarrassing speed and she found herself alone.

Her arrival into the familiar sounds and sights of Paris produced a new and disturbing element. She did not know quite what to do. The porters were asking questions. *Where am I to go?* she thought. *To an apartment will involve fresh complications which I can't face.* There is the Gare Montparnasse. Shall I go there? In the taxi she dismissed all minor details from her mind. *Marston, I will see you soon.* A wave, warm and sensual, flowed through her.

Later she was on another train, and then in a car. Then at the familiar turn in the road, Fleuris came into view. She covered her face with her hands. Perhaps it would not be the same.

## A Love Affair

The car stopped with a jerk and she opened her eyes. She was at the château. The driver was climbing out of his seat. Dimly she saw Maurice on the terrace. He held something white which fluttered on a tray in his hand. There was no one else about, and she got out of the car and took the fluttering paper. At first she could not read it, then Marston's writing became clear:

> *I will be back later, sweet heart. I have gone for a*
> *walk.*

The texture of the paper conveyed the touch of his hand.

Her first sensation, when she could feel anything at all, was one of numbness. She remembered that last year she had started their new life here alone; but what an infinite difference! Fleuris, how many times she had tried to envision it! For weeks she remembered only the sadness of it, mentally marred on the morning after Eileen's death. Now she looked up at the tower, her favorite part of the château. Its rugged lines rose from the little terrace base, stalwart and proud, while the rest of the building seemed gracefully to lie in its protection.

Quickly she went into the house and straight to the library. Everything was as she remembered they had left it: his books and piled papers, their chairs on either side of the fireplace. She took off her hat and threw it on the sofa. Then looked up to see that a new picture had been hung above it. It was her sketch of the aviation field with Merrimée in his aeroplane. She paused, arrested by the thought of the last time she had seen it: the evening Bea had spent

with them. A strange fancy jumped momentarily into her mind. Had it unconsciously played a role in Beatrice's existence? It had played a part in Marston's. She wanted now to feel nearer her Bea and went into the sitting room where they had sat together that evening long ago. Here Bea was all about her in the air. Her yellow dress still glowed against the blue chairs.

Years ago, when they were children at school in Switzerland, Beatrice wore a yellow dress, but the shade had not been as pretty. She liked Bea best in blue. She had worn a blue dress the last time she saw her, and her eyes had been dark, but when she went away, her eyes had been the blue of happiness.

She rushed out now down the path that led to the river. It was down by the bridge that her most poignant memories of Bea centered. Of Marston, too. But she saw, in her mind's eye, the bank on the edge of the river. Bea was seated there, her back against a tree trunk and the tea things spread in front of her.

Her steps flew faster, and with each step now Bea came closer into her memory. *The shadow,* she thought, *It was a slight shadow I felt, but it fell on us that day we sat there. Now I know that her concern and worry were for Marston and me.*

She saw the old gateposts ahead and for a moment noticed that though the vines showed a year's growth, yet they also showed more care, folded back into place, encouraged to twine where they should. Then she observed that the woodland path was cleared.

On she went, then hearing the sound of the river, stopped, and the whole weight of her loneliness for Bea

402

swept over her. She clutched at her throat as if to strangle the pain, and then scarcely knowing what she did, ran on at top speed over the uneven path till she came to the open space at the bridge, where she drew up panting and exhausted. Someone, she felt, must be twisting her lacerated feelings. She ached through and through. In a moment she stumbled on a few steps and dropped under the tree, where Beatrice had sat, her body shaken by sobs.

After a time she gained some control and raised herself to a sitting position. She started straight ahead and without knowing spoke aloud: "Bea, Bea, I want you, I need you. You did it for us. Oh, darling Bea!"

Marston, who had been watching her for the last few minutes, took a quick step forward and she was in his arms. "Sweet heart."

They clung to each other. It was enchantment.

"It's been so long," she kept repeating. Her instantaneous change from misery to joy left her weak.

Later Marston caressed her hair, passed his hand along the line of her neck to her back, fondled her cheek, laid his head on her lap to gaze up into her face noticing how pale and thin she was. He could not bear not to touch her. He wanted to explore her afresh, gently, as if she were a fragile flower. She responded to him. She stroked his face with trembling fingers, laid her head on his chest and held his hand to kiss his fingers.

At last she returned from a sad world to the world around her. She saw the silvery gold of the river and the bridge.

Marston spoke first, "My darling, if I had known how..."

She interrupted, "You were right to leave me alone with her."

"I thought so, but when I saw you just now..."

"It was my own loss that I was suffering, that can never be minimized. But I have something more to tell you. It belongs to you as it does to me." She had never doubted that the recognition of Bea's gift was as real to Marston as it was to herself.

He caressed her hand as he held her against him.

"I went to America," she said, looking at him, "because I had to know about her. I went when she was away." Her voice shook, but she did not falter. "In November she said to me, 'Nothing in the physical world is possible for us.' I knew that she was right. I never tried to disprove it."

Sandra drew away so that she could look into his eyes. He saw the tears that made hers misty, and took her face between his hands with infinite passion. The tears overflowed onto her cheeks as she moved closer to him, so close that she felt his heart beat against her. When she spoke her voice was tremulous. "She is free now. She did something that made her free. I can't explain why, but it's true. It's not just because I want to think it so, because it *is* true. She is free."

Marston held her and said, "There are no words for Beatrice. She transcends words."

"She is Beatrice," Sandra sobbed, her head against his shoulder.

When in a few minutes she looked up, he spoke to her. "Sandra, see, there is our bridge."

He kissed her tears till they were dry.

"I see it now. Who has been fixing it?"

He looked rather shamefaced. "I came down to get the place in order. It was fun making it safe.

404

*A Love Affair*

"Did you fix the vines on the gateposts, too?" she asked.

"Yes, and the library door. Didn't you notice?"

Each step as they progressed over the steadied planks gave her a sense of being reborn. She stopped for a second midway, captivated. Marston's back against the forest greens! She hurried forward, joined him on the other side, and suddenly she was aware of him as her lover. She knew that with him as her lover, the future was limitless.

On through the fields they went and into the forest where the sun and cloud dappled the ground with designs. When the path became very narrow, she fell behind. "Go on, I like to know you are there," Sandra said.

It was not until he stopped just ahead of her and she saw him staring up into the trees that she felt the sky, the forest, or the clearing.

She followed his look, saw smoke spiralling in the air.

"Darling, our gypsies!"

He no longer looked upward but turned to face her, intent. "There certainly is smoke."

"Wouldn't it be wonderful if they were the *same* gypsies?" In her eagerness she took a few steps forward. The twigs snapped under her feet so that in the stillness, sounds reverberated through the forest.

"Hush," he said. "We may want to creep back as we did before."

"No, no, let's go and speak to them. What fun!" she laughed.

With wary steps they moved on towards the clearing, Sandra's eyes bright with excitement. "How lovely of them to be here now..."

Marston fell back. He wanted to be able to look at her. He would have liked to gain time before coming to the gypsy camp. Her litheness was like the swaying of tree branches when the wind ruffles their serenity. Her very frailness gave force to her vitality, like a tree that bends, then rights itself after the storm, because it is supple. Marston caught his breath at the memory.

Suddenly she stopped. Her hand stretched for his with a quick movement. Together they crouched behind a fallen tree trunk.

"It could be a year ago." He could scarcely hear her words, but he watched her while she watched the smoldering fire beside the same half-charred stump with its overhanging kettle.

She gasped. "The same tree, but it's not the same kettle. Look how too bright it is."

"Our gypsies have become civilized," Marston said.

"Look at their wagon," she exclaimed. "It's beautifully painted. And *no* refuse. It doesn't even smell of onions."

"They will hear us."

Sandra was conscious of the silence of the woods. Her arm around Marston's shoulder, she leaned against him.

Near the red-and-orange cart a horse browsed, not an old nag, but a strong, happy, well-fed animal.

A breeze came through the clearing. As the fire beneath the kettle blew to one side, an added shaft of smoke immediately followed it.

Sandra wondered if she listened whether she would be able to hear the sounds of gypsy language? Her eyes fixed on the door of the cart. Could it be true? There was no

sound and no gypsies appeared to duplicate the past.

Hiding her thoughts, she asked, "Where are they?"

"Lazy devils, gypsies!" he said close to her ear. "Roaming, loving, nothing but endless joy."

She hid her smile. "They must have built the fire and stolen a new horse. He is positively fat."

"Very amorous, gypsies... Nothing else to do."

"The wagon seems a little brighter," she said.

He raised himself to a standing position.

"No, no," she seized him, now eager to prolong the game. She drew him back beside her. She repeated his words of long, long ago: "We might spoil it."

Marston kissed her hair and the nape of her neck, his arms tight around her waist. "Are you glad their wagon is here, Sandra?"

"What fun to see what it's like inside. Do we dare? It's risky, sweet heart."

Together they ran across the clearing. When they were close to the door of the cart, she stopped suddenly.

"Listen!"

Marston stepped up and opened the door of the cart. Sandra was close behind. He turned, swept her in his arms and lifted her over the threshold into the bright interior. She saw a riot of color within, and she found, as she knew she would, that it was empty. "Oh, darling, how wonderful!"

"Do you like your gypsy, darling?" he asked.

She threw her head back and laughed. "I had supposed gypsies always lived like this. I suppose there are hygienic gypsies, just like hygienic everything else."

Marston gazed into her upturned face. He saw in it a kind

of childlike eagerness that responded to his own cravings.

"Fleuris is ours now," he said.

"Everything I have is here," she said.

A whisper floated through Sandra's lips as she laid her cheek against Marston's. Then quickly she jumped aside and went delightedly to finger the painted crockery, the stove, its array of saucepans and underneath cabinets with glassware and shiny chromium spoons.

"This lovely bright blue sofa makes into a bed," she said excitedly, "and look, here is where the gypsies hang their clothes." She paused to throw an arm around his neck, and pulled aside the curtain. Her clothes hung on hooks. Turning to the built-in chest of drawers, she passed her hand over his. She caressed them, feeling their texture. "I am going crazy! And your own hairbrushes!" With reckless gestures, she pulled open the drawers. "My stockings, my scarves, my pajamas."

He slipped his arm around her waist. She swept him aside as her eyes fastened on a colored map hanging over the sofa. She knelt on the cushions to examine it. Stretched before her lay Middle Europe and the Near East.

She reached for Marston. Their hands met. The life in her eyes drew him.

"Hitch up the horse," she said, "while I brew a gypsy libation to drink before supper."

"A libation, sweet heart?"

She touched his shoulder. "A libation to freedom."